Oil Paintings in Public Ownership in Birmingham

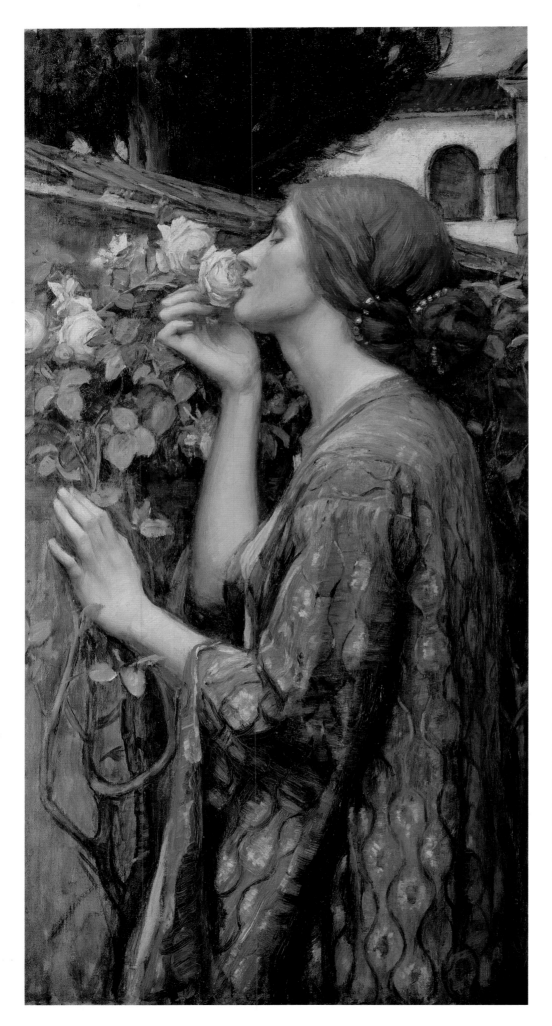

Christie's is proud to be the sponsor of The Public Catalogue Foundation in its pursuit to improve public access to paintings held in public collections in the UK.

Christie's is a name and place that speaks of extraordinary art. Founded in 1766 by James Christie, the company is now the world's leading art business. Many of the finest works of art in UK public collections have safely passed through Christie's, as the company has had the privilege of handling the safe cultural passage of some of the greatest paintings and objects ever created. Christie's today remains a popular showcase for the unique and the beautiful.
In addition to acquisition through auction sales, Christie's regularly negotiates private sales to the nation, often in lieu of tax, and remains committed to leading the auction world in the area of Heritage sales.

CHRISTIE'S

Oil Paintings in Public Ownership in Birmingham

The Public Catalogue Foundation

Andrew Ellis, Director
Sonia Roe, Editor
Dr Camilla Stewart, Catalogue Coordinator
Robert Glowacki, Todd-White Art Photography

First published in 2008 by the Public Catalogue Foundation, 33 Maiden Lane, Covent Garden, London WC2E 7JS

ISBN 1-904931-38-3 (hardback)
ISBN 1-904931-39-1 (paperback)

Birmingham photography: Robert Glowacki, Todd-White Art Photography

Designed by Jeffery Design, London

Distributed by the Public Catalogue Foundation
33 Maiden Lane, Covent Garden
London WC2E 7JS
Telephone 020 7395 0330

Printed and bound in the UK by Butler & Tanner Printers Ltd, Frome, Somerset

Cover image:

Millais, John Everett 1829–1896
The Blind Girl (detail), 1856
Birmingham Museums and Art Gallery, (see p. 144)

Back cover images (from top to bottom):

Botticelli, Sandro 1444/1445–1510
The Descent of the Holy Ghost, c.1495–1510
Birmingham Museums and Art Gallery (see p. 41)

Derain, André 1880–1954
Bartolomeo Savona, 1906
The Barber Institute of Fine Arts (see p. 229)

Bartlett, Paul T. b.1955
Triangular Relationship, 1979–1980
Royal Birmingham Society of Artists (see p. 205)

Contents

Foreword

In March this year, we celebrate our fifth anniversary. Five years since the launch of the Foundation at the National Gallery, thanks importantly to the courage and vision of its then new Director, Charles Saumarez Smith; and four years since the publication of our first catalogue. This, our twentieth catalogue, is therefore both something of a watershed and a milestone. The journey so far has provided some 40,000 images and some 11,000 artists. By the middle of this year, we expect to have catalogued about 25% of the UK's National Collection.

So, Birmingham, in the heartland of the Kingdom, is a good place to pause and reflect. This City offers two outstanding collections: Birmingham Museums and Art Gallery and The Barber Institute of Fine Arts. Both happen to be housed in very different but wonderful buildings by fine architects. Both report impressive increases in visitor numbers in 2007. What is the catchment area for this rising audience? It is not entirely clear but the evidence suggests it is essentially local – and not the least of the reasons for this, in the case of the Birmingham Museums and Art Gallery, is that as a local authority gallery, it is centrally marketed by the authority as a local service – which is entirely as it should be. But does this make sense in the context of a National Collection?

Elsewhere in Europe, it is a little different. We are as likely to visit a gallery in Lille as in Paris; in Barcelona, as in Madrid; or Munich, as in Berlin or Bonn; in Florence or Venice as in Rome. Yet, how many visitors to Britain understand that by visiting our galleries in Edinburgh, Oxford, Manchester, Liverpool, Leeds, Chichester, Cambridge, Cardiff, Southampton or Birmingham and so many other places they can enjoy collections of transforming value, that provoke, please, educate and entrance and that in quality and quantity and range match or challenge anything to be seen anywhere else in the world?

More importantly, how many of us in Britain know that? Not many of us, is one answer. Not enough of us, another. My hope and belief is that the work that we are doing at the PCF will help to change this: that for good social and economic reasons, these collections will be recognised as a National Collection that needs to be promoted and maintained as such: and that visitors interested in visiting Birmingham's museums are as likely to be found in Bristol or Southampton, Bordeaux or Turin, as in Edgbaston or even Stoke.

I would like to thank our small Birmingham team for their excellent work in the field. The team comprised our local County Coordinator, Dr Camilla Stewart, and our photographer in this instance, Robert Glowacki. They have contributed towards a fine catalogue.

The funding of the publication of this catalogue was made possible first and foremost by the generosity of the Renaissance West Midlands Museums Hub. This is the second West Midlands catalogue to be funded by the Hub. Special thanks go to Rita McLean. A number of charitable trusts have also supported us in the financing of this publication. The Charles Hayward Foundation, having supported us already in Staffordshire, in particular deserves our appreciation for lending a hand a second time. However, they were not alone in providing support and to all the financial supporters of this catalogue I extend our great thanks.

Fred Hohler, Chairman

The Public Catalogue Foundation

The Public Catalogue Foundation is a registered charity. It is publishing a series of illustrated catalogues of all oil paintings in public ownership in the United Kingdom.

The rationale for this project is that whilst the United Kingdom holds in its public galleries and civic buildings arguably the greatest collection of oil paintings in the world, an alarming four in five of these are not on view. Furthermore, few collections have a complete photographic record of their paintings let alone a comprehensive illustrated catalogue. In short, what is publicly owned is not publicly accessible.

The Public Catalogue Foundation has three aims. First, it intends to create a complete record of the nation's collection of oil, tempera and acrylic paintings in public ownership. Second, it intends to make this accessible to the public through a series of affordable catalogues which will later go online. Finally, it aims to raise funds for the conservation and restoration of paintings in participating collections through the sale of catalogues by these collections.

Collections benefit substantially from the work of the Foundation not least from the digital images that are given to them for free following photography and the increased recognition that the catalogues bring. These substantial benefits come at no financial cost to the collections. The Foundation is funded by a combination of support from individuals, companies, the public sector and charitable trusts.

Financial Supporters

The Public Catalogue Foundation would like to express its profound appreciation to the following organisations and individuals who have made the publication of this catalogue possible.

Donations of £10,000 or more

Renaissance West Midlands

The Monument Trust

Donations of £5,000 or more

The 29th May 1961 Charitable Trust
The FIRS Trust

The Charles Hayward Foundation
The Owen Family Trust

Donations of £1,000 or more

Birmingham Common Good Trust
Covent Garden London
John Feeney Charitable Trust
Marc Fitch Fund
National Gallery Trust
P. F. Charitable Trust

The Pilgrim Trust
Stuart M. Southall
The Bernard Sunley Charitable
	Foundation
Garfield Weston Foundation

Other Donations

S. & D. Lloyd Charity

National Supporters

The Bulldog Trust
The John S. Cohen Foundation
Covent Garden London
Marc Fitch Fund
The Monument Trust
National Gallery Trust

Stavros Niarchos Foundation
P. F. Charitable Trust
The Pilgrim Trust
The Bernard Sunley Charitable
	Foundation
Garfield Weston Foundation

National Sponsor

Christie's

Acknowledgements

The Public Catalogue Foundation would like to thank the individual artists and copyright holders for their permission to reproduce for free the paintings in this catalogue. Exhaustive efforts have been made to locate the copyright owners of all the images included within this catalogue and to meet their requirements. Copyright credit lines for copyright owners who have been traced are listed in the Further Information section.

The Public Catalogue Foundation would like to express its great appreciation to the following organisations for their kind assistance in the preparation of this catalogue:

Bridgeman Art Library
Flowers East
Marlborough Fine Art
National Association of Decorative & Fine Arts Societies (NADFAS)
National Gallery, London
National Portrait Gallery, London
Royal Academy of Arts, London
Tate

The participating collections included in this catalogue would like to express their thanks to the following organisations which have so generously enabled them to acquire paintings featured in this catalogue:

Contemporary Art Society
The Friends of Birmingham Museums and Art Gallery
The Friends of the Barber Institute
Heritage Lottery Fund (HLF)
MLA/ V & A Purchase Grant Fund
National Art Collections Fund (The Art Fund)
The Public Picture Gallery Fund

Catalogue Scope and Organisation

Medium and Support

The principal focus of this series is oil paintings. However, tempera and acrylic are also included as well as mixed media, where oil is the predominant constituent. Paintings on all forms of support (e.g. canvas, panel, etc.) are included as long as the support is portable. The principal exclusions are miniatures, hatchments or other purely heraldic paintings and wall paintings *in situ*.

Public Ownership

Public ownership has been taken to mean any paintings that are directly owned by the public purse, made accessible to the public by means of public subsidy or generally perceived to be in public ownership. The term 'public' refers to both central government and local government. Paintings held by national museums, local authority museums, English Heritage and independent museums, where there is at least some form of public subsidy, are included. Paintings held in civic buildings such as local government offices, town halls, guildhalls, public libraries, universities, hospitals, crematoria, fire stations and police stations are also included.

Geographical Boundaries of Catalogues

The geographical boundary of each county is the 'ceremonial county' boundary. This county definition includes all unitary authorities. Counties that have a particularly large number of paintings are divided between two or more catalogues on a geographical basis.

Criteria for Inclusion

As long as paintings meet the requirements above, all paintings are included irrespective of their condition and perceived quality. However, painting reproductions can only be included with the agreement of the participating collections and, where appropriate, the relevant copyright owner. It is rare that a collection forbids the inclusion of its paintings. Where this is the case and it is possible to obtain a list of paintings, this list is given in the Paintings Without Reproductions section. Where copyright consent is refused, the paintings are also listed in the Paintings Without Reproductions section. All paintings in collections' stacks and stores are included, as well as those on display. Paintings which have been lent to other institutions, whether for short-term exhibition or long-term loan, are listed under the owner collection. In addition, paintings on long-term loan are also included under the borrowing institution when they are likely to remain there for at least another five years from the date of publication of this catalogue. Information relating to owners and borrowers is listed in the Further Information section.

Layout

Collections are grouped together under their home town. These locations are listed in alphabetical order. In some cases collections that are spread over a number of locations are included under a single owner collection. A number of collections, principally the larger ones, are preceded by curatorial forewords. Within each collection paintings are listed in order of artist surname. Where there is more than one painting by the same artist, the paintings are listed chronologically, according to their execution date.

The few paintings that are not accompanied by photographs are listed in the Paintings Without Reproductions section.

There is additional reference material in the Further Information section at the back of the catalogue. This gives the full names of artists, titles and media if it has not been possible to include these in full in the main section. It also provides acquisition credit lines and information about loans in and out, as well as copyright and photographic credits for each painting. Finally, there is an index of artists' surnames.

Key to Painting Information

Almost all paintings are reproduced in the catalogue. Where this is not the case they are listed in the Paintings Without Reproductions section. Where paintings are missing or have been stolen, the best possible photograph on record has been reproduced. In some cases this may be black and white. Paintings that have been stolen are highlighted with a red border. Some paintings are shown with conservation tissue attached to parts of the painting surface.

Adam, Patrick William 1854–1929
Interior, Rutland Lodge: Vista through Open Doors 1920
oil on canvas 67.3 × 45.7
LEEAG.PA.1925.0671.LACF

Artist name This is shown with the surname first. Where the artist is listed on the Getty Union List of Artist Names (ULAN), ULAN's preferred presentation of the name is given. In a number of cases the name may not be a firm attribution and this is made clear. Where the artist name is not known, a school may be given instead. Where the school is not known, the painter name is listed as *unknown artist*. If the artist name is too long for the space, as much of the name is given as possible followed by (…). This indicates the full name is given at the rear of the catalogue in the Further Information section.

Painting title A painting title followed by *(?)* indicates that the title is in doubt. Where the alternative title to the painting is considered to be better known than the original, the alternative title is given in parentheses. Where the collection has not given a painting a title, the publisher does so instead and marks this with an asterisk. If the title is too long for the space, as much of the title is given as possible followed by *(…)* and the full title is given in the Further Information section.

Execution date In some cases the precise year of execution may not be known for certain. Instead an approximate date will be given or no date at all.

Artist dates Where known, the years of birth and death of the artist are given. In some cases one or both dates may not be known with certainty, and this is marked. No date indicates that even an approximate date is not known. Where only the period in which the artist was active is known, these dates are given and preceded with the word *active*.

Medium and support Where the precise material used in the support is known, this is given.

Dimensions All measurements refer to the unframed painting and are given in cm with up to one decimal point. In all cases the height is shown before the width. An (E) indicates where a painting has not been measured and its size has been calculated by sight only. If the painting is circular, the single dimension is the diameter. If the painting is oval, the dimensions are height and width.

Collection inventory number In the case of paintings owned by museums, this number will always be the accession number. In all other cases it will be a unique inventory number of the owner institution. (P) indicates that a painting is a private loan. Details can be found in the Further Information section. Accession numbers preceded by 'PCF' indicate that the collection did not have an accession number at the time of catalogue production and therefore the number given has been temporarily allocated by the Public Catalogue Foundation. The ✹ symbol indicates that the reproduction is based on a Bridgeman Art Library transparency (go to www.bridgeman.co.uk) or that Bridgeman administers the copyright for that artist.

Facing page: Brueghel, Pieter the younger, 1564/1565–1637/1638, *Two Peasants Binding Faggots* (detail), The Barber Institute of Fine Arts, (p. 222)

THE PAINTINGS

Aston University

Edwards, John b.1940
Dr Joseph Albert Pope, Vice-Chancellor
(1966–1979) c.1980
oil on canvas 89.5 x 69.8
OP003

Edwards, John b.1940
Lord Nelson of Stafford, 1st Chancellor of Aston
(1966–1979) c.1980
oil on canvas 90 x 69.8
OP002

Lewis, Reginald b.1901
James Gracie
oil on canvas 75 x 62.2
OP005

Shephard, Rupert 1909–1992
Sir Joseph Hunt, MBE, Pro-Chancellor c.1970
oil on canvas 89.2 x 69
OP001

Shephard, Rupert 1909–1992
Sir Peter Venables, Principal of the College of
Advanced Technology (1955–1966) and Vice-
Chancellor of Aston (1966–1969) c.1970
oil on canvas 89.5 x 69
OP004

unknown artist late 20th C
Mount Fuji
oil on canvas 44.2 x 60
OP006

Birmingham and Midland Institute

Manns, H. C.
John Alfred Langford (1823–1903) 1863
oil on canvas 74 x 62
MI002

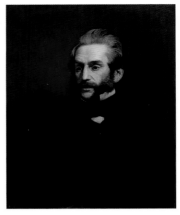

unknown artist
George Jabet 1863
oil on canvas 74 x 62
MI005

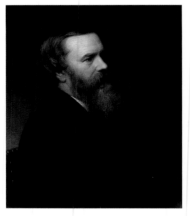

unknown artist
John Henry Chamberlain (d.1883) c.1883
oil on canvas 75 x 62
MI001

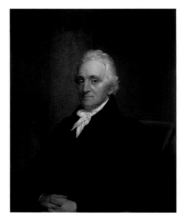

unknown artist 19th C
John Lee Junior (b.c.1803)
oil on canvas 89 x 72
MI003

unknown artist
*Reverend Samuel Wilson Warnefield
(1763–1840), LLD, First Visitor*
oil on canvas 236 x 147
MI004

Birmingham
Central Library

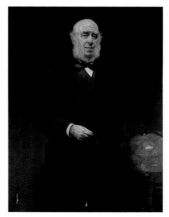

Priest, Alfred 1874–1929
Sir Benjamin Stone (1838–1914) 1903
oil on canvas 121.9 x 101.6
01

Birmingham City University

The University Art Collection is an interesting and unique collection reflecting over 150 years in the history of Birmingham City University. The University has eight faculties spread across nine sites around the city. There has been no formal collecting policy and as a result the collection is stylistically diverse, as it has grown through acquisitions and donations in ways that reflect the history and interests of individual staff members, departments and faculties.

The present University has grown from a number of colleges, each with distinctive histories. Renamed Birmingham City University in 2007, the institution was formally designated a university as the University of Central England in Birmingham (UCE) in 1992, prior to which it was known as Birmingham Polytechnic. The Polytechnic was initially formed in 1971 out of five colleges: Birmingham College of Art, Birmingham School of Music, Birmingham College of Commerce, South Birmingham Technical College and North Birmingham Technical College. In 1975, a further three colleges joined the Polytechnic: Anstey College of Physical Education, Bordesley College of Education and the City of Birmingham College of Education. In 1988 Bournville College joined the Polytechnic. As a University, the institution has continued to expand. During 1995 it merged with two more colleges: Birmingham and Solihull College of Nursing and Midwifery and West Midlands School of Radiography. In 2001, the Defence School of Health Care Studies joined the Faculty of Health and Community Care. Most recently, in 2005, the Birmingham School of Acting became the eighth faculty.

The University Art Collection has grown along with the institution. In line with the University's vision of itself as an institution which fosters intellectual, critical and creative endeavour, the Collection demonstrates a strong commitment to acquiring works by staff and students of its own art and design faculty, Birmingham Institute of Art and Design (BIAD). The focus on student work means that much of the art in the Collection is by artists whose names will be largely unfamiliar. However, the Collection's holdings also include works by internationally renowned artists. These include paintings by the abstract artist William Gear (1915–1997), Head of the Faculty of Fine Art from 1964 until his retirement in 1975, whose work hangs in both the Birmingham Institute of Art and Design and the Directorate. Other notable works include the large *Interior Scene* by Mike Holland (1947–2002), which is housed in the library of the Grade I listed School of Art building in Margaret Street. Holland joined the University as Head of Painting in 1993 and from 1997 was Head of the School of Fine Art.

BIAD was formed originally as the Birmingham Government School of Design in October 1843 and has always taught both fine art and design. The University Art Collection includes not only paintings, but also designs for fashion, furniture, jewellery, ceramics, glass, products, theatre as well as interior and architectural designs. Whilst most of these design works are in other media and beyond the remit of this PCF publication, examples in oil paint can be seen in student William James Barber's (b.1946) two paintings entitled: *Design for an Axminster Carpet* (1967). Encompassing all media, the wider University Art Collection includes over 500 works and is still growing. In addition there are over 4,000 further art works by former staff and students in the Archives,

although these are primarily works in pencil, watercolour and prints.

This focus on works by staff and students is one of several key themes that can be uncovered in the Collection. Another theme is the depiction of portraits of staff and notable figures in the institution's history. For example, the portrait, *Frank Jackson* (1898) depicts the artist at the time of his retirement from the Birmingham School of Art. Jackson had taught at the School of Art for 34 years, starting as a Pupil Teacher in 1864 and rising to Second Master. The portrait was painted by Edward Samuel Harper (1854–1941), a former pupil and teacher of life drawing at Birmingham School of Art for over 35 years (1885–1920). In the Conservatoire hangs a portrait by an unknown artist of Sir Granville Bantock (c.1940) the College of Music's first principal from 1900–1934. A third theme that can be discerned in the Collection is the close relationship between the University and the City. In 1885 Birmingham became the first Municipal School of Art and introduced a strong Arts and Crafts ethos to the curriculum. The Birmingham School of Art was instrumental in shaping the fine arts of Birmingham and the surrounding region in the late nineteenth and early twentieth centuries. The majority of the artists in the loosely termed 'Birmingham School' were students or staff (often both) at the School and the majority are represented in the Collection and Archives in other media. A key work illustrated in this volume is the fresco *Self Portrait* (1925) by Joseph Edward Southall (1861–1944). An advisor to the School of Art and a Birmingham artist, Southall was instrumental in the rediscovery of the techniques of tempera painting.

More recently, in 2006 the City returned to the University the large painting *Life's Journey* (1961–1962) by Katherine Mary Fryer (b.1910). The painting was originally one of a number of works commissioned by the City Council from staff at the then College of Art for the new Birmingham Register Office in 1961. With the move of the Register Office again to newer premises, the painting now hangs in the TIC, the University's Technology Innovation Centre at Millennium Point. In many ways, the title of Fryer's painting can be taken as a metaphorical description for the Collection. The Art Collection reflects the history and journey of the University. Stylistically it demonstrates the journey of painting from the nineteenth-century to contemporary practices. Centred as it is on the works of staff and students, the Collection embodies the educational mission of the University and the formative role it plays in preparing students of all ages for their future lives. Both the Collection and the institution are growing and the journey continues.

Sian Everitt, Keeper of Archives

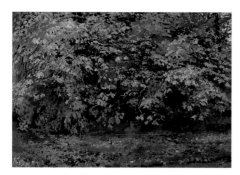

Abell, Roy b.1931
Woodland Scene c.1990
oil on canvas 98 x 127
UA.PB.104

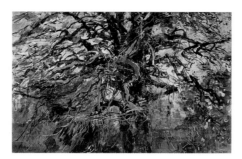

Abell, Roy b.1931
Autumnal Scene
acrylic on paper 68.5 x 83
UA.GG.027

Abell, Roy b.1931
Street Scene
oil on canvas 105 x 132
UA.GG.087

Abell, Roy b.1931
Woodland Scene
oil on paper 80 x 102
UA.PB.121

Barber, Natalie b.1984
Now We Are Having Fun 2006
acrylic & mixed media on canvas 102 x 102
UA.PB.152

Barber, William James b.1946
Design for an Axminster Carpet 1967
oil on card 46 x 46
SA/AT/24/1/4

Barber, William James b.1946
*Design for an Axminster Carpet with Wool
Samples* (detail) 1967
oil on paper with wool 76.3 x 113
SA/AT/24/1/5

Barnard, Elizabeth Fay b.1984
Hastings: Past and Present 2006
acrylic & mixed media on board 123 x 251 (E)
UA.PB.022

Baxter, Emma b.1984
Cellular 2006
acrylic & mixed media on canvas 150 x 100
UA.PB.023

Bird, Daniel b.1984
Persona 2006
acrylic on canvas 50.6 x 40.4
UA.PB.020

Bird, Daniel b.1984
Persona 2006
acrylic on canvas 50.6 x 40.4
UA.PB.021

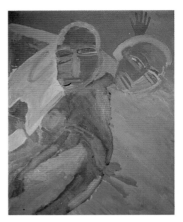

Bond, Joanna
Figure Study 1987
oil on canvas 182 x 142.5
UA.GG.106

Bradley, Roy
Untitled 1993
acrylic on canvas 152 x 210
UA.PB.066

Brindley, Amy b.1983
Untitled c.2005
acrylic on board 122 x 121.5
UA.PB.077

Brindley, Amy b.1983
Untitled c.2005
acrylic on board 30.2 x 30.2 (E)
UA.PB.078

Brindley, Amy b.1983
Untitled c.2005
acrylic on board 30.2 x 30.2 (E)
UA.PB.079

Brindley, Amy b.1983
Untitled c.2005
acrylic on board 30.2 x 30.2 (E)
UA.PB.080

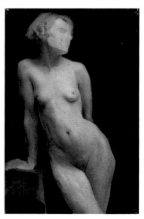

Brockhurst, Gerald Leslie 1890–1978
Study of a Standing Female Nude
c.1901–1907
oil on canvas on card 56.1 x 35.1
SA/AT/10/1/12

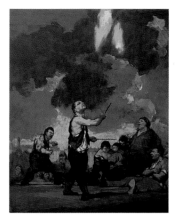

Burroughs, Matthew
Performance Scene 1993
oil on canvas 245 x 184.5
UA.GG.005

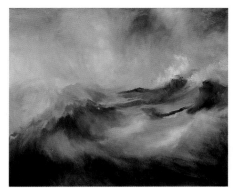

Cam
Vuleen Jewell 1986
oil on paper 121 x 135
UA.PB.034

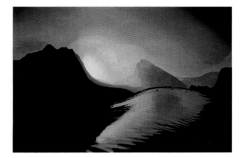

Capers, Hilary Jane b.1976
Sunset 1998
acrylic on canvas 76 x 105
UA.WB.012

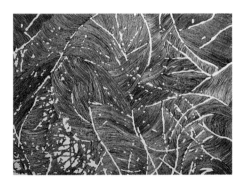

Cestari, Clarissa b.1977
Abstract Study 2000
oil on canvas 201 x 262
UA.GG.044

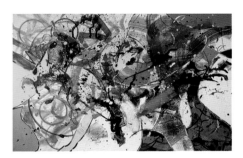

Chadwick, Mark b.1983
Motor Painting by Random No.3 2006
acrylic on canvas 143 x 219
UA.GG.139

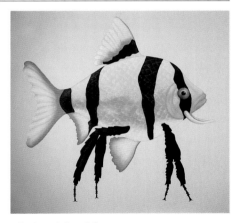

Clarke, Richard b.1975
Fish Creature c.1999
oil on canvas 158 x 158
UA.MS.020

Cope, Diana b.1948
Chips c.2005
oil on canvas 104 x 53 (E)
UA.PB.041

Corby, Samantha b.1981
Head of a Girl 2004
oil on canvas 69 x 59.7
UA.GG.032

Dubnyckyj, Alicia b.1979
Half-Nice 2001
emulsion on canvas 183.2 x 122
UA.OG.027

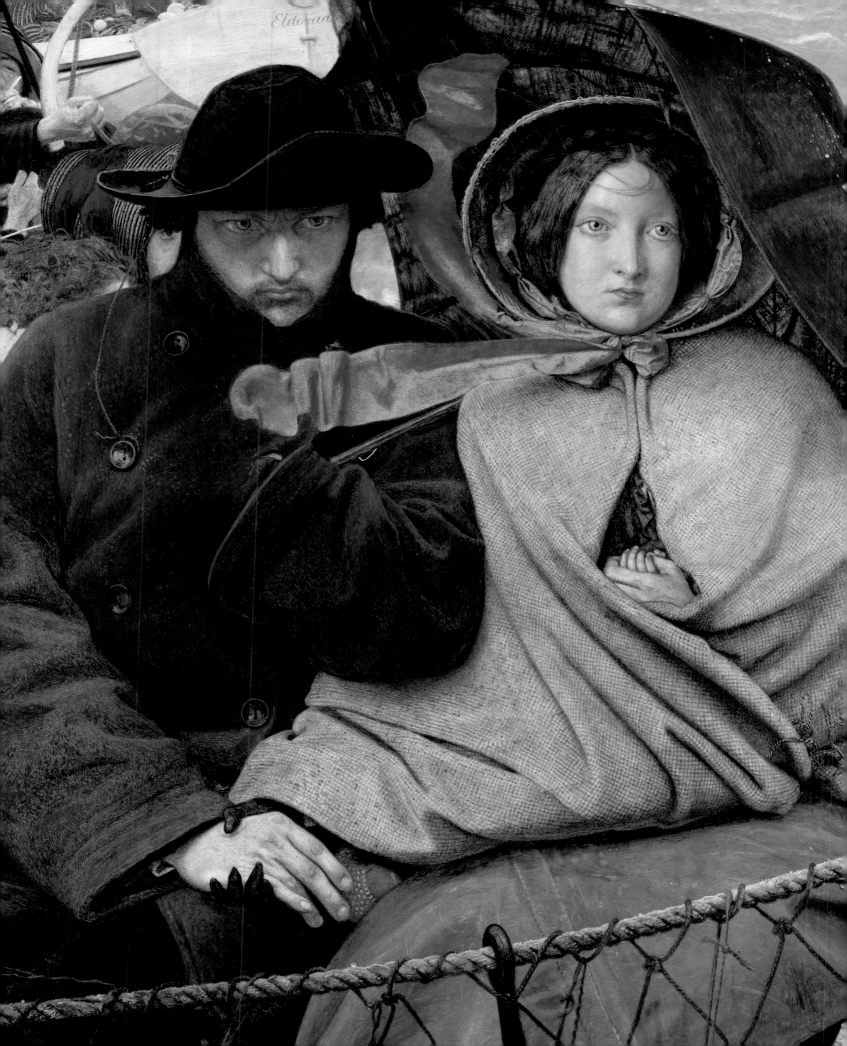

Dubnyckyj, Alicia b.1979
Untitled 2001
emulsion on canvas 122 x 183
UA.OG.028

Dubnyckyj, Alicia b.1979
Untitled 2001
emulsion on canvas 61 x 92
UA.OG.032

Dubnyckyj, Alicia b.1979
Untitled 2001
gloss paint on canvas 122 x 76
UA.PB.135

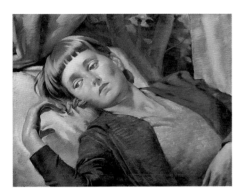

Fleetwood-Walker, Bernard 1893–1965
Joan c.1959
oil on canvas 52.1 x 61.7
SA/AT/1/1/8

Fryer, Katherine Mary b.1910
Life's Journey 1961–1962
oil on chipboard 215 x 528 (E)
UA.TC.001

Gear, William 1915–1997
Untitled c.1960
oil on canvas 182.3 x 152
UA.GG.033

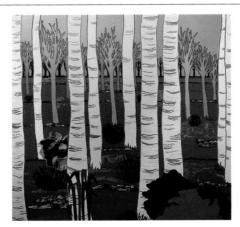

Gear, William 1915–1997
Tall Structure No. 2 1966
oil on canvas 184 x 102
UA.PB.105

Gillot, Amanda b.1979
Landscape 2002
mixed media on canvas 200 x 200.5
UA.GG.093

Green, Suzanne Claire b.1968
Abstract Study 2000
oil on paper 160 x 160
UA.GG.004

Facing page: Brown, Ford Madox, 1821–1893, *The Last of England* (detail), 1855, Birmingham Museums and Art Gallery, (p. 59)

Green, Suzanne Claire (attributed to)
b.1968
Abstract Study 2000
oil on paper 153 x 153
UA.GG.083

Groves, Robert b.1935
'In the Penal Settlement', Kafka
oil on canvas 76.5 x 61
UA.GG.140

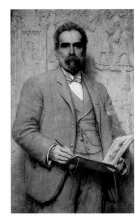

Harper, Edward Samuel 1854–1941
Frank Jackson 1898
oil on canvas 125.3 x 74.8
SA/AT/1/1/2

Hatch active late 20th C
Dream
oil on canvas 203 x 148
UA.PB.067

Haugse, Jorunn b.1982
Tree 2004
oil on canvas 141 x 108
UA.GG.003

Heap, Nik b.1959
Landscape 1987
oil on canvas 187 x 125.2
UA.PB.073

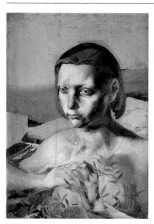

Hodgson, Frank 1902–c.1977
Frank Hodgson's Wife c.1930
oil on canvas 56.4 x 37.9
SA/AT/1/1/6

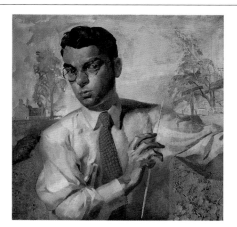

Hodgson, Frank 1902–c.1977
Self Portrait c.1930
oil on canvas 62.4 x 62.4 (E)
SA/AT/1/1/5

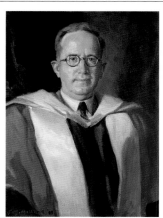

Holland, George H. Buckingham
1901–1986
Christopher Edmunds (1899–1990), Fellow of
Birmingham School of Music 1949
oil on canvas 89 x 70
UA.CT.006

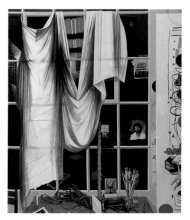

Holland, Michael 1947–2002
Interior Scene c.1997
oil on canvas 243 x 198.2
UA.MS.006

Jiang, Pei Juan b.1983
Mindscape 2006
oil on canvas 93 x 67.5
UA.PB.114

Jones, Gareth
Lips 1996
oil on canvas 208 x 208
UA.GG.065

Jones, H.
Landscape 1989
oil on canvas 248 x 186.5
UA.PB.072

Kim, Jung Hyun b.1972
Face c.1997
oil on canvas 180 x 160.5
UA.GG.081

Laurey, Madonna active late 20th C
Landscape
oil on canvas 110 x 117.5
UA.PB.037

Lawrence
Male Figures 1994
oil on canvas 196 x 130
UA.GG.002

Lee, Paul
Urban Scene 1991
acrylic on canvas 83 x 128
UA.PB.103

Livingstone, Amy b.1983
Patterns and Textures in Nature 2006
acrylic & fabric on canvas 100 x 100
UA.PB.019

Love, Alistair
Untitled 2005
oil on canvas 60 x 60
UA.OG.006

Love, Alistair
Untitled 2005
oil on canvas 60 x 60
UA.OG.007

Love, Alistair
Untitled 2005
oil on canvas 60 x 60
UA.OG.008

Love, Alistair
Untitled 2005
oil on canvas 60 x 60
UA.OG.009

Love, Alistair
Untitled 2005
oil on canvas 60 x 60
UA.OG.010

Love, Alistair
Untitled 2005
oil on canvas 60 x 60
UA.OG.011

Love, Alistair
Untitled 2005
oil on canvas 70 x 109.5
UA.OG.013

Love, Alistair
Untitled 2005
oil on canvas 70 x 109.5
UA.OG.014

Love, Alistair
Untitled 2005
oil on canvas 80 x 79.5
UA.OG.018

Manna, Anita b.1973
Iron Age, Round Houses 1995
oil on canvas 183 x 228
UA.GG.066

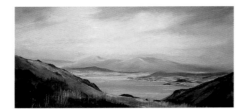

Marlowe, James active late 20th C
Landscape
acrylic on canvas 49 x 95
UA.WB.001

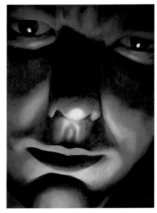

Massey, David b.1975
Figure 1998
oil on canvas 214 x 150
UA.WB.057

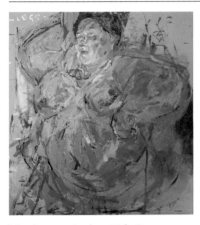

Matthew active late 20th C
Legs
oil on canvas 244 x 213.5
UA.GG.080

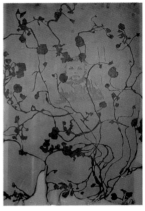

Miller
Still Life with Bottles 1959
oil on paper 44 x 57
UA.PB.069

Munn, Michelle b.1981
Untitled 1954 2004
acrylic on board 180 x 119
UA.GG.077

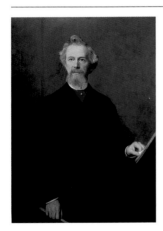

Munns, Henry Turner 1832–1898
William Stockley (1829–1919), Conductor
c.1890
oil on canvas 150 x 109
UA.CT.010

Nelson, Thomas Christopher b.1982
Abstract Study 2004
oil on canvas 122 x 91.8
UA.GG.040

Newham, Teana
Abstract Study 1964
acrylic on board 122.8 x 153.1
SA/AT/1/1/12

Normansell, Paul b.1978
Untitled c.2001
acrylic on MDF 60.6 x 60.6
UA.PB.122

Normansell, Paul b.1978
Untitled c.2001
acrylic on MDF 60.6 x 60.6
UA.PB.123

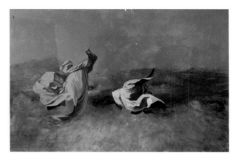

Ochman, Christina Faith b.1927
Clothing 1998
oil on canvas 115 x 166
UA.WB.022

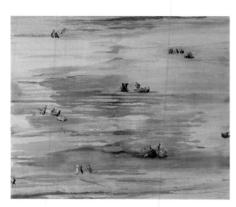

Ochman, Christina Faith b.1927
Clothing 1998
oil on canvas 110 x 140 (E)
UA.WB.042

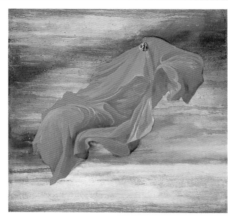

Ochman, Christina Faith b.1927
Drapery 1998
acrylic on canvas 61 x 61
UA.WB.011

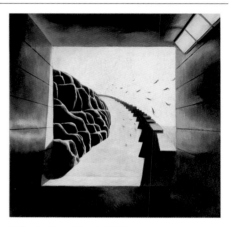

Odagir, Yuse Ke b.1980
The Last Visions 2003
oil on canvas 111 x 111
UA.PB.035

Price, Katie b.1980
Step into the Complex 2004
acrylic on canvas 300 x 217 (E)
UA.PB.102

Rees, Amanda b.1959
Women 2002
oil on canvas 184 x 214
UA.GG.047

Riley, Kay Louisa b.1974
Abstract Study 1998
gloss paint on canvas 213 x 213
UA.GG.051

Russell, Sarah b.1984
Botanical 2006
acrylic on canvas 60.7 x 60.7
UA.PB.016

Russell, Sarah b.1984
Botanical 2006
acrylic on canvas 60.7 x 60.7
UA.PB.017

Russell, Sarah b.1984
Botanical 2006
acrylic on canvas 60.7 x 60.7
UA.PB.018

Ryende, Claude
All Digested 1994
oil on canvas 180 x 180 (E)
UA.GG.075

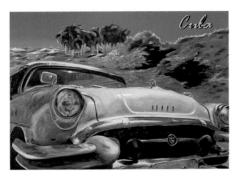

Sanders, Louise b.1981
Cuba 2004
oil on canvas 92.4 x 123
UA.GG.023

Sanderson, Kate b.1984
The Nature of It 2006
acrylic on canvas 76.4 x 61
UA.PB.015

Skelcher, Mark J. b.1984
Frozen 2006
oil & wood on canvas 277 x 297 (E)
UA.NT.001

Southall, Joseph Edward 1861–1944
Self Portrait 1925
tempera on plaster 56.3 x 43.5
SA/AT/1/1/14

Spencer
Nude with Cat c.1986
oil on canvas 220 x 153 (E)
UA.PB.070

Talifero, Janice b.1966
Untitled c.2005
acrylic on canvas 150 x 150
UA.PB.057

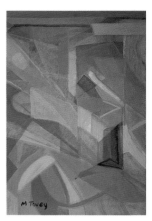

Tovey, Mark b.1956
Disused Tin Mine (Cornish Postcard Series)
2006
acrylic on canvas 60 x 39.5
UA.WB.004

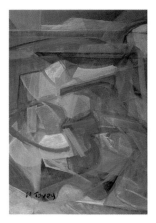

Tovey, Mark b.1956
Trevose Head (Cornish Postcard Series) 2006
acrylic on canvas 60 x 39.5
UA.WB.005

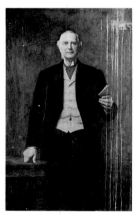

unknown artist
Portrait of a Man c.1890–1900
oil on canvas 165.4 x 100.5
SA/AT/1/1/4

unknown artist
*Portrait of a Man Holding a Pen and
Book* c.1890–1900
oil on canvas 92.8 x 67.6
SA/AT/1/1/3

unknown artist
Mythological Study c.1930
oil on board 61.6 x 61.2
SA/AT/1/1/7

unknown artist
*Sir Granville Bantock, 1st Principal
(1900–1934)* c.1940
oil on canvas 106 x 85
UA.CT.005

unknown artist
Abstract Study c.1960
oil on board 37.1 x 29.5
SA/AT/1/1/10

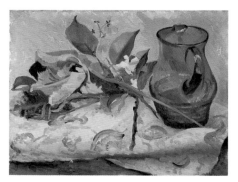

unknown artist
Still Life with Flowers and Water Jug c.1960
oil on canvas 35.8 x 46.4
SA/AT/1/1/9

Facing page: Turner, Joseph Mallord William, 1775–1851, *The Pass of Saint Gotthard, Switzerland* (detail), 1803–1804, Birmingham Museums and Art Gallery, (p. 191)

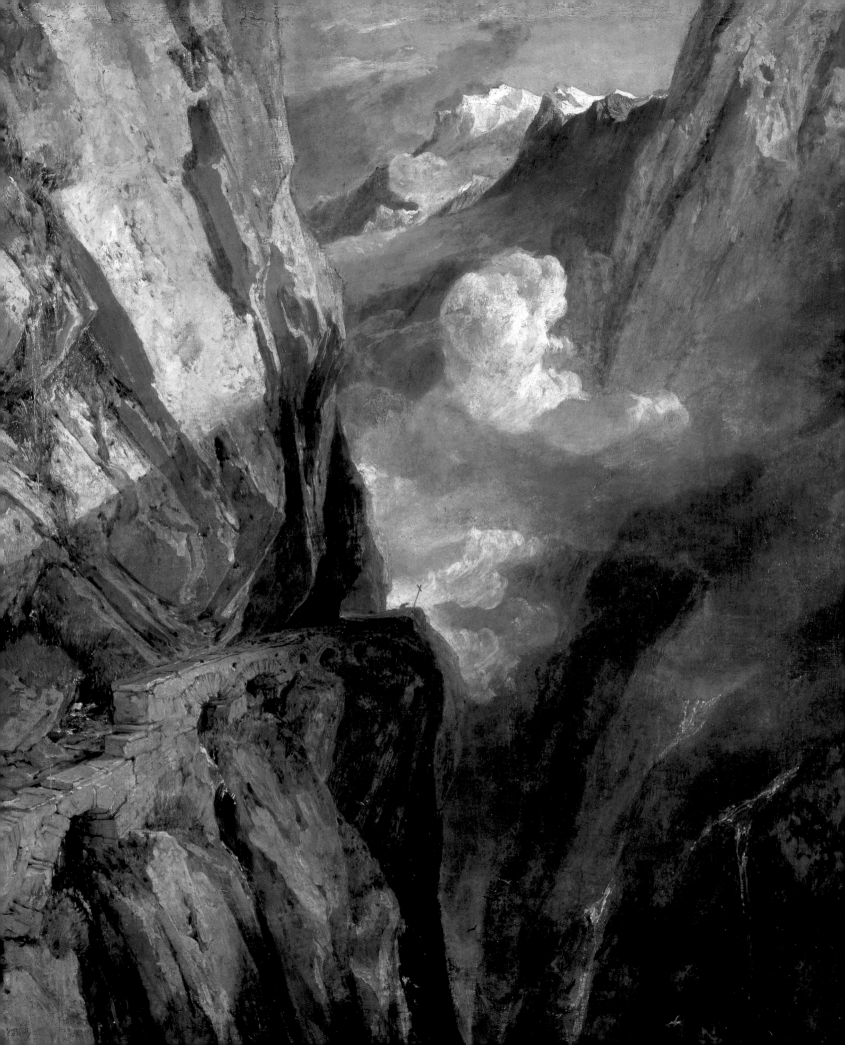

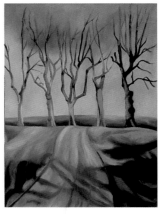

unknown artist
Landscape c.1989
oil on canvas 97 x 71
UA.PB.138

unknown artist
Mind to Motion No.4 2006
acrylic & oil on canvas 177 x 286
UA.GG.136

unknown artist late 20th C
Abstract Study
oil on canvas 182 x 152.5
UA.GG.006

unknown artist late 20th C
Abstract Study
acrylic on paper 109 x 91 (E)
UA.GG.007

unknown artist late 20th C
Abstract Study
acrylic on paper 109 x 91 (E)
UA.GG.025

unknown artist late 20th C
Abstract Study
mixed media on board 220 x 220 (E)
UA.GG.041

unknown artist late 20th C
Abstract Study
mixed media on board 211 x 211
UA.GG.042

unknown artist late 20th C
Abstract Study
oil on canvas 191 x 133
UA.GG.048

unknown artist late 20th C
Abstract Study
oil on canvas 180.5 x 65.2
UA.GG.049

unknown artist late 20th C
Abstract Study
oil on canvas 181 x 151
UA.GG.050

unknown artist late 20th C
Abstract Study
oil on canvas 180 x 180 (E)
UA.GG.074

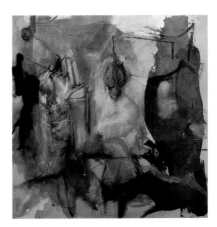

unknown artist late 20th C
Abstract Study
oil on canvas 198.5 x 182.5
UA.GG.082

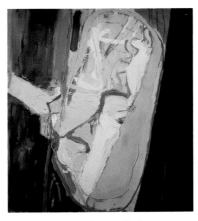

unknown artist late 20th C
Abstract Study
oil on paper 203 x 178
UA.GG.084

unknown artist late 20th C
Abstract Study
oil on canvas 174 x 204
UA.GG.085

unknown artist late 20th C
Abstract Study
acrylic on canvas 189 x 201
UA.GG.092

unknown artist late 20th C
Abstract Study
oil on canvas 187 x 161.2
UA.GG.107

unknown artist late 20th C
Abstract Study
oil on canvas 181 x 221
UA.GG.108

unknown artist late 20th C
Abstract Study
oil on canvas 183 x 168.5
UA.GG.110

unknown artist late 20th C
Abstract Study
oil on canvas 179 x 209
UA.GG.124

unknown artist late 20th C
Abstract Study
oil on canvas 210 x 189.7
UA.GG.125

unknown artist late 20th C
Abstract Study
oil on canvas 71 x 102.3
UA.PB.009

unknown artist late 20th C
Abstract Study
oil on canvas 66 x 202
UA.PB.063

unknown artist late 20th C
Abstract Study
acrylic on board 60 x 81
UA.PB.065.1

unknown artist late 20th C
Abstract Study
acrylic on board 60 x 81 (E)
UA.PB.065.2

unknown artist late 20th C
Abstract Study
acrylic on board 60 x 81 (E)
UA.PB.065.3

unknown artist late 20th C
Abstract Study
acrylic on board 81 x 60
UA.PB.065.4

unknown artist late 20th C
Abstract Study
acrylic on board 81 x 60
UA.PB.065.5

unknown artist late 20th C
Abstract Study
acrylic on board 60 x 81
UA.PB.065.6

unknown artist late 20th C
Abstract Study
acrylic on board 81 x 60
UA.PB.065.7

unknown artist late 20th C
Abstract Study
acrylic on board 60 x 81
UA.PB.065.8

unknown artist late 20th C
Abstract Study
oil on canvas 152 x 188
UA.PB.084

unknown artist late 20th C
Abstract Study
oil on canvas 225 x 165
UA.WB.024

unknown artist late 20th C
Clown Toy Lying Down
oil on canvas 94.5 x 71.5
UA.WB.043

unknown artist late 20th C
Clown Toy Sitting
oil on canvas 96 x 71.5
UA.WB.044

unknown artist late 20th C
Experimentation of Materials and Methods
acrylic on canvas 181 x 181.2
UA.PB.154

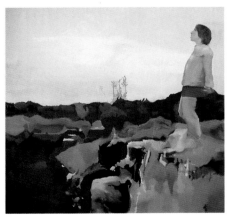

unknown artist late 20th C
Figure in Landscape
oil on canvas 179.2 x 180
UA.GG.024

unknown artist late 20th C
Figure Study
oil on canvas 245 x 185 (E)
UA.GG.053

unknown artist late 20th C
Figure Study
acrylic & pastel on paper 115 x 84
UA.PB.107

unknown artist late 20th C
Figure with a Red Cloth
oil on canvas 183 x 153
UA.PB.033

unknown artist late 20th C
Figure with Toys
oil on canvas 180 x 153
UA.GG.094

unknown artist late 20th C
Girl and Dog
oil on canvas 179 x 121
UA.GG.009

unknown artist late 20th C
Hanging Man
oil on canvas 213 x 152
UA.GG.126

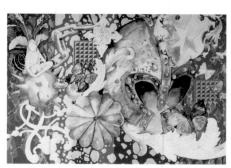

unknown artist late 20th C
Helmet and Butterfly
acrylic on paper 41 x 58.5
UA.WB.047

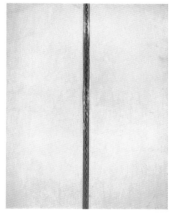

unknown artist late 20th C
Hinge
gloss paint & metal on board 183 x 140
UA.GG.062

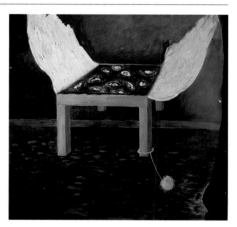

unknown artist late 20th C
Interior Scene
oil on canvas 183 x 182.5
UA.GG.079

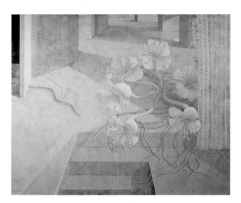

unknown artist late 20th C
Interior Scene
acrylic on canvas 150 x 174.8
UA.WB.019

unknown artist late 20th C
Landscape
oil on canvas 213 x 198
UA.GG.020

unknown artist late 20th C
Landscape
oil on board 173 x 127
UA.GG.105

unknown artist late 20th C
Landscape
oil on canvas 181 x 90
UA.PB.010

unknown artist late 20th C
Landscape
oil on canvas 181 x 90
UA.PB.011

unknown artist late 20th C
Landscape
oil on canvas 84 x 154.6
UA.PB.071

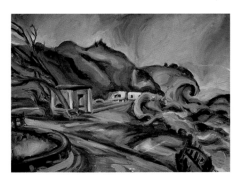

unknown artist late 20th C
Landscape
oil on canvas 92 x 122
UA.PB.087

unknown artist late 20th C
Man in Sunglasses
oil on canvas 224 x 163.3
UA.WB.020

unknown artist late 20th C
Woman in Sunglasses
oil on canvas 224 x 163.3
UA.WB.021

unknown artist late 20th C
Marble
acrylic on paper 51.3 x 33.4
UA.WB.046

unknown artist late 20th C
Office Window
oil on canvas 198 x 300
UA.GG.010

unknown artist late 20th C
Purple Abstract
acrylic on canvas 199 x 183
UA.GG.141

unknown artist late 20th C
Red Abstract
acrylic & glue on canvas 69 x 59
UA.PB.133

unknown artist late 20th C
Red Figure
oil on canvas 243 x 182.5
UA.GG.054

unknown artist late 20th C
Two Figures
oil on canvas 243 x 181.5
UA.GG.078

unknown artist
Figure
mixed media on canvas 198 x 163
UA.GG.052

unknown artist late 20th C
Spots
oil on canvas 152 x 210.5
UA.GG.091

unknown artist late 20th C
Still Life
oil on canvas 94 x 79
UA.PB.062

unknown artist late 20th C
Still Life with Work Boots
oil on canvas 93 x 124
UA.PB.088

unknown artist late 20th C
Surreal Landscape
oil on canvas 126.5 x 127
UA.PB.058

unknown artist late 20th C
Three Men
oil on canvas 224 x 195
UA.WB.023

unknown artist late 20th C
Three Women
acrylic on paper 72 x 51.5
UA.PB.075

unknown artist late 20th C
Tiger
oil on board 130 x 91
UA.GG.116

Wilkinson, Ann b.1940
Interior Scene 2005
oil on canvas 153.5 x 184
UA.GG.043

Wood, Mary Anita Virginia b.1945
666 (multiple work) c.2005
acrylic on canvas 100 x 153 (E)
UA.TC.004.1

Wood, Mary Anita Virginia b.1945
666 (multiple work) c.2005
acrylic on canvas with perspex 47 x 42
UA.TC.004.2

Wood, Mary Anita Virginia b.1945
666 (multiple work) c.2005
acrylic on canvas with perspex 47 x 42
UA.TC.004.3

Wood, Mary Anita Virginia b.1945
666 (multiple work) c.2005
acrylic on canvas with perspex 47 x 42
UA.TC.004.4

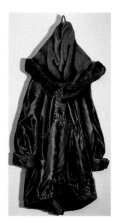

Woodhall, Beryl Christina b.1944
Coat 2000
acrylic on board 104 x 51
UA.GG.015

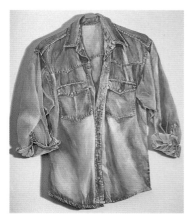

Woodhall, Beryl Christina b.1944
Denim Shirt 2000
acrylic on board 84 x 70
UA.GG.014

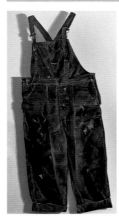

Woodhall, Beryl Christina b.1944
Dungarees 2000
acrylic on board 132.4 x 49
UA.GG.016

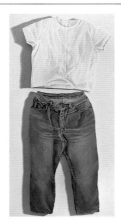

Woodhall, Beryl Christina b.1944
T-Shirt and Jeans 2000
acrylic on board 147.4 x 68 (E)
UA.GG.017

Woodhall, Beryl Christina b.1944
Underwear 2000
acrylic on board 102.2 x 50 (E)
UA.GG.013

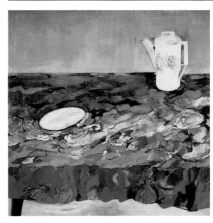

Woodward, F.
Still Life with Plate and Coffee Pot 1965
oil on canvas 127.4 x 122.9
SA/AT/1/1/13

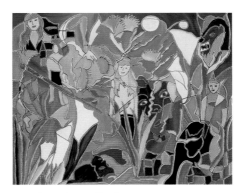

Woodward, Natalie b.1980
Of Significance 2006
acrylic on canvas 102 x 127
UA.PB.014

Facing page: British (English) School, *Abd el-Ouahed ben Messaoud ben Mohammed Anoun (b.1558), Moorish Ambassador to Queen Elizabeth I* (detail), 1600, University of Birmingham, (p. 245)

Birmingham Museums and Art Gallery

In the entrance hall to Birmingham Museum and Art Gallery is a plaque commemorating the opening of the Museum in 1885 inscribed with the words: 'By the gains of industry, we promote Art' referring to the building of the Museum with income from the council-owned Gas Department. The City's visionary civic leader, Joseph Chamberlain, believed access to the visual arts was an essential cultural and industrial resource for a community whose fortunes relied on the manufacture of metal wares and glass. Giving the people of Birmingham a chance to see fine examples of British and European art would help to raise the quality of craftsmanship and design in the innumerable workshops of the city. Not surprisingly, many of the earliest patrons of the Collection were leading industrialists. In 1871, T. Clarkson Osler of the glass company F. & C. Osler gave £3,000 for the foundation of a public picture gallery fund to buy works of art. Ten years later, the Tangye engineering company presented £10,000 for acquisitions with a further £7,000 raised by public subscription and a purchasing committee was established.

Since 1867, the City Council had maintained a corporation art gallery in a room in the Central Library but as the Collection grew it was obvious that a custom-built Museum and Art Gallery was required. Aston Hall, ancestral home of the Holte family, was acquired by the Council in 1864 and housed part of the growing civic collection. When the long awaited Museum and Art Gallery opened, the collections expanded rapidly under the aegis of the first Curator, Whitworth Wallis who was himself a talented painter. He bought lavishly and widely, especially in Europe and established the reputation of the Museum as a centre of excellence for the fine and applied arts. The premises were greatly extended in 1912 with a donation of £50,000 by the local newspaper magnate, John Feeney, allowing the collections to be further developed and properly presented.

The City's world famous Pre-Raphaelite collection grew steadily through a series of timely purchases and gifts: *The Last of England* by Ford Madox Brown, bought in 1891; *The Blind Girl* by John Everett Millais presented by William Kenrick in 1892. One of the greatest religious paintings of the Victorian age, *The Finding of the Saviour in the Temple* by Holman Hunt was given in 1896 by Sir John Middlemore. This direction was confirmed by the acquisition of Charles Fairfax Murray's magnificent collection of Pre-Raphaelite drawings in 1906.

The Pre-Raphaelite influence on local and regional painters was intensified by the example of the Birmingham born artist, Edward Burne-Jones who was a frequent visitor to the Birmingham School of Art. The last decade of the nineteenth century saw an extraordinary flowering of art and design in the city reflected in the Collection with works by the tempera revivalists, Joseph Edward Southall, Kate Elizabeth Bunce, and Arthur Joseph Gaskin. The so-called Birmingham School has remained an important focus for collecting, enabling the gallery to illustrate the evolving art history of the City from the eighteenth century to the present.

The end of the Second World War heralded a resurgence of collecting. Birmingham's small but significant collection of French Impressionist painting

was assembled during this period. It also saw the acquisition of major Old Master paintings including *The Rest on the Flight into Egypt* by Orazio Gentileschi, the only autographed work by the artist in a public collection in the UK and *Erminia and the Shepherd* by Guercino, commissioned in 1620 by Cardinal Prince Ferdinando Gonzaga for his Villa della Favorita in Mantua. They helped to lay the foundations of a fine European Baroque Collection recently enhanced by loans from Sir Dennis Mahon. The Cook Bequest, through the National Art Collections Fund, of *Landscape near Rome with a View of the Ponte Molle* by Claude Lorrain and the chance discovery and purchase of *Coast Scene with the Embarkation of Saint Paul* by the same artist were great moments in the history of the Birmingham Collection. These were equalled in 1977 by the purchase of the *Madonna and Child Enthroned with Saints and Donor* by Giovanni Bellini and two exquisite views of Warwick Castle by Canaletto the following year.

Tracing the story of British painting from the seventeenth century to the present has been a key aspect of the collecting policy. Portraiture is especially well represented in works by Lely, Zoffany and Reynolds. Gainsborough's *Isabelle Franks (c.1769/1770–1855)* depicting Miss Franks as a shepherdess is one of the most popular oil paintings in the Collection. From the twentieth century, the achievements of the Newlyn and Camden Town painters are seen in works by Walter Langley, Laura Knight and Walter Richard Sickert while more radical aspects of inter-war art are seen in paintings by Gwen John, Paul Nash, Stanley Spencer and the Birmingham born artist, David Bomberg. St Ives in Cornwall was the crucible of British Modernism in the 1950s and the Collection boasts fine examples by Ben Nicholson, Patrick Heron and Barbara Hepworth, alongside Peter Lanyon's sublime painting, *Offshore* which encapsulates the spirit of the Penwith coast. Recent gifts of works by Paul Feiler and the purchase of *Caliban* by Karl Weschke help to illustrate the vital role that émigré artists have played in the development of art in this country.

The British 1960s and Pop Art collection has been greatly improved by the addition of *Whitley Bay* by Richard Hamilton and *Red and White Still Life* by Patrick Caulfield both of which were amongst a series of special purchases made to mark the advent of the Millennium. The successful acquisition of *Wall of Light Blue* by Sean Scully and *Desk Murder* by R. B. Kitaj have helped to establish one of the best collections of modern and contemporary painting in the UK. Birmingham was one of 15 museums to benefit from the recent Contemporary Art Society Special Collections Scheme, funded by the Arts Council Lottery. The Museum was given £250,000 for the purchase of contemporary painting and metalwork – the largest single injection of funding for contemporary art in the history of the institution. Paintings by Fiona Rae, Jason Martin, Basil Beattie, Lubaina Himid and many others were acquired through this scheme, often with related drawings that give an insight into the artist's creative process. The Waterhall Gallery of Modern Art which opened in 2001, is now home to the Modern and Contemporary Collection, the largest dedicated space of its kind in the Midlands.

With very limited acquisition funds of its own, the Museum has always had to rely on the generosity of charitable trusts and other external sources of public funding. The Art Fund (previously The National Art Collections Fund) the Museums, Archives and Libraries Council/Victoria & Albert

Museum Purchase Grant Fund, have been unstinting in their support for the collections at Birmingham. In recent years, the Heritage Lottery Fund and Arts Council have also been instrumental in the acquisition of major works. Birmingham's own Public Picture Gallery Fund has played a leading role in the evolution of the Collection for over 140 years, keeping alive that spirit of enlightened patronage that informed the foundation of the Museum and Art Gallery service. The Friends of Birmingham Museums and Art Gallery have offered both encouragement and financial support to the curators who have approached them for assistance in fundraising for acquisitions. Regular gifts of works from the Contemporary Art Society have given an invaluable boost to the Collection, not least in the donation of *Figures in a Landscape* by Francis Bacon in 1959.

The generosity of private collectors and donors has also enabled the Museum to enhance its own collections with works that, in many cases, would be beyond the resources of the Museum to acquire. The efforts of funders, lenders, donors, directors and curators have created a collection now designated as of national quality. It is a vital educational and cultural resource for the region and the nation. It continues to develop, attracting over 500,000 visitors a year and lending out hundreds of works to national and international exhibitions.

Brendan Flynn, Curator of Fine Arts

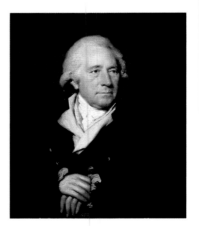

Abbott, Lemuel Francis 1760–1803
Matthew Boulton (1728–1809) 1801–1803
oil on canvas 77.2 x 64.1
1908P20

Abell, Roy b.1931
Sea and Sky 1973
oil on canvas 70.2 x 90.5
1974P7

Adams, Norman 1927–2005
The Sun 1956
oil on canvas 76.4 x 83.8
1957P2

Aertsen, Pieter 1507/1508–1575
Preparations for a Feast 1550–1575
oil on canvas 95 x 170.5
1925P344

Aitchison, Craigie Ronald John b.1926
Crucifixion 1984–1986
oil on canvas 220.9 x 187.9
1999P37 🐝

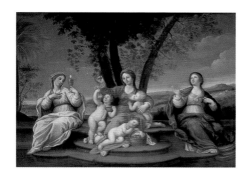

Albani, Francesco (studio of) 1578–1660
Faith, Hope and Charity 17th C
oil on canvas 39.5 x 53.5
1999PL14 (P)

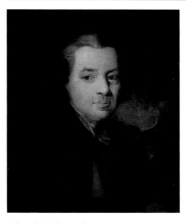

Alcock, Edward d.1778
William Shenstone (1714–1763)
oil on canvas 60.9 x 50.9
1891P30

Aldin, Cecil 1870–1935
Golfing 1899
oil on canvas 146.2 x 108.3
1980P24

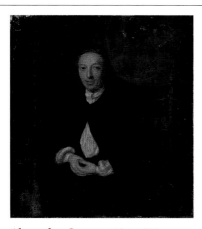

Alexander, Cosmo 1724–1772
Portrait of a Man 1753
oil on canvas 30.8 x 26.9
1966P16

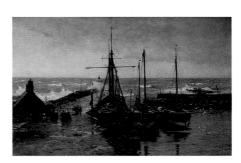

Allan, Robert Weir 1852–1942
Home and Shelter 1900–1905
oil on canvas 120 x 181.5
1912P27

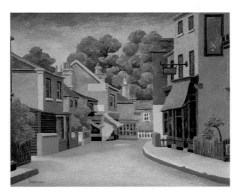

Allen, Frank Humphrey 1896–1977
Thames Ditton 1920–1945
oil on canvas 50.7 x 60.7
1943P290

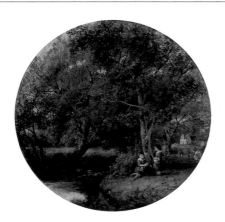

Allen, James Bayliss 1803–1876
The Stream
oil on canvas 37.8
1920P453

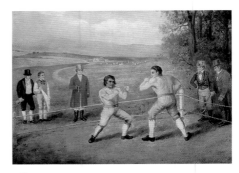

Allen, W.
A Birmingham Prize Fight c.1840
oil on canvas 50.4 x 67.3
1945P50

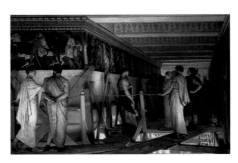

Alma-Tadema, Lawrence 1836–1912
Pheidias and the Frieze of the Parthenon
1868/1869
oil on mahogany panel 72.5 x 109
1923P118

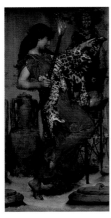

Alma-Tadema, Lawrence 1836–1912
Autumn Vintage Festival 1877
oil on canvas 75.3 x 38.1
1911P62

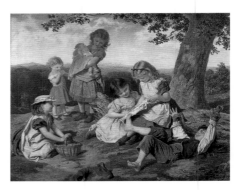

Anderson, Sophie 1823–1912
The Children's Story Book
oil on canvas 100.3 x 125.7
1892P25

Anderson, Stanley 1884–1966
Richard Cadbury (1835–1899) c.1940–1960
oil on canvas 101 x 78
1980V73

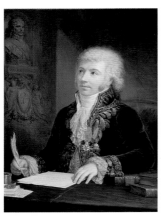

Appiani, Andrea the elder 1754–1817
Comte Nicholas Frochot (1761–1828) 1806
oil on canvas 99.5 x 74
1976P98

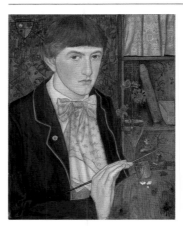

Armfield, Maxwell Ashby 1882–1972
Self Portrait 1901
tempera on sketching board 29.3 x 23.1
1980P1

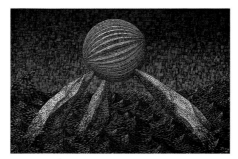

Armstrong, John 1893–1973
Lapping Waters 1944
tempera on panel 47.5 x 70
1946P28

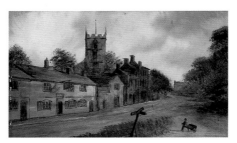

Ash, Albert Edward active 1878–1898
Moseley Village
oil on canvas 14 x 21.7
1977V496

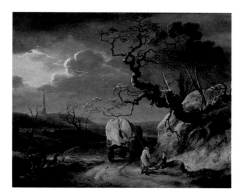

Ashford, William 1746–1824
The Thunderstorm 1780
oil on canvas 56.2 x 66.8
1925P95

Ashmore, Charles 1823/1824–1903
Aston Hall from the Park 1891
oil on millboard 30.1 x 47.7
1973P4

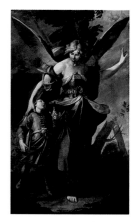

Assereto, Gioacchino 1600–1649
The Guardian Angel
oil on canvas 226.1 x 143.5
1948P35

Aumonier, James 1832–1911
A Nook in Nature's Garden 1879
oil on canvas 154 x 89
1885P2466

Ayres, Gillian b.1930
A Midsummer Night 1990
oil on three panels 183 x 369
1995P30

Bacon, Francis 1909–1992
Figures in a Landscape 1956
oil on canvas 150 x 107.5
1959P35

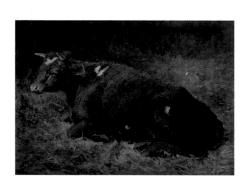

Baker, Alfred 1850–1874
A Cow Lying on the Ground c.1870
oil on canvas 25.1 x 31.1
1934P262

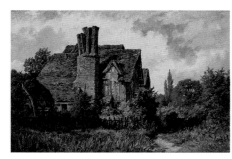

Baker, Henry 1849–1875
Selly Manor c.1870
oil on canvas 30.7 x 46
1969P9

Baker, Samuel Henry 1824–1909
Wigmore Church near Ludlow (panel in the
Everitt Cabinet) 1875–1880
oil on wood panel 25.5 x 17
1892P41.1

Baker, Thomas 1809–1869
Gorge and River in Ireland c.1830–1860
oil on canvas 55.5 x 50.2
1918P48

Baker, Thomas 1809–1869
Stoneleigh Park 1839
oil on canvas 61.3 x 72.5
1912P18

Baker, Thomas 1809–1869
Ullswater from Pooley Bridge 1847
oil on canvas 22.2 x 35.6
1906P28

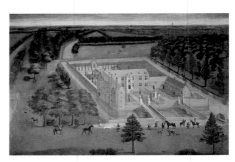

Bardwell, Thomas 1704–1767
View of Perry Hall, near Birmingham
c.1720–1730
oil on canvas 93.8 x 133.6
1920P674

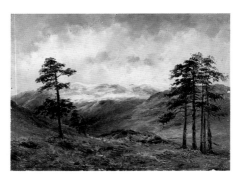

Barnes, Samuel John 1847–1901
Near Balmoral 1893
oil on board 45.8 x 61
1935P199

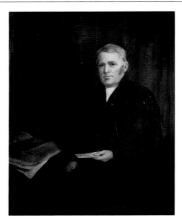

Barratt, Jerry 1824–1906
Joseph Sturge (1793–1859) 1855
oil on canvas 124.7 x 82.6
1885P2562

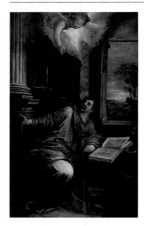

Bassano, Francesco II 1549–1592
St John the Divine c.1579–1592
oil on canvas 256.5 x 154.9
1948P36

Bates, David c.1840–1921
On the Long Mynd, Church Stretton 1907
oil on canvas 101.4 x 152.3
1978P1

Bath, William active 1836–1851
Wooded Landscape 1840–1851
oil on board 13.1 x 19.2
1974P2

Facing page: Burne-Jones, Edward, 1833–1898, *Pygmalion and the Image: The Godhead Fires* (detail), 1878, Birmingham Museums and Art Gallery, (p. 63)

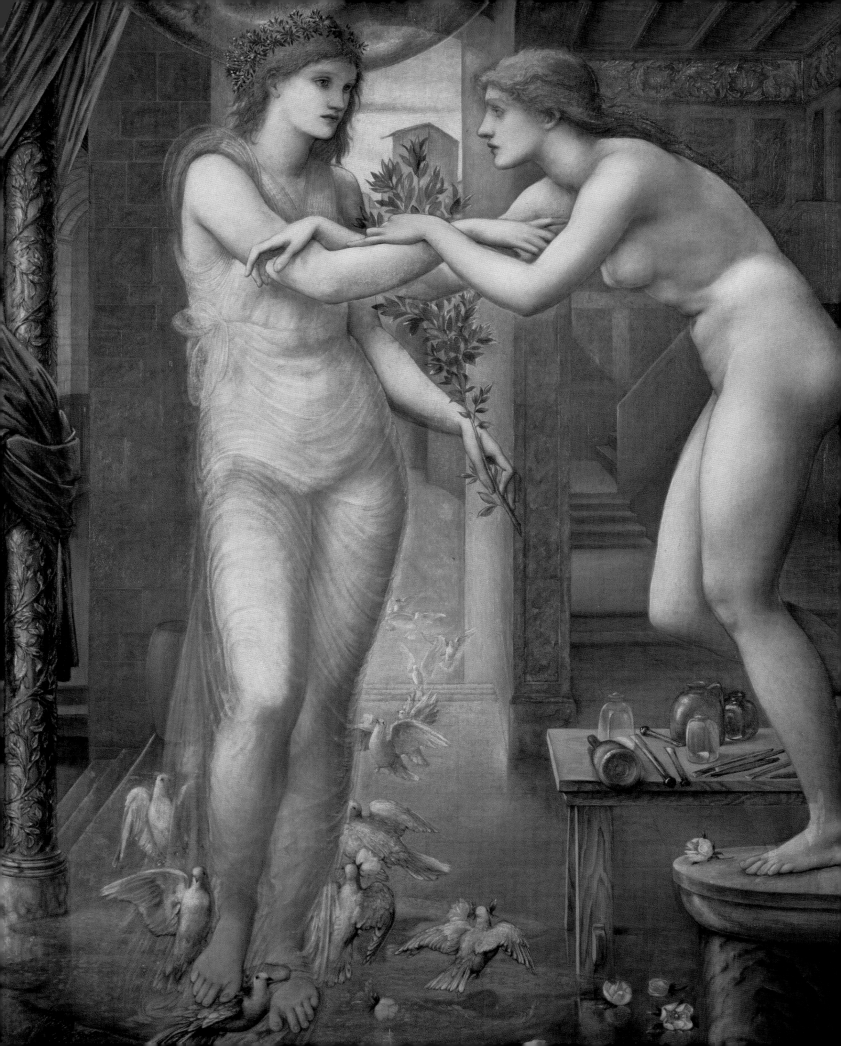

Batoni, Pompeo 1708–1787
Duchess Sforza Cesarini (d.1765) 1760–1770
oil on canvas 97.8 x 72.4
1961P37

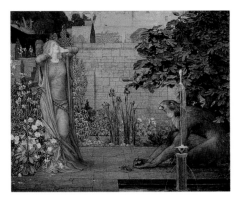

Batten, John Dickson 1860–1932
Beauty and the Beast 1904
tempera on canvas 66 x 77.5
1936P322

Beardmore, J.
View of Handsworth Parish Church 1850
oil on canvas 33.3 x 50
1973V146

Beardmore, J.
Aston Hall from the West
oil on canvas 76.3 x 127
1966P50

Beattie, Basil b.1935
Tell Me 1992
oil on canvas 260 x 371
1999Q27

Beechey, William 1753–1839
James Watt (1736–1819) c.1790–1810
oil on canvas 76.2 x 63.5
1910P6

Beechey, William 1753–1839
James Watt (1736–1819) c.1790–1810
oil on canvas 76.2 x 63.5
1910P6.1

Beechey, William 1753–1839
Matthew Boulton (1728–1809) c.1802–1803
oil on canvas 124.7 x 99
2003.0007.44

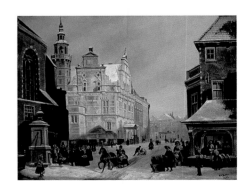

Behr, Carel Jacobus 1812–1895
Town Hall, The Hague 1853
oil on panel 44.5 x 55.7
1977P3

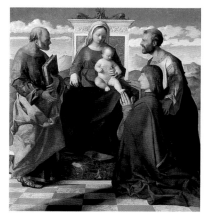

Bellini, Giovanni 1431–1436–1516
Madonna and Child Enthroned with Saints and Donor 1505
oil on poplar panel 91.4 x 81.3
1977P227

Berchem, Nicolaes 1620–1683
Pastoral Landscape with Figures
oil on panel 26 x 38.7
1932P117

Bevan, Robert Polhill 1865–1925
The Ploughing Team, Dawn 1904–1906
oil on canvas 48.2 x 59.7
1985P57

Bevan, Tony b.1951
Rafters 1999
acrylic & charcoal on canvas 216 x 180
2000Q36

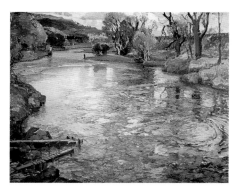

Birch, Samuel John Lamorna 1869–1955
A Cornish Stream c.1910–1928
oil on canvas 61.3 x 74
1928P155

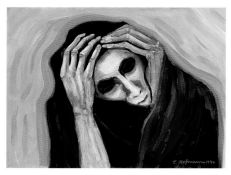

Birkin, Edith b.1927
'They Took My Child', Lodz Ghetto, 1942 1994
acrylic on board 51 x 60.7
1995P12

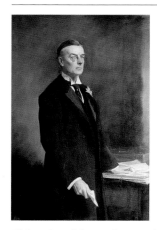

Birley, Oswald Hornby Joseph 1880–1952
The Right Honourable Joseph Chamberlain (1836–1914), PC, MP 1937
oil on canvas 119.4 x 93.3
1937P137

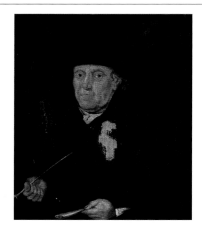

Bisset, James 1762–1832
John Freeth (1731–1808)
oil on canvas 30.5 x 25.5
1964P39

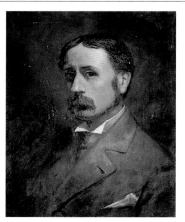

Blackham, George Warren
active 1870–1906
Self Portrait
oil on canvas 61 x 51
1977V432

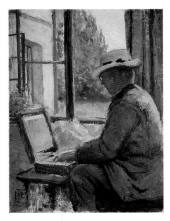

Bladon, T. Murray Bernard 1864–1939
Harold Wilson Painting 1936
oil on panel 22.4 x 16.5
1990P38

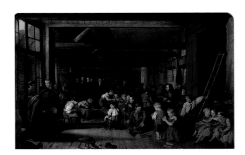

Blaikley, Alexander 1816–1903
The First Ragged School, Westminster 1851
oil on canvas 61.2 x 91
1892P46

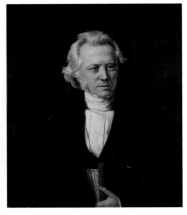

Blakiston, Douglas Yeoman 1810–1870
Reverend Hugh Hutton (1795–1871)
c.1840–1860
oil on canvas 76.6 x 63.8
1885P2571

Bles, Herri met de c.1510–after 1550
Nativity
oil on canvas 66 x 52.1
1960P61

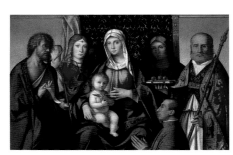

Boccaccino, Boccaccio before 1466–1525
*Virgin and Child with Saints and a
Donor* c.1505–1515
oil on panel 71.1 x 106.7
1957P11

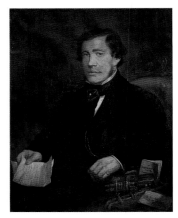

Bolt, E. H.
James Webster 1862
oil on canvas 89 x 70.5
1978P4

Bomberg, David 1890–1957
Carnival 1920–1922
oil on paper 31 x 40
1981P80

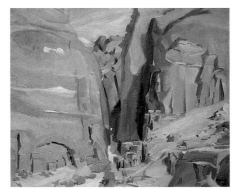

Bomberg, David 1890–1957
Bab-Es-Siq, Petra 1924
oil on canvas 51.2 x 61
1928P555

Bomberg, David 1890–1957
Hezekiah's Pool 1924
oil on board 60.5 x 50.3
1981P79

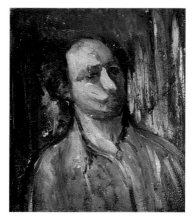

Bomberg, David 1890–1957
Self Portrait 1937
oil on cardboard 60.5 x 50.5
1960P45

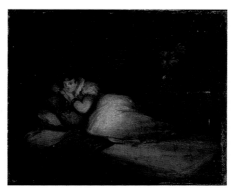

Bond, John Daniel 1725–1803
Interior with Woman on a Bed c.1760–1780
oil on canvas 21.5 x 26
1992P13

Bonington, Richard Parkes 1802–1828
An Italian Town 1822
oil on panel 15.8 x 11.4
1929P43

Booth, J. active 1838
Old Pebble Mill Pool, Birmingham
oil on board 32.8 x 45.5
1965V221.92

Borgognone, Ambrogio c.1455–1524
The Crucifixion with the Virgin, St John and Mary Magdalen
tempera on linen 55.9 x 35.9
1960P57

Bott, R. T. c.1810–c.1865
Portrait of a Woman 1830
oil on canvas 90.8 x 71.1
1968P5

Bott, R. T. c.1810–c.1865
Portrait of a Man 1839
oil on canvas 92 x 71.5
1968P4

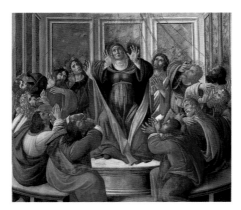

Botticelli, Sandro 1444/1445–1510
The Descent of the Holy Ghost c.1495–1505
oil on panel 207 x 229.8
1959P31

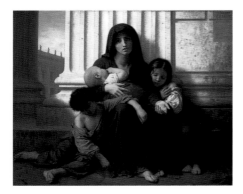

Bouguereau, William-Adolphe 1825–1905
Charity 1865
oil on canvas 121.9 x 152.4
1897P11

Bowley, Edward Orlando active 1840–1874
Hockley Abbey, Birmingham 1842
oil on canvas 29.3 x 41 (E)
1997V166

Bowley, Edward Orlando active 1840–1874
Witton Brook, Witton 1872
oil on canvas 38.5 x 58.3
1974V3

Bramer, Leonard 1596–1674
Christ before Caiaphas
oil on canvas 71.1 x 100.3
1960P28

Brangwyn, Frank 1867–1956
The Bridge, Subiano 1921
oil on canvas 64.5 x 80.5
1928P631 ☀

Brangwyn, Frank 1867–1956
Enrico Canziani (1848–1931) 1924
oil on cardboard 50 x 63.5
1974P1 ☀

Braque, Georges 1882–1963
Pichet et fruits 1927
oil on canvas 21.3 x 70.7
1978L12 (P)

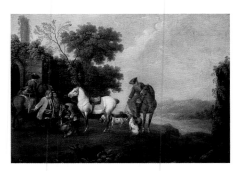

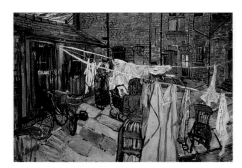

Brasch, Wenzel Ignaz 1708–1761
The Deer Hunt c.1740–1760
oil on canvas 26.5 x 36.5
1970P59

Bratby, John Randall 1928–1992
Courtyard with Washing 1956
oil on masonite board 122 x 172.7
2001P22 ☀

Breakspeare, William Arthur 1855–1914
In Time of War c.1900
oil on canvas 75 x 52
2000P9

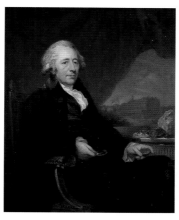

Breda, Carl Fredrik von 1759–1818
Matthew Boulton (1728–1809) 1772
oil on canvas 127 x 102
1987V106

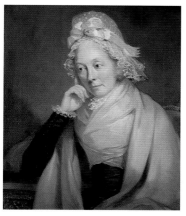

Breda, Carl Fredrik von 1759–1818
Mrs Joseph Priestley (1744–1796) 1793
oil on canvas 76 x 63.1
1906P31

Brett, John 1830–1902
*A North-West Gale off the Longships
Lighthouse* 1873
oil on canvas 105 x 212.2 (E)
1885P2471

Brett, John 1830–1902
Caernarvon 1875
oil on canvas 25.2 x 48.3
1921P81

Brett, John 1830–1902
Southern Coast of Guernsey 1875
oil on canvas 60.9 x 108.2
1927P275

Bridgwater, Emmy 1906–1999
Night Work is about to Commence 1940–1943
oil on board 46 x 61
2001P8

Briggs, Henry Perronet 1791/1793–1844
The Challenge of Rodomont to Rogero
1825–1827
oil on canvas 122 x 184
1885P2536

Bright, Beatrice 1861–1940
Atlantic Rollers
oil on canvas 25.1 x 35.2
1940P555

Bright, Beatrice 1861–1940
Trevose Head, Cornwall
oil on canvas 45.7 x 55.9
1940P554

Bril, Paul 1554–1626
Christ Tempted in the Wilderness 1626
oil on canvas 120.6 x 149.2
1963P10

British (English) School mid-19th C
A Woodland Scene
oil on canvas 48 x 128
PCF 16

British School
Katherine, Lady Gresley 1585
oil on panel 56.8 x 47
1933P223

British School 16th C
Portrait of an Old Man
oil on panel 55.5 x 41.2
1944P261

British School
*William Brereton, 3rd Lord of Laghlin
(1631–1679)* c.1650–1660
oil on canvas 74.9 x 62.2
1885P3185

British School
Prince Charles (1630–1685) c.1660–1680
oil on canvas 64.4 x 53.7
1970P267

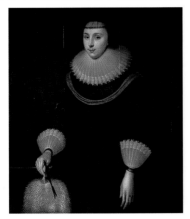

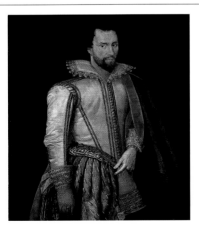

British School early 17th C
Lady of the Brereton Family
oil on canvas 71.1 x 57.2
1885P3186

British School early 17th C
Portrait of a Lady with a Fan
oil on panel 97.9 x 81.6
1885P3187

British School early 17th C
*Sir Thomas Holte (1751–1854), 1st Bt of Aston
Hall*
oil on panel 106 x 88.9
1885P3184

British School 17th C
Portrait of a Man
oil on wood 38 x 31
2004.0331

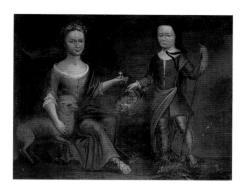

British School late 17th C
Two Children of the Holte Family
oil on canvas 102.9 x 125.7
1942P71

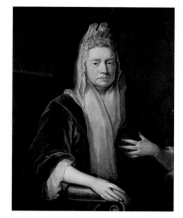

British School
Portrait of a Lady 1711
oil on canvas 83.5 x 64.5
1989P13

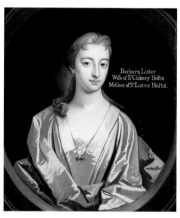

British School
Barbara Lister (d.1742) c.1714–1724
oil on canvas 76.4 x 64
1959P7

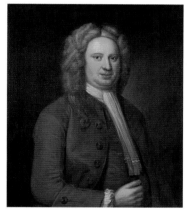

British School
Portrait of an Unknown Man c.1720–1740
oil on canvas 91.5 x 71.1
1981P18

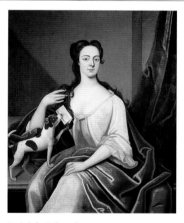

British School
Barbara Lister (d.1742) 1740–1750
oil on canvas 124.5 x 102.8
1968P17

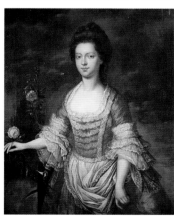

British School
Portrait of a Woman of the Holte Family c.1740–1760
oil on canvas 116.7 x 91.5
1981P19

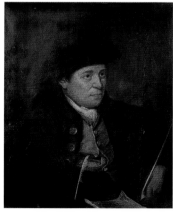

British School
John Freeth (1731–1808) c.1750–1799
oil on canvas 74 x 62.2
1885P2567

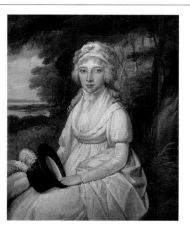

British School
Portrait of a Lady of the Osler Family c.1780–1800
oil on canvas 37 x 30.5
1981P41

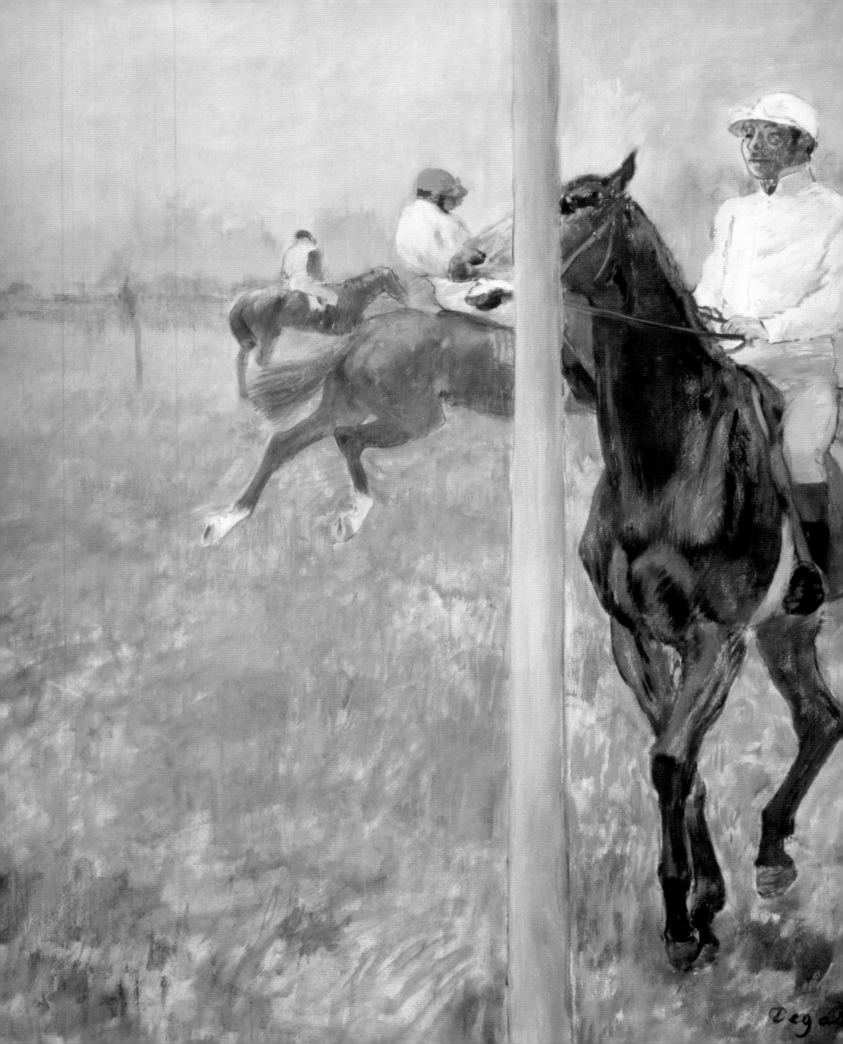

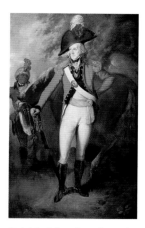

British School early 18th C
Lieutenant Colonel Archibold John Macdonnell (d.1798)
oil on canvas 243.8 x 182.9
1935P3

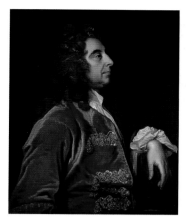

British School early 18th C
Portrait of a Man in Red
oil on canvas 83.8 x 68.6
1961P25

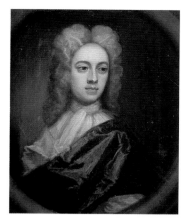

British School early 18th C
Reverend Dr John Holte (1694–1734)
oil on canvas 35.5 x 28
1981P8

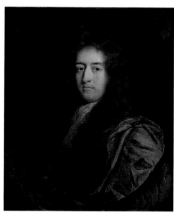

British School early 18th C
Sir Charles Holte (1649–1722), 3rd Bt of Aston Hall
oil on canvas 75 x 61
1885P3183

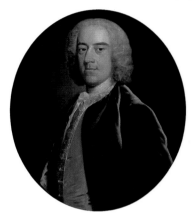

British School mid-18th C
Sir Lister Holte (1720–1770), 5th Bt of Aston Hall
oil on canvas 73.7 x 50.8
1981P10

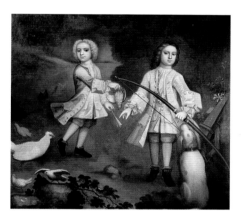

British School mid-18th C
Sir Lister Holte (1720–1770) and Sir Charles Holte (1721–1782), as Boys
oil on canvas 136 x 150.5
1885P3188

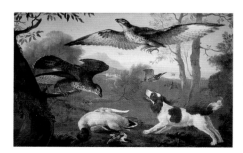

British School 18th C
Dog Guarding a Dead Duck from Birds of Prey
oil on canvas 93 x 142.2
1953P29

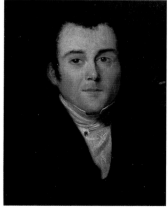

British School 18th C
Portrait of a Man
oil on board 20.5 x 17
1978V896

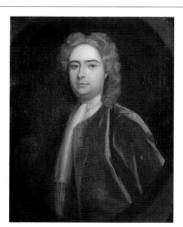

British School 18th C
Portrait of a Man in Brown
oil on canvas 70 x 50
PCF06

Facing page: Degas, Edgar, 1834–1917, *Jockeys before the Race* (detail), 1878–1879, The Barber Institute of Fine Arts, (p. 228)

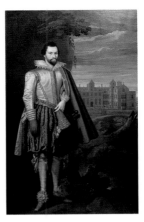

British School 18th C
Sir Thomas Holte (1571–1654)
oil on canvas 239.5 x 148
1970P281

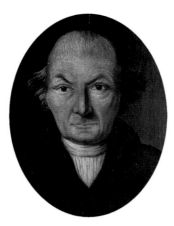

British School 18th C
William Hutton (1723–1816)
oil on board 19 x 15
1932P68

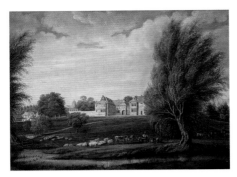

British School late 18th C
Birdingbury Hall, Warwickshire
oil on canvas laid on millboard 38.7 x 50.7
1970P268

British School late 18th C
Distant View of Birdingbury Hall,
Warwickshire
oil on canvas laid on millboard 39.1 x 50.5
1970P269

British School late 18th C
Dr Joseph Priestly (1733–1804)
oil on panel 28.4 x 20.6
1940P732

British School late 18th C
Dr William Bache (1773–1814)
oil on canvas 76.4 x 63.8
1940P427

British School late 18th C
Edward Jesson as a Cavalier
oil on canvas 76.2 x 71.1
1981P17

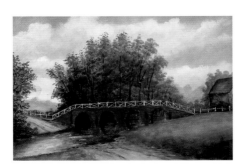

British School late 18th C
Four Arches, Hall Green
oil on canvas 35.6 x 52.7
1969P4

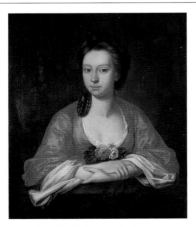

British School late 18th C
Portrait of a Woman (possibly Anne Jesson,
1734–1799)
oil on canvas 73.7 x 63.5
1981P20

British School late 18th C
Sarehole Mill, Hall Green
oil on canvas 36.2 x 52.7
1969P3

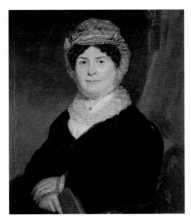

British School
Mary Parker c.1800–1825
oil on canvas 76.4 x 64.3
1978V787

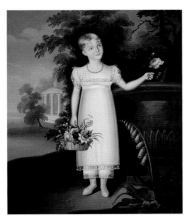

British School
Fanny, Daughter of James Beale c.1810–1820
oil on canvas 124.5 x 103
1938P9

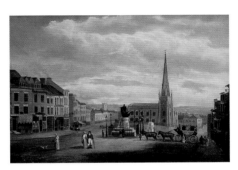

British School
Bull Ring, Birmingham 1820
oil on canvas 39.6 x 49.7 (E)
1968P48

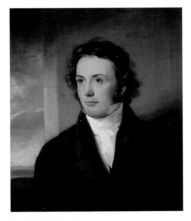

British School
James Tibbetts Willmore (1800–1863)
1825–1830
oil on canvas 71 x 58.2
1940P6

British School
Christ Church, Birmingham New Street c.1840–1860
oil on board 22.7 x 30.3
1983V27

British School
Old Tree at Alum Rock c.1840–1860
oil on canvas 30.5 x 40.4
1978V791

British School
Washwood Heath c.1840–1860
oil on canvas 31.5 x 41.5
1978V790

British School
George Dawson (1821–1876) c.1850–1899
oil on canvas 61.3 x 51
1935P147

British School
Saltley College, Birmingham 1852
oil on canvas 35.5 x 40.5
1978V789

British School
John Pix Weston c.1860
oil on canvas 75 x 62
1966P13

British School
Solihull Church, Birmingham 1870
oil on board 20.2 x 15.4
1978V5

British School
Tudor Garden Party c.1870
oil on canvas 76.5 x 127.5
PCF09

British School
George Dawson (1821–1876) 1872
oil on canvas 35.5 x 30.3
1929P34

British School
Portrait of Man in Red c.1885
oil on canvas 61 x 51
PCF07

British School early 19th C
Birmingham by Moonlight
oil on board 35.9 x 50.1
1984V200

British School early 19th C
Charles Pemberton
oil on canvas 75 x 62.9
1940P426

British School early 19th C
Elizabeth Pemberton
oil on canvas 77 x 64.3
1940P425

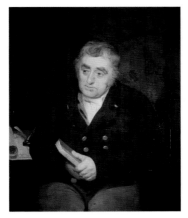

British School early 19th C
James Luckock (1761–1835)
oil on canvas 36 x 28
1931P691

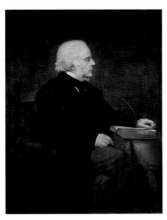

British School early 19th C
John Bright (1811–1889)
oil on canvas 142.1 x 106.5
1978V797

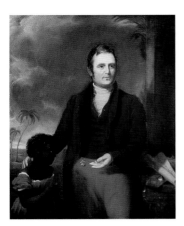

British School early 19th C
Joseph Sturge (1793–1859)
oil on canvas 127 x 101.5
1978V796

British School early 19th C
Moonlight Scene
oil on canvas 38 x 66
1981P5

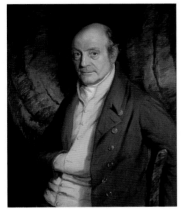

British School early 19th C
Mr Messenger
oil on canvas 77.2 x 63.6
1929P521

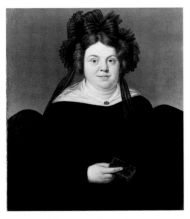

British School early 19th C
Mrs Thomas Harcourt
oil on canvas 81 x 69
1988V1529

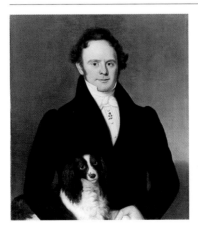

British School early 19th C
Mr Thomas Harcourt
oil on canvas 81 x 69
1988V1530

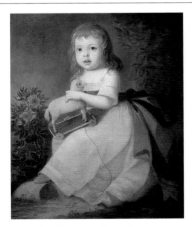

British School early 19th C
Portrait of a Child
oil on canvas 76.2 x 63.5
1992P8

British School early 19th C
Portrait of a Clergyman
oil on copper 21 x 14.3
1940P611

British School early 19th C
Thomas Wright Hill
oil on canvas 74 x 64
1885P2577

British School early/mid-19th C
John Freeth (1731–1808)
oil on canvas 75.3 x 63.3
1885P3191

British School mid-19th C
Jane Elizabeth Weston
oil on canvas 77 x 64
1966P14

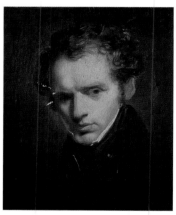

British School mid-19th C
Portrait of a Young Man
oil on canvas 44.5 x 39
1955P106

British School 19th C
Aston Church and Village
oil on canvas 63.2 x 77
1975V27

British School 19th C
Aston Parish Church
oil on board 17.8 x 25.5
1978V6

British School 19th C
Cow in a Field
oil on canvas 65.1 x 76.6
1988V1837

British School 19th C
Dead Game
oil on canvas 64.5 x 72
1938P127

British School 19th C
Dr Bell Fletcher
oil on canvas 125.6 x 100
1978V815

British School 19th C
Erdington Church
oil on board 23.6 x 39
1978V798

British School 19th C
Four Arches, Yardley Wood
oil on canvas 20.6 x 25.7
1969V371

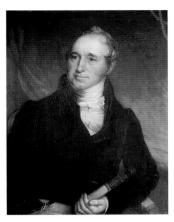

British School 19th C
George Attwood (1777–1834)
oil on canvas 91 x 71
1963P28

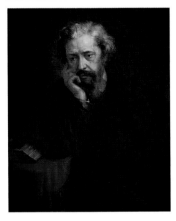

British School 19th C
George Dawson (1821–1876)
oil on canvas 90.8 x 70.8
1978P6

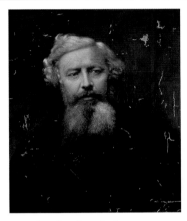

British School 19th C
George Dawson (1821–1876)
oil on canvas 76.2 x 54
2005.1233

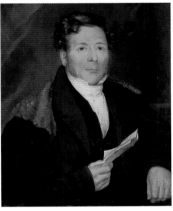

British School 19th C
George Edmonds
oil on canvas 76.7 x 63.4
1885P2578

British School 19th C
Helen Howard Evans
oil on canvas 62 x 51.3
1986P3

British School 19th C
Henry Port
oil on canvas 95 x 60 (E)
2004.1724

British School 19th C
Hockley Abbey, Birmingham
oil on canvas 64.5 x 91.5
1979V696

British School 19th C
Interior of Aston Parish Church
oil on canvas 76.3 x 63.5
1957P36

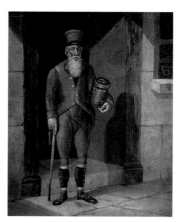

British School 19th C
James Guidney 'Jimmy, the Rock Man'
oil on board 29.7 x 23.7
1968P11

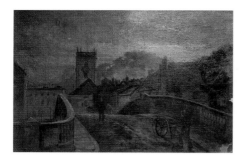

British School 19th C
Load Street and Severn Bridge, Bewdley
oil on canvas 25.7 x 36
1972V93

British School 19th C
Path through a Wood
oil on panel 14.3 x 25.2
1970P138

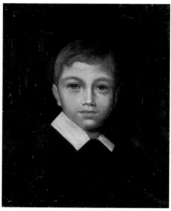

British School 19th C
Portrait of a Boy
oil on canvas 51 x 40.5
1982P50

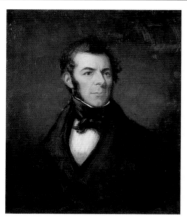

British School 19th C
Portrait of a Gentleman
oil on canvas 75.5 x 63.2
PCF02

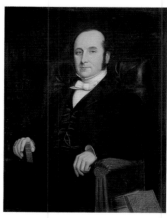

British School 19th C
Portrait of a Gentleman
oil on canvas 92 x 71
PCF11

British School 19th C
Portrait of a Gentleman with a Dog
oil on canvas 75 x 63
PCF 37

British School 19th C
Portrait of a Man
oil on canvas 76.5 x 63.5
1978F78

Facing page: Gear, William, 1915–1997, *Untitled* (detail), c.1960, Birmingham City University, (p. 11)

British School 19th C
Portrait of a Man
oil on canvas 87 x 72.5
2005.1225

British School 19th C
Portrait of a Town Crier
oil on canvas 76 x 63
M12

British School 19th C
Portrait of a Woman
oil on canvas 75.7 x 63.5
PCF01a

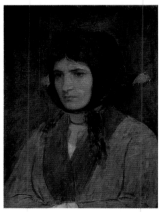

British School 19th C
Portrait of a Woman (possibly Louisa Starr
Canziani, 1845–1909)
oil on canvas laid on board 61.7 x 42.2
PCF 35

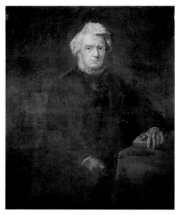

British School 19th C
Portrait of an Elderly Gentleman
oil on canvas 127.3 x 102
PCF10

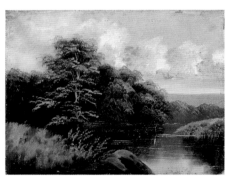

British School 19th C
River Scene
oil on panel 17.9 x 22.8
PCF 34

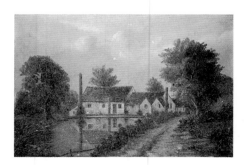

British School 19th C
Sarehole Mill (?)
oil on canvas 30.5 x 46
1977V311

British School 19th C
Sir Rowland Hill (1795–1879)
oil on canvas 78.6 x 63.7
1966P17

British School 19th C
Unidentified Canal Man
oil on canvas 108 x 83.5
1988V1630

British School late 19th C
E. R. Taylor (1838–1912)
oil on canvas 55.2 x 46.2
1984P27

British School late 19th C
William Hutton (1723–1816)
oil on canvas 69 x 59 (E)
1969P105

British School
Cottage Scene c.1900
oil on canvas 47.6 x 73.5
PCF04

British School
Cottage Scene c.1900
oil on canvas 47.6 x 73.5
PCF05

British School
*The Right Honourable Joseph Chamberlain
(1836–1914), PC, MP* c.1900
oil on canvas 50.3 x 35
1987P63

British School
Portrait of a Man c.1900–1910
oil on canvas 76 x 57
PCF03

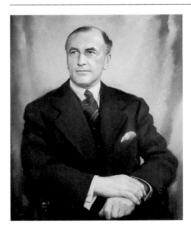

British School
Sir Frank Wiltshire, Town Clerk, Birmingham
1950
oil on canvas 75 x 62
1975Q1 (P)

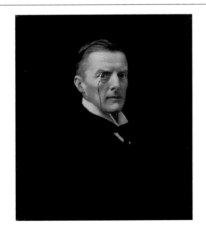

British School early 20th C
*The Right Honourable Austen Chamberlain
(1863–1937), MP*
oil on canvas 75 x 62.7
PCF 30

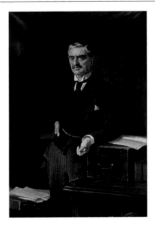

British School early 20th C
*The Right Honourable Neville Chamberlain
(1869–1940), MP*
oil on canvas 160 x 100 (E)
PCF 31

British School 20th C
'Jimmy the Rockman'
oil on canvas 41.2 x 30.5
1996V213

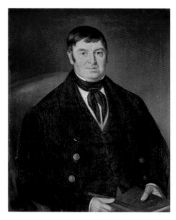

British School 20th C
John Mayon
oil on canvas 91 x 71
1988V1839

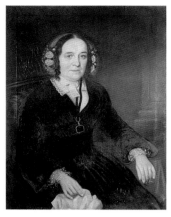

British School 20th C
Mrs Mayon
oil on canvas 92 x 71.4
1988V1840

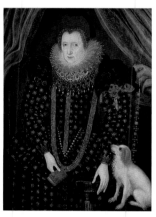

British School
Portrait of a Lady
oil on panel 113.9 x 84
1977P316

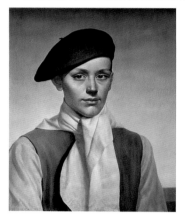

Brockhurst, Gerald Leslie 1890–1978
Basque Boy, Cypriano 1963
oil on panel 43.3 x 35.5
1983P73

Bromley active 20th C
The Judges Postillion
oil on canvas 62.1 x 82.3
PCF 28

Brown, F. Gregory 1887–1941
*The Visit of the King and Queen to Bournville,
16 May 1919* 1919
oil on canvas 108 x 133
1980P43

Brown, Ford Madox 1821–1893
Portrait of a Boy c.1850
oil on canvas 35.5 x 30.5
1960P25

Brown, Ford Madox 1821–1893
Pretty Baa-Lambs 1851–1859
oil on panel 60.9 x 76.2
1956P9

Brown, Ford Madox 1821–1893
An English Autumn Afternoon 1854
oil on canvas 71.2 x 134.8 (E)
1916P25

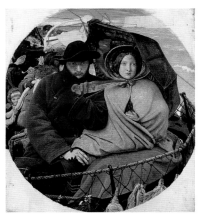

Brown, Ford Madox 1821–1893
The Last of England 1855
oil on panel 82.5 x 75
1891P24

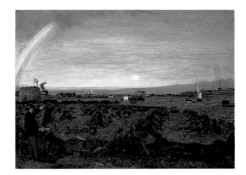

Brown, Ford Madox 1821–1893
Walton-on-the-Naze 1860
oil on canvas 84 x 174.2
1915P97

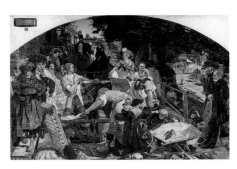

Brown, Ford Madox 1821–1893
Work 1863
oil on canvas 68.4 x 99
1927P349

Brown, Ford Madox 1821–1893
Elijah and the Widow's Son 1864
oil on canvas 57 x 33
1912P23

Brown, Ford Madox 1821–1893
The Death of Sir Tristram 1864
oil on canvas 65 x 59
1916P26

Brown, Ford Madox 1821–1893
The Finding of Don Juan by Haidee 1873
oil on canvas 171 x 213
1912P22

Brown, Ford Madox 1821–1893
Wycliffe on His Trial 1891–1893
oil on canvas 148.9 x 318.8
1912P10

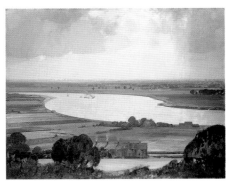

Brown, John Alfred Arnesby 1866–1955
The Smug and Silver Trent c.1914–1924
oil on canvas 98.3 x 124.5
1924P252

Bruton, Jesse b.1933
Winding 1967–1968
oil on canvas 160.3 x 206.4
1968P34

Buckner, Richard 1812–1883
Marie Adeline Plunket (1824–1910) 1854
oil on canvas 89 x 54.5
1939P378

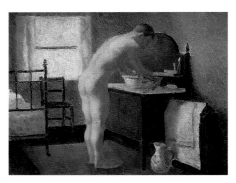

Buhler, Robert A. 1916–1989
Early Morning 1939
oil on board 30.1 x 35.7
1963P31

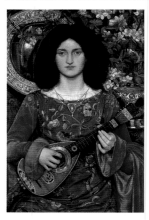

Bunce, Kate Elizabeth 1858–1927
Musica c.1890–1902
oil on canvas 76.3 x 50.9
1897P17

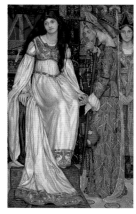

Bunce, Kate Elizabeth 1858–1927
The Keepsake c.1895–1905
oil on canvas 81.3 x 49.5
1928P156

Bundy, Edgar 1862–1922
Stradivarius in His Workshop 1913
oil on canvas 60.3 x 90.3
1925P130

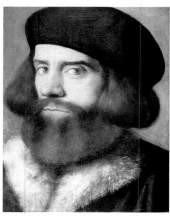

Buonconsiglio, Giovanni c.1465–c.1537
Head of a Bearded Man
oil on panel 29.5 x 22.5
1950P9

Burch, Iain George active 1981–1991
Interior with Blooms 1991
oil on canvas 122 x 76.5
1992PL8

Burke, Peter
Wave Path 1993
acrylic on paper 88.8 x 69
1993Q5

Burne-Jones, Edward 1833–1898
The Annunciation 1857
oil on canvas 53.4 x 19.5
1927P406

Burne-Jones, Edward 1833–1898
Study of 'Fame Overthrowing Fortune' (Troy
Triptych) 1872–1875
oil on canvas 146.6 x 67.3
1922P180

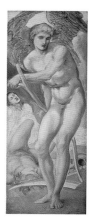

Burne-Jones, Edward 1833–1898
Study of 'Oblivion Conquering Fame' (Troy
Triptych) 1872–1875
oil on canvas 146.6 x 67.3
1922P181

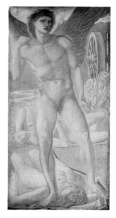

Burne-Jones, Edward 1833–1898
Study of 'Love Subduing Oblivion' (Troy
Triptych) 1872–1875
oil on canvas 148.5 x 69.8
1922P182

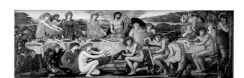

Burne-Jones, Edward 1833–1898
The Feast of Peleus (predella of the Troy
Triptych) 1872–1881
oil on panel 36.9 x 109.9
1956P8

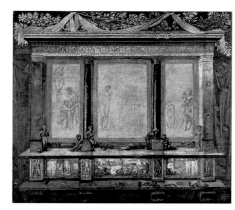

Burne-Jones, Edward 1833–1898
Troy Triptych c.1872–1898
oil on canvas 273 x 294.6
1922P178

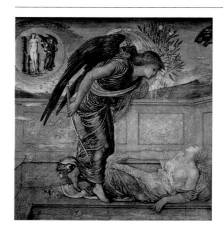

Burne-Jones, Edward 1833–1898
Cupid Finding Psyche Asleep by a Fountain
(Palace Green Murals) 1872–1881
oil on canvas 124.5 x 119.5
1922P187

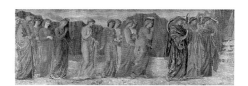

Burne-Jones, Edward 1833–1898
The King and Other Mourners (Palace Green
Murals) 1872–1881
oil on canvas 119.5 x 328.5
1922P188

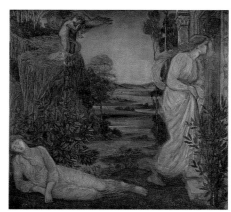

Burne-Jones, Edward 1833–1898
Zephyrus Bearing Psyche (Palace Green
Murals) 1872–1881
oil on canvas 119.5 x 124.5
1922P189

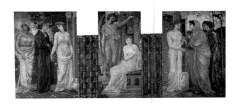

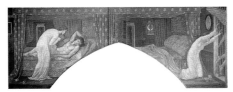

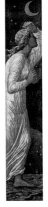

Burne-Jones, Edward 1833–1898
Psyche's Sisters Visit Her (Palace Green Murals) 1872–1881
oil on canvas 119.5 x 266.7
1922P190

Burne-Jones, Edward 1833–1898
Psyche, Holding the Lamp, Gazes at Cupid (Palace Green Murals) 1872–1881
oil on canvas 119.5 x 330
1922P191

Burne-Jones, Edward 1833–1898
Psyche Gazes in Despair at Cupid (Palace Green Murals) 1872–1881
oil on canvas 122.5 x 23
1922P192

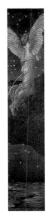

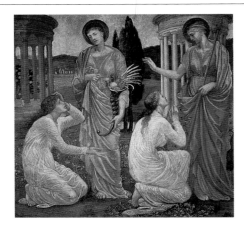

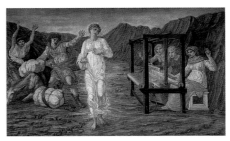

Burne-Jones, Edward 1833–1898
Cupid Flying away from Psyche (Palace Green Murals) 1872–1881
oil on canvas 122.5 x 23
1922P193

Burne-Jones, Edward 1833–1898
Psyche at the Shrines of Juno and Ceres (Palace Green Murals) 1872–1881
oil on canvas 119.5 x 124.5
1922P194

Burne-Jones, Edward 1833–1898
Psyche Sent by Venus (Palace Green Murals) 1872–1881
oil on canvas 119.5 x 201
1922P195

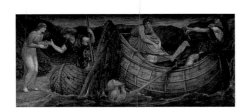

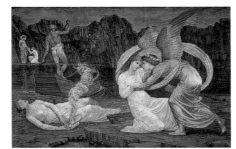

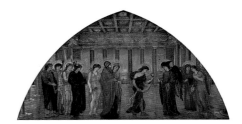

Burne-Jones, Edward 1833–1898
Psyche Giving the Coin to Charon (Palace Green Murals) 1872–1881
oil on canvas 119.4 x 266.7
1922P196

Burne-Jones, Edward 1833–1898
Psyche Receiving the Casket Back (Palace Green Murals) 1872–1881
oil on canvas 119 x 183
1922P197

Burne-Jones, Edward 1833–1898
Psyche Entering the Portals of Olympus (Palace Green Murals) 1872–1881
oil on canvas 141 x 264
1922P198

Burne-Jones, Edward 1833–1898
Wheel of Fortune, Nude Study of a Slave
1877–1882
oil on canvas 19.3 x 30.7
1904P224

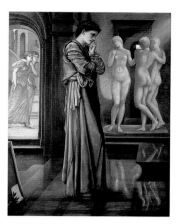

Burne-Jones, Edward 1833–1898
Pygmalion and the Image: The Heart Desires
1878
oil on canvas 99 x 76.3
1903P23

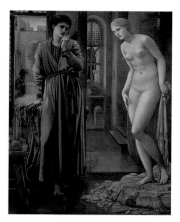

Burne-Jones, Edward 1833–1898
Pygmalion and the Image: The Hand Refrains
1878
oil on canvas 98.7 x 76.3
1903P24

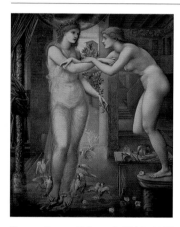

Burne-Jones, Edward 1833–1898
Pygmalion and the Image: The Godhead Fires
1878
oil on canvas 99 x 76.3
1903P25

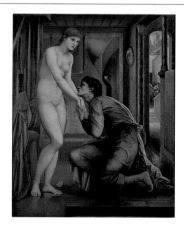

Burne-Jones, Edward 1833–1898
Pygmalion and the Image: The Soul Attains
1878
oil on canvas 99.4 x 76.6
1903P26

Burne-Jones, Edward 1833–1898
The Wizard 1896–1898
oil on canvas 93 x 55.5
1912P17

Burt, Charles Thomas 1823–1902
Metchley Park Farm, Harborne 1845
oil on canvas 23.5 x 34.3
1903P7

Burt, Charles Thomas 1823–1902
Lundy Island, Devon 1857
oil on canvas 91 x 71
1933P75

Burt, Charles Thomas 1823–1902
Crossing the Sands 1858
oil on canvas 51 x 76.5
1909P64

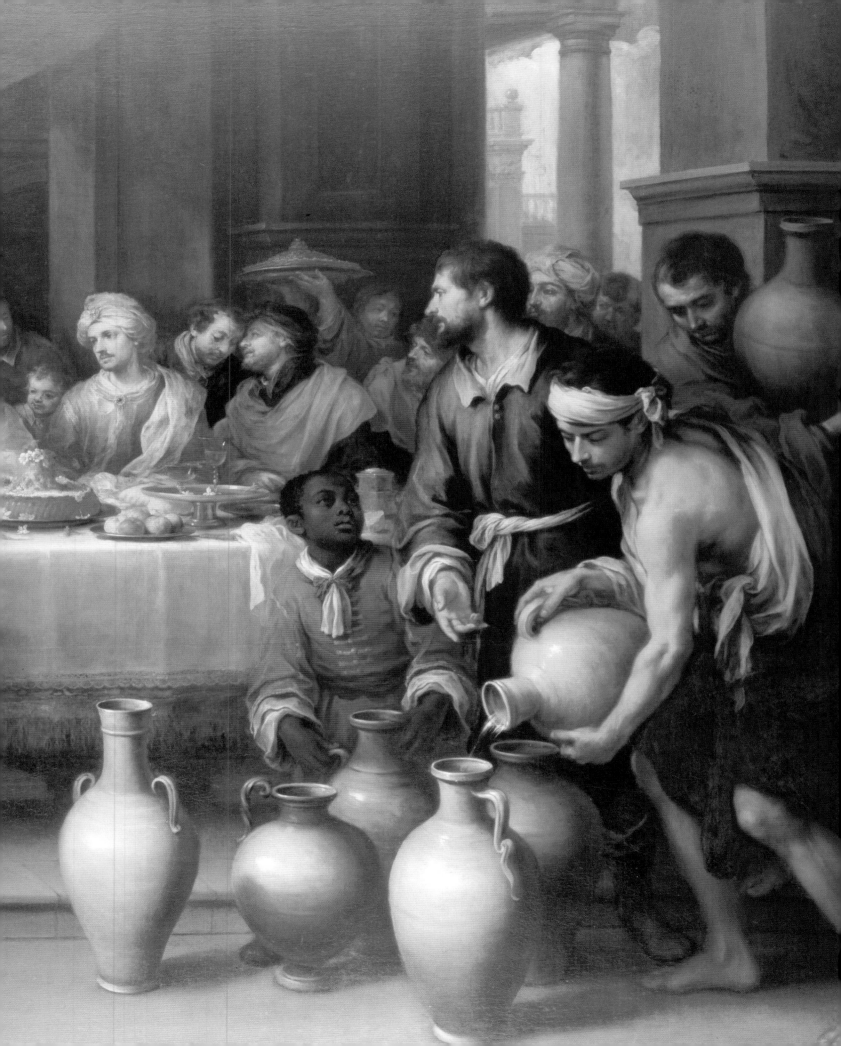

Burt, Charles Thomas 1823–1902
Near Llanbedr, Barmouth 1872
oil on canvas 62 x 92.5
1885P2475

Burt, Charles Thomas 1823–1902
Snowdon from Pensarn 1872
oil on canvas 58.5 x 112.2
1915P29

Burt, Charles Thomas 1823–1902
The Skylark 1874
oil on canvas 58.5 x 88.9
1887P939

Burt, Charles Thomas 1823–1902
Sea Waves (panel in the Everitt Cabinet) 1880
oil on panel 20.2 x 22.6
1892P41.4

Burt, Charles Thomas 1823–1902
Sea Coast 1887
oil on paper 13 x 18.5
1901P31.4

Burt, Charles Thomas 1823–1902
The Grove, Harborne
oil on canvas 33.2 x 43.7
1938P324

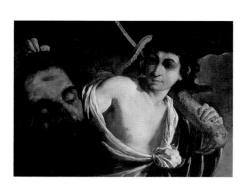

Caletti, Giuseppe c.1600–c.1660
David with the Head of Goliath c.1650
oil on canvas 73.7 x 88.3
1960P42

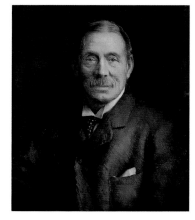

Calkin, Lance 1859–1936
John Feeney (1839–1905) 1906
oil on canvas 63.9 x 54.9
1909P1

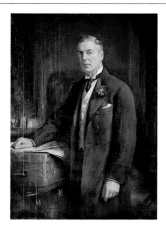

Calkin, Lance 1859–1936
*The Right Honourable Joseph Chamberlain
(1836–1914), MP*
oil on canvas 143 x 102
PCF 19

Facing page: Murillo, Bartolomé Esteban, 1618–1682, *The Marriage Feast at Cana* (detail), c.1672, The Barber Institute
of Fine Arts, (p. 236)

Callery, Simon b.1960
Six Pace Painting 1999
oil on canvas 200 x 385
2001Q2

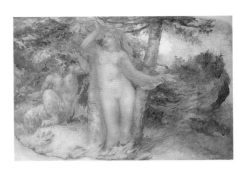

Calvert, Edward 1799–1883
Pan and Pithys c.1850
oil on millboard 26 x 38.1
1904P553

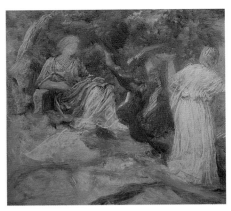

Calvert, Edward 1799–1883
The Grove of Artemis c.1850
oil on millboard 15.3 x 16.5
1904P554

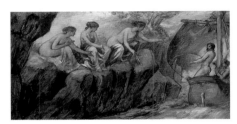

Calvert, Edward 1799–1883
Ulysses and the Sirens c.1850
oil on millboard 19.7 x 36.9
1904P552

Cambier, Nestor 1879–1957
*The Right Honourable Joseph Chamberlain
(1836–1914), MP* c.1900
oil on canvas 170 x 124 (E)
PCF 29

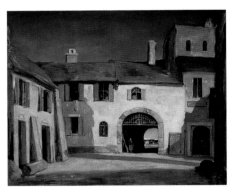

Cameron, David Young 1865–1945
Rambelli, near Rome, Italy 1922
oil on canvas 60.2 x 73
1932P182

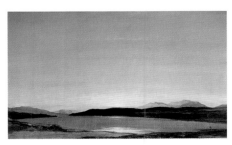

Cameron, David Young 1865–1945
Sundown, Loch Rannoch 1922–1923
oil on canvas 45.5 x 76
1924P1

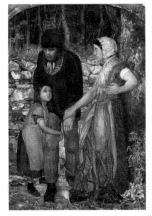

Campbell, James 1828–1903
The Wife's Remonstrance 1857–1858
oil on canvas 73 x 48
1958P8

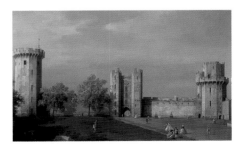

Canaletto 1697–1768
Warwick Castle, East Front from the Courtyard
1752
oil on canvas 75 x 122
1978P174

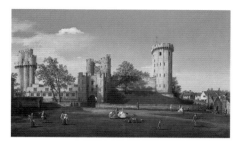

Canaletto 1697–1768
Warwick Castle, East Front from the Outer Court 1752
oil on canvas 73 x 122
1978P173

Canziani, Estella Louisa Michaela
1887–1964
Gepin e la vecchia, Biella, Piedmont
1907–1910
tempera on panel 20.4 x 14
1931P968.561

Canziani, Estella Louisa Michaela
1887–1964
Procession of the Confraternity of Saint Croix, Aosta, Piedmont 1907–1910
tempera on panel 25.4 x 20.3
1931P968.547

Canziani, Estella Louisa Michaela
1887–1964
Repentance, Pragelato, Piedmont 1907–1910
tempera on panel 20.4 x 15.1
1931P968.536

Canziani, Estella Louisa Michaela
1887–1964
The Plains of Lombardy 1907–1910
tempera on panel 15.4 x 20.5
1931P968.556

Canziani, Estella Louisa Michaela
1887–1964
Valdesi Reading the Bible 1907–1910
tempera on panel 20.4 x 15.2
1931P968.542

Canziani, Estella Louisa Michaela
1887–1964
Wedding Costume of Fobello, Piedmont
1907–1910
tempera on panel 20.3 x 15.2
1931P968.554

Canziani, Estella Louisa Michaela
1887–1964
When the Leaves Fall 1907–1910
tempera on panel 15.2 x 20.3
1931P968.562

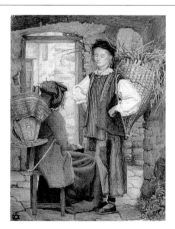

Canziani, Estella Louisa Michaela
1887–1964
Down from the Mountains, Cradle and Gerlo (basket), Antrona Piana, Piedmont 1910–1911
tempera on panel 20.4 x 15.1
1931P968.528

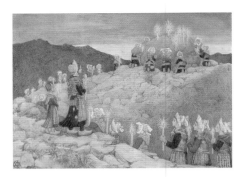

Canziani, Estella Louisa Michaela
1887–1964
Pierres à cupules, Savoy 1910–1911
tempera on panel 15.1 x 20.3
1931P968.584

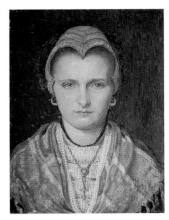

Canziani, Estella Louisa Michaela
1887–1964
Costume de ma grandmère, Bourg Saint Maurice, Savoy
tempera on panel 20.1 x 15.1
1931P968.519

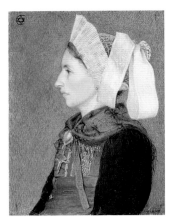

Canziani, Estella Louisa Michaela
1887–1964
Costume for Mourning, Saint Colomban, Savoy
tempera on panel 20.3 x 15.2
1931P968.495

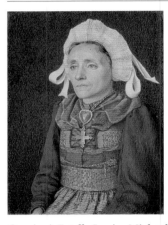

Canziani, Estella Louisa Michaela
1887–1964
Everyday Working Costume of Saint Colomban, Savoy
tempera on panel 20.3 x 15.2
1931P968.494

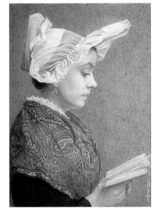

Canziani, Estella Louisa Michaela
1887–1964
Girl in Mourning, Costume of La Valloire
tempera on panel 20.3 x 15.1
1931P968.500

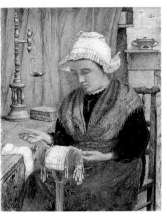

Canziani, Estella Louisa Michaela
1887–1964
Girl Making Lace, Savoy, France
tempera on panel 20.3 x 15.1
1931P968.512

Canziani, Estella Louisa Michaela
1887–1964
Girl's Costume of Jarrier, Savoy
tempera on panel 20.2 x 15
1931P968.499

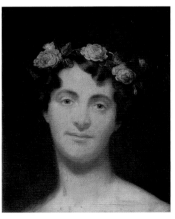

Canziani, Estella Louisa Michaela
1887–1964
Piemonte
tempera on paper 27.8 x 19.2
1931P968.557

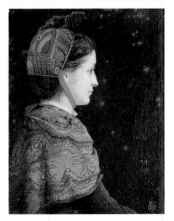

Canziani, Estella Louisa Michaela
1887–1964
Portrait of a Woman with a Garland
oil on canvas 41.6 x 33.6
PCF 25

Canziani, Estella Louisa Michaela
1887–1964
Study for Costume Jewellery
tempera on paper 24 x 19
1931P968.548

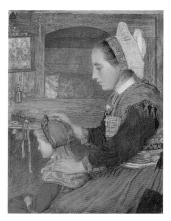

Canziani, Estella Louisa Michaela
1887–1964
Sunday, Saint Jean d'Arves
tempera on panel 20.3 x 15.1
1931P968.508

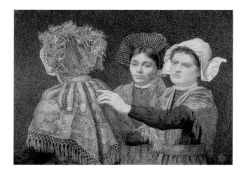

Canziani, Estella Louisa Michaela
1887–1964
The Wedding Cap, Savoy
tempera on panel 15.1 x 20.3
1931P968.520

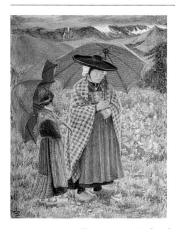

Canziani, Estella Louisa Michaela
1887–1964
Woman of Saint Jean d'Arves in a Hat
tempera on panel 20.2 x 15.1
1931P968.504

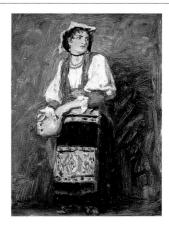

Canziani, Louisa Starr 1845–1909
Study of a Russian Peasant Girl 1874–1880
oil on paper mounted onto board 36 x 26
1931P968.592

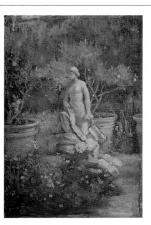

Canziani, Louisa Starr 1845–1909
Fountain in a Garden, Cairate, Lombardy
1875–1877
oil on panel 23 x 15.2
1931P968.558

Canziani, Louisa Starr 1845–1909
The Village of Cairate, Lombardy 1875–1877
oil on panel 15 x 22.9
1931P968.560

Canziani, Louisa Starr 1845–1909
The Eternal Door (Cairate, Lombardy) 1876
oil on panel 169 x 236.4
1931P967

Canziani, Louisa Starr 1845–1909
*Sketch of the Honourables Dudley and Archie
Hamilton Gordon* 1889–1890
oil on canvas 9.9 x 13.1
1929P635

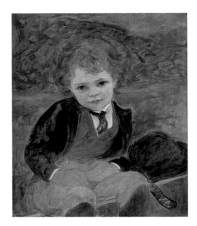

Canziani, Louisa Starr 1845–1909
Study of a Boy Sitting on a Wheelbarrow
1889–1890
oil on canvas 68.8 x 50.8
1929P633

Canziani, Louisa Starr 1845–1909
Study of a Boy Sitting in a Wheelbarrow
1889–1890
oil on canvas 61.1 x 51
1929P634

Canziani, Louisa Starr 1845–1909
*Enrico and Estella Louisa Michaela Canziani
(1887–1964)*
oil on a wooden panel 13.3 x 17.8
1979P211

Canziani, Louisa Starr 1845–1909
*Head of a Woman Superimposed over an
Italian Building*
oil on canvas 25.6 x 20.4
1979P215

Canziani, Louisa Starr 1845–1909
Italian Peasant in Stone Archway
oil on linen laid on oak panel 18 x 12.8
1979P213

Canziani, Louisa Starr 1845–1909
*Two Women in White Seated in a Wooded
Glade*
oil on canvas 15.1 x 23.1
1979P212

Canziani, Louisa Starr 1845–1909
Woman in White, Seated on a Terrace
oil on oak panel 17.5 x 13.4
1979P214

Carlevarijs, Luca 1663–1730
Study of Two Gondolas and Figures
c.1700–1710
oil on canvas 19 x 31.8
1948P50

Carlevarijs, Luca 1663–1730
*The Arrival of the Earl of Manchester in
Venice* 1707–1710
oil on canvas 132 x 264
1949P36

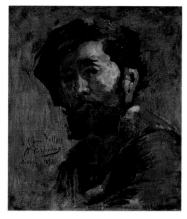

Carpeaux, Jean-Baptiste 1827–1875
Antoine Vollon (1833–1900) 1873
oil on canvas 45.7 x 38.1
1960P26

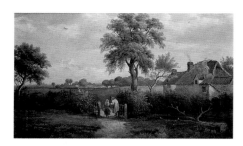

Cartwright, William P. 1864–1911
Cottage Scene, Marston Green
oil on canvas 29.8 x 45.7
1968P31

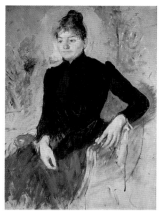

Cassatt, Mary 1844–1926
Portrait of a Woman 1881–1883
oil on canvas 99.1 x 72.4
1951P63

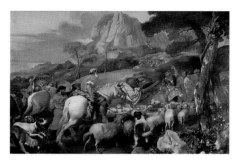

Castiglione, Giovanni Benedetto 1609–1664
The Angel Appearing to the Shepherds
c.1640–1660
oil on canvas 107.3 x 160.8
1958P12

Caulfield, Patrick 1936–2005
Red and White Still Life 1964
oil on board 160 x 213.4
1998P29

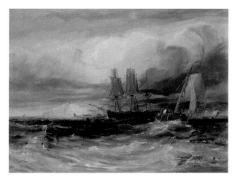

Chambers, George 1803–1840
On the Thames, Tilbury Fort
oil on millboard on wood panel 16.9 x 21.6
1919P79

Chandler, Robert b.1952
Untitled (Maroon) 2003
oil on canvas 101.8 x 101.5
2007.0927

Chandler, Robert b.1952
Untitled (Red) 2003
oil on canvas 91 x 86
2007.0926

Chandler, Robert b.1952
Untitled (Green) 2005
oil on canvas 101.8 x 91.5
2006.1391

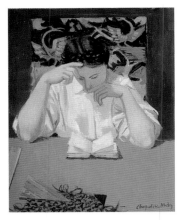

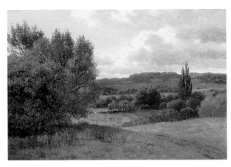

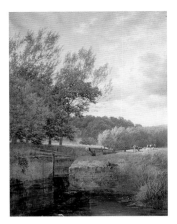

Chapelain-Midy, Roger 1904–1992
La liseuse 1950–1952
oil on canvas 41.9 x 33
1953P10

Cheadle, Henry 1852–after 1931
Landscape with Trees
oil on canvas 30.6 x 40.5
1931P86

Cheadle, Henry 1852–after 1931
Wooded Landscape with Boy Fishing in a Lock
oil on canvas 91.5 x 70.8
1931P84

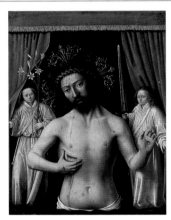

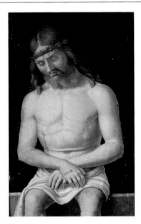

Chinnery, George 1774–1852
Bengal Village Scene 1819–1821
oil on canvas 32.4 x 40.7
1943P287

Christus, Petrus c.1410–c.1475
Christ as the Man of Sorrows c.1450
oil on panel 11.2 x 8.5
1935P306

Cima da Conegliano, Giovanni Battista
c.1459–1517
The Dead Christ 1499–1501
oil on panel 26.9 x 16.7
1930P16

Clare, Oliver c.1853–1927
Still Life with Peach and Plums 1916
oil on board 21.5 x 30.9
1989P2

Clare, Oliver c.1853–1927
Still Life with Strawberries 1916
oil on board 22.9 x 30.6
1989P1

Clausen, George 1852–1944
Building the Rick 1907
oil on canvas 108 x 132.6
1923P48

Facing page: Rae, Fiona, b.1963, *Dark Star* (detail), 2001, Birmingham Museums and Art Gallery, (p. 164)

Clausen, George 1852–1944
Albert Toft (1862–1949) 1913
oil on canvas 46.4 x 35.6
1947P17

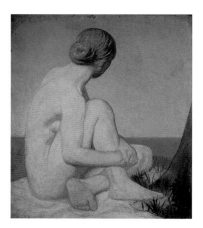

Clausen, George 1852–1944
The Watcher 1927/1928
oil on canvas 39.2 x 35.1
1928P645

Clough, Prunella 1919–1999
Electrical Installation III 1959
oil on canvas 101.6 x 76.2
1972P26

Clough, Prunella 1919–1999
Enclosed Area c.1980
oil on canvas 35.3 x 35.6
2007.0929

Clough, Prunella 1919–1999
Vegetation 1999
oil & sand on canvas 152 x 184
2000Q50

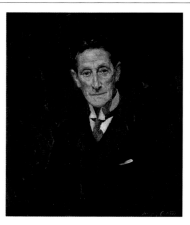

Coates, George James 1869–1930
Sir Johnstone Forbes-Robertson (1853–1937)
oil on canvas 72 x 61.1
1932P293

Cohen, Harold b.1928
Orestes Returning 1966
acrylic on canvas 198.5 x 198.5
1976P100

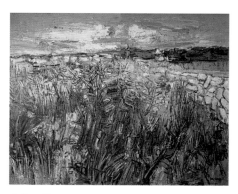

Coker, Peter 1926–2004
Gorse and Bracken, Audierne 1956–1957
oil on hardboard 122 x 152.4
1977P134

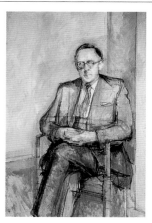

Coldstream, William Menzies 1908–1987
Sir Trenchard Cox (1905–1995) 1967
oil on canvas 135.9 x 90.8
1968P21 🐝

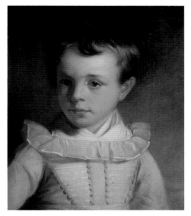

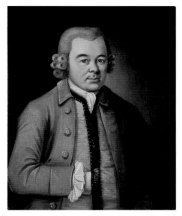

Coleman, Edward 1795–1867
Master Joseph Fussell 1826
oil on canvas 44.2 x 37.4
1903P9

Coleman, Edward 1795–1867
Dead Game 1829
oil on canvas 188.6 x 148.6
1885P2587

Coleman, James active c.1750–1780
Christopher Fuller (d.1786)
oil on canvas 71.5 x 58.5
1930P38

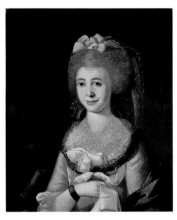

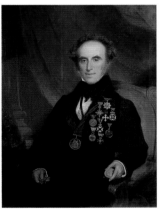

Coleman, James active c.1750–1780
Ann Fuller
oil on canvas 71.3 x 58.5
1930P39

Coleman, Samuel active c.1820–1859
The Delivery of Israel out of Egypt
c.1820–1840
oil on canvas 135.6 x 199.1
1950P22

Coleman, Samuel active c.1820–1859
Sir Edward Thomason (1769–1849)
1840–1859
oil on canvas 122 x 94
1951P109

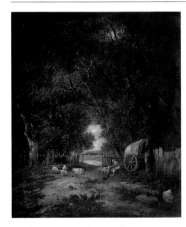

Colkett, Samuel David 1806–1863
Walnut Tree Walk, Earlham c.1850
oil on canvas 59.7 x 48.3
1928P597

Colley, Reuben b.1976
Brindley Light 2003
oil on board 71 x 89
2003.0524

Collins, Cecil 1908–1989
The Pilgrim 1934
oil on canvas 40.5 x 30.5
2001P25

Collins, Cecil 1908–1989
The Sibyl 1958
oil on board 120.5 x 112.2
2001P26

Collins, James Edgell 1819–1895
Alderman Thomas Phillips, Mayor of Birmingham 1871
oil on canvas 93 x 72.5
1899P1

Collins, James Edgell 1819–1895
Alderman Thomas Phillips, Mayor of Birmingham 1876
oil on canvas 91.8 x 71.2
1967P17

Collins, William 1788–1847
The Reluctant Departure 1815
oil on canvas 88 x 112.4
1885P2528

Colonia, Adam 1634–1685
The Angel Appearing to the Shepherds c.1660–1685
oil on canvas 171 x 191.8
1957P12

Commère, Jean 1920–1986
The Pheasant 1955–1957
oil on canvas 54.6 x 104.1
1957P25

Conroy, Stephen b.1964
Sorrow, Nature's Son 1986
oil on canvas 106.5 x 106.5
1988P107

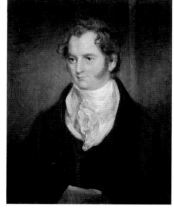

Constable, John 1776–1837
James Lloyd 1806
oil on canvas 76.6 x 64
1992P9

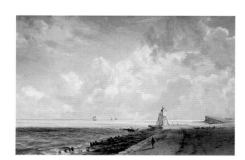

Constable, John 1776–1837
Harwich Lighthouse c.1820
oil on canvas 32 x 50
2002P4

Constable, John 1776–1837
Study of Clouds, Evening, 31 August 1822
1822
oil on paper 48.7 x 59.5
1929P45

Cook, Barrie b.1929
Black Space c.1974
acrylic spray on canvas 274 x 274
2007.0918

Cook, Barrie b.1929
Dean 1977
oil applied with spray gun on cotton duck
122 x 183
1987P1

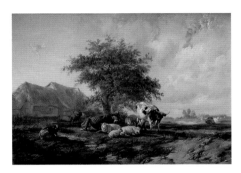

Cooper, Thomas Sidney 1803–1902
Landscape with Cattle and Sheep 1837
oil on panel 22.3 x 29.9
1908P23

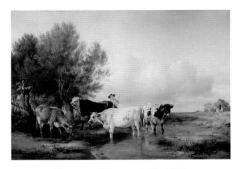

Cooper, Thomas Sidney 1803–1902
Cattle in a Stream 1841
oil on canvas 110.5 x 146.5
1927P276

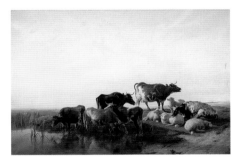

Cooper, Thomas Sidney 1803–1902
Landscape with Cattle and Sheep 1872
oil on canvas 76.5 x 109
1941P456

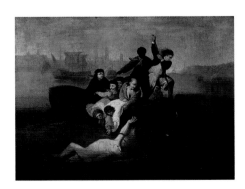

Copley, John Singleton 1738–1815
Brook Watson and the Shark
oil on canvas 71.3 x 92
1938P128

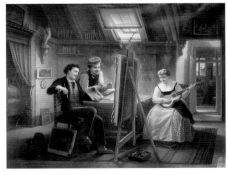

Correns, Jozef Cornelius 1814–1907
The Artist's Studio 1869
oil on canvas 63.5 x 78.7
1931P112

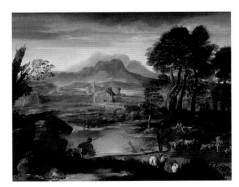

Cortona, Pietro da 1596–1669
Landscape with a Lake and a Walled Town
c.1620–1640
oil on canvas 62.3 x 77.7
1985P61

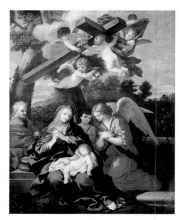

Cortona, Pietro da 1596–1669
The Holy Family with Angels
oil on canvas 144.8 x 115.6
1975P407

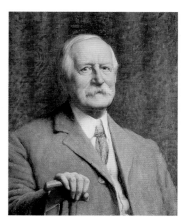

Cossins, Jethro Anstice 1830–1917
Self Portrait 1911–1912
oil on canvas 60.5 x 51.5
1973V11

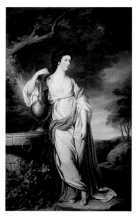

Cotes, Francis 1726–1770
Miss Catherine Eld 1767
oil on canvas 241.6 x 148.8
1961P31

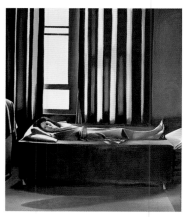

Couch, Christopher b.1946
Afternoon 1982
oil on canvas 271 x 229
1982P47

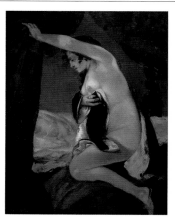

Courbet, Gustave 1819–1877
Study for Venus in 'Venus and Psyche'
1863–1865
oil on canvas 81.7 x 65.8
1949P1

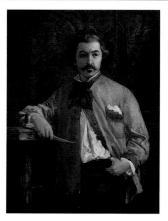

Couture, Thomas 1815–1879
Antoine Etex (1808–1888) 1845–1855
oil on canvas 117.2 x 85.4
1958P3

Cox, David the elder 1783–1859
All Saints' Church, Hastings 1812
oil on panel 14.6 x 22.2
1885P2509

Cox, David the elder 1783–1859
All Saints' Church, Hastings 1812–1813
oil on cardboard laid on panel 15.5 x 22.5
1885P2485

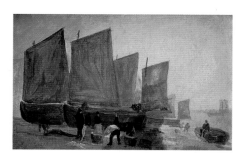

Cox, David the elder 1783–1859
Fishing Boats, Hastings 1812–1813
oil on panel 13.6 x 22.2
1885P2486

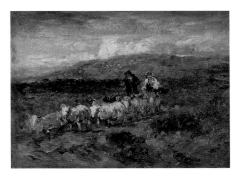

Cox, David the elder 1783–1859
Welsh Shepherds 1839–1841
oil on panel 25 x 27.3
1885P2513

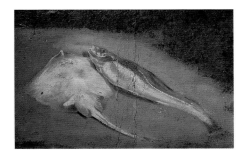

Cox, David the elder 1783–1859
Study of Fish, Skate and Cod 1839–1842
oil on millboard 13 x 19.7
1927P666

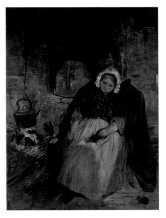

Cox, David the elder 1783–1859
An Old Woman Asleep c.1839–1859
oil on board 47.6 x 38.1
1958P32

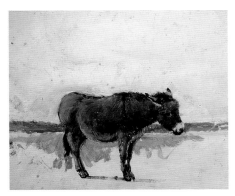

Cox, David the elder 1783–1859
Study of a Donkey 1841–1843
oil on millboard 25.4 x 29.4
1907P349

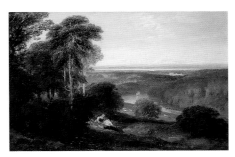

Cox, David the elder 1783–1859
The Wyndcliffe, River Wye 1842
oil on canvas 35.2 x 45.9
1912P3

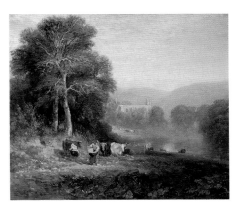

Cox, David the elder 1783–1859
Bolton Abbey 1844
oil on canvas 35.3 x 46.3
1948P32

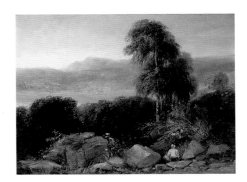

Cox, David the elder 1783–1859
Windermere 1844
oil on canvas 21.6 x 30.5
1885P2497

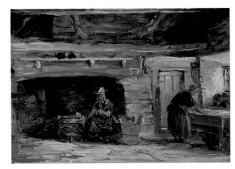

Cox, David the elder 1783–1859
Cottage Interior, Trossavon near Betws-y-Coed
1844–1847
oil on board 27.9 x 39.1
1885P2494

Cox, David the elder 1783–1859
A Farm at Betws-y-Coed 1844–1856
oil on canvas 60.7 x 86.6
1919P84

Cox, David the elder 1783–1859
The Church, Betws-y-Coed c.1844–1856
oil on canvas 27.4 x 38.7
1885P2496

Cox, David the elder 1783–1859
Waiting for the Ferry 1845
oil on canvas 35 x 46.4
1885P2493

Cox, David the elder 1783–1859
The Farmstead 1846–1848
oil on canvas 25.2 x 35.5
1885P2507

Cox, David the elder 1783–1859
Changing Pasture 1847
oil on canvas 48 x 73.2
1885P2495

Cox, David the elder 1783–1859
Driving Cattle 1847–1849
oil on board mounted on panel 28.1 x 39.2
1885P2515

Cox, David the elder 1783–1859
Crossing the Sands 1848
oil on panel 26.7 x 37.9
1885P2487

Cox, David the elder 1783–1859
The Welsh Funeral 1848
oil on canvas 46.4 x 71.1
1943P3

Cox, David the elder 1783–1859
Sheep Shearing 1849
oil on canvas 26.7 x 38.1
1885P2508

Cox, David the elder 1783–1859
Tending Sheep, Betws-y-Coed 1849
oil on canvas 31.9 x 43
1885P2499

Cox, David the elder 1783–1859
The Skylark 1849
oil on canvas 71.1 x 91.4
1947P76

Cox, David the elder 1783–1859
Market Gardeners 1849–1851
oil on panel 25.5 x 40.2
1885P2505

Cox, David the elder 1783–1859
On the Sands 1849–1851
oil on canvas 22.9 x 35
1885P2514

Cox, David the elder 1783–1859
The Crossroads 1850
oil on panel 17.4 x 25.4
1885P2502

Cox, David the elder 1783–1859
The Peat Gatherers 1850
oil on canvas 17.7 x 28.1
1885P2504

Cox, David the elder 1783–1859
Waiting for the Ferry, Morning 1851
oil on canvas 36 x 49.6
1885P2500

Cox, David the elder 1783–1859
Evening 1851–1853
oil on canvas 36.6 x 46.5
1885P2503

Cox, David the elder 1783–1859
The Missing Lamb 1851–1853
oil on canvas 69.9 x 90.5
1885P2517

Cox, David the elder 1783–1859
Kilgerran Castle, Pembrokeshire 1852
oil on panel 22.7 x 30.7
1885P2498

Cox, David the elder 1783–1859
Going to the Hayfield 1853
oil on canvas 28 x 37.5
1885P2501

Cox, David the elder 1783–1859
The Shrimpers 1853
oil on canvas 26.3 x 39.1
1885P2511

Cox, David the elder 1783–1859
Rhyl Sands 1854–1855
oil on canvas 74.3 x 135.3
1885P2489

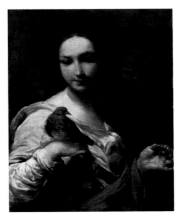

Cox, David the elder 1783–1859
The Skirts of the Forest 1855
oil on canvas 70.5 x 90.2
1885P2484

Coxon, Raymond James 1896–1997
Sussex Meadow 1928
oil on canvas 69.4 x 92
1931P230

Crespi, Giuseppe Maria 1665–1747
Girl Holding a Dove 1690–1700
oil on canvas 62.9 x 48.3
1955P112

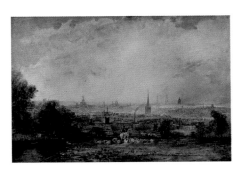

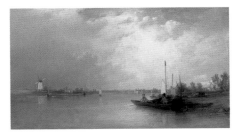

Creswick, Thomas 1811–1869
A Distant View of Birmingham 1825–1830
oil on panel 20.7 x 30.5
1896P86

Creswick, Thomas 1811–1869
English Landscape 1829
oil on canvas 146 x 124
1905P190

Creswick, Thomas 1811–1869
View of the Thames at Battersea 1834
oil on canvas 31.8 x 55.3
1912P21

Facing page: Vigée-LeBrun, Elisabeth Louise, 1755–1842, *Countess Golovine (1766–1821)* (detail), 1797–1800,
The Barber Institute of Fine Arts, (p. 240)

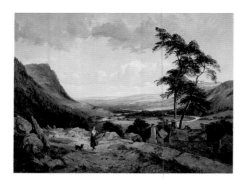

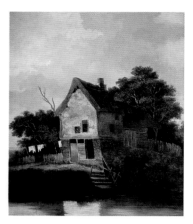

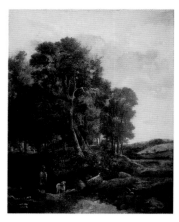

Creswick, Thomas 1811–1869
The Valley of Llangollen, North Wales 1856
oil on canvas 68.6 x 91.4
1943P4

Crome, John 1768–1821
View at Blofield, near Norwich 1810–1811
oil on canvas 76.1 x 63.3
1947P73

Crome, John 1768–1821
The Way through the Wood 1812–1813
oil on panel 73.7 x 40.3
1950P10

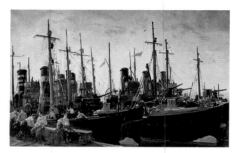

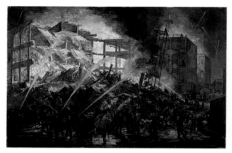

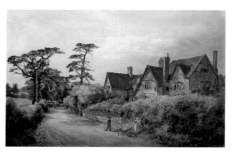

Cundall, Charles Ernest 1890–1971
Minesweepers off Duty 1940
oil on canvas 59.4 x 90.3
1947P27

Cundall, Charles Ernest 1890–1971
*Destruction of Birmingham Small Arms
Factory Building* 1946
oil on canvas 102.1 x 152.1
1984V254

Currie, Sidney d.1930
Tennal Old Hall 1879
oil on canvas 51.2 x 76.5
1936P247

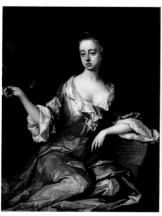

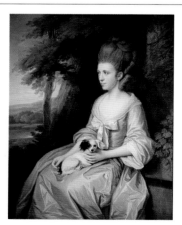

Dahl, Michael I 1656/1659–1743
Elizabeth, Countess of Sandwich (c.1674–1757)
oil on canvas 127.7 x 101.6
1957P24

Danby, Thomas 1818–1886
Landscape
oil on canvas 69.5 x 122.8
1941P455

Dance-Holland, Nathaniel 1735–1811
Miss Hargreaves
oil on canvas 126.5 x 102.5
1931P87

Daubigny, Charles-François 1817–1878
La vigne 1860–1863
oil on canvas 62.3 x 81.3
1962P6

Davenport, Ian b.1966
Untitled (Orange) 1988
oil on canvas 214 x 214
2006.139

Dawson, Henry 1811–1878
In Port: A Calm 1856
oil on canvas 56.5 x 81.8
1892P44

Dawson, Henry 1811–1878
The Wooden Walls of England 1856
oil on canvas 50.7 x 76.3
1892P43

Dawson, Henry 1811–1878
St Paul's from the River Thames 1877
oil on canvas 104.5 x 165
1890P82

De Karlowska, Stanislawa 1876–1952
Snow in Russell Square c.1935–1940
oil on canvas 48.9 x 59.1
1968P15

De Wint, Peter 1784–1849
Extensive Landscape
oil on canvas 35.8 x 54.6
1928P595

De Wint, Peter 1784–1849
Jetty with Boats
oil on millboard 33 x 50.8
1928P596

Degas, Edgar 1834–1917
A Roman Beggar Woman 1857
oil on canvas 100.3 x 75.2
1960P44

Delacroix, Eugène (attributed to)
1798–1863
Madame Simon
oil on canvas 59.7 x 48.2
1963P32

Delane, Solomon 1727–1812
Italian Landscape
oil on canvas 44.2 x 58.2
1930P365

Delaney, Barbara b.1941
Distant Sounds 1997
acrylic on canvas 20 x 20
2000P15

Delaney, Barbara b.1941
Light Gathers 1997
acrylic on canvas 20 x 20
2000P13

Delaney, Barbara b.1941
Pastorale 1997
acrylic on canvas 20 x 20.5
2000P14

Delaney, Barbara b.1941
Several Pleasures 1997
acrylic on canvas 20 x 20.5
2000P12

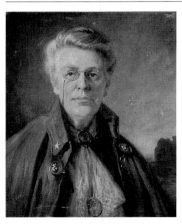

Delle, M. R.
Sophia Sturge (1849–1936) c.1917
oil on canvas 59.5 x 49
2003.0576

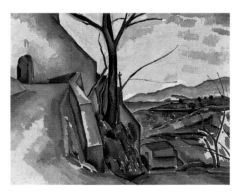

Derain, André 1880–1954
Landscape near Cagnes 1905–1915
oil on canvas 65.1 x 81.3
1962P27

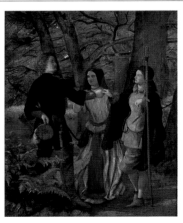

Deverell, Walter Howell 1827–1854
As You Like It, Act IV Scene I, ('Rosalind Tutoring Orlando in the Ceremony of Marriage' (…) 1845–1850
oil on canvas 60.8 x 50.6
1912P19

Devey, Phyllis 1907–1982
Myself when Young
oil on plywood panel 49.7 x 40.5
1983P69

Devey, Phyllis 1907–1982
Working at Night
oil on canvas 50.7 x 40.5
1983P70

Devis, Arthur 1712–1787
Portrait of a Man in Blue c.1750
oil on canvas 50 x 35
1953P454

Devis, Arthur 1712–1787
Portrait of a Man in Red c.1750
oil on canvas 50.3 x 35
1953P453

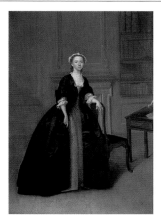

Devis, Arthur 1712–1787
Portrait of a Woman in Dark Blue c.1750
oil on canvas 50.3 x 35.5
1953P457

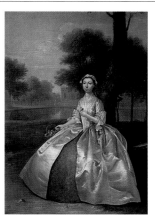

Devis, Arthur 1712–1787
Portrait of a Woman in Gold c.1750
oil on canvas 50.5 x 35.1
1953P455

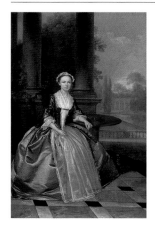

Devis, Arthur 1712–1787
Portrait of a Woman in Light Blue c.1750
oil on canvas 50.5 x 35
1953P456

Diaz de la Peña, Narcisse Virgile 1808–1876
Woodland Scene
oil on canvas 45.7 x 66
1939P642

Dismorr, Jessica 1885–1939
Superimposed Forms 1938
tempera on gesso board 46 x 61
1994P40

Dobson, William 1611–1646
Portrait of a Woman 1645
oil on canvas 85.1 x 80
1951P124

Dolci, Carlo 1616–1686
*St Andrew Praying before His
Martyrdom* 1643
oil on canvas 115.6 x 91.4
1962P45

Donley, John Gilbert
A Field of Swedes c.1930
oil on canvas 51.5 x 61
1939P631

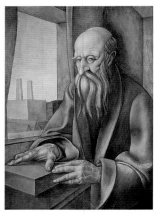

Downton, John 1906–1991
The Battle 1935
tempera on panel 72.4 x 52.4
1998P28

Dufrenoy, Georges Léon 1870–1942
La Place des Vosges 1928
oil on canvas 81.3 x 65
1945P52

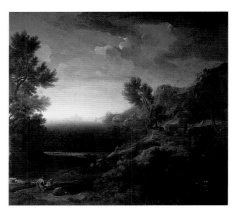

Dughet, Gaspard 1615–1675
Classical Landscape c.1650–1660
oil on canvas 121.9 x 144.8
1951P104

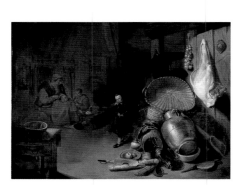

Duifhuyzen, Pieter Jacobsz. 1608–1677
Interior with Figures 1643
oil on panel 37.5 x 50.4
1928P205

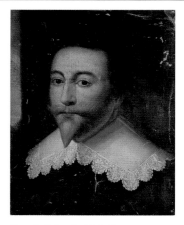

Dutch School 17th C
Head of a Man
oil on canvas 41.3 x 33
1931P317

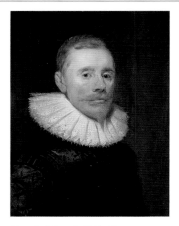

Dutch School 17th C
Portrait of a Gentleman
oil on panel 62.2 x 48.9
1966P3

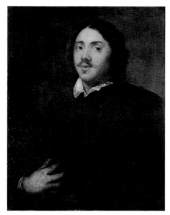

Dutch School 17th C
Portrait of a Gentleman in Black
oil on canvas 86.4 x 73.7
1925P80

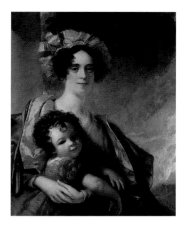

Dyce, William 1806–1864
Mrs John Clerk Maxwell (1792–1839), and
Her Son, James (1831–1879) 1832/1833
oil on canvas 91.6 x 71.3
1941P333

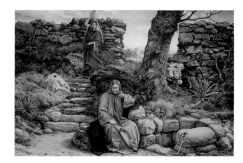

Dyce, William 1806–1864
The Woman of Samaria c.1850–1864
oil on panel 34.2 x 48.4
1897P8

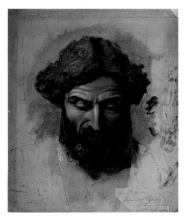

Dyce, William 1806–1864
Head of a Man
oil on canvas 61.7 x 42
1975P174

Dyck, Anthony van 1599–1641
Lord Strafford (1593–1641), and His Secretary
Sir Phillip Mainwaring (1589–1661)
oil on canvas 61 x 76.2
1981P12

Dyck, Anthony van (after) 1599–1641
King Charles I (1600–1649) c.1750–1770
oil on canvas 73.7 x 53.4
1981P15

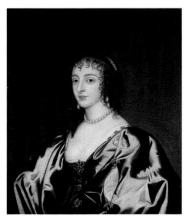

Dyck, Anthony van (after) 1599–1641
Queen Henrietta Maria (1609–1669)
c.1750–1770
oil on canvas 73.7 x 53.4
1981P16

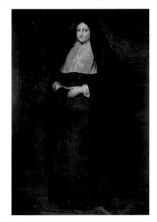

Dyck, Anthony van (after) 1599–1641
Infanta Isabella Clara Eugenia (1566–1633),
Regentess of the Netherlands 18th C
oil on canvas 153.7 x 102.2
1934P686

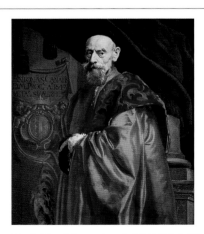

Dyck, Daniel van den 1610/1614–1670
Antonio Canal (1567–1650) 1647
oil on canvas 113 x 98.4
1958P5

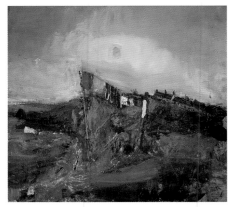

Eardley, Joan Kathleen Harding 1921–1963
Winter Sun No.1 1961–1962
oil on canvas 121.9 x 130.8
1963P29

East, Alfred 1849–1913
Reedy Mere and Sunlit Hills 1890–1891
oil on canvas 88.9 x 151.1
1920P10

East, Alfred 1849–1913
Hayle from Lelant, Cornwall 1891–1892
oil on canvas 110 x 174.7
1892P40

Eastlake, Charles Lock 1793–1865
The Champion 1824
oil on canvas 122.5 x 174
1956P15

Eckstein, Johannes 1736–1817
*John Freeth and His Circle (Birmingham Men
of the Last Century)* 1792
oil on canvas 112 x 166
1909P6

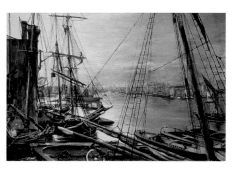

Edwards, Edwin 1823–1879
The Pool, London
oil on canvas 45.6 x 60.6
1905P223

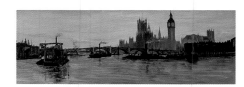

Edwards, Edwin 1823–1879
The Thames at Westminster
oil on canvas 34.7 x 95.6
1905P222

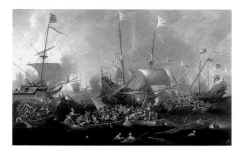

Eertvelt, Andries van 1590–1652
The Battle of Lepanto, 7 October 1571
c.1615–1620
oil on canvas 143.5 x 221
1933P311

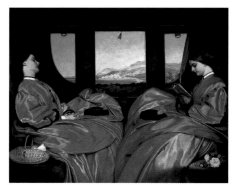

Egg, Augustus Leopold 1816–c.1863
The Travelling Companions 1862
oil on canvas 65.3 x 78.7
1956P7

Facing page: Bellini, Giovanni, 1431–1436–1516, *Madonna and Child Enthroned with Saints and Donor* (detail), 1505,
Birmingham Museums and Art Gallery, (p. 39)

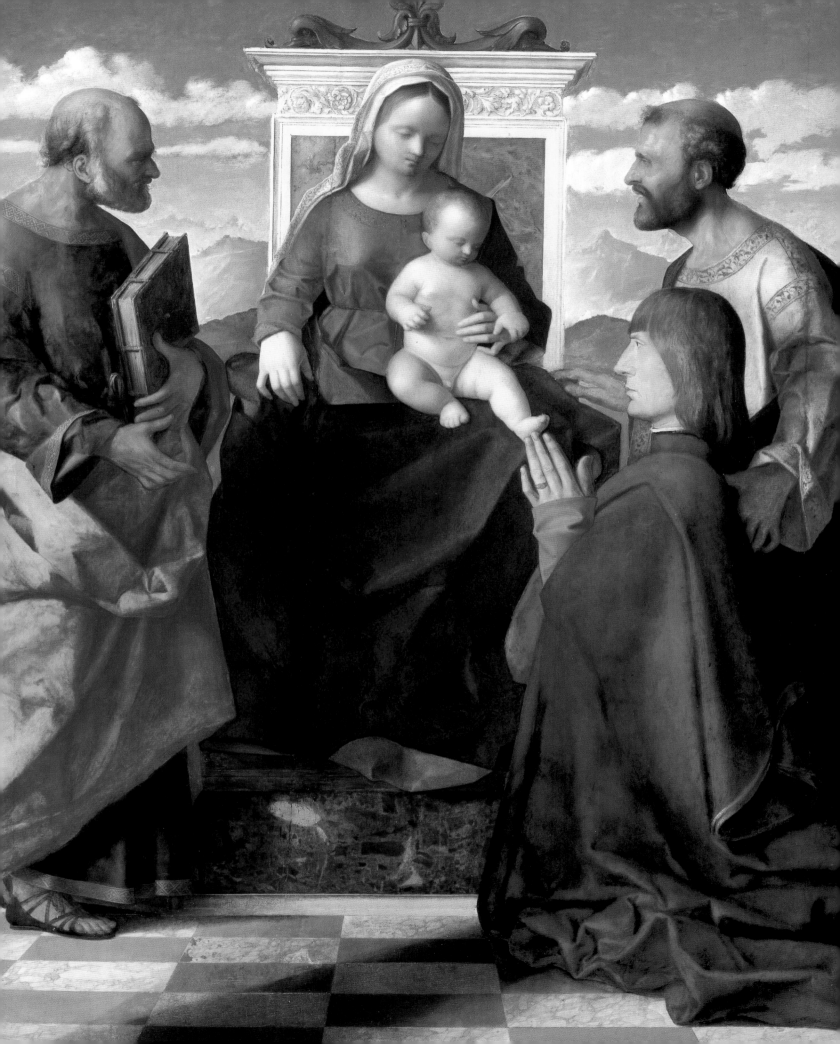

Eldridge, Mildred E. 1909–1991
Morning Flight 1936
oil on canvas 76.5 x 61
1937P371

Ellis, William 1747–1810
Haymaking, Handsworth
oil on canvas 44.9 x 55.9
1978V786

Emery, Louis 1918–1993
Black Forest 1988–1989
oil on canvas 178 x 115.4
1993P31

Engelbach, Florence 1872–1951
Alpes Maritimes c.1920–1931
oil on board 27 x 29.5
1931P704

Engelbach, Florence 1872–1951
Summer 1930
oil on canvas 76 x 63.5
1932P289

Engelbach, Florence 1872–1951
Cyclamen 1931
oil on canvas 58.4 x 48.4
1932P238

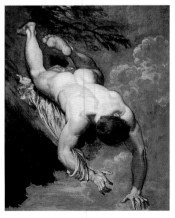

Etty, William 1787–1849
Manlius Hurled from the Rock 1818
oil on canvas 127.8 x 102.9
1967P45

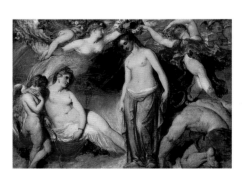

Etty, William 1787–1849
Pandora Crowned by the Seasons 1823–1824
oil on canvas 172.5 x 243.3
1885P2547

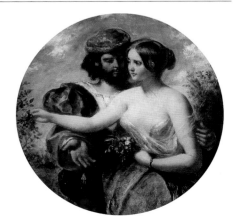

Etty, William 1787–1849
'Gather the rose of love while yet 'tis time' 1848
oil on board 49.5
1931P229

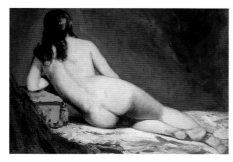

Etty, William 1787–1849
Nude Study of a Reclining Woman
oil on canvas 28.4 x 37.4
1929P204

Eurich, Richard Ernst 1903–1992
A Destroyer Escort in Attack 1941
oil on canvas 50.5 x 101.5
1947P56

Eurich, Richard Ernst 1903–1992
'Grock', a Dalmation Dog 1943
oil on canvas 22.7 x 37.4
1944P169

Evans, Merlyn Oliver 1910–1973
Paesaggio tragico 1945
oil on canvas 99 x 119.5
1988P102

Eves, Reginald Grenville 1876–1941
Thomas Hardy (1840–1928) 1924
oil on canvas 80 x 70.2
1941P452

Fanner, Alice Maud 1865–1930
Yacht Racing in the Solent 1912–1913
oil on canvas 126.7 x 182.9
1917P1

Fanner, Alice Maud 1865–1930
Yachts Racing in Bad Weather, Burnham-on-Crouch 1919
oil on canvas 83.5 x 137.5
1931P583

Fantin-Latour, Henri 1836–1904
Mademoiselle Marie Fantin-Latour 1859
oil on canvas 85.5 x 60.5
1953P13

Fantin-Latour, Henri 1836–1904
Bouquet de dahlias 1871
oil on canvas 28.3 x 33.3
1958P15

Fantin-Latour, Henri 1836–1904
Roses dans un verre à pied 1873
oil on canvas 36.2 x 36.8
1956P5

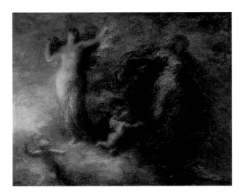

Fantin-Latour, Henri 1836–1904
L'aurore et la nuit 1894
oil on canvas 39.4 x 47.3
1939P673

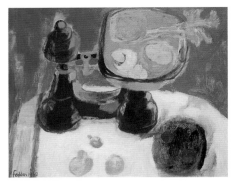

Fedden, Mary b.1915
The Weighing Machine 1962
oil on canvas 51 x 60.8
2001P3

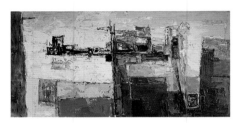

Feiler, Paul b.1918
Atlantic Coast, Evening 1952
oil on canvas 58.5 x 118.1
1956P10

Feiler, Paul b.1918
Porth Ledden 1958
oil on masonite board 91.5 x 122
1999P12

Feiler, Paul b.1918
Aduton L11 1992
oil on canvas laid on board 152.5 x 152.5
1999P13

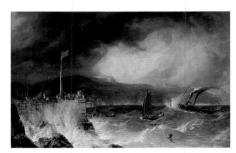

Fielding, Anthony V. C. 1787–1855
Packet Boat Entering Harbour
oil on canvas 60 x 89.6
1930P328

Fielding, Brian 1933–1987
Lune 1984
acrylic on canvas 122 x 91.8
1987Q10

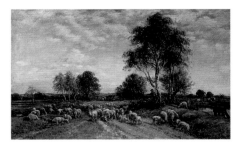

Fisher, Mark 1841–1923
The Halt 1880
oil on canvas 110.6 x 183
1907P61

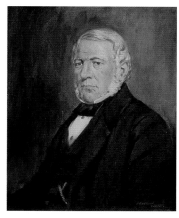

Fleetwood-Walker, Bernard 1893–1965
Joseph Wright c.1930
oil on canvas 59.5 x 48.3
2005.4799.3

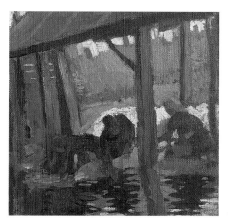

Fleetwood-Walker, Bernard 1893–1965
Washerwomen c.1930
oil on canvas laid on card 26 x 26
2002P1

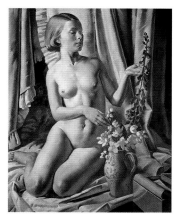

Fleetwood-Walker, Bernard 1893–1965
The Bane 1931
tempera on canvas 91.5 x 73.7
1936P507

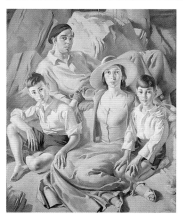

Fleetwood-Walker, Bernard 1893–1965
The Family at Polperro 1934–1939
oil on canvas 127.6 x 101.9
1939P30

Fleetwood-Walker, Bernard 1893–1965
Alderman A. H. James, CBE 1950
oil on canvas 102 x 76.5
1988Q10 (P)

Fleetwood-Walker, Bernard 1893–1965
Professor Thomas Bodkin (1887–1961) 1955
oil on canvas 91.5 x 76.4
1955P114

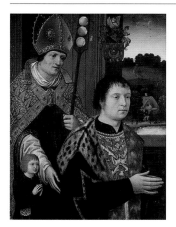

Flemish School early 16th C
Nicholas Gaze, His Son and St Nicholas
oil on panel 48.3 x 38.1
1933P26

Flemish School 16th C
Autumn
oil on oak panel 30 x 50
PCF 33

Flemish School 16th C
The Angels Appearing to the Shepherds
oil on panel 13.3 x 7
1930P440.1

Flemish School 16th C
The Angels Appearing to the Shepherds
oil on panel 13.3 x 5.1
1930P440.2

Flemish School
Portrait of a Gentleman 1635–1645
oil on canvas 78.1 x 55.9
1965P23

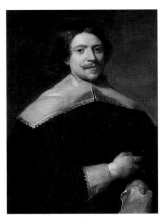

Flemish School 19th C
Landscape with Cattle
oil on canvas 54 x 67
PCF 15

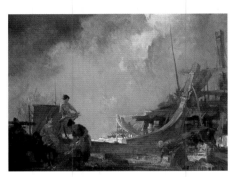

Flint, William Russell 1880–1969
Shipyard Gleaners 1924–1925
oil on canvas 102 x 137.5
1929P477

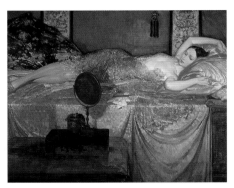

Flint, William Russell 1880–1969
Silver and Gold 1929/1930
oil on canvas 102.2 x 127.6
1930P333

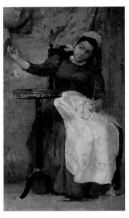

Florence, Mary Sargant 1857–1954
The Nursemaid
oil on canvas 69.8 x 40.3
1962P16

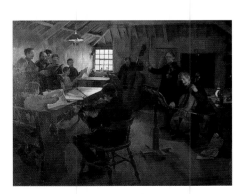

Forbes, Stanhope Alexander 1857–1947
The Village Philharmonic 1888
oil on canvas 133.5 x 172.5
1889P2 🐝

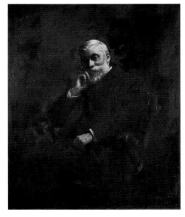

Forbes, Stanhope Alexander 1857–1947
Alderman G. J. Johnson (1826–1912) 1895
oil on canvas 138.7 x 112.5
1912P26 🐝

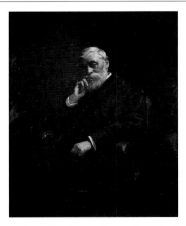

Forbes, Stanhope Alexander 1857–1947
Alderman G. J. Johnson (1826–1912) 1895
oil on canvas 138.7 x 112.5
1983P50 🐝

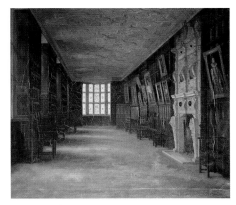

Foster, Cecilia C. active c.1870–1908
View of the Long Gallery at Aston Hall
c.1870–1880
oil on canvas 52.9 x 58
1989P3

Frampton, Edward Reginald 1872–1923
Flora of the Alps 1918
tempera on canvas 58.5 x 112.5
1928P161

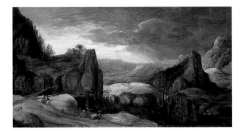

Francken, Frans II 1581–1642
Landscape with Minerva Expelling Mars to Protect Peace and Plenty
oil on oak panel 60.6 x 107
1978P7

Freedman, Barnett 1901–1958
Sicilian Puppets 1934
oil on canvas 101 x 71.2
1935P496

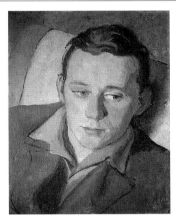

Freeth, Hubert Andrew 1913–1986
Raymond Teague Cowern (1913–1986) c.1940
oil on wood 42 x 31.9
2006.0376

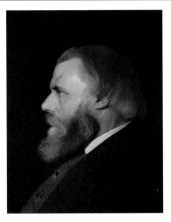

Freeth, Walter active c.1895–1941
Portrait of the Artist's Father c.1895–1910
oil on canvas 52 x 42.7
1941P347

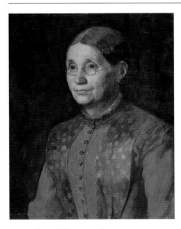

Freeth, Walter active c.1895–1941
Portrait of the Artist's Mother c.1895–1910
oil on canvas 61 x 50.5
1941P348

French School 17th C
The Conversion of Saint Paul
oil on canvas 27 x 92.1
1933P336

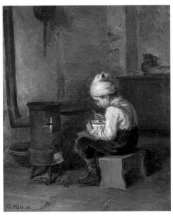

Frère, Pierre Edouard 1819–1886
Supper Time 1876
oil on panel 26.9 x 21.4
1925P343

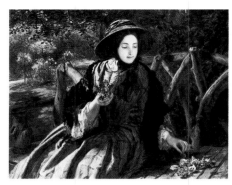

Frith, William Powell 1819–1909
Garden Flowers (Making a Posy) 1855–1856
oil on canvas 33.4 x 42.4
1947P64

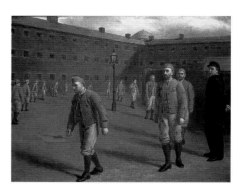

Frith, William Powell 1819–1909
Retribution 1880
oil on panel 32.7 x 41.2
1962P1

Frost, Terry 1915–2003
Black and Lemon 1960
oil on canvas 50.8 x 61
1977P136

Frost, Terry 1915–2003
Black and Dust Pink 1978
oil on canvas 148 x 94.7
1980P100

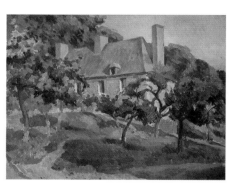

Fry, Roger Eliot 1866–1934
A Surrey House 1927–1928
oil on millboard 31.8 x 39.4
1928P556

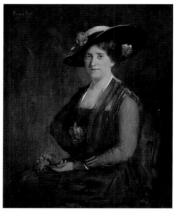

Fuchs, Emil 1866–1929
Mrs Olga Myers 1915
oil on canvas 100 x 81.5
1972P2

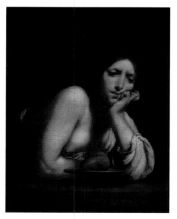

Furini, Francesco 1603–1646
Sigismunda with the Heart of Guiscardo
c.1635–1645
oil on canvas 73 x 59
1991P28

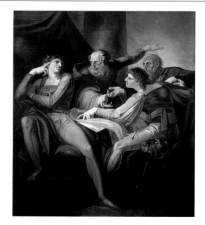

Fuseli, Henry 1741–1825
*Dispute between Hotspur, Glendower,
Mortimer and Worcester* (from William
Shakespeare's 'Henry IV Part I') 1784
oil on canvas 21.1 x 18
1947P6

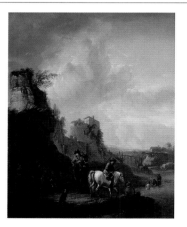

Gael, Barend c.1635–1698
The Ford 1655–1665
oil on oak panel 55.7 x 44.9
1937P367

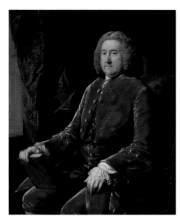

Gainsborough, Thomas 1727–1788
Thomas Coward 1760–1765
oil on canvas 124.5 x 99.1
1955P60

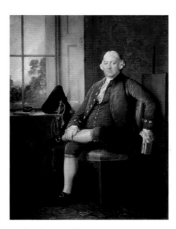

Gainsborough, Thomas 1727–1788
Matthew Hale (1728–1786) 1761–1763
oil on canvas 200.7 x 155
1960P12

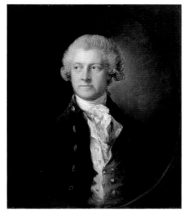

Gainsborough, Thomas 1727–1788
Lewis Bagot (1740–1802), Bishop of Bristol
1770–1774
oil on canvas 73.7 x 61
1965P22

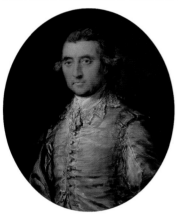

Gainsborough, Thomas 1727–1788
Sir Charles Holte (1721–1782) 1770–1774
oil on canvas 75.2 x 62.9
1885P3181

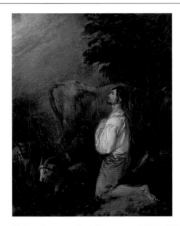

Gainsborough, Thomas 1727–1788
The Prodigal Son (after Salvator Rosa)
c.1774–1797
oil on canvas 49.7 x 39.5
1948P45

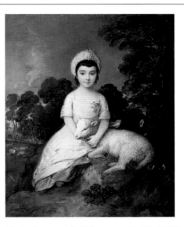

Gainsborough, Thomas 1727–1788
Isabelle Franks (c.1769/1770–1855)
1775–1778
oil on canvas 125.5 x 102
1983P51

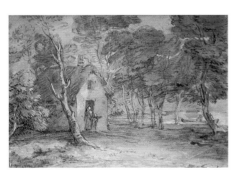

Gainsborough, Thomas 1727–1788
*Wooded Landscape with Cottage, Figures and
Boat on a Lake* 1783–1785
brown chalk, sepia wash & oil on buff
paper 21.7 x 31
1953P198

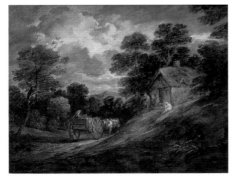

Gainsborough, Thomas 1727–1788
Landscape with a Cottage and a Cart
1784–1786
oil on canvas 39.4 x 49.5
1953P27

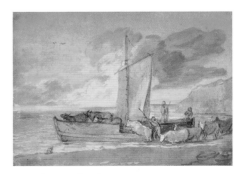

Gainsborough, Thomas 1727–1788
A Cattle Ferry 1784–1788
oil & grey wash on paper 22.3 x 31
1953P190

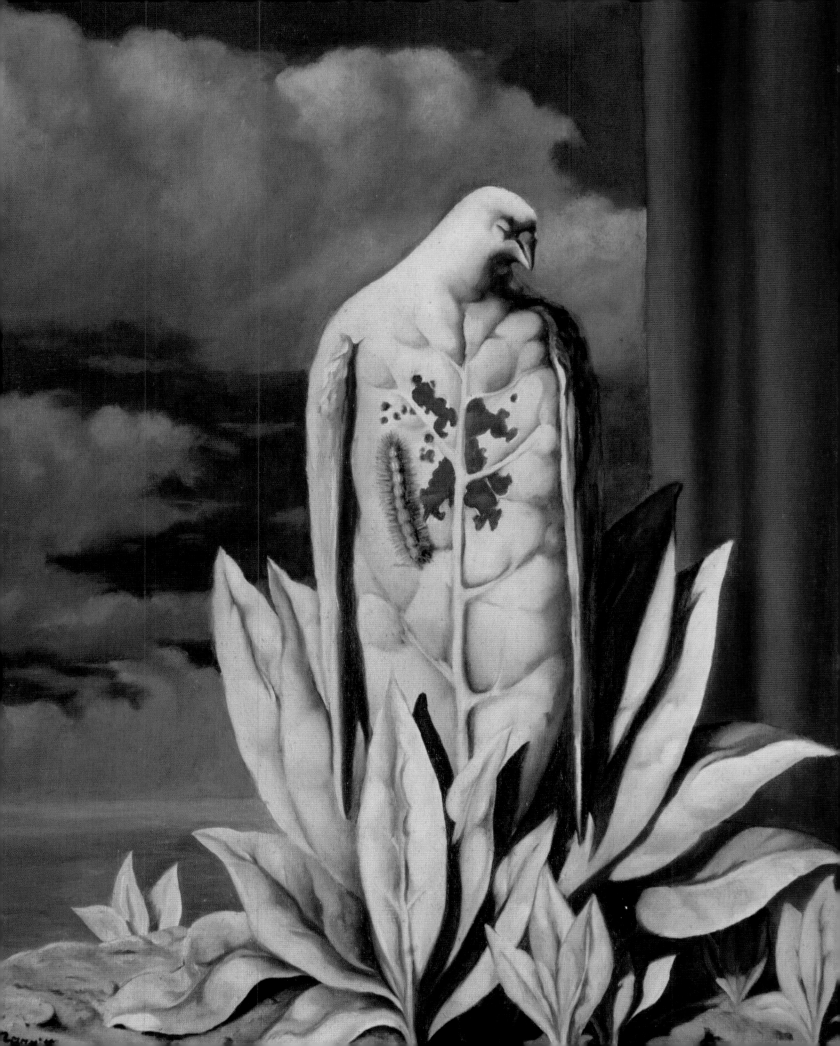

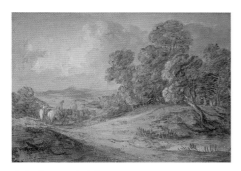

Gainsborough, Thomas 1727–1788
Wooded Landscape with Figures on Horseback
1785–1788
oil & black chalk on paper 21.5 x 30.5
1953P215

Gainsborough, Thomas 1727–1788
A Wooded Landscape, Autumn Evening
oil on canvas 74 x 61.3
1924P274

Garofalo 1481–1559
The Agony in the Garden 1524
oil on canvas 119.4 x 152.5
1964P10

Garvie, Thomas Bowman 1859–1944
Barrow Cadbury 1912
oil on canvas 50.7 x 40.7
1979V533

Garvie, Thomas Bowman 1859–1944
Geraldine Cadbury, née Southall 1912
oil on canvas 50.3 x 41.2
1979V534

Gaskin, Arthur Joseph 1862–1928
Portrait of a Reflective Lady 1886–1887
oil on canvas 41.2 x 30.6
1980P124

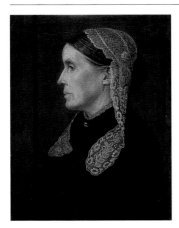

Gaskin, Arthur Joseph 1862–1928
Mrs Henry Gaskin (The Artist's Mother) 1888
oil on canvas 62.3 x 47
1928P273

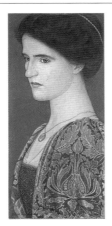

Gaskin, Arthur Joseph 1862–1928
Fiammetta (Georgie Gaskin) 1898
tempera on panel 44.7 x 20.7
1989P27

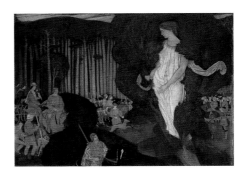

Gaskin, Arthur Joseph 1862–1928
The Twelve Brothers 1898
oil on panel 39.4 x 49.7
2002P35

Facing page: Magritte, René, 1898–1967, *The Flavour of Tears* (detail), 1948, The Barber Institute of Fine Arts, (p. 233)

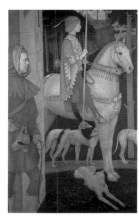

Gaskin, Arthur Joseph 1862–1928
Kilhwych, the King's Son 1901
tempera on panel 53.8 x 33.3
1914P212

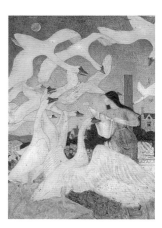

Gaskin, Arthur Joseph 1862–1928
The Twelve Brothers Turned into Swans 1928
tempera on panel 51 x 41
2007.0592 (P)

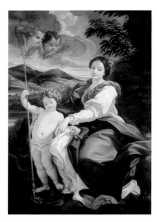

Gaulli, Giovanni Battista 1639–1709
The Virgin and Child Piercing the Head of the Serpent c.1695
oil on canvas 142 x 99
1999PL15 (P)

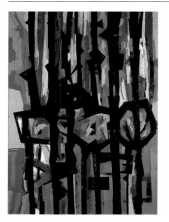

Gear, William 1915–1997
Mau, Mau 1953
oil on canvas 185 x 112
2001P23

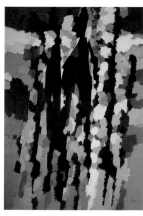

Gear, William 1915–1997
Landscape Image No.1 1961
oil on canvas 182.9 x 121.9
1972P1

Gear, William 1915–1997
Cold Spring 1982
oil on canvas 181.8 x 120.5
1990P28

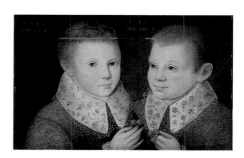

Geeraerts, Marcus the younger 1561–1635
Portrait of Two Brothers 1586
oil on panel 34.3 x 53.9
1931P734

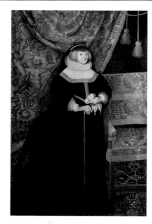

Geeraerts, Marcus the younger 1561–1635
Elizabeth, Countess of Devonshire (1562–1607)
oil on canvas 205.7 x 132.1
2002PL10 (P)

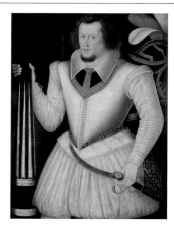

Geeraerts, Marcus the younger 1561–1635
Robert Devereux (1566–1601), 2nd Earl of Essex
oil on panel 113.7 x 84.5
1977P317

Geeraerts, Marcus the younger 1561–1635
Robert Devereux (1566–1601), 2nd Earl of Essex
oil on canvas 210.8 x 120.7
2002PL11 (P)

Geets, Willem 1838–1919
A Martyr of the Sixteenth Century, Johanna van Santhoven 1883
oil on canvas 180.3 x 259.1
1885P2470

Gennari, Benedetto the younger 1633–1715
The Holy Family 1682
oil on canvas 213.8 x 168
1974P12

Gentileschi, Orazio 1563–1639
The Rest on the Flight into Egypt 1615–1620
oil on canvas 175.6 x 218
1947P5

Gere, Charles March 1869–1957
A Cotswold Quarry 1920
oil on canvas 39.4 x 60.4
1921P62

Gere, Charles March 1869–1957
The View from Wyndcliffe 1932–1933
oil on canvas 86.4 x 133.4
1936P1

German School 19th C
Man with a Winning Lottery Ticket
oil on canvas 68 x 55
PCF 20

Gerrard, Kaff 1894–1970
Artemisia in a Glass Vase
oil on canvas 61.2 x 51.3
1991P24

Gerrard, Kaff 1894–1970
Haysom's Quarry, Isle of Purbeck
oil on board 91.4 x 122.1
1991P25

Gerrard, Kaff 1894–1970
Moonlight at Thetford Priory
oil on board 36 x 46
1991P26

Gerrard, Kaff 1894–1970
Phoenix Entering Paradise
oil on board 61 x 86
1991P27

Gertler, Mark 1892–1939
Portrait of the Artist's Family, a Playful Scene
1910–1911
oil on canvas 76.3 x 101.5
1949P24

Ghosh, Amal b.1933
Lunacy 1988
oil on canvas 102 x 127
1994P26

Gilbert, John 1817–1897
*Sir John Falstaff Reviewing His Ragged
Regiment* 1858
oil on canvas 121.3 x 182
1918P27

Gilbert, John 1817–1897
The Taming of the Shrew 1859–1861
oil on canvas 59.7 x 89.5
1885P2534

Gilbert, John 1817–1897
*Scene from Shakespeare's 'The Merchant of
Venice'* 1863–1865
oil on panel 17.8 x 25.3
1984P15

Gilbert, John 1817–1897
Preparing for the Charge 1873
oil on canvas 25.4 x 35.7
1893P8

Gilbert, John 1817–1897
Study of Trees 1874
oil on canvas 25.5 x 35.8
1893P4

Gilbert, John 1817–1897
Old Cottages at Lewisham 1876
oil on canvas 37.7 x 50.9
1893P7

Gilbert, John 1817–1897
Landscape Sketch 1877
oil on canvas 17.9 x 25.1
1893P5

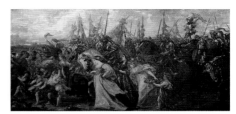

Gilbert, John 1817–1897
The Return of the Victors 1878–1879
oil on canvas 138 x 275
1893P10

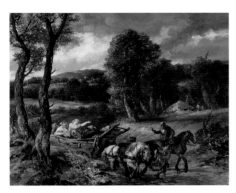

Gilbert, John 1817–1897
The Baggage Wagon 1884
oil on canvas 63.8 x 76.5
1893P6

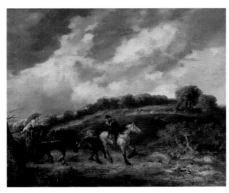

Gilbert, John 1817–1897
A Windy Day 1885
oil on canvas 51 x 61.2
1893P3

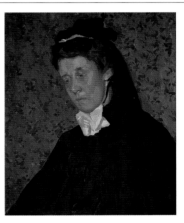

Gilman, Harold 1876–1919
The Nurse 1908
oil on canvas 61.3 x 31.1
1947P63

Gilman, Harold 1876–1919
Portrait Study of a Woman 1908–1910
oil on canvas 41 x 30.5
1959P34

Giordano, Luca 1634–1705
Dives and Lazarus
oil on canvas 116 x 195
1954P41

Girard, Paul-Albert 1839–1920
Ritual Slaying of Cockerels
oil on canvas 51 x 68.3
1987P58

Girodet de Roucy-Trioson, Anne-Louis 1767–1824
The Death of Hippolytus
oil on canvas 71.8 x 97.2
1960P46

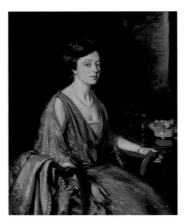

Glehn, Wilfred Gabriel de 1870–1951
Mrs Neville Chamberlain 1924
oil on canvas 127.6 x 99.7
1966P49

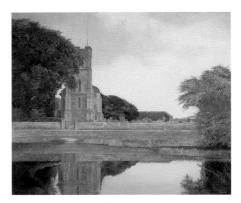

Gluckstein, Hannah 1895–1978
The Village Church and Pond, Falmer, Sussex
1937
oil on canvas 75.6 x 87.6
1937P1286

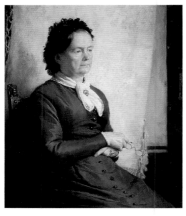

Gogin, Charles 1844–1931
Portrait of the Artist's Mother 1885
oil on mahogany panel 49 x 40.7
1935P501

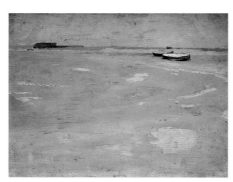

Gogin, Charles 1844–1931
Shoreham-on-Sea, Sussex 1889
oil on panel 30.9 x 30
1931P154

Goodman, Robert Gwelo 1871–1939
The Karroo, Cape of Good Hope at Evening
1923–1924
oil on canvas 76.2 x 93.7
1924P249

Goodman, Robert Gwelo 1871–1939
Welgelegen, near Groote Schuur, South Africa
1924
oil on canvas 63.5 x 76.4
1924P248

Gordon, John Watson 1788–1864
David Cox (1783–1859) 1855
oil on canvas 124.5 x 100.3
1978P185

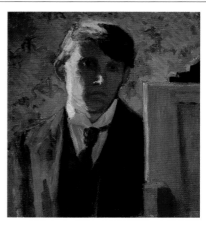

Gore, Spencer 1878–1914
Portrait of the Artist 1906
oil on canvas 53.1 x 42
1962P35

Gore, Spencer 1878–1914
Portrait of the Artist's Wife 1911
oil on canvas 40.5 x 33
1983P3

Gore, Spencer 1878–1914
Wood in Richmond Park 1914
oil on canvas 50.5 x 60.9
1928P166

Goyen, Jan van 1596–1656
A River Scene 1642
oil on canvas 97.8 x 132.2
1947P15

Graham-Gilbert, John 1794–1866
William Murdoch (1754–1839) 1823–1827
oil on canvas 137.9 x 107.9
1885P2543

Grainger, Gertrude active 1950–1953
Landscape near Shoreham, Kent
oil on paper 28.1 x 38.6
1953P26

Grant, Duncan 1885–1978
Boats at Twickenham 1926
oil on panel 53.5 x 81.3
1942P76

Grant, Duncan 1885–1978
Dancers, a Decoration 1934
oil on canvas 128.3 x 245.2
1947P2

Grant, Duncan 1885–1978
On the Table 1938
oil on canvas 63.2 x 50.5
1946P33

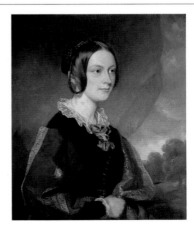

Grant, Francis 1803–1878
Katherine Boulton (d.c.1890) 1845–1850
oil on canvas 77 x 64
1987P11

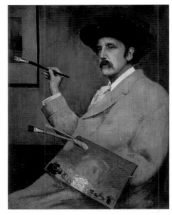

Greaves, Walter 1846–1930
Portrait of the Artist c.1900–1910
oil on panel 91.4 x 71.1
1948P18

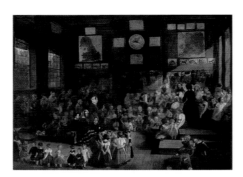

Green, Alfred H. b.c.1822
Ann Street School, Birmingham 1855
oil on canvas 58 x 76
1928P644

Green, W. active 1829–1850
Longmore Pool, Sutton Park
oil on board 18.2 x 25
1952V1129.2

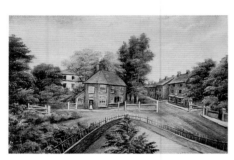

Green, W. active 1829–1850
The Old Toll Gate, Villa Road, Handsworth
oil on board 17.4 x 24.6
1952V1129.1

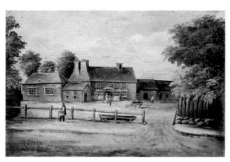

Green, W. active 1829–1850
'Waggon and Horses Inn', Handsworth
oil on board 17.8 x 25.4
1952V1129.3

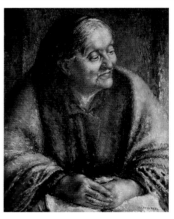

Greenberg, Mabel 1889–1933
The Matriarch 1930
oil on canvas 69 x 56.2
1933P483

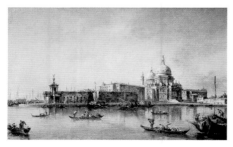

Guardi, Francesco 1712–1793
Venice, Santa Maria delle Salute and the Dogana c.1760–1790
oil on canvas 32.5 x 52
1947P74

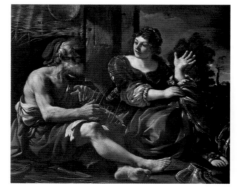

Guercino 1591–1666
Erminia and the Shepherd 1619–1620
oil on canvas 149 x 178
1962P17

Guillaumin, Armand 1841–1927
Les environs de Paris 1873–1875
oil on canvas 60.8 x 100.2
1958P19

Facing page: Sandys, Frederick, 1829–1904, *Medea*, 1868 (detail), Birmingham Museums and Art Gallery, (p. 175)

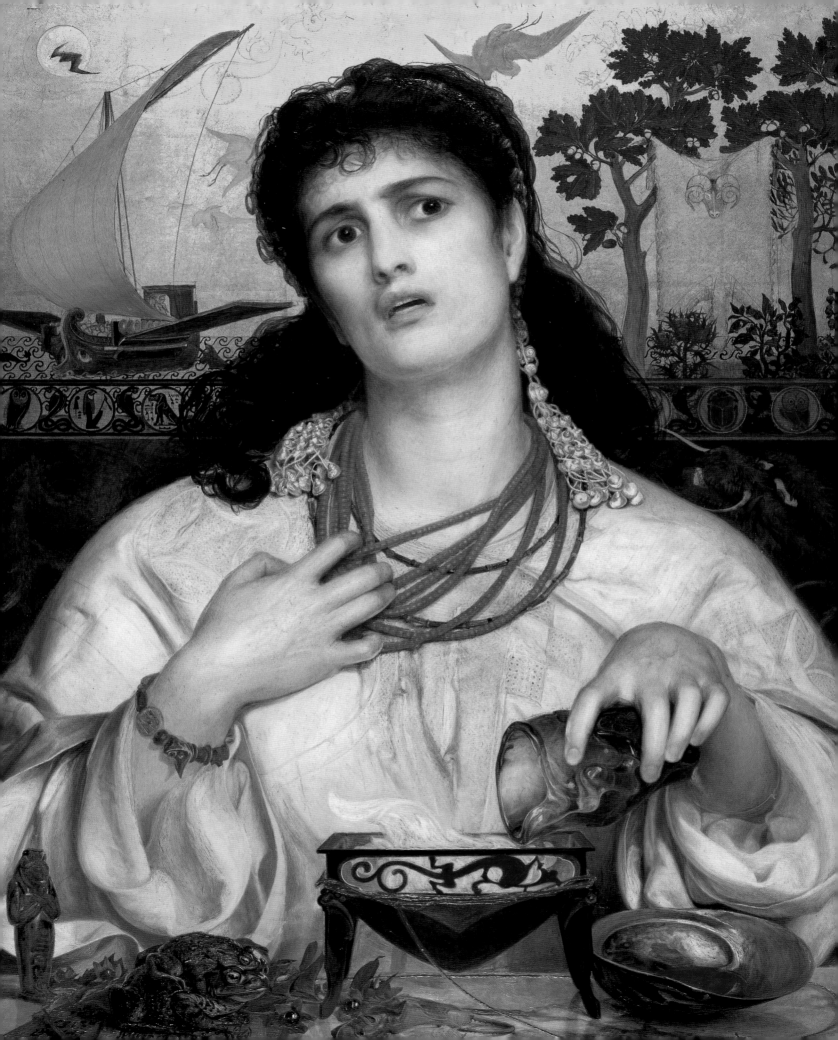

Gwynne-Jones, Allan 1892–1982
Spring Evening, Froxfield 1922
oil on canvas 63.8 x 76.5
1924P2 🐝

Hall, Oliver 1869–1957
A Breezy Day, Bardsea Forest 1904
oil on canvas 32.8 x 45.6
1930P324

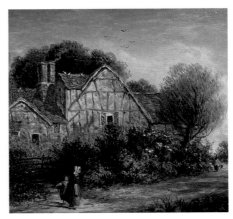

Hall, William Henry 1812–1880
An English Cottage (panel in the Everitt
Cabinet) 1879–1880
oil on card 20.2 x 22.8
1892P41.14

Hambling, Maggi b.1945
Max and Me: In Praise of Smoking 1982
oil on canvas 195.3 x 97.4
1986P1

Hamilton, Richard b.1922
Whitley Bay
oil on photograph laid on panel 81.3 x 121.9
2000P10

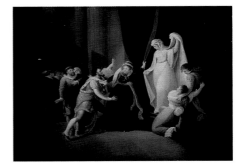

Hamilton, William 1751–1801
Scene from Shakespeare's 'A Winter's Tale'
oil on canvas 65 x 75
1979P165

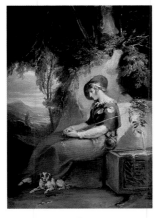

Hamilton, William 1751–1801
The Pilgrim
oil on canvas 54.7 x 37.5
1961P26

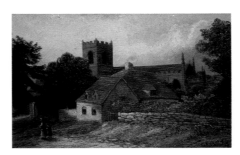

Hammond, Robert John b.c.1854
Moseley Church, Birmingham
oil on canvas 25.8 x 35.5
1977V495

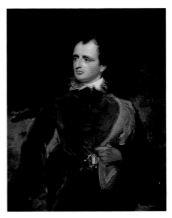

Harlow, George Henry 1787–1819
Benjamin Robert Haydon (1786–1846) 1816
oil on panel 53.2 x 41.6
1957P28

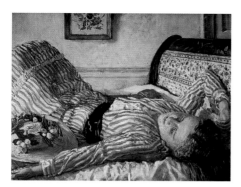

Harmar, Fairlie 1876–1945
After a Game of Tennis 1923–1924
oil on canvas 55.8 x 68.6
1924P22

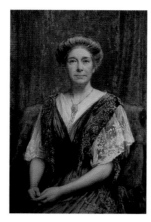

Harper, Edward Steel II 1878–1951
Mrs Alfred C. Osler 1917–1918
oil on canvas 91.5 x 61.1
1918P28

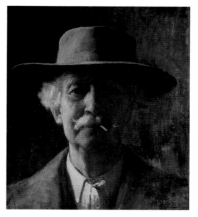

Harper, Edward Steel II 1878–1951
Self Portrait 1930
oil on canvas 39.5 x 35.5
1941P122

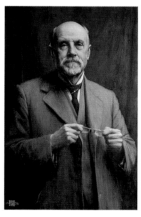

Harper, Edward Steel II 1878–1951
Harry Lucas (d.1939) 1936
oil on canvas 90 x 59
1988V1304

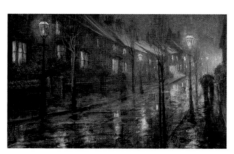

Harper, Edward Steel II 1878–1951
A Street at Night in Wet Weather
oil on canvas 42 x 63.6
1941P123

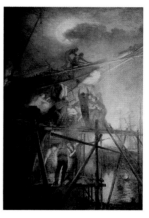

Harper, Edward Steel II 1878–1951
'By untamable hope our bodies are enthralled'
oil on canvas 146.5 x 99.2
PCF 17

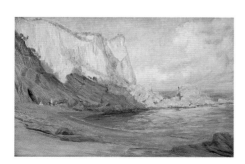

Harper, Edward Steel II 1878–1951
Evening in South Devon
oil on canvas 51 x 76.2
1941P124

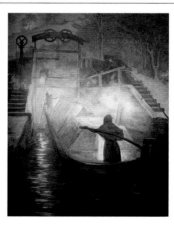

Harper, Edward Steel II 1878–1951
Guillotine Lock at Lifford
oil on canvas 90.5 x 70.5
1954S00042

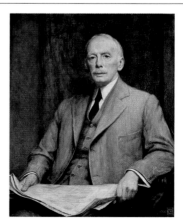

Harper, Edward Steel II 1878–1951
Henry William Sambidge
oil on canvas 87.5 x 69
PCF 18

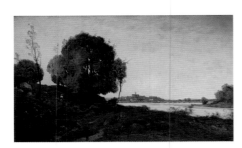

Harpignies, Henri-Joseph 1819–1916
Le pont de Nevers c.1861–1893
oil on canvas 96.7 x 162
1936P549

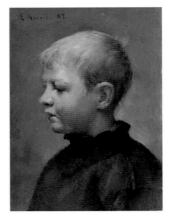

Harris, Edwin 1855–1906
Head of a Fisher Boy 1887
oil on board 17.8 x 12.8
1901P31.15

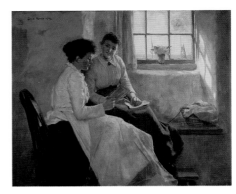

Harris, Edwin 1855–1906
The Valentine 1894
oil on canvas 71.1 x 91.4
1951P62

Harris, Frederick Henry Howard
1826–1901
At Tangier (panel in the Everitt Cabinet)
1879–1880
oil on mahogany panel 20.6 x 22.9
1892P41.8

Harris, Jane b.1956
Pine 1999
oil on canvas 193 x 244
2000Q49

Hartung, Hans Heinrich 1904–1989
T 1966-H28 1966
acrylic vinyl on canvas 50.2 x 130.2
1968P43

Harvey, Harold C. 1874–1941
The Critics 1922
oil on canvas 60.3 x 75.6
1922P169 ✳

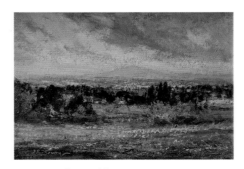

Harvey, John Rathbone 1862–1933
A Scene in Surrey
oil on canvas 18.8 x 26.7
1934P277

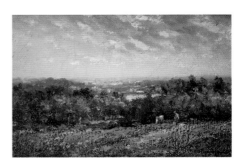

Harvey, John Rathbone 1862–1933
Landscape with a Distant View
oil on canvas 25.6 x 36
1934P278

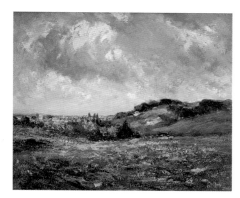

Harvey, John Rathbone 1862–1933
Windswept Hills
oil on canvas 30.2 x 35.4
1934P279

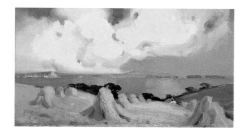

Haughton, Benjamin 1865–1924
Mounts Bay, Cornwall 1916
oil on panel 12.1 x 18.5
1937P320

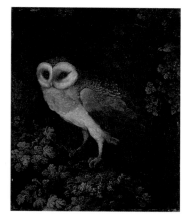

Haughton, Moses the elder 1734–1804
An Owl c.1780–1790
oil on panel 42.2 x 33.8
1935P76

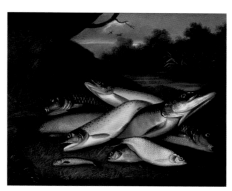

Haughton, Moses the elder 1734–1804
Fish c.1780–1790
oil on canvas 52.5 x 64.6
1885P2557

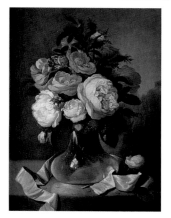

Haughton, Moses the elder 1734–1804
Floral Piece 1796
oil on canvas 40 x 29.8
1997PL6 (P)

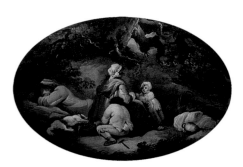

Haughton, Moses the elder 1734–1804
Gypsies in a Landscape
oil on plated iron 19.5 x 26
1935P483

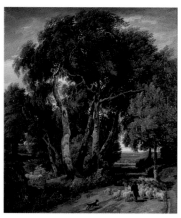

Havell, William 1782–1857
Driving Home the Flock 1806
oil on millboard 43.4 x 36.1
1912P20

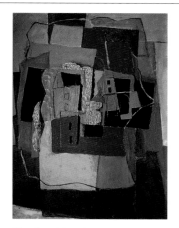

Hayden, Henri 1883–1970
Cassis 1920
oil on canvas 81 x 60
1972P29

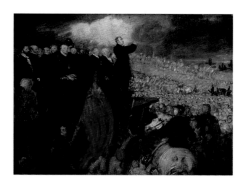

Haydon, Benjamin Robert 1786–1846
The Meeting of the Birmingham Political Union 1832/1833
oil on canvas 71.1 x 91.7
1937P370

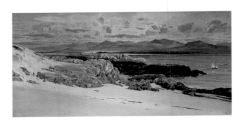

Hayes, Frederick William 1848–1918
Snowdon and Caernarvon from Llanddwyn Island
oil on paper 43.2 x 85.2
1921P9

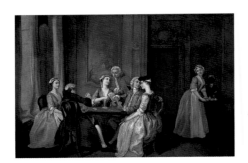

Hayman, Francis c.1708–1776
Playing at Quadrille c.1740–1750
oil on canvas 137.8 x 204.5
1955P118

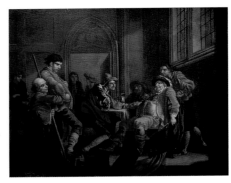

Hayman, Francis c.1708–1776
Sir John Falstaff Raising Recruits 1760–1765
oil on canvas 51.8 x 60.1
1956P6

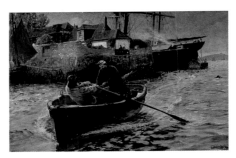

Hemy, Charles Napier 1841–1917
Homeward 1885
oil on canvas 91 x 137.5
1887P942

Henderson, Keith 1883–1982
The Castle of St Hilarion, Cyprus, Early Morning 1928–1929
oil on panel 46 x 93
1929P627

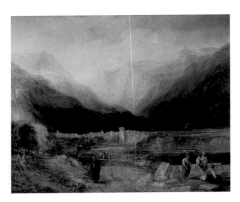

Henshaw, Frederick Henry 1807–1891
Sarzana, La Spezia, Italy 1837–1840
oil on canvas 64 x 76.5
1923P120

Henshaw, Frederick Henry 1807–1891
Valley Crucis c.1840
oil on panel 14.8 x 19.7
1995P232

Henshaw, Frederick Henry 1807–1891
Five-Barred Gate at Yardley 1841
oil on canvas 41.3 x 55.7
1929V201

Henshaw, Frederick Henry 1807–1891
Worcestershire Scenery in Autumn 1843
oil on canvas 107.5 x 152.8
1887P960

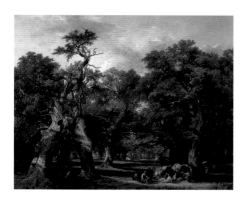

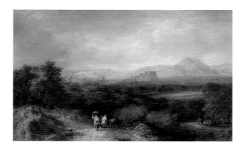

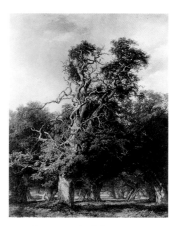

Henshaw, Frederick Henry 1807–1891
A Forest Glade, Arden, Warwickshire
1844–1845
oil on canvas 96 x 114
1885P2661

Henshaw, Frederick Henry 1807–1891
Edinburgh from Corstorphine 1846
oil on panel 41 x 67.3
1923P119

Henshaw, Frederick Henry 1807–1891
An Old Oak, Forest of Arden, Warwickshire
1850
oil on canvas 112.2 x 86.3
1885P2539

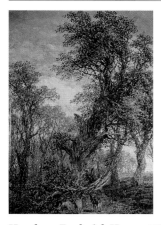

Henshaw, Frederick Henry 1807–1891
The Broken Bough (panel in the Everitt
Cabinet) 1881
oil on panel 25.4 x 17.1
1892P41.6

Henshaw, Frederick Henry 1807–1891
A Glimpse of Wharfdale, Yorkshire
oil on canvas 61 x 46
1917P13

Henshaw, Frederick Henry 1807–1891
*The Old Footbridge over the River Cole at
Yardley*
oil on canvas 54.1 x 76.3
1957P31

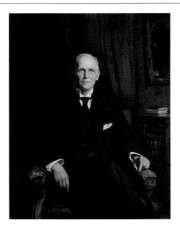

Henshaw, Frederick Henry 1807–1891
The Road to the Abbey, Bolton, Yorkshire
oil on canvas 45.8 x 60.7
1917P14

Hepworth, Barbara 1903–1975
Prelude I 1948
oil & pencil on gesso ground board 40 x 52
1948P24

Herkomer, Hubert von 1849–1914
Sir Edward George Jenkinson (1836–1919)
1906
oil on canvas 142.9 x 111.8
1988P62

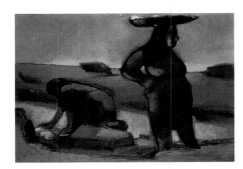

Herman, Josef 1911–2000
The Washerwomen 1953–1954
oil on canvas board 75.4 x 96.7
1968P25

Heron, Patrick 1920–1999
Standing Figure, Rachel 1950
oil on canvas 92 x 51
2001P2

Heron, Patrick 1920–1999
Porthmeor 1965, Rumbold 1970 1970
oil on canvas 182.9 x 121.9
1999P38

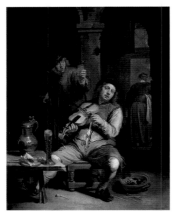

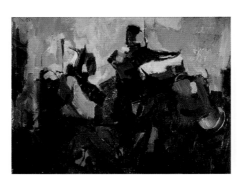

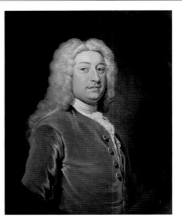

Herp, Willem van I c.1614–1677
The Blind Fiddler
oil on panel 59.4 x 47.6
1970P263

Hewitt, Geoffrey b.1930
Cavalryman 1962
oil on canvas 35 x 49.5
PL60

Highmore, Joseph 1692–1780
John Whitehall of 'Furnivall's Inn' 1731
oil on canvas 76.4 x 63.8
1936P503

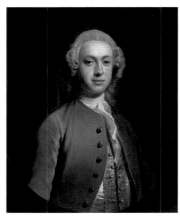

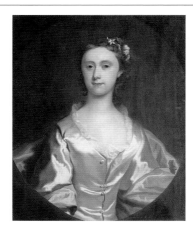

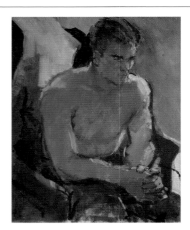

Highmore, Joseph 1692–1780
Portrait of a Man 1745
oil on canvas 76 x 64.3
1954P5

Highmore, Joseph 1692–1780
Portrait of a Woman 1745
oil on canvas 76 x 64.3
1954P6

Hill, Derek 1916–2000
Boxer Resting, Don Cockell 1949
oil on canvas 61 x 51
1962P5

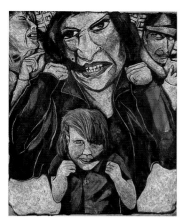

Hill, Paul b.1959
Little Street Fighter 1995
acrylic on paper 114.8 x 92.5
2006P0425

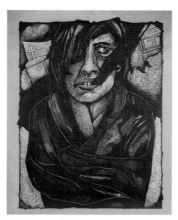

Hill, Paul b.1959
Getting His Bottle In 1997
acrylic on paper 105 x 75
2006.0426

Hill, Paul b.1959
Changing of the Guard 2000
acrylic on paper 103 x 77
2006.043

Hillier, Tristram Paul 1905–1983
The Gate 1943
oil on oak panel 15.4 x 23.1
1979P320

Himid, Lubaina b.1954
My Parents, Their Children (detail) 1986
acrylic & mixed media on canvas 151 x 184
2001Q4

Himid, Lubaina b.1954
Plan B 1999
acrylic on canvas 122 x 244 (E)
2001Q11 (P)

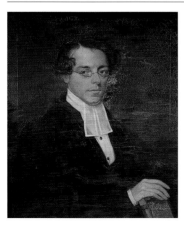

Hirkby, Thomas active 19th C
Reverend Henry Martin
oil on canvas 76.5 x 64
PCF 21

Hitchens, Ivon 1893–1979
Tangled Pool Number Nine 1946
oil on canvas 52.1 x 90.2
1949P10

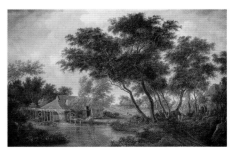

Hobbema, Meindert 1638–1709
The Watermill
oil on panel 67.7 x 99.2
1938P260

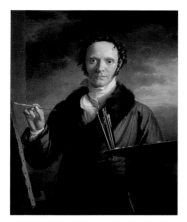

Hobday, William Armfield 1771–1831
Self Portrait 1813–1814
oil on canvas 91.6 x 70.8
1922P33

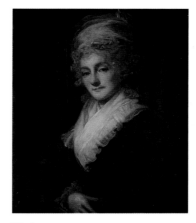

Hodges
Lady Holte (1734–1799), Wife of Sir Charles Holte of Aston Hall
oil on canvas 76 x 64.5
1981P4

Hodgkin, Howard b.1932
Gardening 1960–1963
oil on canvas 101.6 x 127
1997P49

Hodgkin, Howard b.1932
Large Staff Room 1964–1967
oil on wood 122 x 182
1998PL15 (P)

Hodgkin, Howard b.1932
Room with Chair 1969–1970
oil on panel 66.1 x 73.6
1998PL16 (P)

Hodgkin, Howard b.1932
Venice Sunset 1989
oil on wood 26 x 30
1998Q20 (P)

Hogarth, William 1697–1764
Scene from John Gay's 'The Beggar's Opera'
1726–1728
oil on canvas 49.2 x 56.6
1985P47

Hogarth, William 1697–1764
The Distressed Poet 1733–1735
oil on canvas 65.9 x 79.1
1934P500

Holl, Frank 1845–1888
Head of an Old Man 1871
oil on canvas 39.4 x 32.8
1986P5

Facing page: Donne, Eithne, b.1934, *San Polo, Venice* (detail), Royal Birmingham Society of Artists, (p. 209)

Holl, Frank 1845–1888
Edmund Tonks (1824–1898) 1881
oil on canvas 77 x 64.2
1898P58

Holl, Frank 1845–1888
Sir Thomas Martineau (1828–1893) 1887
oil on canvas 90.2 x 75
1887P957

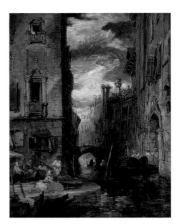

Holland, James 1800–1870
A Recollection of Venice 1853
oil on millboard 33.4 x 26.3
1912P4

Holmes, Charles John 1868–1936
A Warehouse 1921
oil on canvas 46 x 81.5
1960P7

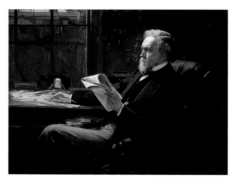

Holyoake, William 1834–1894
George Jacob Holyoake (1817–1906)
oil on canvas 113.1 x 141.4
1906P32

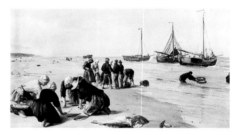

Hook, James Clarke 1819–1907
*Fish from the Dogger Bank, Scheveningen,
Holland* 1870
oil on canvas 76.3 x 138.5
1892P24

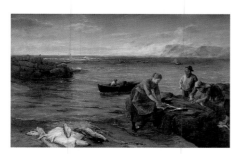

Hook, James Clarke 1819–1907
Breakfasts for the Porth
oil on canvas 88.6 x 139.4
1919P152

Horsley, Hopkins Horsley Hobday
1807–1890
Heads of Children, Boy and Girl, Three Studies
1850
oil on paper 25.4 x 35.5
1928P170

Horsley, Hopkins Horsley Hobday
1807–1890
On the Sands at Rhyl, North Wales 1856
oil on canvas 51.2 x 76.4
1992P3

Horsley, Hopkins Horsley Hobday
1807–1890
Andermatt, Switzerland (panel in the Everitt
Cabinet) 1879/1880
oil on mahogany panel 20.5 x 22.8
1892P41.13

Howitt, Samuel c.1765–1822
Lion and Leopard
oil on canvas 45.3 x 58.4
1972P31

Hoyland, John b.1934
10.9.75 1975
acrylic on canvas 213 x 198
1980P2

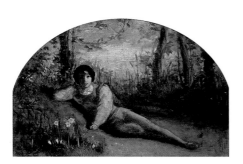

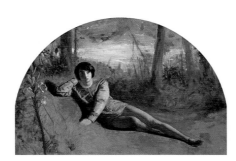

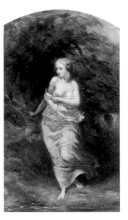

Hughes, Arthur 1832–1915
*Study for 'The Young Poet (Portrait of the
Artist)'* 1848–1849
oil on millboard 24.2 x 34.3
1957P30

Hughes, Arthur 1832–1915
The Young Poet (Portrait of the Artist) 1848–
1849
oil on canvas 63.5 x 91.4
1935P38

Hughes, Arthur 1832–1915
Study for 'Musidora Bathing' 1848–1849
oil on card 18.2 x 11.1
1957P29

Hughes, Arthur 1832–1915
Musidora Bathing 1849
oil on canvas 83.8 x 56
1935P39

Hughes, Arthur 1832–1915
The Annunciation 1872–1873
oil on canvas 61.3 x 35.9
1892P1

Hughes, Arthur 1832–1915
The Nativity 1857–1858
oil on canvas 61.2 x 35.8
1892P2

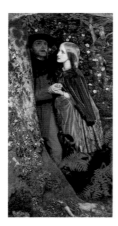

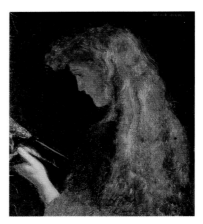

Hughes, Arthur 1832–1915
Amy (study for 'The Long Engagement')
1853–1859
oil on panel 32.5 x 19.2
1925P222

Hughes, Arthur 1832–1915
The Long Engagement 1859
oil on canvas 107 x 53.3
1902P13

Hughes, Arthur 1832–1915
Study of a Girl's Head 1865
oil on canvas 26.7 x 22.9
1922P23

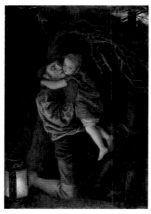

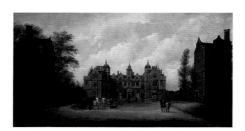

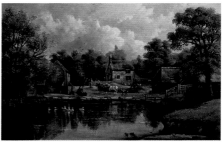

Hughes, Arthur 1832–1915
The Lost Child 1865–1870
oil on canvas 52.8 x 30.5
1926P3

Hughes, John Joseph 1820–1909
Aston Hall, East Front 1854
oil on canvas 38.6 x 66.3
1981P11

Hughes, John Joseph 1820–1909
View of a Farm in Wood Lane, Handsworth
oil on canvas 50 x 76
1965V337

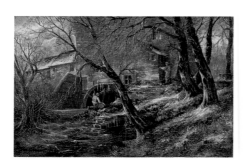

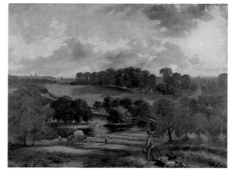

Hughes, John Joseph 1820–1909
View of Hamstead Mill, Handsworth
oil on canvas 50 x 77.5
1960P33

Hughes, John Joseph 1820–1909
View of Hay Time, Hamstead Mill,
Handsworth
oil on canvas 66.6 x 88.7
1960P34

Hughes, Patrick b.1939
Superduperspective 2002
oil on three-dimensional wooden structure
81 x 231
2003.0044

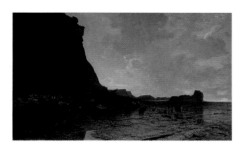

Hunt, Alfred William 1830–1896
Whitby Scar, Yorkshire c.1860–1896
oil on canvas 82 x 127
1925P340

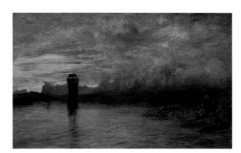

Hunt, Alfred William 1830–1896
A Norwegian Midnight 1878–1879
oil on canvas 91.2 x 137.2
1885P2535

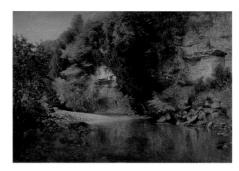

Hunt, Alfred William 1830–1896
Leafy June 1878–1879
oil on canvas 87.5 x 122.4
1925P339

Hunt, William Holman 1827–1910
Self Portrait 1845
oil on canvas 45.7 x 39.3
1961P32

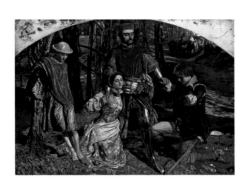

Hunt, William Holman 1827–1910
Valentine Rescuing Sylvia from Proteus 1851
oil on canvas 98.5 x 133.3
1887P953

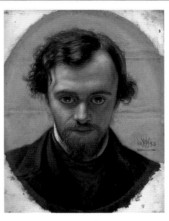

Hunt, William Holman 1827–1910
Dante Gabriel Rossetti (1828–1882) 1853
oil on panel 29.2 x 21.5
1961P33

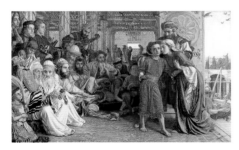

Hunt, William Holman 1827–1910
The Finding of the Saviour in the Temple
1854–1860
oil on canvas 85.7 x 141
1896P80

Hunt, William Holman 1827–1910
The Lantern Maker's Courtship (Cairo Street Scene) 1854–1861
oil on canvas 54.8 x 34.7
1962P68

Hunt, William Holman 1827–1910
May Morning on Magdalen College Tower, Oxford, Ancient Annual Ceremony 1888–1891
oil on canvas 39.3 x 50.6
1907P132

Hurlstone, Frederick Yeates 1800–1869
A Young Savoyard 1835–1836
oil on canvas 89.5 x 68.6
1892P45

Ibbetson, Julius Caesar 1759–1817
Gypsies with an Ass Race 1792
oil on canvas 41.5 x 59.8
1915P31

Inchbold, John William 1830–1888
Springtime in Spain, near Gordella 1869
oil on canvas 30.5 x 46
1913P25

Innes, Callum b.1962
Exposed Painting, Paynes Grey, Red Violet on White 1998
oil on canvas 70.5 x 64.5
1999PL3

Innes, Callum b.1962
Exposed Painting, Paynes Grey, Yellow Oxide on White 1998
oil on canvas 228.5 x 223.5
1999Q4

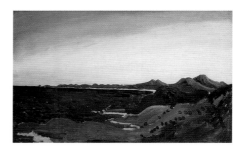

Innes, James Dickson 1887–1914
Provençal Coast, Sunset 1911–1913
oil on canvas 51 x 76.1
1948P10

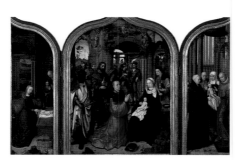

Isenbrandt, Adriaen c.1500–before 1551
The Nativity (left wing); *The Adoration of the Magi* (centre panel); (…) 1510–1512
oil on oak panel
90.3 x 28.5; 95.9 x 66; 90.3 x 28.5
1928P554

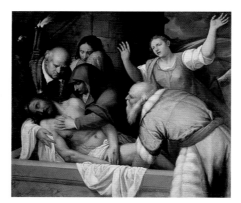

Italian (Venetian) School 16th C
The Entombment of Christ
oil on canvas 130.8 x 151.1
1960P16

Italian (Venetian) School 18th C
View of Venice: The Church of Il Redentore
oil on canvas 53.3 x 68.6
1981P6

Italian School 15th C
Madonna and Child with Infant
oil on poplar panel 66 x 39
PCF 32

Jackowski, Andrzej b.1947
Christopher 1981
oil on canvas 131.8 x 113.8
1986P107

Jackson, Frank George 1831–1905
William Costen Aitken (1817–1876) 1870
oil on canvas 72.4 x 60.2
1890P134

Jackson, Gilbert active 1621–1658
Portrait of a Girl 1638
oil on canvas 73.5 x 62.2
1954P7

Jagamarra, Malcolm b.1955
Warna Warlu
oil on linen 152 x 66
2006.0427

Jagger
Sir Archibald Boyd 1953
oil on canvas 74 x 62
2005.4799.2

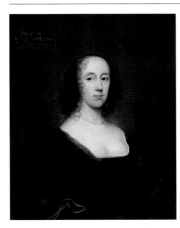

Janssens van Ceulen, Cornelis 1593–1661
Elizabeth Holte (c.1605–after 1670) 1635
oil on canvas 78 x 63.5
2007.1606.1

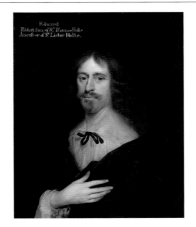

Janssens van Ceulen, Cornelis 1593–1661
Edward Holte 1635
oil on canvas 78.2 x 64
2007.1606

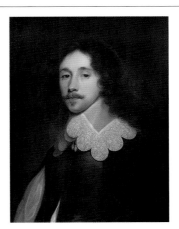

Janssens van Ceulen, Cornelis 1593–1661
Lucius, 2nd Viscount Falkland (1610–1643)
1635
oil on canvas 59.5 x 47.5
1970P266

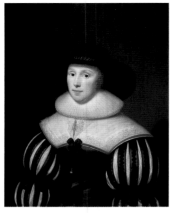

Janssens van Ceulen, Cornelis (attributed to)
1593–1661
*Grace Bradbourne (d.1627), Wife of Sir
Thomas Holte*
oil on panel 78.4 x 62.4
1981P13

Janssens van Ceulen, Cornelis (attributed to)
1593–1661
Sir Thomas Holte (1571–1654)
oil on panel 70.3 x 58.7
1981P14

Jelley, James Valentine 1856–1943
The Lily Garden 1911–1914
oil on canvas 72.5 x 93.6
1914P207

John, Augustus Edwin 1878–1961
A Canadian Soldier 1918
oil on canvas 76.4 x 63.6
1920P94 🐝

John, Augustus Edwin 1878–1961
King Feisal of Iraq (1883–1933) 1919
oil on canvas 90.2 x 63.5
1920P93 🐝

John, Gwen 1876–1939
Woman Holding a Flower c.1908–1922
oil on canvas 44.8 x 29.3
1949P32

Johnson, Benjamin active 1850–1872
Beach Scene, Marazion, Cornwall 1850–1860
oil on paper 24.7 x 37.1
1982P36

Johnson, Benjamin active 1850–1872
Beach Scene 1858
oil on paper 36.5 x 52.7
1982P35

Johnson, Benjamin active 1850–1872
Cliffs at Marazion, Cornwall 1858
oil on paper 52.4 x 35.7
1982P37

Facing page: Gossaert, Jan, c.1478–1532, *Hercules and Deianira* (detail), 1517, The Barber Institute of Fine Arts, (p. 232)

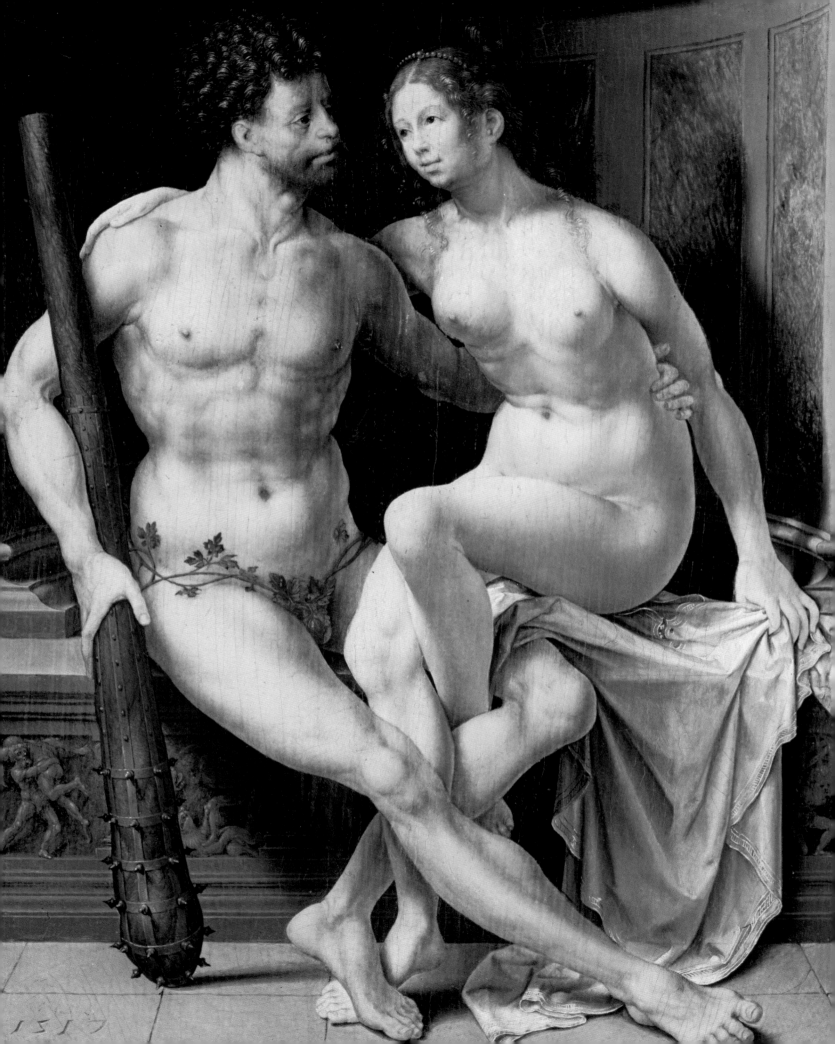

Johnson, Benjamin active 1850–1872
Ruins, St Michael's Mount, Cornwall 1858
oil on paper 37.1 x 24.2
1982P38

Johnson, Harry John 1826–1884
Athens 1863–1865
oil on canvas 72.9 x 153.8
1895P22

Jolly, J. active 1875–1879
Spinner's Mill, Bournbrook 1875
oil on canvas 41.2 x 61.5
1959V178

Jolly, J. active 1875–1879
Rural Scene with Horses at a Stream 1879
oil on canvas 44.4 x 55.9
1984V107

Jolly, J. active 1875–1879
Hind's Farm, Sparkhill
oil on canvas 32.9 x 43.2
1984V109

Jolly, J. active 1875–1879
Hobb Moor Road Ford, Birmingham
oil on canvas 56 x 69.6
1984V108

Jones, Allen b.1937
3rd Big Bus, Red 1962
oil on canvas 202.7 x 202.7
1964P35

Jones, George 1786–1869
The Battle of Hyderabad, March 1843 1843
oil on panel 28 x 52.2
1885P2525

Jones, George 1786–1869
The Conflict at the Guns, Balaclava 1854
oil on panel 27.5 x 52.7
1885P2524

Jones, Thomas 1742–1803
Pencerrig 1772
oil on paper 22.8 x 30.5
1954P56

Jones, Thomas 1742–1803
A Hilltop near Naples 1782
oil on paper 14.2 x 21.6
1954P55

Jongkind, Johan Barthold 1819–1891
The Sea at Étretat 1853
oil on canvas 53.3 x 63.5
1951P127

Kendrick, Thomas b.c.1839
Sket's Cottage, Northfield
oil on canvas 22.5 x 33.5
1977V498

Kendrick, Thomas b.c.1839
Walton's Cottage, Northfield
oil on canvas 23 x 33.5
1977V497

Kessell, Mary 1914–1977
A Girl with Grasses c.1936–1946
oil on paper 44.5 x 59.7
1946P34

King, William Joseph 1857–after 1943
Coastal Scene with Criccieth Castle 1892
oil on canvas 46.3 x 76.8
1987P59

King, William Joseph 1857–after 1943
A Lone Grey Sea
oil on canvas 55.9 x 76.2
1938P285

Kitaj, R. B. 1932–2007
Desk Murder c.1970–1984
oil on canvas 76.2 x 122
2005.3184

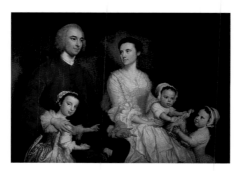

Knapton, George 1698–1778
Dr Samuel Walthen with His Wife and Children 1755
oil on canvas 114.7 x 160.8
1952P8

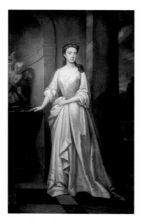

Kneller, Godfrey 1646–1723
Mary, Marchioness of Rockingham (d.1761) 1720
oil on canvas 236.2 x 134.6
1947P21

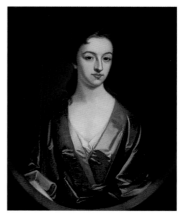

Kneller, Godfrey 1646–1723
Barbara, Wife of Sir Clobury Holte (d.1742)
oil on canvas 73.5 x 63.5
1981P7

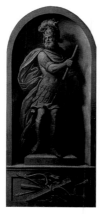

Kneller, Godfrey (school of) 1646–1723
A Warrior c.1690–1710
oil on canvas 260.7 x 128.9
1976P7

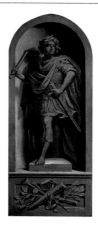

Kneller, Godfrey (school of) 1646–1723
A Warrior c.1690–1710
oil on canvas 260.7 x 102.6
1976P8

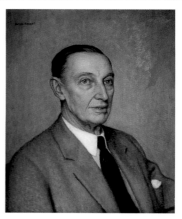

Knight, Harold 1874–1961
Barry Jackson (1879–1961) c.1950
oil on canvas 62 x 52
1986L1 (P)

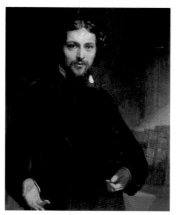

Knight, John Prescott 1803–1881
George Dawson (1821–1876) 1850–1855
oil on canvas 91.7 x 76.2
1935P146

Knight, Laura 1877–1970
Autumn Sunlight, Sennen Cove, Cornwall 1922
oil on canvas 59.7 x 74.9
1922P146

Knight, Laura 1877–1970
Les Sylphides c.1922
oil on canvas 76.2 x 101.6
1931P92

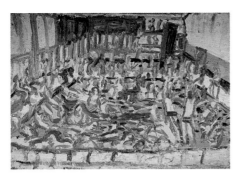

Kossoff, Leon b.1926
Children's Swimming Pool, Friday Evening
1970
oil on canvas 112.2 x 153.9
1976P13

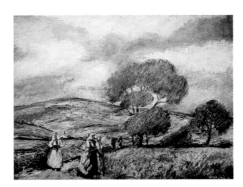

Kotasz, Károly 1872–1941
Stormy Landscape with Blue and Red Figures
oil on canvas 40 x 50.2
1940P1

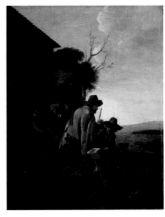

Laer, Pieter van (attributed to) 1599–c.1642
*A Franciscan Saint Distributing Food to
Peasants* c.1650
oil on panel 32.1 x 26.4
1999PL16 (P)

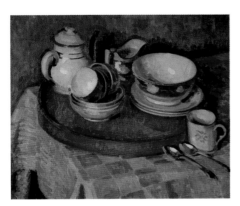

Lamb, Henry 1883–1960
Tea Things 1932
oil on canvas 47 x 52.2
1946P35

Lambert, George c.1700–1765
The Mouth of an Estuary c.1750–1760
oil on canvas 125.5 x 129.5
1951P126

Landseer, Edwin Henry 1802–1873
The Hunting of Chevy Chase 1825–1826
oil on canvas 143.5 x 170.8
1952P2

Landseer, Edwin Henry 1802–1873
*The Duchess of Bedford's Gamekeeper,
J. Michie* 1843
oil on board 25.8 x 23.1
1961P35

Langley, Walter 1852–1922
In Memoriam 1882–1883
oil on canvas 85.4 x 65
1919P123

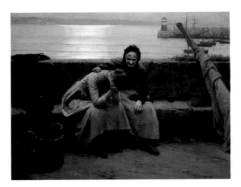

Langley, Walter 1852–1922
*'Never morning wore to evening but some heart
did break'* 1894
oil on canvas 122 x 152.4
1980P18

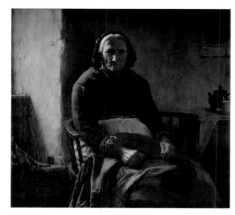

Langley, Walter 1852–1922
An Old Cornish Woman
oil on canvas 75 x 80
1986P113

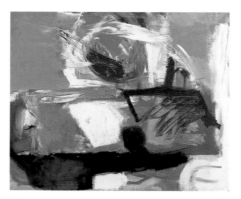

Lanyon, Peter 1918–1964
Offshore 1959
oil on canvas 153 x 184.2
1959P49

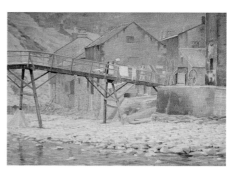

Lavenstein, Cyril 1891–1986
The Trestle Bridge, Staithes, near Whitby, Yorkshire 1919–1921
oil on canvas 41 x 56.1
1984P43

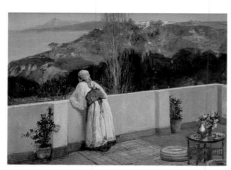

Lavery, John 1856–1941
Evening, Tangiers 1906
oil on canvas 74.7 x 105.2
1908P302

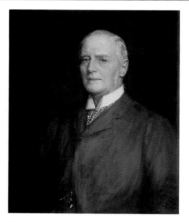

Lavery, John 1856–1941
The Right Honourable William Kenrick (1869–1919) 1907
oil on canvas 76.6 x 64
1908P19

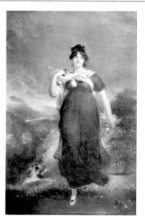

Lawrence, Thomas 1769–1830
Elizabeth, Marchioness Conyngham (1769–1861) 1801–1802
oil on canvas 240 x 149
1975P359

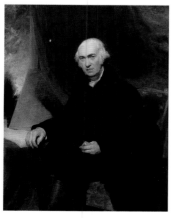

Lawrence, Thomas 1769–1830
James Watt (1736–1819) 1813
oil on canvas 142.3 x 111.9
2006.1389

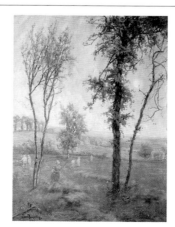

Lawson, Cecil Gordon 1851–1882
Haymaking by Moonlight 1876
oil on canvas 61.5 x 51.7
1908P26

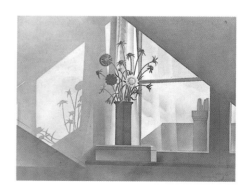

Lea, Eric active 1930–1934
Scabious 1930
oil on canvas 56 x 71.3
1932P38

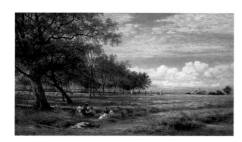

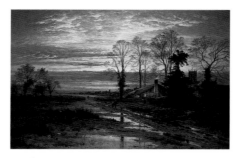

Leader, Benjamin Williams 1831–1923
An English Hayfield 1878
oil on canvas 68.7 x 114.1
1925P131

Leader, Benjamin Williams 1831–1923
February, Fill Dyke 1881
oil on canvas 121.9 x 183
1914P308

Lear, Edward 1812–1888
Campagna di Roma 1878
oil on canvas 24 x 46
1987Q17

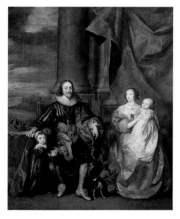

Leemput, Remi van 1607–1675
Charles I (1600–1647), and His Family
oil on canvas 288 x 228.2
1970P264

Lees, Derwent 1885–1931
Crick Barrow, Monmouthshire
oil on panel 33.6 x 42.3
1992P7

Leigh, George Leonard 1857–1942
A Birmingham Canal Lock
oil on canvas 38.1 x 43.2
1942P79

Leigh, George Leonard 1857–1942
A Grey Interior
oil on canvas 25.2 x 34.3
1942P80

**Leighton, Frederic, 1st Baron Leighton of
Stretton** 1830–1896
Garden of an Inn, Capri 1859
oil on canvas 48.9 x 66.7
1960P41

**Leighton, Frederic, 1st Baron Leighton of
Stretton** 1830–1896
A Condottiere 1871–1872
oil on canvas 124.5 x 78
1885P2468

Leighton, Frederic, 1st Baron Leighton of Stretton 1830–1896
'And the sea gave up the dead which were in it' 1891–1892
oil on paper 43.6
1894P1

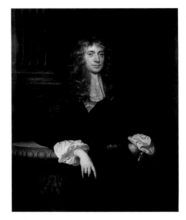

Lely, Peter 1618–1680
Susanna and the Elders c.1645–1655
oil on canvas 117 x 157.5
1948P23

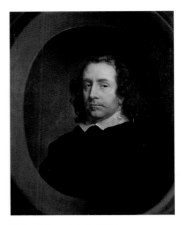

Lely, Peter 1618–1680
Possibly the Earl Rivers (detail) c.1650–1660
oil on canvas 75.5 x 62.5
1928P270

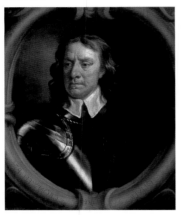

Lely, Peter 1618–1680
Oliver Cromwell (1599–1658) 1653–1654
oil on canvas 76.2 x 62.9
1949P27

Lely, Peter 1618–1680
Sir John Nicholas 1667
oil on canvas 125.4 x 102
1937P891

Lely, Peter 1618–1680
The Honourable Mrs Lucy Loftus 1667
oil on canvas 127 x 101.6
1941P338

Lely, Peter 1618–1680
Elizabeth, Lady Monson (1613–1695)
oil on canvas 188 x 137
1953P1

Lessore, Thérèse 1884–1945
Music Hall Audience c.1926–1945
oil on canvas 61 x 45.7
1947P10

Lever, Gillian b.1963
Composition c.2002
oil on paper 74.5 x 57
2007.0946

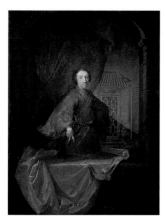

Levrac-Tournières, Robert 1667–1752
Richard (Dicky) Bateman (d.1773) 1741
oil on canvas 49 x 35.8
1974P19

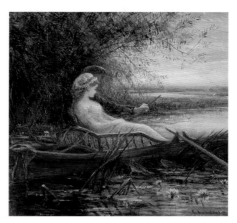

Lewis, Charles James 1830–1892
Two Figures in a Boat (panel in the Everitt
Cabinet) 1881
oil on mahogany panel 20.2 x 22.6
1892P41.7

Lewis, John Frederick 1805–1876
The Pipe Bearer 1856
oil on panel 43 x 31
1954P11

Lewis, John Frederick 1805–1876
The Doubtful Coin 1869
oil on panel 74.9 x 87.3
1891P28

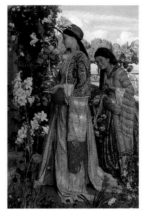

Lewis, John Frederick 1805–1876
Lilium Auratum 1871
oil on canvas 136.6 x 87.5
1911P61

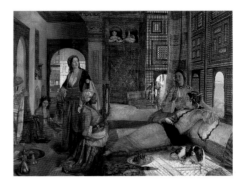

Lewis, John Frederick 1805–1876
The Harem 1876
oil on mahogany panel 91.1 x 114
1949P14

Lines, Frederick Thomas 1809–1898
Samuel Lines (1778–1863)
oil on canvas 63.5 x 50.8
1991P125

Lines, Samuel 1778–1863
*Birmingham from the Dome of St Philip's
Church* 1821
oil on canvas 53.3 x 122
1893V72

Lines, Samuel 1778–1863
Birmingham Town Hall and Queen's College
1850–1852
oil on canvas 73.4 x 99
1937P369

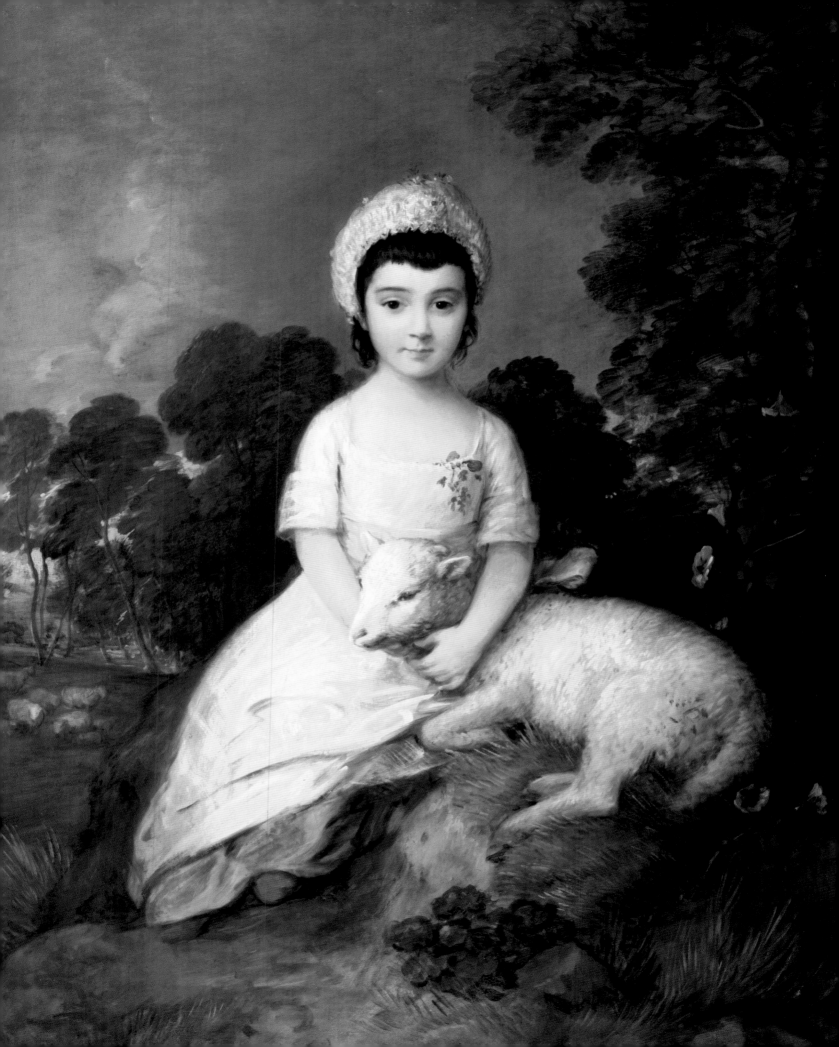

Lines, Samuel 1778–1863
*The Duke of Cambridge Leaving the Town
Hall, Birmingham* 1857
oil on canvas 63.3 x 76.2
1902P14

Lines, Samuel 1778–1863
The Opening of Calthorpe Park, Birmingham
1857
oil on canvas 63 x 76.2
1902P15

Lines, Samuel 1778–1863
Llyn Idwal, North Wales
oil on canvas 94.3 x 127.2
1978P183

Lines, Samuel 1778–1863
Panoramic View of the Severn Estuary
oil on canvas 63.5 x 84
1991P56

Lines, Samuel (circle of) 1778–1863
Gordale Scar, Yorkshire
oil on card 8.4 x 11.6
1977V172

Lines, Samuel (circle of) 1778–1863
Grove
oil on card 8.1 x 5.9
1977V173

Lines, Samuel (circle of) 1778–1863
Kirkstall Abbey
oil on card 11.6 x 9.6
1977V174

Lines, Samuel (circle of) 1778–1863
Mountain Scene with Trees
oil on board 25.6 x 36.7
1977V154

Lines, Samuel (circle of) 1778–1863
Mountain Stream and Rocks
oil on card 11.2 x 16.2
1977V175

Facing page: Gainsborough, Thomas, 1727–1788, *Isabelle Franks (c.1769/1770–1855)* (detail), 1775–1778, Birmingham
Museums and Art Gallery, (p. 100)

Lines, Samuel (circle of) 1778–1863
Pastoral Scene with Cattle
oil on card 8.5 x 11.4
1977V176

Lines, Samuel (circle of) 1778–1863
Rural Scene with Buildings and Trees
oil on card 27.6 x 20.8
1977V199

Lines, Samuel (circle of) 1778–1863
Stone Ruin on Hilltop
oil on card 23 x 26.6
1977V185

Lines, Samuel Restell 1804–1833
Landscape with Trees
oil on canvas 25.5 x 32.2
1937P846

Linnell, John 1792–1882
The Sheep Drive 1863
oil on canvas 71.2 x 99.7
1897P7

Linnell, William 1826–1906
A Wooded Valley and Hill 1865
oil on canvas 61 x 84.5
1936P328

Lobley, James 1829–1888
The Free Seat 1869
oil on panel 55.2 x 84.5
1937P364

Lockwood, Frank Taylor 1895–1961
Town by the Sea 1908
oil on board 14.1 x 19.3
1995V576

Lockwood, Frank Taylor 1895–1961
Town by the Sea 1908
oil on board 14.6 x 18.9
1995V577

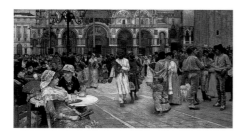

Logsdail, William 1859–1944
St Mark's Square, Venice 1883
oil on canvas 126.2 x 222.3
1898P59 🐝

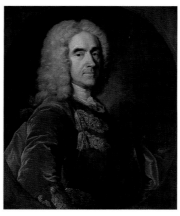

Loo, Jean-Baptiste van 1684–1745
*Sir Richard Temple (1675–1749), 4th Viscount
of Birmingham* 1738–1742
oil on canvas 75.6 x 62
1987P71

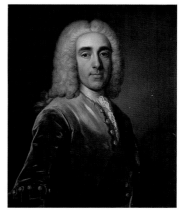

Loo, Jean-Baptiste van 1684–1745
The 4th Earl of Chesterfield (1694–1773)
1738–1742
oil on canvas 75.1 x 61.8
1987P70

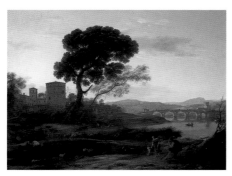

Lorrain, Claude 1604–1682
*Landscape near Rome with a View of the Ponte
Molle* 1645
oil on canvas 73.7 x 96.5
1955P111

Lorrain, Claude 1604–1682
*Coast Scene with the Embarkation of Saint
Paul* 1653–1655
oil on silver plated copper 38 x 53
1962P69

Loutherbourg, Philip James de 1740–1812
Christ Appearing to the Disciples at Emmaus
1797
oil on canvas 127.5 x 101.2
1982P44

Loutherbourg, Philip James de 1740–1812
The Betrayal of Christ 1798
oil on canvas 122.8 x 99.5
1982P45

Loutherbourg, Philip James de 1740–1812
The Milkmaid c.1800–1812
oil on canvas 43.2 x 34.3
1920P682

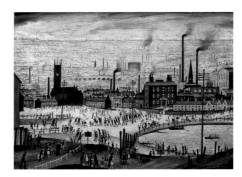

Lowry, Laurence Stephen 1887–1976
An Industrial Town 1944
oil on canvas 43.8 x 55.2
1946P22

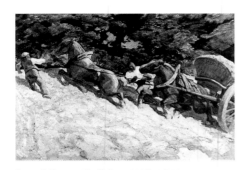

Luard, Lowes Dalbiac 1872–1944
Chestnut Horses
oil on canvas 82 x 117.2
1946P19

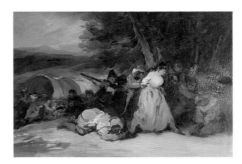

Lucas, Eugenio the elder 1824–1870
The Ambush c.1850–1870
oil on metal 35.5 x 50.8
1965P21

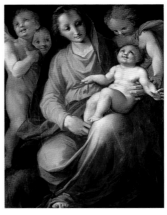

Manzuoli, Tommaso 1531–1571
Madonna and Child with the Infant St John
c.1560–1570
oil on poplar panel 77 x 61
1966P41

Marcoussis, Louis 1883–1941
Le lecteur 1937
oil on canvas 88.9 x 130.2
1951P97

Marks, Henry Stacey 1829–1898
Dominicans in Feathers 1880–1887
oil on canvas 62 x 185.5
1890P84

Marks, Henry Stacey 1829–1898
Where Is It? 1882
oil on canvas 91.6 x 71.5
1890P79

Marlow, William 1740–1813
The Temple of Venus, Bay of Baiae
oil on canvas 71 x 91.4
1930P376

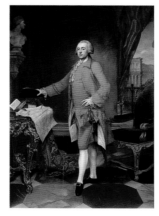

Maron, Anton von 1733–1808
Peter du Cane (1741–1823) 1763
oil on canvas 238.5 x 167
1951P128

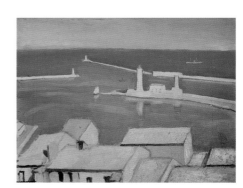

Marquet, Albert 1875–1947
The Port of Cette, Marseilles 1924
oil on canvas 31.8 x 39.3
1946P7

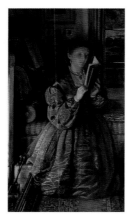

Martin, Jason b.1970
Serengetti
acrylic on aluminium 150 x 150
2001PL5

Martineau, Robert Braithwaite 1826–1869
The Last Chapter 1860–1863
oil on canvas 71.5 x 41.9
1942P64

Martini, Simone c.1284–1344
A Saint Holding a Book c.1330–1344
tempera on panel 19 x 19.7
1959P37

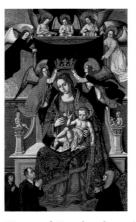

Mason, George Heming 1818–1872
Cattle at a Drinking Place in the Campagna, Rome 1854
oil on canvas 32.5 x 65
1983P74

Mason, Gilbert 1913–1972
Self Portrait 1951
oil on plywood 49.8 x 63.5
1984P46

Master of Castelsardo active c.1475–c.1525
The Virgin and Child with Angels and Donors
tempera on canvas laid on wood panel
165.1 x 96.5
1885P2593

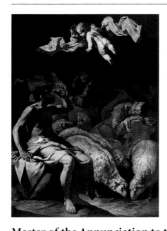

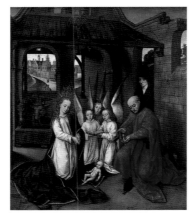

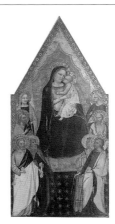

Master of the Annunciation to the Shepherds
The Angel Appearing to the Shepherds
1630–1631
oil on canvas 180.5 x 127.5
1949P7

Master of the Prado Adoration of the Magi
(**attributed to**) active c.1470–1500
Nativity
oil on panel 58.4 x 50.1
1973P7

Master of the San Lucchese Altarpiece
Madonna and Child Enthroned with Saints c.1350–1400
tempera on panel 54 x 24.8
1958P30

Matteo di Giovanni c.1430–1495
Angel Appearing to Joachim
oil on panel 61
1959P8

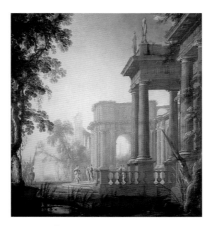

Mauperché, Henri 1602–1686
Jephthah and His Daughter
oil on canvas 122 x 111
1967P59

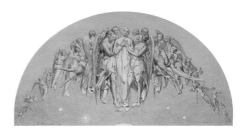

Mayson, S. active c.1840–1860
The Approach to the Celestial City
oil, pen & ink on milboard 14 x 25.5 (E)
1945P10

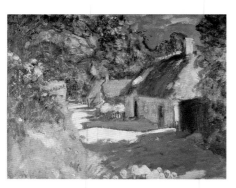

McEvoy, Ambrose 1878–1927
Cottages at Aldbourne 1915
oil on canvas 69.9 x 90.2
1945P25

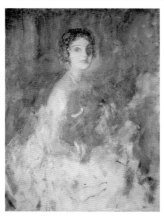

McEvoy, Ambrose 1878–1927
Mrs Richard Jessel 1920–1921
oil on canvas 101.9 x 76.2
1948P25

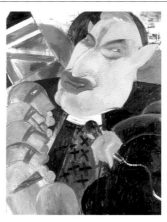

McFadyen, Jock b.1950
Ian Paisley: 'You can knock me down, steal my car, drink my liquor from an old fruit jar, but don'tcha…' 1981
oil on card 137.2 x 101.6
1984P153

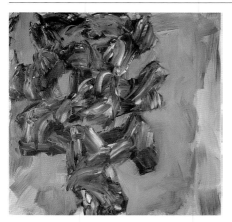

McGowan, Richard b.1950
Late Witness 1990
acrylic on canvas 121.5 x 121.5
1992Q7

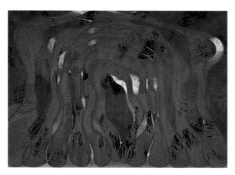

McKeever, Ian b.1946
Assumptio II (Breathing) 1999
oil & acrylic on canvas 245 x 330
1999Q32

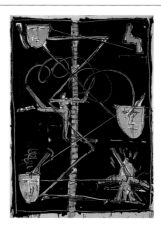

McLean, Bruce b.1944
Spoon 2 Spoon, II 1980
acrylic & wax crayon on photographic paper 180 x 120 (E)
2007.0917

Medley, Robert 1905–1994
The Perambulator 1954
oil on canvas 124.5 x 105.4
1955P109

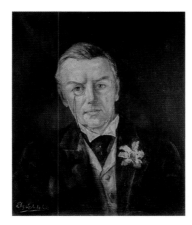

Melville, Elizabeth
Joseph Chamberlain (1836–1914) c.1935
oil on canvas 60 x 49
PCF 24

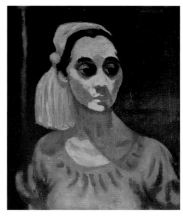

Melville, John 1902–1986
Portrait of the Artist's Wife 1955
oil on canvas 61 x 51
1989P61

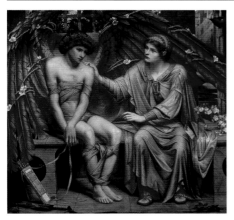

Meteyard, Sidney Harold 1868–1947
Hope Comforting Love in Bondage 1901
oil on canvas 104.2 x 109.2
1948P5

Methuen, Paul Ayshford 1886–1974
Town of Richelieu, Indre-et-Loire 1954
oil on canvas 63.5 x 76.5
1955P119

Meulen, Adam Frans van der (attributed to)
1631/1632–1690
*View of Versailles with Louis XIV and
Huntsmen*
oil on canvas 48.3 x 69.5
1966P27

Middleton, W. H. active 19th C
Autumn at Olton Mill
oil on canvas 76.7 x 51.3
1983V469

Millais, John Everett 1829–1896
Three Sword Hilts 1838–1839
oil on canvas 33 x 23.8
1946P4

Millais, John Everett 1829–1896
Elgiva Seized by Order of Archbishop Odo
c.1846
oil on millboard 31 x 46.9
1980P127

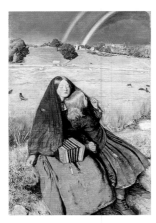

Millais, John Everett 1829–1896
The Blind Girl 1856
oil on canvas 80.8 x 53.4
1892P3

Millais, John Everett 1829–1896
My Second Sermon 1864
oil on wood 27.3 x 21
1909P61

Millais, John Everett 1829–1896
Waiting 1864
oil on panel 32.4 x 25
1909P62

Millais, John Everett 1829–1896
The Enemy Sowing Tares (St Matthew XIII,
24–25) 1865
oil on canvas 111.8 x 86
1925P103

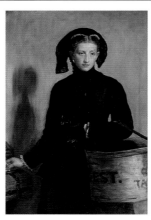

Millais, John Everett 1829–1896
A Widow's Mite 1870
oil on canvas 131.5 x 92.4
1891P26

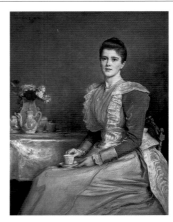

Millais, John Everett 1829–1896
Mrs Joseph Chamberlain 1891
oil on canvas 134.1 x 102.4
1989P60

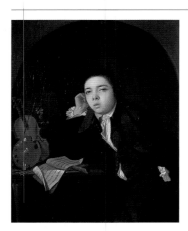

Millar, James 1735–1805
Self Portrait 1766
oil on canvas 39.8 x 32
1982P49

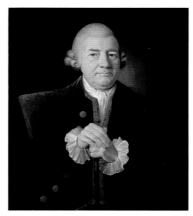

Millar, James 1735–1805
John Baskerville (1706–1775) 1774
oil on canvas 73.3 x 62.8
1940P605

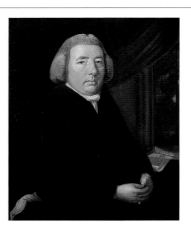

Millar, James 1735–1805
Francis Eginton (1736/1737–1805) 1796
oil on canvas 89.8 x 73.6
1912P24

Facing page: Bratby, John Randall, 1928–1992, *Self Portrait* (detail), c.1980, University of Birmingham, (p. 245)

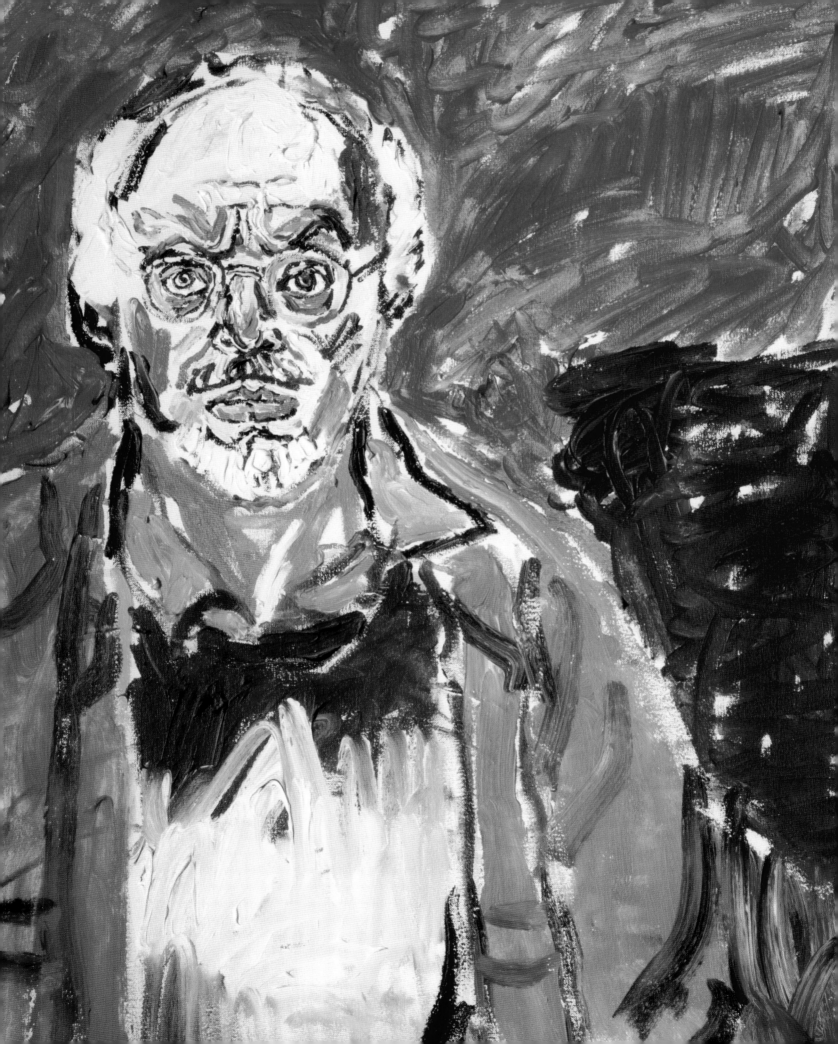

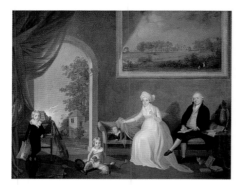

Millar, James 1735–1805
Robert Mynors and His Family 1797
oil on canvas 102 x 127.7
1977P1

Millar, James 1735–1805
Artist's Advertisement
oil on canvas 68.2 x 51.5
1988V1506

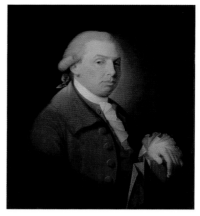

Millar, James 1735–1805
Dr John Derrington (1747–1805)
oil on canvas 70.9 x 61
1923P17

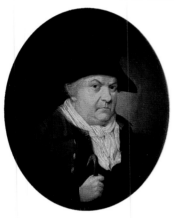

Millar, James 1735–1805
John Freeth (1731–1808)
oil on wood panel 28.6 x 24.1
1922P144

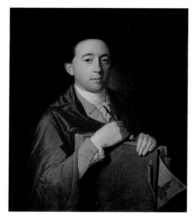

Millar, James 1735–1805
William Westley
oil on canvas 76.8 x 64
1979P6

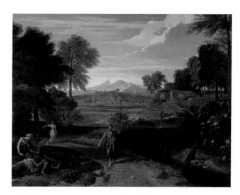

Millet, Jean-François the elder 1642–1679
Regulus Returning to Carthage
oil on canvas 65.4 x 81.3
1958P17

Modigliani, Amedeo 1884–1920
Madame Z 1918
oil on canvas 54 x 37.5
1978L31 (P)

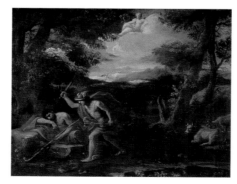

Mola, Pier Francesco 1612–1666
Mercury and Argus c.1650
oil on canvas 29.4 x 38.7
1999PL17 (P)

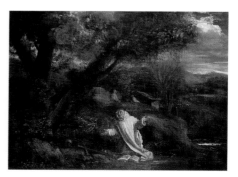

Mola, Pier Francesco 1612–1666
Landscape with Saint in Ecstasy
oil on canvas 49 x 64
1960P47

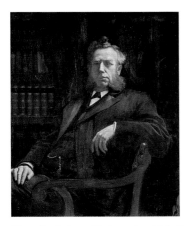

Montford, Arnold G. active 19th C
Alderman Samuel Edwards, 1st Lord Mayor of Birmingham
oil on canvas 127.3 x 102.7
2004.0186

Moon, Mick b.1937
Varengeville 1978
acrylic & mixed media on two canvases
186 x 189.5
1979P190

Moore, Albert Joseph 1841–1893
Canaries 1875–1880
oil on canvas 157.4 x 64.8
1914P229

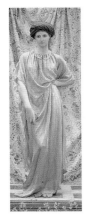

Moore, Albert Joseph 1841–1893
Sapphires 1877
oil on canvas 156.4 x 55.2
1914P228

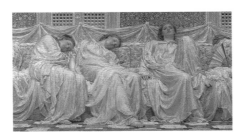

Moore, Albert Joseph 1841–1893
Dreamers c.1882
oil on canvas 70 x 121
1885P2467

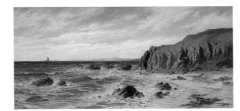

Moore, Edward d.1920
Coastal Scene 1887
oil on canvas 63.6 x 127.3
1987P62

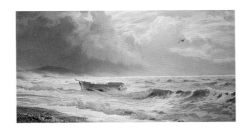

Moore, Henry 1831–1895
Rough Weather on the Coast, Cumberland 1874
oil on canvas 85.7 x 161.3
1929P37

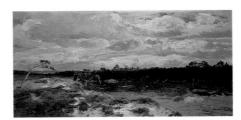

Moore, Henry 1831–1895
Near Lossiemouth 1876
oil on canvas 35.6 x 66.2
1929P202

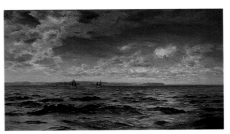

Moore, Henry 1831–1895
Summertime off Cornwall 1883
oil on canvas 90.7 x 154.5
1885P2469

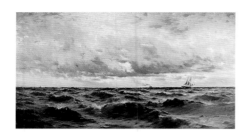

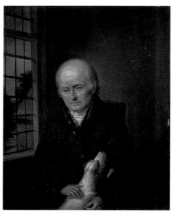

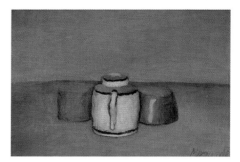

Moore, Henry 1831–1895
Newhaven Packet 1885
oil on canvas 122 x 213.4
1887P941

Moore, William I 1790–1851
James Millar (1735–1805)
oil on copper 25.4 x 20.3
1933P73

Morandi, Giorgio 1890–1964
Still Life 1955–1959
oil on canvas 35.5 x 51
1959P12

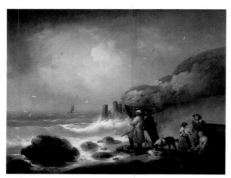

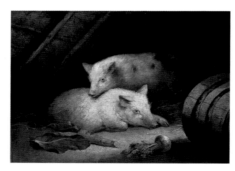

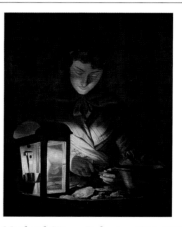

Morland, George 1763–1804
Shooting Sea Fowl 1795
oil on canvas 69.9 x 90.1
1947P58

Morland, George 1763–1804
Pigs
oil on canvas 71.2 x 90
1887P956

Morland, Henry Robert c.1716–1797
Oyster Girl
oil on canvas 76.5 x 62.5
1972P30

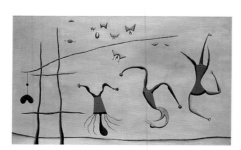

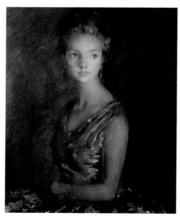

Morris, Desmond b.1928
The Jumping Three 1949
oil on canvas 77.3 x 127.1
1991P29

Muirhead, David 1867–1930
Blue and Silver 1929
oil on canvas 76.4 x 63.6
1929P523

Muller, William James 1812–1845
Font, Walsingham Church 1831
oil on canvas 39.8 x 29.1
1933P299

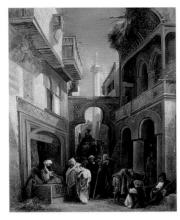

Muller, William James 1812–1845
Street Scene in Cairo 1839
oil on canvas 127 x 101.2
1885P2530

Muller, William James 1812–1845
Prayers in the Desert 1840–1849
oil on canvas 104.5 x 184
1885P2529

Muller, William James 1812–1845
View at Gillingham with Cottages 1841
oil on canvas 39.8 x 29.1
1921P79

Muller, William James 1812–1845
Arab Shepherds 1842
oil on canvas 86 x 168.5
1885P2531

Muller, William James 1812–1845
Hampstead Heath, the Bird Trap 1845
oil on canvas 51.3 x 61.2
1919P20

Muncaster, Claude 1903–1979
Getting the Fish in Winter Weather, North Atlantic 1930–1937
oil on canvas 76.4 x 101.8
1937P833

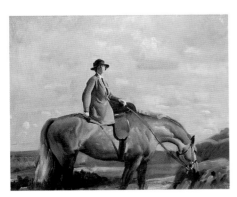

Munnings, Alfred James 1878–1959
In Cornwall (Portrait of the Artist's Wife)
c.1911–1921
oil on canvas 50.4 x 61
1921P85

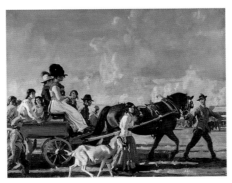

Munnings, Alfred James 1878–1959
Arrival at Epsom Downs for Derby Week 1920
oil on canvas 103.5 x 130.8
1921P84

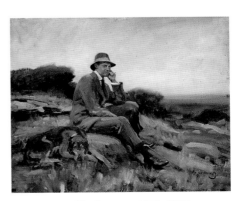

Munnings, Alfred James 1878–1959
Barry Jackson (1879–1961) c.1930
oil on canvas 51 x 61
1986L2 (P)

Munns, Bernard 1869–1942
Portrait of John Baptist Kramer (1874–1952)
c.1920
oil on canvas 59 x 48
1997P11

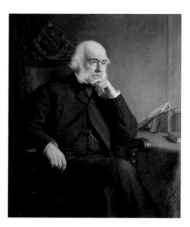

Munns, Henry Turner 1832–1898
Alderman T. C. Sneyd Kinnersley c.1870
oil on canvas 125.8 x 100
PCF 27

Munns, Henry Turner 1832–1898
Joseph Gillot (1799–1872) 1872
oil on canvas 127.5 x 101.4
1973P12

Munns, Henry Turner 1832–1898
Sir Josiah Mason (1795–1881) 1873
oil on canvas 261 x 175.9
1885P2586

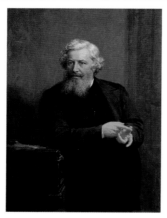

Munns, Henry Turner 1832–1898
George Dawson (1821–1876) 1877
oil on canvas 125.7 x 92.7
1885P2545

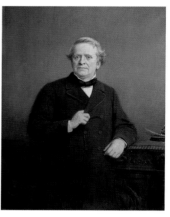

Munns, Henry Turner 1832–1898
Alderman William Brinsley 1880
oil on canvas 124.4 x 100.3
1906P236

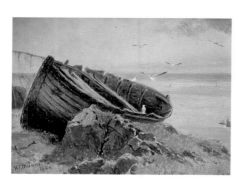

Munns, Henry Turner 1832–1898
Boat (panel in the Everitt Cabinet) 1881
oil on panel 20.5 x 28
1892P41.10

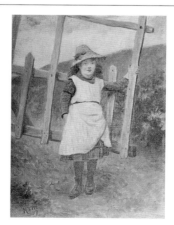

Munns, Henry Turner 1832–1898
Girl at a Gate 1887
oil on panel 18.3 x 13.6
1901P31.6

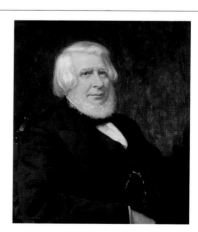

Munns, Henry Turner 1832–1898
Alderman Thomas Avery 1894
oil on canvas 76.5 x 63.8
1896P101

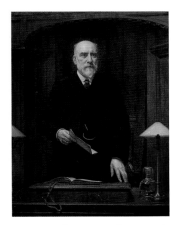

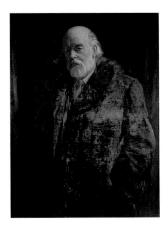

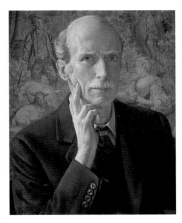

Munns, John Bernard 1869–1942
Isaac Bradley 1916
oil on canvas 114.2 x 86.4
1927P281

Munns, John Bernard 1869–1942
Sir Oliver Lodge (1851–1940) 1923
oil on canvas 105.4 x 74.9
1943P5

Munns, John Bernard 1869–1942
Self Portrait
oil on canvas 51.1 x 40.8
1943P6

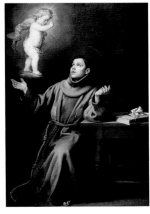

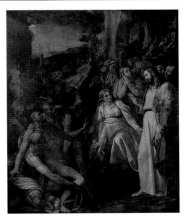

Murillo, Bartolomé Esteban 1618–1682
The Vision of St Anthony of Padua 1650–1670
oil on panel 209.8 x 144.5
1974P24

Muziano, Girolamo 1528/1532–1592
The Raising of Lazarus
oil on canvas 299 x 244.2
1975P358

Nash, Paul 1889–1946
Oxenbridge Pond 1927–1928
oil on canvas 99.7 x 87.6
1950P12

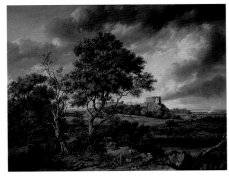

Nash, Paul 1889–1946
Landscape of the Moon's First Quarter 1943
oil on canvas 63.3 x 70.1
1953P463

Nasmyth, Patrick 1787–1831
Carisbrooke Castle, Isle of Wight
oil on canvas 71.6 x 93
1924P81

Neiland, Brendan b.1941
Torquay, Window Reflections 1974
acrylic on paper 43.1 x 71.1
1975P173

Nevinson, Christopher 1889–1946
Column on the March 1915
oil on canvas 63.8 x 76.6
1988P105 🐝

Nevinson, Christopher 1889–1946
La patrie 1916
oil on canvas 60.8 x 91.5
1988P104 🐝

Newton, Algernon Cecil 1880–1968
Birmingham with the Hall of Memory 1929
oil on canvas 71.2 x 152.7
1929P478

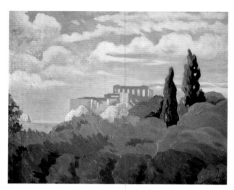

Nicholas of Greece 1872–1938
Sunrise on the Parthenon, Athens 1933
oil on millboard 37.5 x 45.7
1935P347

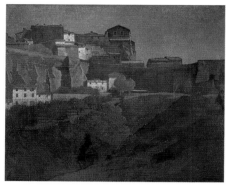

Nicholls, Bertram 1883–1974
Orvieto 1926
oil on canvas 64.2 x 76.5
1926P86

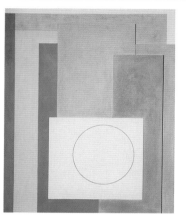

Nicholson, Ben 1894–1982
1944–1945 (painted relief - Arabian desert)
1944–1945
oil on board 92.8 x 78.2
1980P122

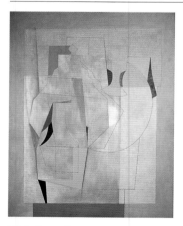

Nicholson, Ben 1894–1982
1950 (still life, Dolomites) 1950
oil on canvas 121.9 x 96.5
1951P125

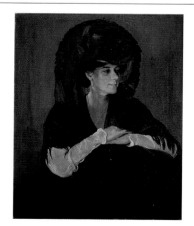

Nicholson, William 1872–1949
The Brown Veil (Mrs Harrington Mann) 1905
oil on canvas 76.2 x 63.2
1929P476

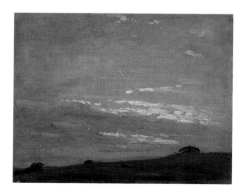

Nicholson, William 1872–1949
The Silver Sunset 1909–1910
oil on canvas laid on board 32.8 x 40.9
1954P16

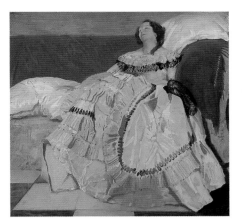

Nicholson, William 1872–1949
The Pink Dress 1934
oil on panel 53.4 x 59.1
1944P288

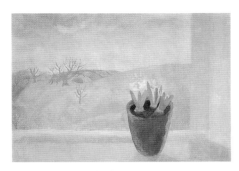

Nicholson, William 1872–1949
Pink Still Life with Jug 1935–1936
oil on panel 35.6 x 43.2
1943P2

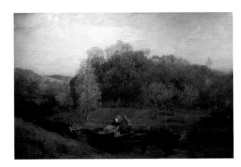

Nicholson, Winifred 1893–1981
Flowers at a Window 1939
oil on board 55.2 x 76.8
2001P6

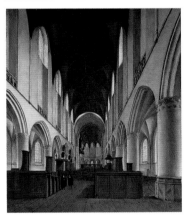

Nickele, Isaak van active 1660–1703
Interior of St Bavo, Haarlem c.1690
oil on canvas 47.5 x 39.7
1987P10

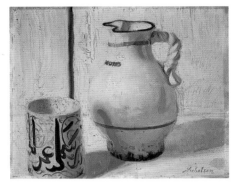

Nicklin, Gary
Vernon Burgess 2006
oil on canvas 61 x 46
2007.2336

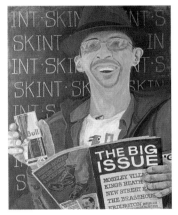

North, John William 1842–1924
Sweet Water Meadows of the West 1892–1893
oil on canvas 129.6 x 185.4
1894P2

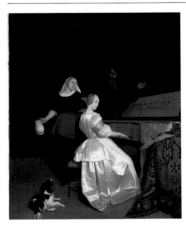

Ochtervelt, Jacob 1634–1682
The Music Lesson 1670
oil on canvas 97.1 x 78.1
1955P113

O'Donoghue, Hughie b.1953
Incident at Huppy 2000–2002
oil on canvas with photography 208 x 181
2003.0018

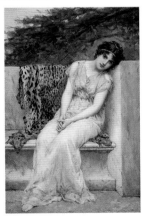

Oliver, William 1823–1901
Portrait of a Young Woman Sitting on a Marble Seat c.1867–1882
oil on canvas 76.2 x 50.7
1987P60

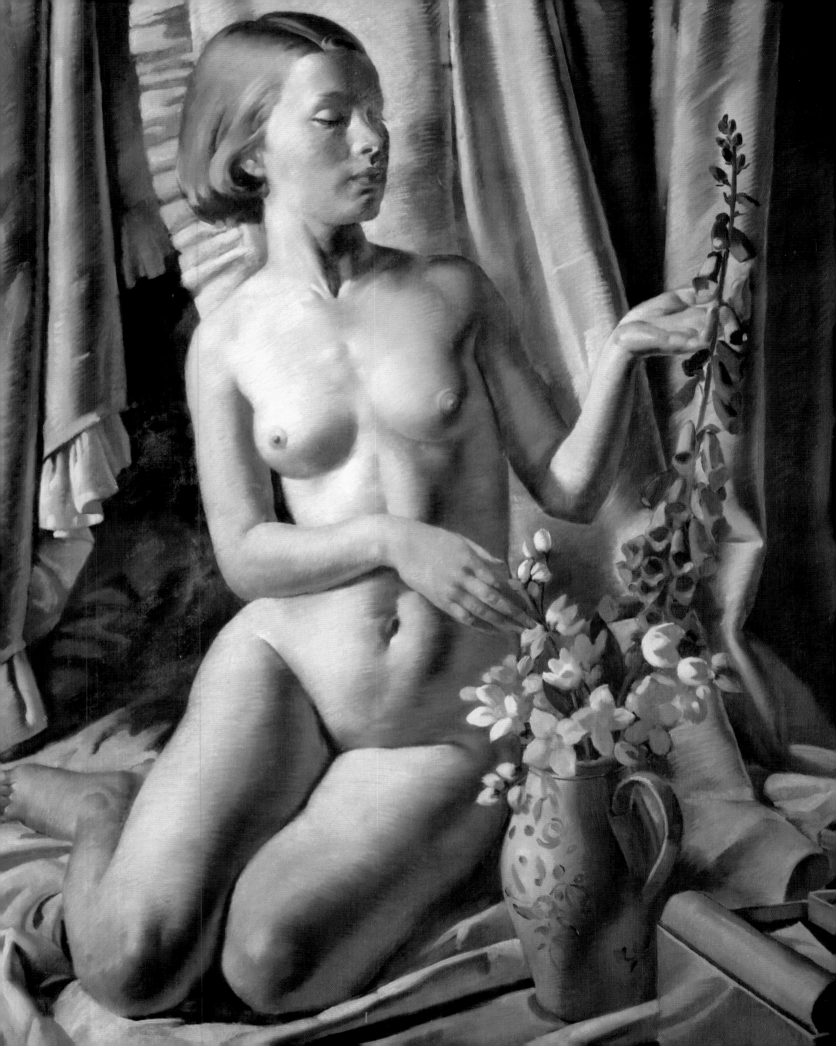

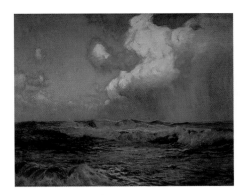

Olsson, Albert Julius 1864–1942
The White Squall 1902–1903
oil on canvas 69.8 x 90.2
1904P584

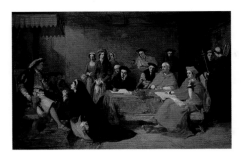

O'Neil, Henry Nelson 1817–1880
The Trial of Queen Catherine of Aragon
1846–1848
oil on canvas 43.4 x 65.2
1885P2540

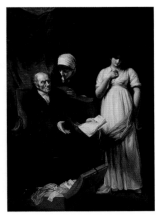

Opie, John 1761–1807
*The Angry Father (The Discovery…
Correspondence)* 1801–1802
oil on canvas 240.4 x 167.2
1885P2584

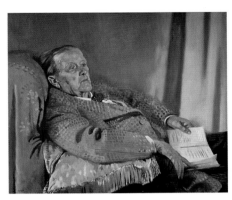

Orpen, William 1878–1931
Sir Edwin Ray Lankester (1847–1929) 1928
oil on canvas 86.2 x 101.7
1942P125

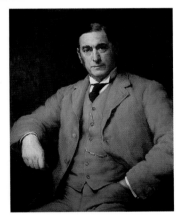

Ouless, Walter William 1848–1933
Alderman Charles Gabriel Beale 1901
oil on canvas 91.7 x 71.2
1901P39

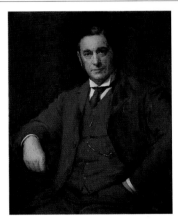

Ouless, Walter William 1848–1933
Alderman Charles Gabriel Beale 1901
oil on canvas 91.7 x 71.2
1901P39.1

Owen, George Elmslie 1899–1964
Abstract 1938
oil on canvas 34 x 44.5
1968P10

Owen, Mark b.1963
Untitled
acrylic & collage on wood 24.4 x 30.7
1992Q11

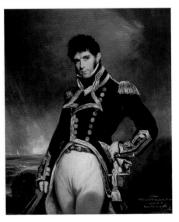

Owen, William 1769–1825
Captain Gilbert Heathcote (1779–1831), RN
1801–1805
oil on canvas 127 x 101.8
1938P680

Facing page: Fleetwood-Walker, Bernard, 1893–1963, *The Bane* (detail), 1931, Birmingham Museums and Art Gallery, (p. 95)

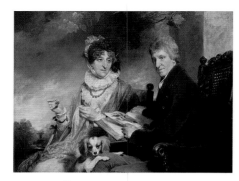

Owen, William 1769–1825
Portrait of a Man and a Woman 1818
oil on canvas 113.7 x 144.2
1956P21

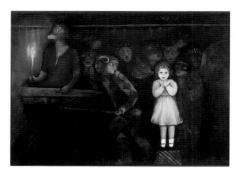

Pacheco, Ana Maria b.1943
In illo tempore I 1994
oil on gesso on board 183.4 x 260
1995P31

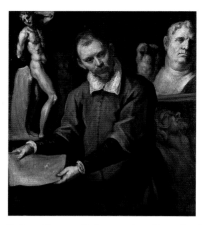

Palma, Jacopo il giovane (attributed to)
1544/1548–1628
Portrait of a Collector c.1600–1620
oil on canvas 111.8 x 103
1961P48

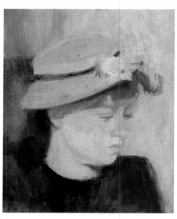

Pasmore, Victor 1908–1998
Girl in a Straw Hat 1939–1940
oil on hardboard 30.4 x 25.3
1957P8

Pasmore, Victor 1908–1998
Spiral Motif, Sea and Sky 1950
oil on hardboard 95.9 x 30.5
1963P8

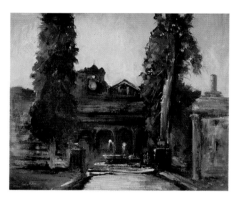

Paterson, Emily Murray 1855–1934
The Baths of Diocletian, Rome 1929–1930
oil on canvas 53.5 x 64.5
1935P134

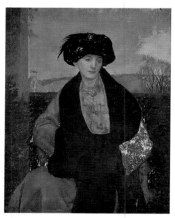

Payne, Henry Albert 1868–1940
Mrs Lester of Slad Valley, Stroud 1913
tempera over pencil on canvas 106.1 x 84.2
1983P81

Payne, Steve b.1949
Notes towards a Definition of Culture 1989
oil on canvas 215 x 155.5
1992Q1 (P)

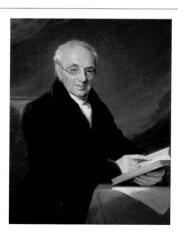

Pearson, Mary Martha 1799–1871
Thomas Wright Hill (1763–1851) 1831
oil on canvas 91.5 x 68.6
1897P1

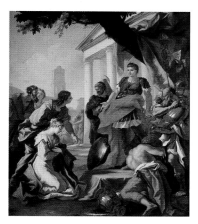

Pellegrini, Giovanni Antonio 1675–1741
The Continence of Scipio c.1708
oil on canvas 126 x 107
1965PL33 (P)

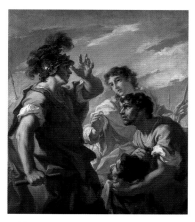

Pellegrini, Giovanni Antonio 1675–1741
Caesar before Alexandria c.1720–1730
oil on canvas 129.5 x 112
1965P20

Penny, Edward 1714–1791
Jane Shore Led in Penance to Saint Paul's 1775–1776
oil on canvas 162.6 x 122
1960P32

Peploe, Samuel John 1871–1935
Still Life with Bowl of Fruit, Bottle, Cup and Glass 1927–1929
oil on canvas 48.9 x 54.6
1978L10 (P)

Peploe, Samuel John 1871–1935
Still Life with Bowl of Fruit, Jug, Cup and Saucer 1927–1929
oil on panel 40.7 x 45.7
1948P34

Perry, Robert b.1944
Blockhouse near Jenlain, France 2002
oil on board 121.9 x 243.8
2006.1409

Perry, Robert b.1944
Black Country Night, 10.45pm, 4 October 2005 2005
oil on board 88.5 x 180
2006.0428 (P)

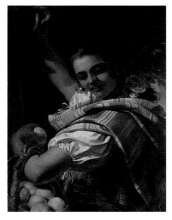

Phillip, John 1817–1867
The Orange Girl 1854
oil on canvas 41.9 x 31.8
1939P801

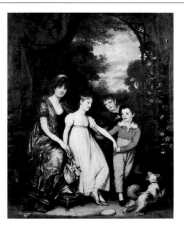

Phillips, Thomas 1770–1845
The Scott Family 1804
oil on canvas 200.5 x 158
1994P23

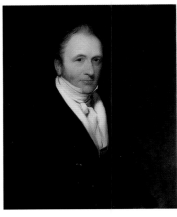

Phillips, Thomas 1770–1845
Joseph Jennens (1769–1848) c.1810–1820
oil on canvas 75 x 62.3
1923P9

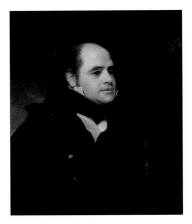

Phillips, Thomas 1770–1845
Sir John Franklin (1770–1847), RN 1825
oil on canvas 76.3 x 62.3
1885P2527

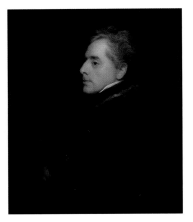

Phillips, Thomas 1770–1845
William Phipson (1770–1845) 1831
oil on canvas 76.7 x 64
1941P5

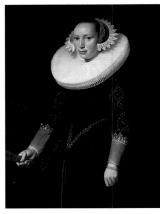

Pickenoy, Nicolaes Eliasz. c.1588–c.1655
Portrait of a Woman
oil on canvas 103.7 x 76.7
1973P8

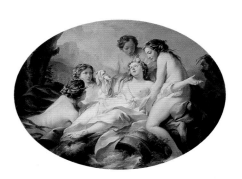

Pierre, Jean Baptiste Marie 1713–1789
Psyche Rescued by Naiads 1750
oil on canvas 83.8 x 115.5
1906P30

Piper, John 1903–1992
Ruined Cottage, Llanthony, Wales 1939–1940
oil on canvas 39.4 x 49.7
1946P39

Pissarro, Camille 1831–1903
Le pont Boieldieu à Rouen, soleil couchant
1896
oil on canvas 74.2 x 92.5
1950P23

Pissarro, Lucien 1863–1944
Mimosa, Lavandou 1923
oil on canvas 53.3 x 63.5
1982P46

Pissarro, Lucien 1863–1944
Notre Dame de Constance, Bormes 1923
oil on canvas 58.5 x 72.4
1929P33

Pitati, Bonifazio de' 1487–1553
The Adoration of the Shepherds c.1520–1540
oil on panel 118.1 x 152.4
1955P101

Platzer, Johann Georg 1704–1761
An Allegory of Misrule
oil on copper 56.4 x 75.7
1971P4

Poole, Paul Falconer 1807–1879
Portrait of a Man c.1850–1879
oil on millboard 19.4 x 15.7
1941P454

Poole, William 1764–1837
Self Portrait
oil on canvas 40.2 x 27
2003.057

Pope, Henry Martin 1843–1908
The Old Bridge, Yardley Wood c.1890
oil on canvas 92 x 71
PCF 23

Pountney, H. E. active 1890–1895
Gateway, Aston Hall 1895
oil on board 56.7 x 41.5
1972V89

Poussin, Nicolas (copy after) 1594–1665
The Blind Men of Jericho
oil on canvas 119.4 x 170.2
1933P77

Poynter, Edward John 1836–1919
The Bells of Saint Mark's, Venice 1903
oil on canvas 92.7 x 66
1916P30

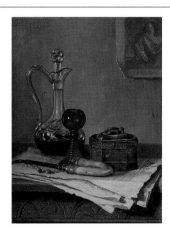

Pratt, Claude 1860–1935
Still Life of Newspaper, Pipe, Decanter and Jar
1887
oil on paper 17.7 x 12.7
1901P31.19

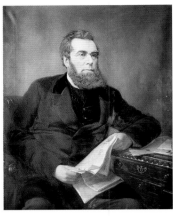

Pratt, Jonathan 1835–1911
John Skirrow Wright (1823–1880) 1880
oil on canvas 125.8 x 99.1
1885P2553

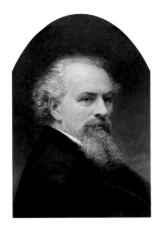

Pratt, Jonathan 1835–1911
Allen E. Everitt (panel in the Everitt Cabinet)
1881
oil on panel 25.5 x 17.2
1892P41.2

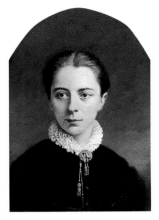

Pratt, Jonathan 1835–1911
Mrs Allen E. Everitt (panel in the Everitt Cabinet) 1881
oil on panel 25.5 x 17.2
1892P41.5

Pratt, Jonathan 1835–1911
The Right Honourable Jesse Collings (1831–1920) 1881
oil on canvas 127.5 x 101.3
1885P2551

Pratt, Jonathan 1835–1911
Lady Mason, Wife of Sir Josiah Mason 1883
oil on canvas 76.2 x 63.5
1900P172

Pratt, Jonathan 1835–1911
Reverend Arthur G. O'Neill (1819–1896) 1885
oil on canvas 125.8 x 99.1
1887P938

Pratt, Jonathan 1835–1911
A Breton Cottage Interior 1886–1887
oil on paper 13.1 x 19
1901P31.7

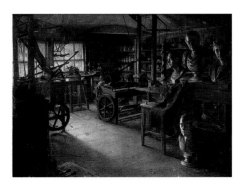

Pratt, Jonathan 1835–1911
James Watt's Work Room, Heathfield Hall 1889
oil on canvas 33.8 x 44.9 (E)
1979V564

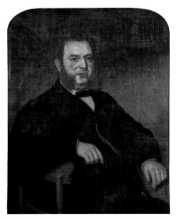

Pratt, Jonathan 1835–1911
George Haynes
oil on canvas 94.4 x 71
1978V792

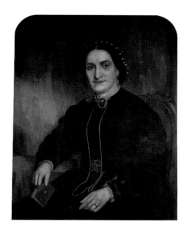

Pratt, Jonathan 1835–1911
Mrs George Haynes
oil on canvas 98 x 71
1978V793

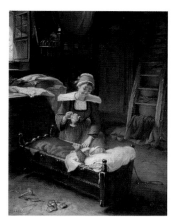

Pratt, Jonathan 1835–1911
Interior with Mother and Child
oil on canvas 46 x 35.5
1972P25

Preece, Lawrence b.1942
Cloche 1978
acrylic on cotton duck 101.5 x 218.4
1983P2

Prentice, David b.1936
Field Grid-Tycho B 1967
oil on canvas 175.6 x 175.6
1968P33

Priest, Alfred 1874–1929
Alderman John Townsend 1902
oil on canvas 192 x 107
1978P3

Priestman, Bertram 1868–1951
Suffolk Water Meadows 1906
oil on canvas 106.8 x 142.2
1906P33

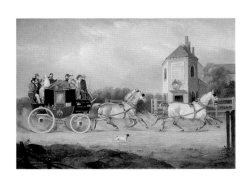

Pringle, William J. active c.1805–1860
Stourbridge to Birmingham Royal Mail Coach
1842
oil on canvas 69 x 100
1934P685

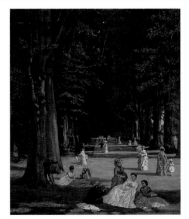

Prinsep, Valentine Cameron 1838–1904
The Avenue, Wildernesse, Kent
oil on canvas 94.6 x 76.5
1948P12

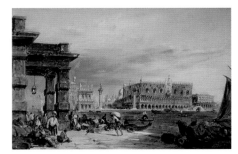

Pritchett, Edward active c.1828–1879
The Dogana, Venice
oil on canvas 20.2 x 30.4
1984P3

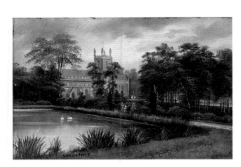

Pryce, George Willis 1866–1949
Handsworth Church, Birmingham c.1900–1925
oil on canvas 20.7 x 30.8
1998V63.1

Pryce, George Willis 1866–1949
View of Handsworth, Birmingham c.1900–1925
oil on canvas 20.7 x 30.8
1998V63.2

Pryce, George Willis 1866–1949
Sarehole Mill, Birmingham
oil on board 28 x 38
1977V312

Pryce, N. W. active 19th C
The Dingles, Hall Green, Yardley
oil on card 25.7 x 38
1964P3

Pryce, N. W. active 19th C
The Dingles, Hall Green, Yardley
oil on card 26.5 x 37.8
1964P4

Pryde, James 1869–1941
An Old Beggar
oil on canvas 91.4 x 69.8
1946P42

Pyne, James Baker 1800–1870
The Island of Burano, Venetian Lagoon 1854
oil on canvas 67 x 92.5
1919P19

Quellinus, Erasmus II 1607–1678 &
Seghers, Daniel 1590–1661
The Miracle of St Bernard in a Garland of Flowers c.1645–1655
oil on canvas 105.5 x 73
1981P81

Quinquela Martín, Benito 1890–1977
Ship under Repair 1925–1930
oil on canvas 140.5 x 130.7
1930P329

Facing page: Veronese, Paolo, 1528–1588, *The Visitation* (detail), The Barber Institute of Fine Arts, (p. 241)

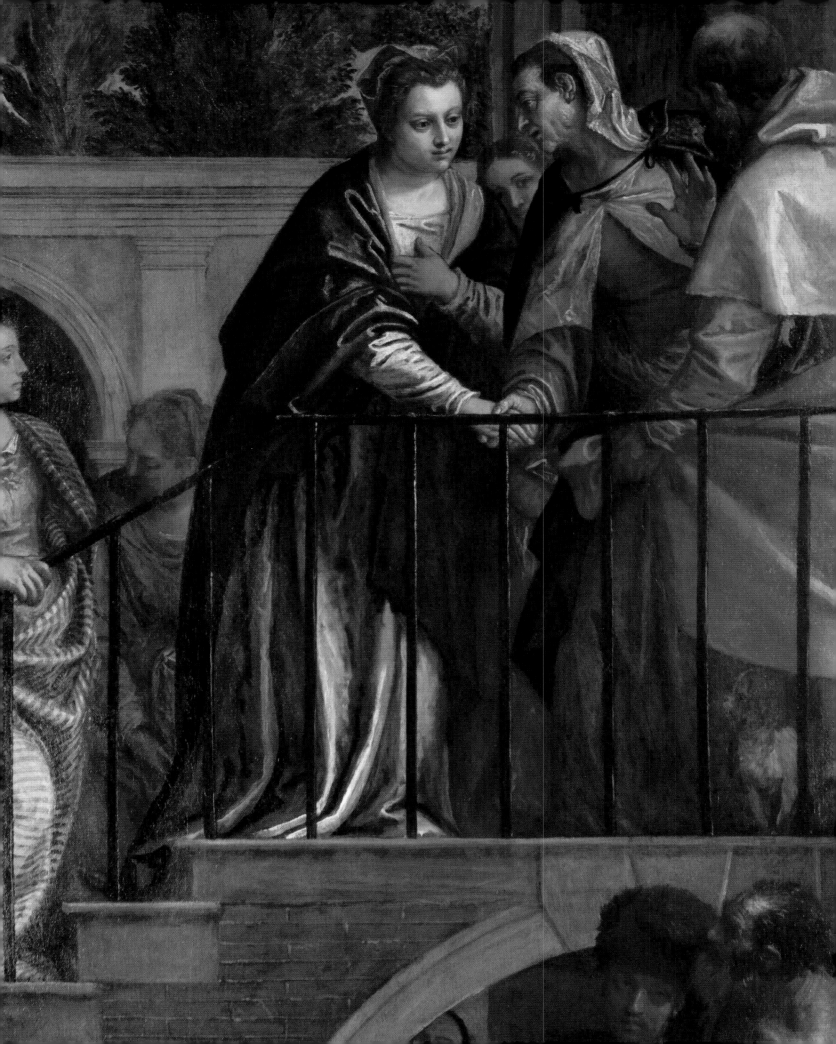

Radclyffe, Charles Walter 1817–1903
River Scene (panel in the Everitt Cabinet)
1879–1880
oil on mahogany panel 20.6 x 28
1892P41.11

Rae, Fiona b.1963
Dark Star 2001
oil, acrylic & coloured glitter on canvas
24.7 x 20.4
2001Q3

Raeburn, Henry 1756–1823
Mrs Farquarson of Finzean c.1800–1823
oil on canvas 76.3 x 63.5
1995P32

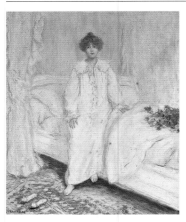

Raffaelli, Jean-François 1850–1924
Le reveil c.1885–1895
oil on canvas 78.7 x 67.3
1953P449

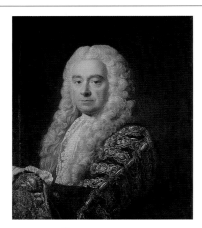

Ramsay, Allan 1713–1784
*Philip Yorke (1690–1764), 1st Earl of
Hardwicke* c.1750–1764
oil on canvas 75 x 64.3
1987P72

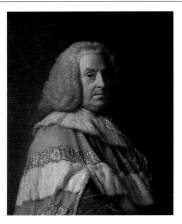

Ramsay, Allan 1713–1784
*Sir William Pulteney (1684–1764), Earl of
Bath* c.1750–1764
oil on canvas 73.6 x 61.5
1987P69

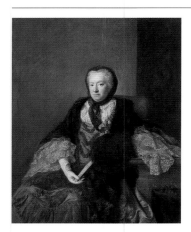

Ramsay, Allan 1713–1784
Mrs Mary Martyn 1761
oil on canvas 127 x 101.8
1957P27

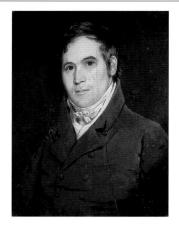

Raven, Samuel 1775–1847
Self Portrait 1816
oil on board 18.5 x 14.8
1935V73

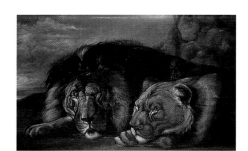

Raven, Samuel 1775–1847
Sleeping Lion and Lioness 1823–1830
oil on mahogany panel 21.9 x 29.2
1935P72

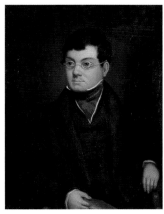

Raven, Samuel 1775–1847
William Scholefield (1809–1867)
oil on panel 24 x 19.2
1944V83

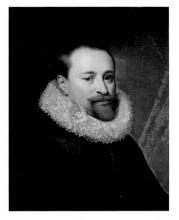

Ravesteyn, Hubert van 1638–before 1691
Portrait of a Man
oil on panel 63.5 x 50.8
1960P22

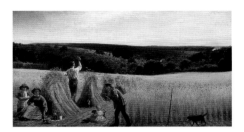

Redgrave, Richard 1804–1888
The Valleys Stand Thick with Corn 1865
oil on canvas 71.1 x 96.5
1890P83

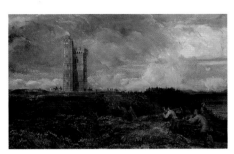

Redgrave, Richard 1804–1888
The Firing of the Beacon 1868–1870
oil on canvas 30.2 x 45.8
1963P22

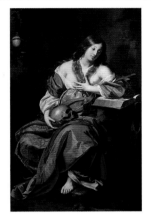

Régnier, Nicolas c.1590–1667
The Penitent Magdalen c.1650–1660
oil on canvas 186 x 120
1958P4

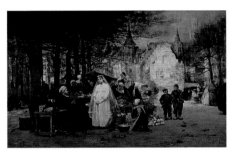

Reid, Flora 1860–c.1940
The First Communion 1894
oil on canvas 122 x 181.6
1896P78

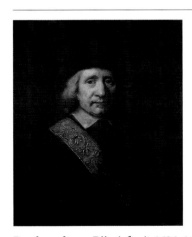

Rembrandt van Rijn (after) 1606–1669
Portrait of a Man
oil on canvas 74 x 62
1970P265

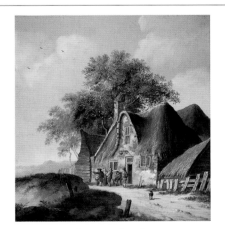

Renard, Fredericus Theodorus 1778–c.1820
Landscape c.1800–1820
oil on canvas 40.3 x 38.2
1946P8

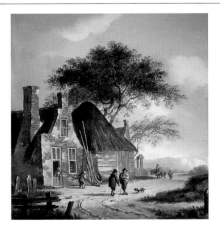

Renard, Fredericus Theodorus 1778–c.1820
Landscape with Buildings and Figures
c.1800–1820
oil on canvas 40 x 38.4
1946P9

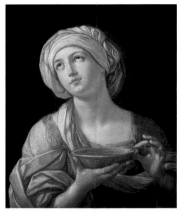

Reni, Guido 1575–1642
Portrait of a Woman (possibly Artemisia),
(Lady with a Lapis Lazuli Bowl) 1638–1639
oil on canvas 73.4 x 60.8
1961P30

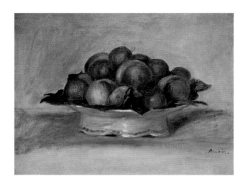

Renoir, Pierre-Auguste 1841–1919
Still Life c.1880
oil on canvas 33 x 41
1978L11 (P)

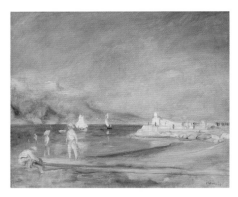

Renoir, Pierre-Auguste 1841–1919
St Tropez, France 1898–1900
oil on canvas 54.5 x 65.4
1980P121

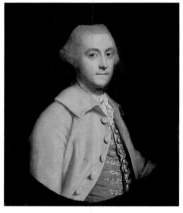

Reynolds, Joshua 1723–1792
William, Lord Bagot (1728–1798) 1762–1764
oil on canvas 70 x 50
1989PL14 (P)

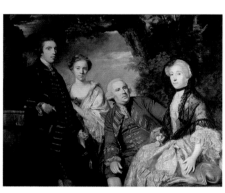

Reynolds, Joshua 1723–1792
The Roffey Family 1765
oil on canvas 208.5 x 246.5
1954P10

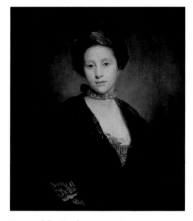

Reynolds, Joshua 1723–1792
Louisa, Lady Bagot (c.1744–1820) 1770
oil on canvas 70 x 50
1989PL19 (P)

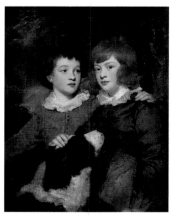

Reynolds, Joshua 1723–1792
The Masters Gawler 1777–1778
oil on canvas 99.9 x 71.4
1983P52

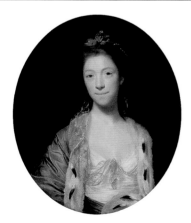

Reynolds, Joshua (studio of) 1723–1792
Mrs Luther 1766
oil on canvas 76.5 x 63.5
1939P952

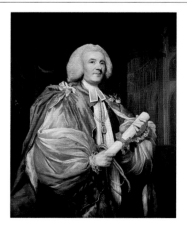

Reynolds, Joshua (studio of) 1723–1792
*Dr John Thomas (1712–1793), Bishop of
Rochester* 1781
oil on canvas 125.1 x 99
1898P4

Rhys-James, Shani b.1953
Caught in the Mirror 1997
oil on canvas 182.5 x 213.5
1999P39

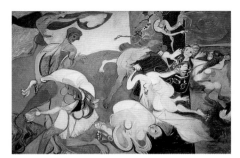

Richards, Ceri Geraldus 1903–1971
The Rape of the Sabines 1948
oil on canvas 124.8 x 185.7
1976P99

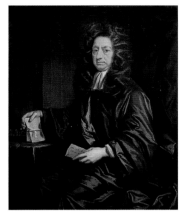

Richardson, Jonathan the elder 1665–1745
Josiah Bateman c.1700–1718
oil on canvas 127 x 102.2
1933P345

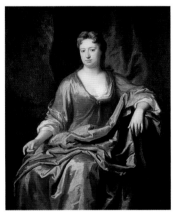

Richardson, Jonathan the elder 1665–1745
*Elizabeth, 1st Countess of Aylesford
(d.1743)* c.1700–1720
oil on canvas 128.2 x 104
1964P15

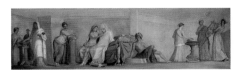

Richmond, George 1809–1896
A Copy of the Aldobrandini Marriage 1838
oil on canvas 81.4 x 242
1955P108

Richmond, George 1809–1896
Self Portrait 1853–1855
oil on canvas 50.9 x 35.6
1941P459

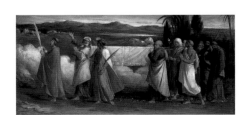

Richmond, George 1809–1896
The Burial of the Virgin
oil on panel 47 x 88.9
1941P460

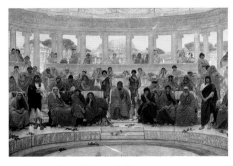

Richmond, William Blake 1842–1921
*An Audience in Athens during 'Agamemnon' by
Aeschylus* 1884
oil on canvas 215 x 307
1887P943

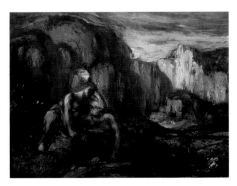

Ricketts, Charles S. 1866–1931
Tobias and the Angel 1902–1905
oil on canvas 47.7 x 58.5
1914P245

Riley, Bridget b.1931
Cherry Autumn 1983
oil on linen 218.4 x 182.2
1998P8

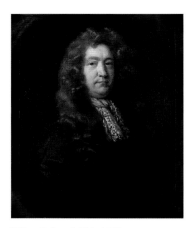

Riley, John 1646–1691
Sir Edward Waldo (1632–1716) 1670–1680
oil on canvas 76.2 x 63.5
1958P14

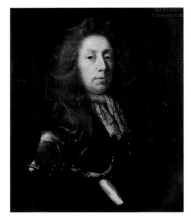

Riley, John 1646–1691
Sir Christopher Musgrave c.1670–1691
oil on canvas 76.2 x 63.5
1964P14

Riopelle, Jean-Paul 1923–2002
Le temoin 1958
oil on canvas 72.4 x 92
1968P26

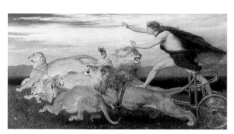

Riviere, Briton 1840–1920
Phoebus Apollo 1895
oil on canvas 135.2 x 243.9
1898P62

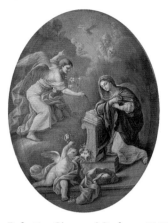

Robatto, Giovanni Stefano 1649–1733
The Annunciation
oil on canvas 101.6 x 76.2 (E)
1972P48

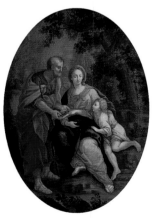

Robatto, Giovanni Stefano 1649–1733
The Holy Family
oil on canvas 101.6 x 76.2 (E)
1972P49

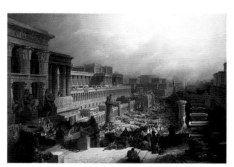

Roberts, David 1796–1864
The Departure of the Israelites 1829
oil on canvas 130 x 183.3
1986P109

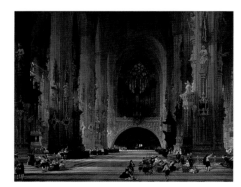

Roberts, David 1796–1864
Interior of the Cathedral of St Stephen, Vienna
1853
oil on canvas 111.7 x 142.3
1937P742

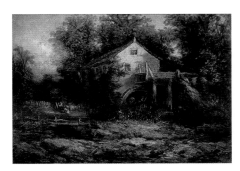

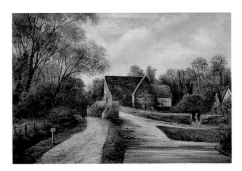

Roberts, William 1788–1867
Old Watermill, North Wales
oil on canvas 36.9 x 51.5
1915P32

Robinson, W. H.
The Dingles Sarehole, near Moseley 1906
oil on canvas 30.7 x 40.5
1970V249

Roden, William Thomas 1817–1892
Joseph Chamberlain (1836–1914), as a Young Man c.1850–1860
oil on canvas 76.1 x 63.3
1978P5

Roden, William Thomas 1817–1892
Joseph Moore (1817–1892) c.1860–1870
oil on canvas 65.2 x 55
1893P82

Roden, William Thomas 1817–1892
Samuel Lines (1778–1863) 1863
oil on canvas 124.5 x 100.3
1978P184

Roden, William Thomas 1817–1892
John Henry Chamberlain (1831–1883) 1864
oil on canvas 73.7 x 62.2
1885P2472

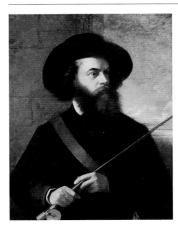

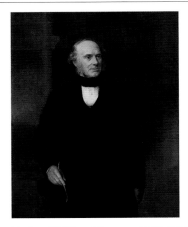

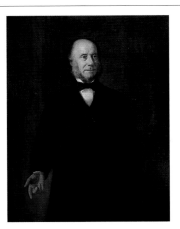

Roden, William Thomas 1817–1892
Oliver Pemberton (1825–1897) 1867
oil on canvas 91.5 x 76.2
1936P315

Roden, William Thomas 1817–1892
Peter Hollins (1800–1886) 1868
oil on canvas 125.7 x 99.4
1885P2554

Roden, William Thomas 1817–1892
Alderman Edward Corn Osborne (1809–1886) 1873
oil on canvas 128.1 x 102.7
1885P2552

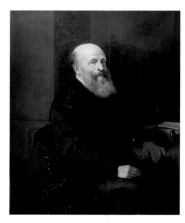

Roden, William Thomas 1817–1892
John Birt Davies 1873
oil on canvas 127.3 x 101.5
1885P2550

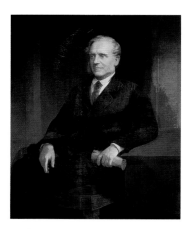

Roden, William Thomas 1817–1892
Alderman Henry Hawkes 1875–1876
oil on canvas 127.2 x 101.7
1887P955

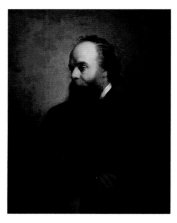

Roden, William Thomas 1817–1892
Samuel Timmins (1826–1902) c.1875–1880
oil on canvas 91.7 x 76.2
1974P18

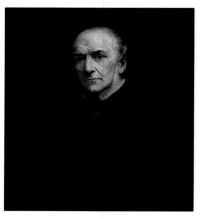

Roden, William Thomas 1817–1892
William Ewart Gladstone (1809–1898) 1877
oil on canvas 75 x 62.3
1885P2599

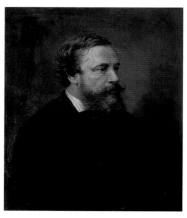

Roden, William Thomas 1817–1892
John Thackray Bunce (1828–1899) 1878–1879
oil on canvas 66.5 x 56.4
1928P201

Roden, William Thomas 1817–1892
Cardinal Newman (1801–1890) 1879
oil on canvas 125.7 x 100.4
1885P2549

Roden, William Thomas 1817–1892
Edwin Yates
oil on canvas 124.7 x 99.3
1978V816

Roden, William Thomas 1817–1892
George Edmonds
oil on canvas 96.5 x 78.8
1973P64

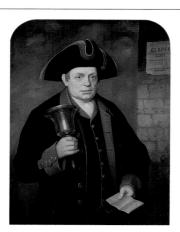

Roden, William Thomas 1817–1892
Jacob Wilson (1799–1892)
oil on canvas 89 x 68.5
1935P136

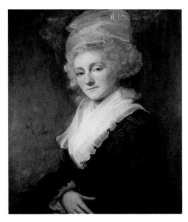

Romney, George 1734–1802
Anne, Lady Holte (1734–1799) 1781–1783
oil on canvas 76.2 x 63.5
1885P3182

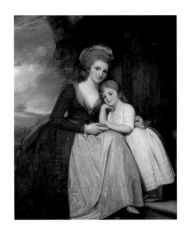

Romney, George 1734–1802
Mrs Bracebridge and Her Daughter Mary
1781–1784
oil on canvas 160 x 123.2
1985P89

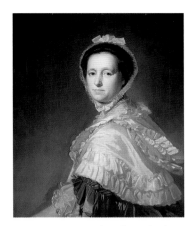

Romney, George (attributed to) 1734–1802
Portrait of a Lady
oil on canvas 76 x 62
1999P11

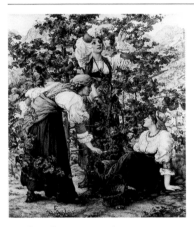

Rooke, Thomas Matthews 1842–1942
Labourers in the Vineyard 1889
oil on canvas 42 x 34.1
1925P141

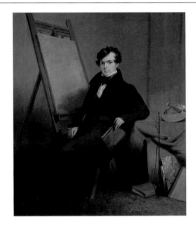

Room, Henry 1803–1850
Self Portrait 1826–1828
oil on canvas 76 x 63
1937P368

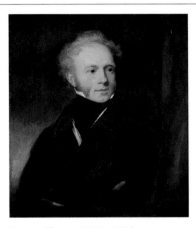

Room, Henry 1803–1850
Joseph Goodyear (1797–1839) c.1830–1849
oil on canvas 76.2 x 63.6
1885P2580

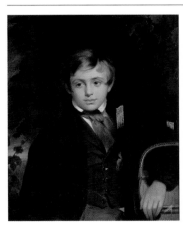

Room, Henry 1803–1850
The Messenger Boy 1837–1839
oil on canvas 73.5 x 61
1900P171

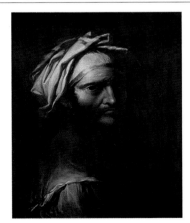

Rosa, Salvator 1615–1673
Head of a Man with a Turban 1650s
oil on canvas 57.2 x 46.3
1999PL18 (P)

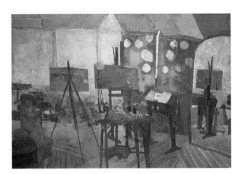

Rosoman, Leonard Henry b.1913
The Studio 1950–1953
oil on canvas 75.6 x 101.6
1972P27

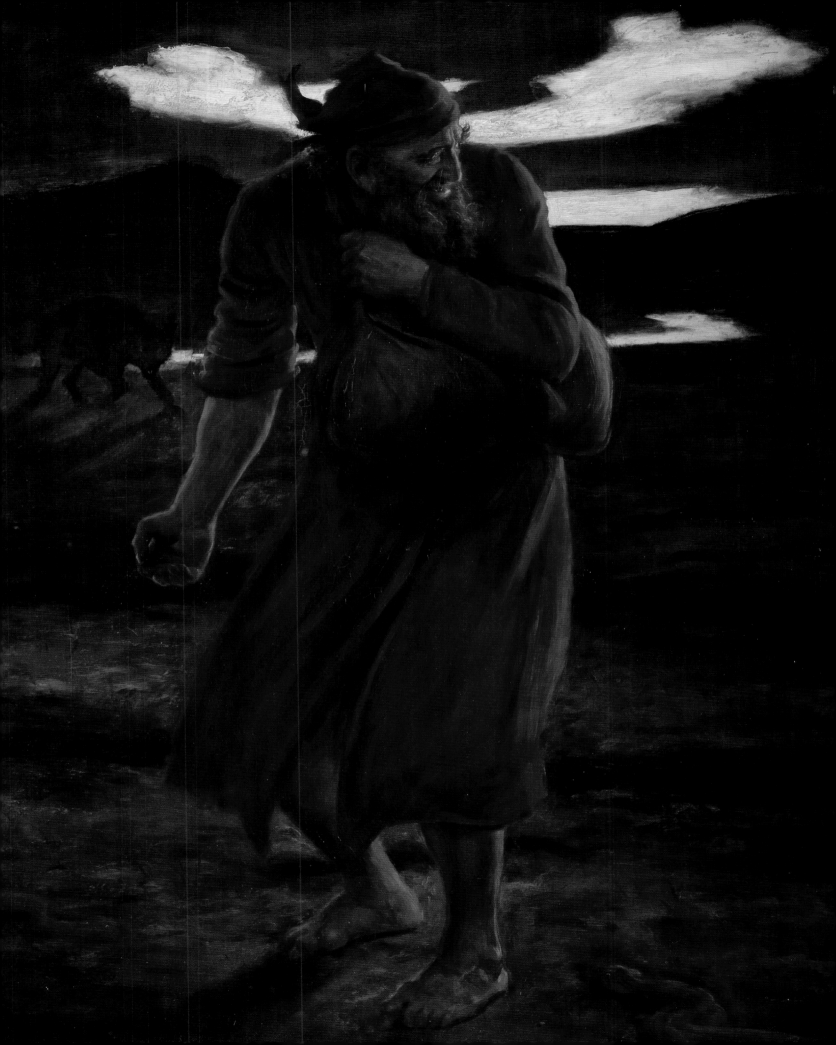

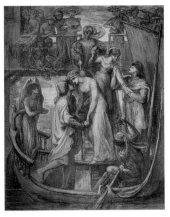

Rossetti, Dante Gabriel 1828–1882
The Boat of Love (unfinished) 1874–1881
oil on canvas 124.5 x 94
1885P2476

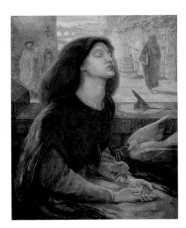

Rossetti, Dante Gabriel 1828–1882
Beata Beatrix 1877
oil on canvas 86.4 x 68.2
1891P25

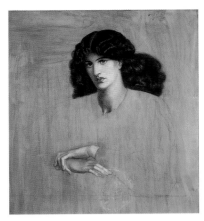

Rossetti, Dante Gabriel 1828–1882
La donna della finestra (unfinished) 1881
oil on canvas over pencil 97 x 87
1885P2465

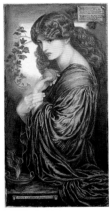

Rossetti, Dante Gabriel 1828–1882
Proserpine 1881–1882
oil on canvas 77.2 x 37.5
1927P7

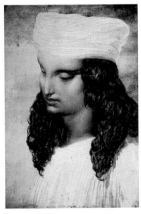

Rossetti, Dante Gabriel (after) 1828–1882
A Persian Youth mid-19th C
oil on canvas 46.7 x 31
1930P379

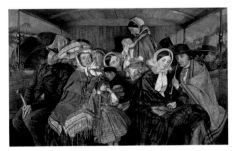

Rossiter, Charles 1827–1897
To Brighton and Back for Three and Sixpence
1859
oil on canvas 61 x 91.5
1930P455

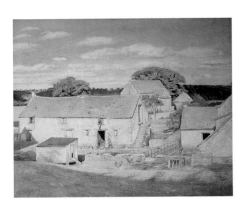

Rothenstein, William 1872–1945
Oakridge Farm, Late Summer 1933
oil on canvas 63.4 x 76.2
1935P195

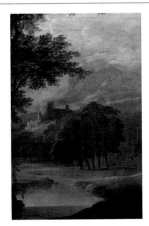

Rousseau, Jacques (school of) 1630–1693
Landscape with Castle in Distance (detail)
early 18th C
oil on canvas 259.1 x 168.9
1976P10

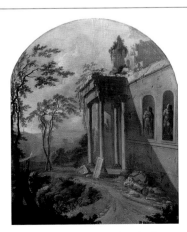

Rousseau, Jacques (school of) 1630–1693
Landscape with Ruin early 18th C
oil on canvas 259.1 x 168.9
1976P9

Facing page: Millais, John Everett, 1829–1896, *The Enemy Sowing Tares* (St Matthew XIII, 24–25) (detail), 1865,
Birmingham Museums and Art Gallery, (p. 144)

Rowe, Elsie Hugo
Three Blouses 1935
oil on panel 25.5 x 20
1936P27

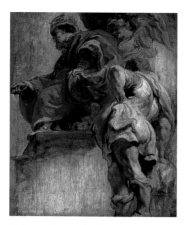

Rubens, Peter Paul 1577–1640
*King James I (1566–1625) Uniting England
and Scotland* 1632–1633
oil on panel 63.5 x 48.3
1984P2

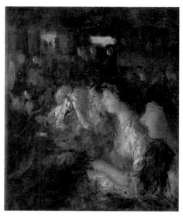

Russell, Walter Westley 1867–1949
Scene in a Theatre 1912
oil on canvas 61 x 51
1950P8

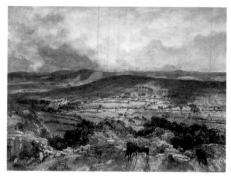

Russell, Walter Westley 1867–1949
Widecombe-in-the-Moor, Devon 1921–1922
oil on canvas 112.5 x 142.8
1971P5

Russell, Walter Westley 1867–1949
River Scene c.1935–1949
oil on canvas 61 x 91.7
1950P7

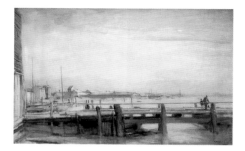

Russell, Walter Westley 1867–1949
The Little Quay, Shoreham 1945
oil on canvas 49.6 x 75
1950P6

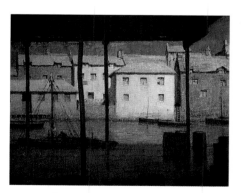

Rutter, Thomas William b.1874
Polperro by Moonlight
oil on canvas 41 x 51
1928P202

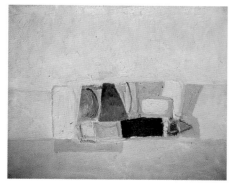

Sadun, Piero 1919–1974
Abstract 1959
oil on canvas 71.1 x 82.5
1962P11

Salt, John b.1937
White Chevy, Red Trailer 1975
airbrushed acrylic on canvas 115 x 170.9
1975P404

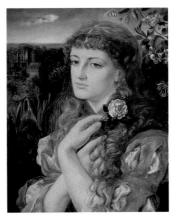

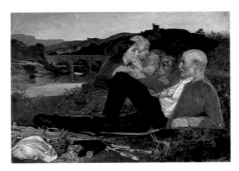

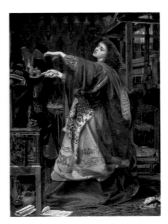

Sandys, Emma 1843–1877
A Lady Holding a Rose c.1870–1873
oil on canvas 48 x 38
1997Q8 (P)

Sandys, Frederick 1829–1904
Autumn 1860–1862
oil on wood panel 25.5 x 35.5
1906P34

Sandys, Frederick 1829–1904
Morgan-le-Fay 1864
oil on panel 61.8 x 43.7
1925P104

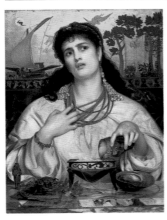

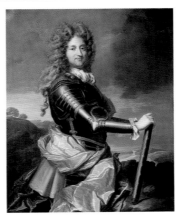

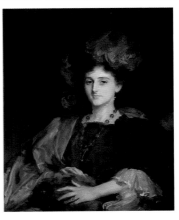

Sandys, Frederick 1829–1904
Medea 1868
oil on panel 61.2 x 45.6
1925P105

Santerre, Jean-Baptiste 1651–1717
Philippe, Duc d'Orleans (1674–1723)
1710–1717
oil on canvas 126.4 x 101
1967P52

Sargent, John Singer 1856–1925
Miss Katherine Elizabeth Lewis (d.1961) 1906
oil on canvas 88.2 x 72.4
1961P49

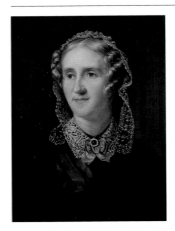

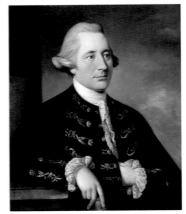

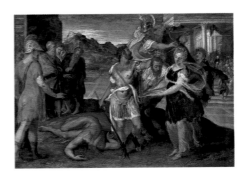

Sayers, Reuben T. W. 1815–1888
Elizabeth Stockdale Wilkinson (1799–1871)
1853
oil on canvas 61.2 x 46.3
1987P12

Schaak, J. S. C. active 1759–1780
Matthew Boulton (1728–1809) c.1770
oil on canvas 100 x 80
1987V330

Schiavone, Andrea c.1500–1563
The Execution of St John the Baptist
c.1540–1563
oil on canvas 116.9 x 161.2
1963P9

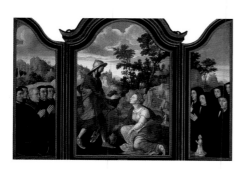

Scorel, Jan van 1495–1562
Noli me tangere 1548–1554
oil on panel 177 x 52; 177 x 117; 177 x 52
1952P9

Scott, John 1850–1919
Laundress Startled by a Blackbird 1891
oil on canvas 98.2 x 56.2
1987P61

Scott, William George 1913–1989
Flowers and a Jug 1946
oil on canvas 49.5 x 59.7
1950P3

Scott, William George 1913–1989
Brown and Black 1960
oil on canvas 101.6 x 127
1977P135

Scully, Sean b.1945
Wall of Light Blue 1999
oil on linen canvas 274.3 x 335.2
2002P15

Seabrooke, Elliott 1886–1950
Surrey Garden 1924
oil on panel 64 x 80
1938P289

Sedgley, Peter b.1930
Cycle 1965
acrylic on board 160 x 160
1974P6

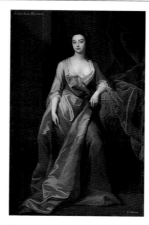

Seemann, Enoch the younger 1694–1744
Lady Maynard
oil on canvas 210.8 x 136
1964P17

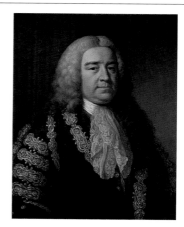

Shackleton, John d.1767
*The Right Honourable Henry Pelham
(c.1695–1754)* c.1740–1750
oil on canvas 75 x 61.5
1987P73

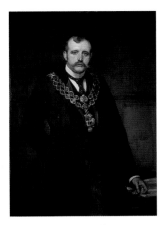

Shannon, James Jebusa 1862–1923
Sir James Smith 1897
oil on canvas 141 x 97.8
1897P10

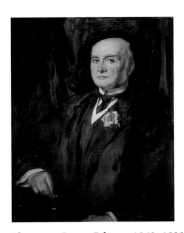

Shannon, James Jebusa 1862–1923
Alderman Edward Lawley Parker 1901–1905
oil on canvas 91.4 x 71
1905P278

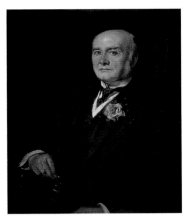

Shannon, James Jebusa 1862–1923
Alderman Edward Lawley Parker 1904
oil on canvas 91.4 x 71
1956P14

Shave, Terry b.1952
Pandemonium 1989
oil on canvas 150 x 120
1990PL17 (P)

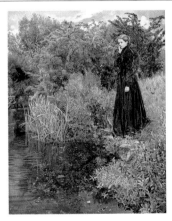

Shaw, Byam 1872–1919
*Boer War (1900–1901), Last Summer Things
Were Greener* 1901
oil on canvas 101.8 x 76
1928P204

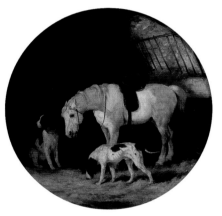

Shayer, William 1788–1879
Pony and Dogs c.1860
oil on canvas 36
1988PL16 (P)

Shayer, William 1788–1879
Pony and Hounds c.1860
oil on canvas 35.5
1988PL17

Shayer, William 1788–1879
Travelling Tinkers
oil on canvas 83.9 x 101.6
1950P15

Shayer, William 1788–1879
Two Young Women and Goats in a Landscape
oil on canvas 76.4 x 63.8
1940P902

Shemza, Anwar Jalal 1928–1985
The Wall c.1958–1985
oil on board 60 x 44.5
1998P81

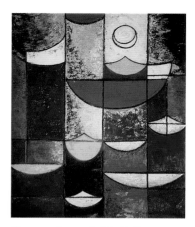

Shemza, Anwar Jalal 1928–1985
Sea, Moon and Boat c.1965
oil on hardboard 71.5 x 60.5
2002P13

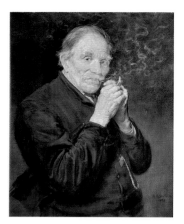

Shorthouse, Arthur Charles 1870–1953
The Old Guard 1926
oil on canvas 60.9 x 50.8
1929P2

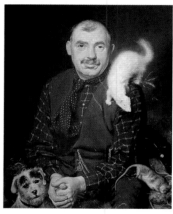

Shorthouse, Arthur Charles 1870–1953
Official Rat Catcher to the City of Birmingham
1927
oil on canvas 68.6 x 56
1934P678

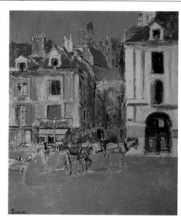

Sickert, Walter Richard 1860–1942
*La Rue Notre Dame and the Quai
Duquesne* 1899–1902
oil on canvas 61 x 49.6
1953P6

Sickert, Walter Richard 1860–1942
La rue Pecquet, Dieppe, France 1900
oil on canvas 55 x 45.7
1948P9

Sickert, Walter Richard 1860–1942
The Horses of St Mark's, Venice 1905–1906
oil on canvas 50.2 x 42.2
1945P1

Sickert, Walter Richard 1860–1942
Noctes Ambrosianae, Gallery of the Old Mogul
1906–1907
oil on canvas 63.7 x 76.6
1949P34

Sickert, Walter Richard 1860–1942
Dieppe Races 1920–1926
oil on canvas 50.6 x 61.1
1945P51

Sickert, Walter Richard 1860–1942
The Miner 1935–1936
oil on canvas 127.6 x 76.8
1944P201

Sisley, Alfred 1839–1899
The Church at Moret in the Rain 1894
oil on canvas 73 x 60
1948P26

Skelton, Pam b.1949
Displacement Ahwaz, 1978 1989
acrylic on canvas 92 x 91.8
1990Q5 (P)

Sleigh, Bernard 1872–1954
Ivy A. Ellis c.1895–1910
oil on imitation canvas board 37.5 x 26.7
1968P39

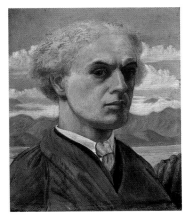

Sleigh, Bernard 1872–1954
Self Portrait 1900
oil on panel 31.8 x 26.7
1968P38

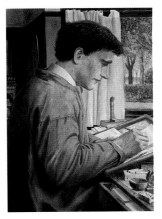

Sleigh, Bernard 1872–1954
William Downing 1913
tempera on board 53.2 x 38
1982P1

Smetham, James 1821–1889
Imogen and the Shepherds c.1860–1870
oil on canvas 25.3 x 61.2
1947P4

Smetham, James 1821–1889
Jacob at Bethel
oil on panel 11.3 x 30.1
1943P280

Smetham, James 1821–1889
The Many-Wintered Crow
oil on panel 14 x 19.4
1943P281

Smith, A. Freeman active 1880–1924
Worcester Street, Birmingham 1883
oil on canvas
2001V42

Smith, Jack b.1928
Child Walking with Wicker Stool 1954
oil on board 152.3 x 121.9
1996P9

Smith, Matthew Arnold Bracy 1879–1959
Sunflowers 1912
oil on canvas 55.9 x 45.7
1952P27

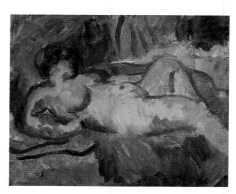

Smith, Matthew Arnold Bracy 1879–1959
Reclining Nude c.1930
oil on canvas 54 x 65
PCF14 (P)

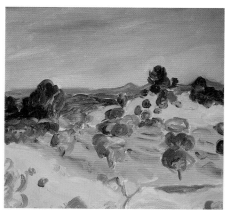

Smith, Matthew Arnold Bracy 1879–1959
Aix-en-Provence 1936
oil on canvas 44.5 x 54
1946P14

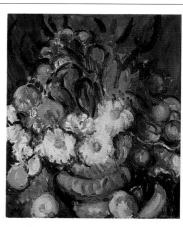

Smith, Matthew Arnold Bracy 1879–1959
Chrysanthemums in a Jug 1952
oil on canvas 75.6 x 63.5
1954P51

Smith, Ray b.1949
Alien Cofactor 1996
acrylic on canvas 101.5 x 20.3
2006.046 (P)

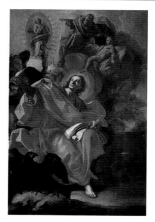

Solimena, Francesco 1657–1747
The Vision of Saint John the Divine
c.1690–1710
oil on canvas 74 x 50.2
1964P18

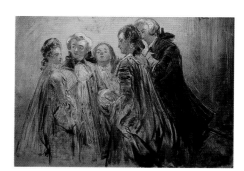

Solomon, Abraham 1824–1862
Conversation Piece 1845–1850
oil on millboard 25 x 35
1959P21

Facing page: Gross, Peter Barrie, 1924–1987, *Euryl Stevens* (detail), 1961, Royal Birmingham Society of Artists, (p. 210)

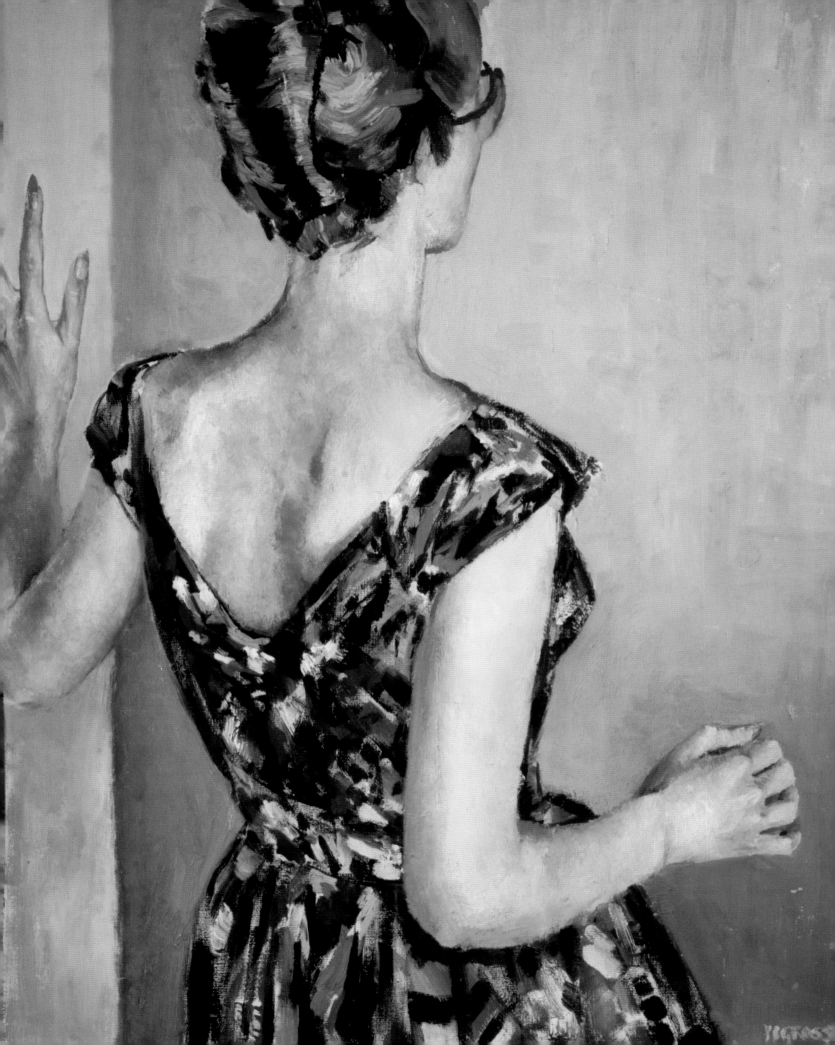

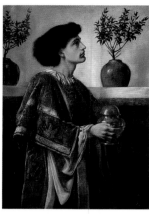

Solomon, Simeon 1840–1905
A Deacon 1863
oil on canvas 35 x 25.4
2003.0174

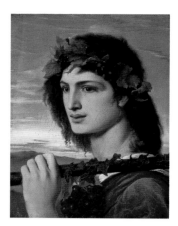

Solomon, Simeon 1840–1905
Bacchus 1867
oil on paper laid on canvas 50.3 x 37.5
1961P52

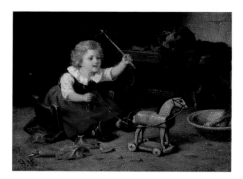

Sondermann, Hermann 1832–1901
Childhood
oil on panel 11.3 x 15.2
1954P54

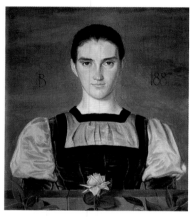

Southall, Joseph Edward 1861–1944
Anne Elizabeth Baker (1859–1947) 1887
tempera on panel 50.8 x 45
1980P123

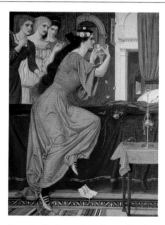

Southall, Joseph Edward 1861–1944
Sigismonda Drinking the Poison 1897
tempera on linen 58.5 x 43
1948P49

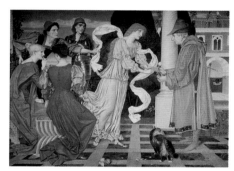

Southall, Joseph Edward 1861–1944
Beauty Receiving the White Rose from Her Father 1898–1899
tempera on canvas 92.5 x 127
1948P1

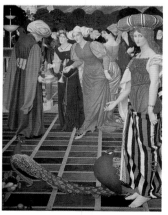

Southall, Joseph Edward 1861–1944
New Lamps for Old 1900
tempera on canvas 96.5 x 74.7
1952P22

Southall, Joseph Edward 1861–1944
Portrait of the Artist's Mother 1902
tempera on panel 48.5 x 35.5
1945P63

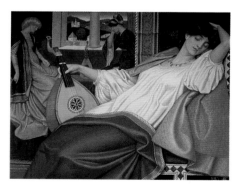

Southall, Joseph Edward 1861–1944
The Sleeping Beauty 1903
tempera on millboard 27.5 x 35.5
1908P303

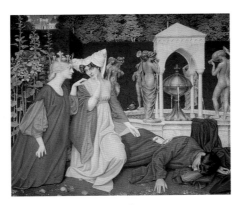

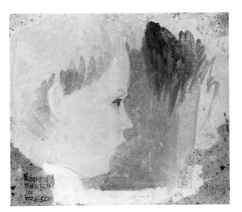

Southall, Joseph Edward 1861–1944
Fisherman Carrying a Sail 1906–1907
tempera on linen 75 x 44.5
1918P45

Southall, Joseph Edward 1861–1944
Changing the Letter 1908–1909
tempera on canvas 97.7 x 113.5
1918P44

Southall, Joseph Edward 1861–1944
Head of a Boy 1916
tempera on plaster on firebrick 20.3 x 22.7
1963P7

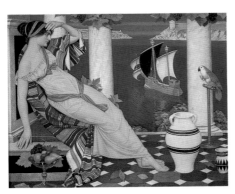

Southall, Joseph Edward 1861–1944
Ariadne on Naxos 1925
tempera on hand-woven linen 83.5 x 101.6
1948P3

Southall, Joseph Edward 1861–1944
Sir Whitworth Wallis (1855–1927) 1927
tempera on linen laid on panel 43.5 x 33
1927P285

Souza, Francis Newton 1924–2002
Negro in Mourning 1957
oil on hardboard 122 x 61
1999P10

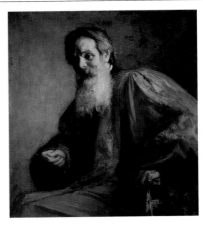

Spear, Ruskin 1911–1990
Mother and Child c.1930–1946
oil on board 43.9 x 52.1
1946P36 ✳

Spear, Ruskin 1911–1990
A London Street 1944–1945
oil on panel 45.8 x 55.9
1945P26 ✳

Speed, Harold 1872–1957
William Holman Hunt (1827–1910) 1909
oil on canvas 97.9 x 89.2
1932P338

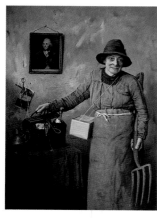

Spencelayh, Charles 1865–1958
Dig for Victory 1942–1943
oil on canvas 61 x 45.8
1943P11

Spencer, Jean 1942–1998
Square Painting No.1 (diptych) 1982
oil on linen 100 x 50; 100 x 50
2002P19

Spencer, Jean 1942–1998
Four Part Painting 1985
oil on linen canvas 71 x 71
2007.0928

Spencer, Jean 1942–1998
Four Part Painting 1985
oil on linen canvas 71 x 71
2007.0928

Spencer, Jean 1942–1998
Four Part Painting 1985
oil on linen canvas 71 x 71
2007.0928

Spencer, Jean 1942–1998
Four Part Painting 1985
oil on linen canvas 71 x 71
2007.0928

Spencer, Stanley 1891–1959
Old Tannery Mills, Gloucestershire 1939
oil on canvas 60.9 x 91.8
1945P48

Spencer, Stanley 1891–1959
Rock Gardens, Cookham Dene 1940–1947
oil on canvas 71.2 x 93.8
1947P1

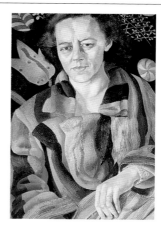

Spencer, Stanley 1891–1959
The Psychiatrist (Mrs Charlotte Murray) 1945
oil on canvas 74.9 x 49.5
1950P4

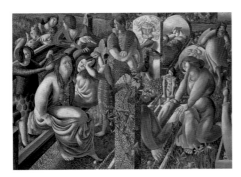

Spencer, Stanley 1891–1959
The Resurrection, Tidying 1945
oil on canvas 76.2 x 101.6
1950P11

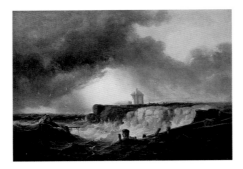

Stanfield, Clarkson 1793–1867
Fishing Boats off the Coast 1837
oil on canvas 41 x 51
PCF 36

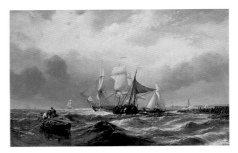

Stanfield, Clarkson 1793–1867
Vessels off the Dutch Coast
oil on panel 50.9 x 78.2
1934P684

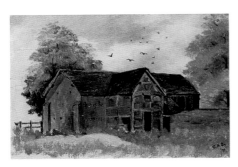

Stanley, Colin A.
Sheepcote Barn, Chapel House Farm 1891
oil on canvas textured paper 9.6 x 13.4
1980V9

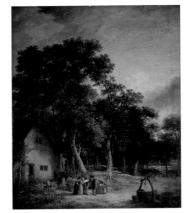

Stark, James 1794–1859
Cottage in a Wood
oil on canvas 74.3 x 59.7
1910P83

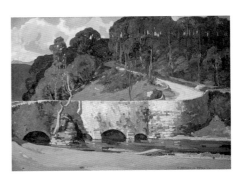

Steel, George Hammond 1900–1960
Conksbury Bridge, Derbyshire 1928
oil on canvas 57.5 x 76.7
1929P42

Steer, Philip Wilson 1860–1942
Springtime 1904
oil on canvas 101.8 x 127
1946P3

Steer, Philip Wilson 1860–1942
The Posy 1904
oil on canvas 61 x 45.8
1945P62

Steer, Philip Wilson 1860–1942
Brill, Buckinghamshire 1923
oil on canvas 42.6 x 62.3
1944P289

Steer, Philip Wilson 1860–1942
A Shipyard, Shoreham, Sussex 1926
oil on canvas 49.6 x 80
1945P24

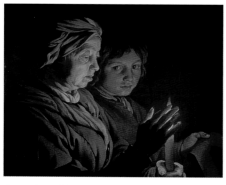

Stom, Matthias c.1600–after 1650
An Old Woman and a Boy by Candlelight
oil on panel 58.4 x 71.1
1958P1

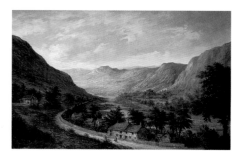

Stone, W.
Elan Valley, Radnorshire 1893
oil on canvas 55.8 x 88.8
1975V25

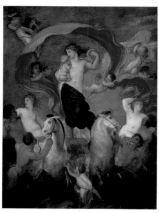

Stothard, Thomas 1755–1834
Amphitrite
oil on canvas 59 x 43.9
1925P83

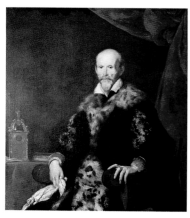

Strozzi, Bernardo 1581–1644
Portrait of a Genoese Nobleman 1610–1615
oil on canvas 127 x 101.6
1971P3

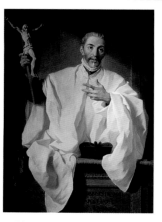

Subleyras, Pierre Hubert 1699–1749
San Juan de Ávila (c.1499–1569) 1746
oil on canvas 136 x 98.5
1959P43

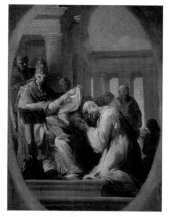

Subleyras, Pierre Hubert 1699–1749
Unidentified Papal Ceremony
oil on canvas 45.8 x 36.8
1961P29

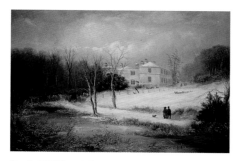

Such, William Thomas 1820–1893
Heathfield Hall 1870s
oil on canvas 80 x 120
PCF 22

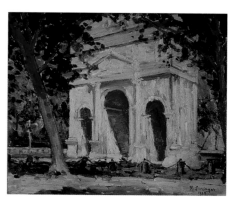

Suringer, Maud
Arc de Triomphe, Orange 1928
oil on millboard 31.3 x 39.6
1928P594

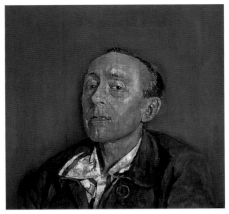

Sutherland, Graham Vivian 1903–1980
*The Honourable Edward Sackville West
(1901–1965)* 1957–1958
oil on canvas 61 x 61
1958P10

Sutton, Philip b.1928
Gorse Landscape 1957
oil on canvas 50.9 x 61
1958P2

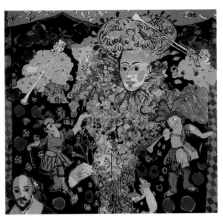

Sutton, Philip b.1928
All the Kingdom for a Stage 1986
oil on canvas 127 x 127
2007.0965

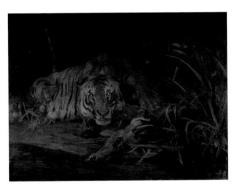

Swan, Cuthbert Edmund 1870–1931
Tiger and Prey
oil on canvas 100.3 x 125.7
1929P532

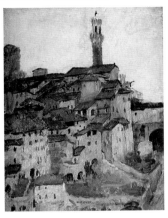

Swynnerton, Annie Louisa 1844–1933
Assisi c.1883–1910
oil on canvas stretched on cork 42.6 x 32.7
1935P78

Tàpies, Antoni b.1923
Grey Relief with an Ochre Line 1960–1961
oil & sand on canvas 65.4 x 81.3
1962P15

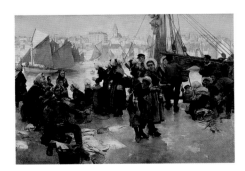

Tayler, Albert Chevallier 1862–1925
The Departure of the Fishing Fleet, Boulogne
1891
oil on canvas 137.6 x 194.2
1891P73

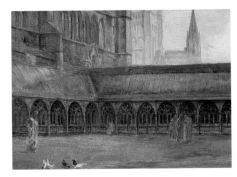

Taylor, Edward Richard 1838–1912
Lincoln Cathedral, the Cloisters (panel in the
Everitt Cabinet) 1879–1880
oil on mahogany panel 20.5 x 28
1892P41.9

Taylor, Edward Richard 1838–1912
*Birmingham Reference Library, the Reading
Room* 1881
oil on canvas 44.9 x 95.7
1885P2464

Taylor, Edward Richard 1838–1912
'Twas a Famous Victory' 1883
oil on canvas 79.3 x 121.8
1987P24

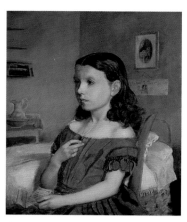

Taylor, Edward Richard 1838–1912
Ellen Bennett c.1900
oil on canvas 65 x 55
2007.1848

Taylor, Edward Richard 1838–1912
Self Portrait 1906
oil on canvas 69.1 x 53.5
1976P101

Taylor, Edwin d.1888
Meadow Scene (panel in the Everitt Cabinet)
1879–1880
oil on mahogany panel 20.5 x 28
1892P41.12

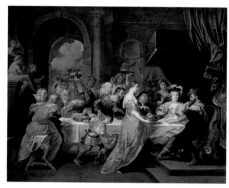

Teniers, David II 1610–1690
The Feast of Herod
oil on copper 57.8 x 75.2
1925P81

Thomas, Thomas active 1854–1896
Harborne Railway Line (?) c.1861–1871
oil on canvas 76.5 x 127.6
1971V3183

Thomas, Thomas active 1854–1896
Kings Norton Church
oil on canvas 68.7 x 89.8
1977V494

Thompson, Ernest Lancaster
active 1873–1879
George Dawson and His Friends 1879
oil on panel 17.2 x 57.8
1885P2574

Thornton, Patricia b.1946
Guns with Fig Leaf 1994
encaustic wax & oil on board 50 x 70.4
2007.0947 (P)

Thornton, Patricia b.1946
Repeat Action 1994
encaustic wax & oil on board 11 x 44
2002P3

Thornton, Patricia b.1946
Vest Pocket Pistol 1994
encaustic wax & oil on board 21 x 26
2002P2

Tift, Andrew b.1968
Repeat 1995
acrylic on steel 76.2 x 101.5
2006.1408

Toft, J. Alfonso 1866–1964
Ludlow Castle 1920
oil on canvas 44.5 x 61
2000P5

Tonks, Henry 1862–1937
The Hat Shop 1892
oil on canvas 67.7 x 92.7
1951P105

Tonks, Henry 1862–1937
The China Cabinet 1902/1903
oil on canvas 61 x 50.9
1953P460

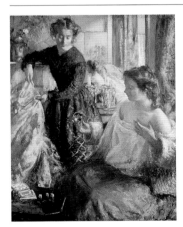

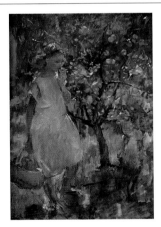

Tonks, Henry 1862–1937
The Crystal Gazers 1905–1906
oil on canvas 78.1 x 64.9
1945P7

Tonks, Henry 1862–1937
The Orchard 1936–1937
oil on canvas 66.1 x 45.7
1938P261

Towne, Charles 1763–1840
A View across an Estuary 1816
oil on canvas 81.3 x 106.7
1941P372

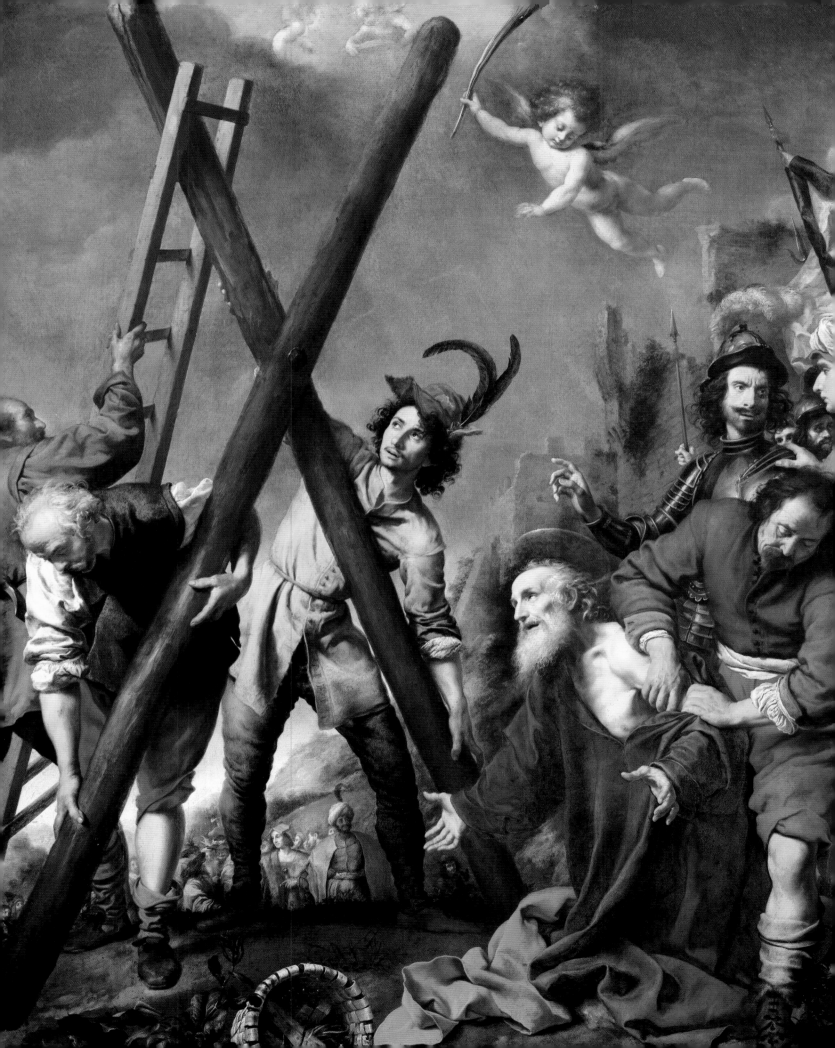

Townsend, William 1909–1973
Winter, Hexden Channel 1956
oil on canvas 71.1 x 91.5
1956P22

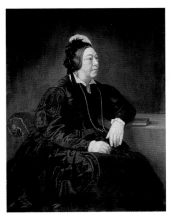

Tranter, E. Butler active c.1850–1890s
Mrs Tranter 1877
oil on canvas 110.6 x 85
1978V795

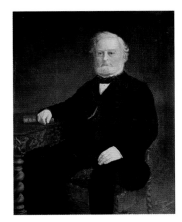

Tranter, E. Butler active c.1850–1890s
William Tranter
oil on canvas 101.7 x 85.7
1978V794

Trembath, Su b.1965
Beautiful Undercurrent c.1980
acrylic on paper 61.5 x 66.2
1992Q12 (P)

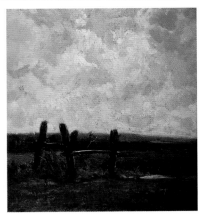

Troyon, Constant 1810–1865
Landscape with Meadowland in the Foreground
oil on panel 31.4 x 25.4
1960P56

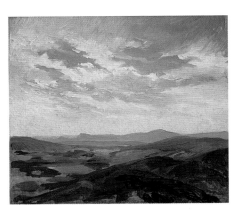

Tudor-Hart, Percyval 1873–1954
Evening in Huntingdonshire
oil on panel 12.8 x 15
1974P13

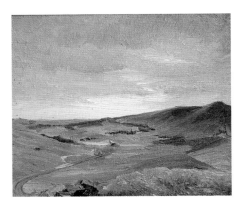

Tudor-Hart, Percyval 1873–1954
Study of Sky in Rosshire
oil on panel 14 x 15.9
1974P14

Turner, Joseph Mallord William 1775–1851
The Pass of Saint Gotthard, Switzerland
1803–1804
oil on canvas 80.6 x 64.2
1935P198

unknown artist 19th C
Farm in Wood Lane, Handsworth
oil on canvas 46.3 x 76.4
1965V337

Facing page: Dolci, Carlo, 1616–1868, *St Andrew Praying before His Martyrdom* (detail), 1643, Birmingham Museums
and Art Gallery, (p. 88)

unknown artist 19th C
Golden Cross
oil on canvas 76.1 x 63.4
1975V24

Urwick, Walter Chamberlain 1864–1943
Portrait of the Artist's Wife c.1895–1910
oil on canvas 48.4 x 34.5
1961P40

Utrillo, Maurice 1883–1955
Rue à Pontoise
oil on canvas 58.5 x 79.5
1978Q5 (P)

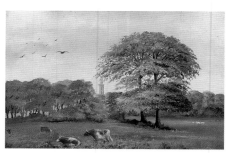

Vale
Tower, Edgbaston Pumping Station c.1894
oil on canvas 23.1 x 33.2
1988V1503

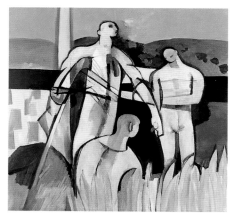

Vaughan, John Keith 1912–1977
Harvest Assembly 1956
oil on canvas 114.4 x 122
1968P24

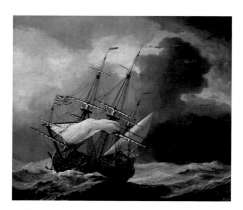

Velde, Willem van de II 1633–1707
The English Ship 'Hampton Court' in a Gale
c.1679–1681
oil on canvas 105.4 x 119.4
1972P53

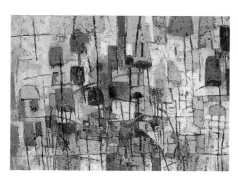

Venton, Patrick 1925–1987
Studio Table Number 1 c.1965
oil on board 91.5 x 122
PL62 (P)

Verhaecht, Tobias c.1560–1631
Orpheus Returning from the Underworld
oil on panel 32 x 45
1960P60

Vernet, Claude-Joseph 1714–1789
Harbour Scene with Man-of-War and Figures on a Quay
oil on canvas 58.1 x 48.6
1925P84

Verwer, Justus de c.1626–before 1688
Distant View of the Dutch Coast
oil on panel 48.5 x 58
1933P319

Vincent, George 1796–1831
Landscape, Cattle Crossing a Stream
oil on canvas 50 x 69.9
1925P119

Vlaminck, Maurice de 1876–1958
La route (avec peupliers) 1922–1923
oil on canvas 54 x 71.8
1945P59

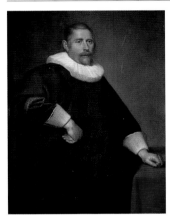

Vos, Cornelis de (attributed to)
c.1584–1651
Portrait of a Man
oil on canvas 116.8 x 88.9
1957P32

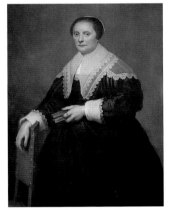

Vos, Cornelis de (attributed to)
c.1584–1651
Portrait of a Woman
oil on canvas 116.8 x 88.9
1957P33

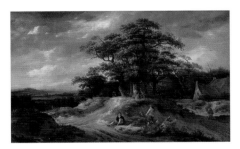

Vries, Roelof van c.1631–after 1681
Travellers at the Edge of a Village
oil on panel 60 x 85
1987P9

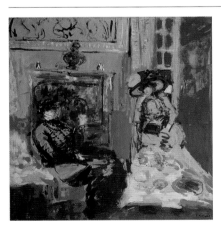

Vuillard, Jean Edouard 1868–1940
Le repas 1909–1911
oil on canvas 53 x 51
1958P7

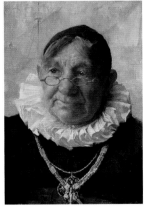

Wainwright, William John 1855–1931
The Old Burgomaster 1884
oil on canvas 44.8 x 29.9
1924P18

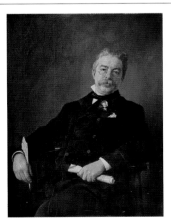

Wainwright, William John 1855–1931
Leonard Brierley 1893
oil on canvas 122 x 91.5
1970P48

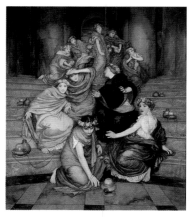

Wainwright, William John 1855–1931
Parable of the Wise and Foolish Virgins 1899
oil on canvas 160 x 139.7
1899P62

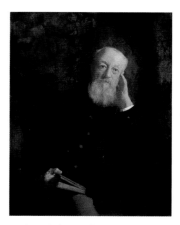

Wainwright, William John 1855–1931
Howard S. Pearson 1906
oil on canvas 111.9 x 86.2
1974P17

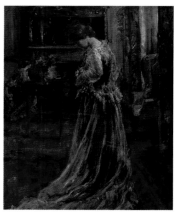

Walker, Ethel 1861–1951
A Symphony in Bronze and Silver
oil on canvas 75 x 62.2
1948P20 🐝

Walker, Frederick 1840–1875
The Old Gate 1868
oil on canvas 93 x 123.9
1894P35

Walker, John b.1939
Serenade 1994–1995
oil on canvas 274 x 427
1997P12

Walker, John b.1939
Kew 2006
oil & wax on canvas 154 x 123
2007.2265

Wallis, George 1811–1891
The Resurrection of the Year 1857
oil on canvas 40.8
1987P15

Wallis, George 1811–1891
The Glory of the Year 1857
oil on canvas 40.9
1987P16

Wallis, George 1811–1891
The Fall of the Year 1857
oil on canvas 41
1987P17

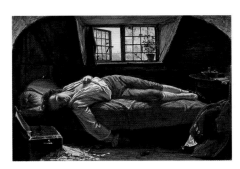

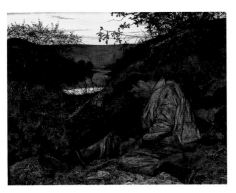

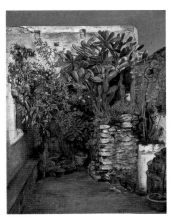

Wallis, Henry 1830–1916
The Death of Chatterton 1856–1858
oil on mahogany panel 17.3 x 25.3
1918P43

Wallis, Henry 1830–1916
The Stone Breaker 1857
oil on panel 65.4 x 78.7
1936P506

Wallis, Henry 1830–1916
Corner of an Eastern Courtyard
oil on canvas 61 x 47
1918P17

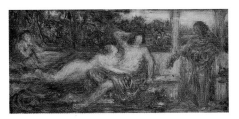

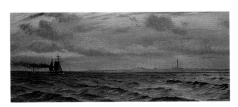

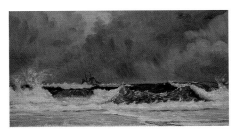

Wallis, Henry 1830–1916
Study of Nude and Draped Figures
oil on canvas 18.1 x 36.6
1918P8

Wallis, Whitworth 1855–1927
Off the Skagerrak 1884
oil on canvas laid on board 33.4 x 54.2
1985P122

Wallis, Whitworth 1855–1927
Rough Weather, the Coast of Jutland 1884
oil on canvas 29.7 x 66.5
1967P2

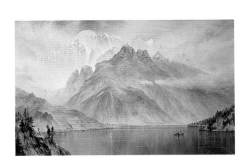

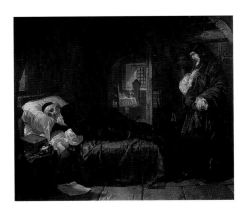

Walton, Elijah 1832–1880
Monte Civita, Italy 1867
oil on canvas 227 x 322
1885P2600

Walton, Elijah 1832–1880
Alpine Climbers 1869
oil on board 130.7 x 98
1935P498

Ward, Edward Matthew 1816–1879
*The Last Sleep of Argyle before His Execution,
1685*
oil on canvas 78.8 x 91.5
1960P43

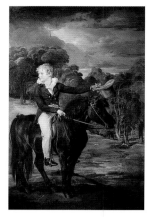

Ward, James 1769–1859
Lord Stanhope (1805–1866), Riding a Pony
1815
oil on canvas 278.8 x 185.9
1960P27

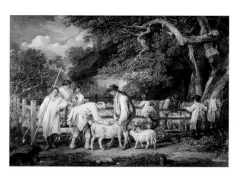

Ward, James 1769–1859
Sheep Salving 1828
oil on canvas 84.3 x 119.8
1947P59

Watts, E. active 1860–1900
Yardley Church and School c.1875–1900
oil on canvas 76 x 63.3
1956V169

Watts, E. active 1860–1900
Hobmore Road Ford
oil on canvas 76.2 x 63.3
1956V168

Watts, Frederick W. 1800–1870
A Watermill near Totnes, Devon 1833–1834
oil on canvas 56.9 x 75
1921P80

Watts, George Frederick 1817–1904
Aspiration 1866
oil on canvas 94 x 68
1973P85

Watts, George Frederick 1817–1904
Sir Edward Burne-Jones (1833–1898)
1869–1870
oil on canvas 64.8 x 52.1
1920P91

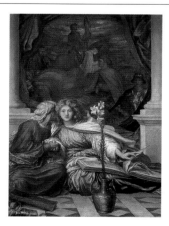

Watts, George Frederick 1817–1904
Britomart 1877–1878
oil on canvas 160.9 x 122
1929P527

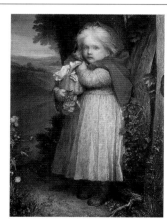

Watts, George Frederick 1817–1904
Little Red Riding Hood 1890
oil on canvas 88.9 x 67.3
1907P166

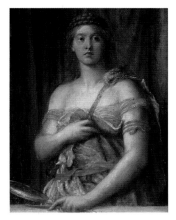

Watts, George Frederick 1817–1904
A Roman Lady 1891–1892
oil on canvas 92.2 x 69.3
1891P29

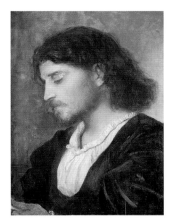

Watts, George Frederick 1817–1904
Study of Gennaro, a Venetian Nobleman
oil on panel 44.3 x 33.2
1962P26

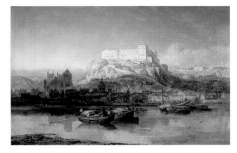

Webb, James c.1825–1895
Huy, Belgium 1878
oil on canvas 61 x 91.3
1933P320

Weber, Audrey M. 1891–1950
Burg Finstergrün c.1920–1940
oil on canvas 36.4 x 21.8
1944P202

Webster, Harry b.1921
Salmon 1961
oil on canvas 71.1 x 91.4
1961P83

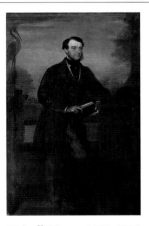

Weigall, Henry 1829–1925
*Charles B. Adderley (1814–1905), 1st Lord
Norton* 1865
oil on canvas 223.2 x 131.6
1885P2585

Weight, Carel Victor Morlais 1908–1997
Pisa, the Campo Santo 1945–1947
oil on canvas 60.3 x 52
1947P36

Weight, Carel Victor Morlais 1908–1997
La symphonie tragique 1946
oil on canvas 99 x 121.9
1946P6

Welburn, Irene active 1936–1955
Victoria in Her Square 1954–1955
oil on hardboard 53.3 x 122.1
1978P8

Wells, John 1907–2000
Painting 1959–1960/61 1957–1961
oil on hardboard 61 x 53.4
1972P28

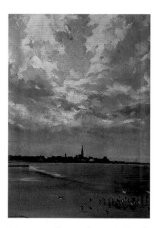

Werner, Alexander Friedrich 1827–1908
Hindeloopen, Holland 1875
oil on canvas 38.1 x 29.7
1931P13

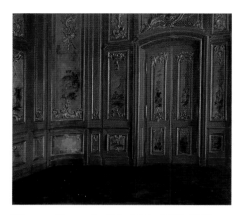

Werner, Alexander Friedrich 1827–1908
Interior of a Room with Rococo Panelling 1896
oil on panel 35.5 x 39.4
1931P14

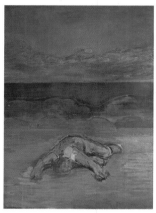

Weschke, Karl 1925–2005
Caliban c.1974
oil on canvas 173 x 129.7
2007.0884

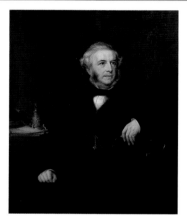

West, Samuel c.1810–after 1867
George Richards Elkington (1800–1865) 1865
oil on canvas 125.1 x 100.3
1969P103

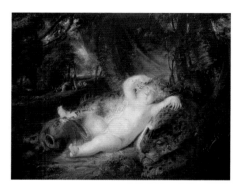

Westall, Richard 1765–1836
The Infant Bacchus 1810–1811
oil on canvas 101 x 124.5
1953P459

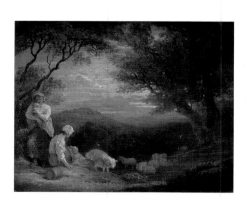

Westall, Richard 1765–1836
Landscape with Women, Sheep and Dog
oil on canvas 28 x 35.6
1947P75

Westwood, Roger b.1936
Question of Windows 1972
oil on board 147.5 x 147.5
PL58 (P)

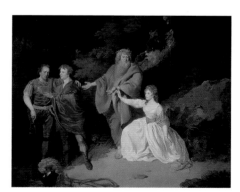

Wheatley, Francis 1747–1801
A Scene from Shakespeare's 'The Tempest'
1787
oil on canvas 101.6 x 126.3
1958P11

Facing page: Rossetti, Dante Gabriel, 1828–1882, *The Blue Bower* (detail), 1865, The Barber Institute of Fine Arts, (p. 238)

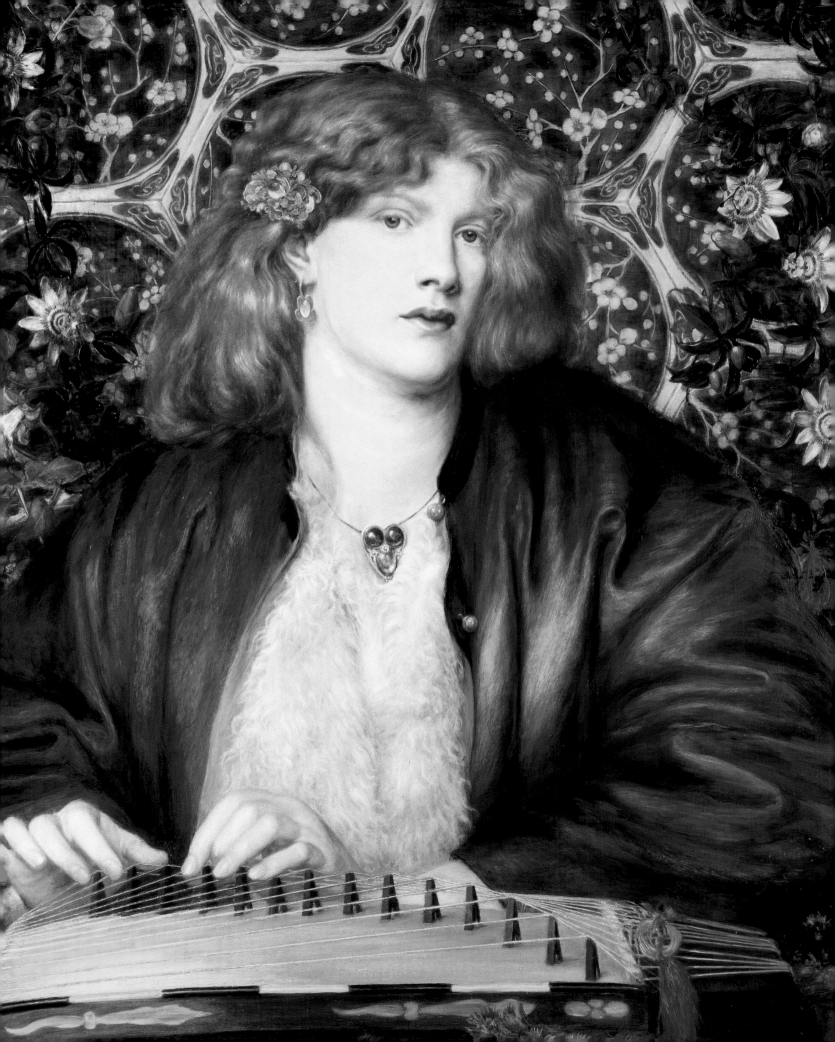

White, Ethelbert 1891–1972
The Farm by the Brook 1928–1929
oil on canvas 60.3 x 75.6
1929P46

White, Franklin 1892–1975
The Metamorphosis of Birmingham 1964
oil on canvas 60.7 x 76
1964P32

White, Franklin 1892–1975
The Blue Pond
oil on canvas 48.9 x 57.8
1948P17

Whitfield, Florence Westwood
active 1879–1925
Christmas Roses (panel in the Everitt Cabinet)
1879–1880
oil on panel 26.1 x 30.1
1892P41.3

Whitfield, Florence Westwood
active 1879–1925
Yellow Rose 1886/1887
oil on paper 12.8 x 17.8
1901P31.16

Whiting, Frederic 1874–1962
Alderman William John Seal
oil on canvas 126.9 x 102.2
1978P2

Whitworth, Charles H. active 1873–1913
Newlyn Harbour 1886/1887
oil on paper 14.5 x 21.9
1901P31.23

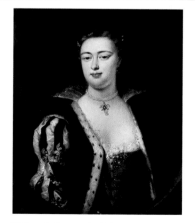

Whood, Isaac 1688/1689–1752
Elizabeth, Marchioness of Lindsey 1736
oil on canvas 73.7 x 61
1964P13

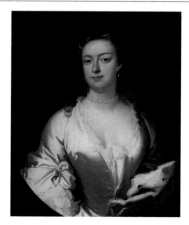

Whood, Isaac 1688/1689–1752
Portrait of a Lady in White and Ermine 1738
oil on canvas 76.3 x 63.5
1964P16

Wilden, Edward active 19th C
Bredon Hill
oil on canvas 21 x 30.5
1999V27

Wilden, Edward active 19th C
Sarehole Mill (?)
oil on canvas 15.6 x 20.5
1999V26

Wilden, Edward active 19th C
The Dingles, near Sarehole
oil on canvas 15.4 x 20.3
1999V25

Wilkie, David 1785–1841
King William IV (1765–1837) 1838
oil on canvas 85 x 62.5
1942P34

Wilkie, David 1785–1841
Grace before Meat 1839
oil on canvas 101 x 127
1954P2

Wilkinson, Norman 1878–1972
Quebec 1926–1927
oil on canvas 100.3 x 100.3
1927P287

Williams, William 1727–1791
Conversation Piece before House on Monument Lane, Edgbaston
oil on canvas 114.5 x 150 (E)
1952P23

Wilson, Harold active 1904–1938
A Park Street Boy 1931
oil on millboard 53.3 x 38.1
1951P101

Wilson, Richard 1713/1714–1782
Tivoli, the Villa of Maecenas 1767
oil on canvas 123.3 x 172.7
1949P28

Wilson, Richard 1713/1714–1782
Okehampton Castle 1771–1773
oil on canvas 171.4 x 265.8
1948P27

Wilson, Richard 1713/1714–1782
Lake Albano and Castel Gandolfo
oil on canvas 74.8 x 100.5
1920P8

Wimperis, Edmund Morison 1835–1900
Snowdon 1894
oil on canvas 61.1 x 91.5
1913P2

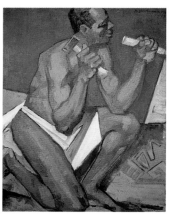

Wivell, Abraham II c.1827–1867
Daniel Joseph O'Neill (1832–1914) 1859
oil on canvas 117.1 x 71.4
1885P2473

Wolfsfeld, Erich 1884–1956
Mother and Child 1910–1950
wash & oil on paper 55.6 x 39
1958P23

Wolmark, Alfred Aaron 1877–1961
Negro Sculptor 1913
oil on canvas 91.9 x 72
1984P1

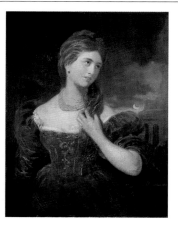

Wootton, John c.1682–1765
Rome from the Aventine Hill c.1700–1710
oil on canvas 42.1 x 108.6
1934P259

Wright, Joseph of Derby 1734–1797
Firework Display at Castel Sant'Angelo
1774–1778
oil on canvas 42.5 x 70.5
1961P34

Wyatt, Henry 1794–1840
Juliet 1832
oil on canvas 88.9 x 68.6
1885P2573

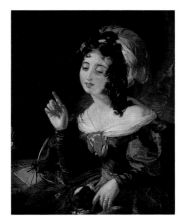

Wyatt, Henry 1794–1840
Naughty Pet
oil on canvas 35.6 x 28
1885P2533

Wynter, Bryan 1915–1975
Sandspoor IV 1962
oil on canvas 152.5 x 122
1959P47

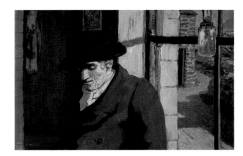

Yeats, Jack Butler 1871–1957
An Old Car Driver 1920–1930
oil on canvas 26.5 x 39
1947P70

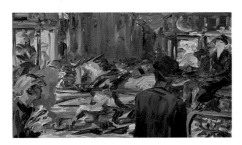

Yeats, Jack Butler 1871–1957
Dublin Night 1925
oil on panel 22.3 x 35
1928P208

Ziegler, Toby b.1972
Comfort or Death 2003
acrylic on canvas 145 x 224.8
2005.4415 (P)

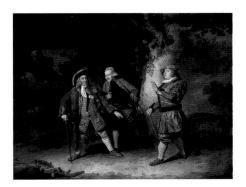

Zoffany, Johann 1733–1810
*Garrick, Ackman and Bransby in a Scene from
Lethe* 1766
oil on canvas 101.4 x 126.5
1948P43

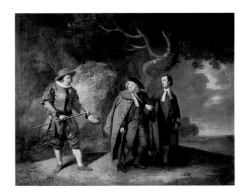

Zoffany, Johann 1733–1810
*Parsons, Bransby and Watkyns in a Scene from
Lethe* 1766
oil on canvas 100.3 x 124.5
1948P39

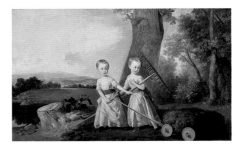

Zoffany, Johann 1733–1810
The Blunt Children 1766–1770
oil on canvas 77.1 x 123.4
1934P397

City of Birmingham Symphony Orchestra Centre

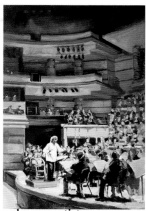

unknown artist
Sir Simon Rattle (b.1955), Conducting the City of Birmingham Symphony Orchestra in Symphony Hall, Birmingham 1995
oil on canvas 131 x 92
CBSO1

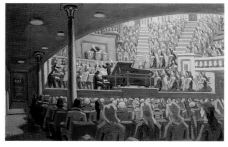

Walker, Alexander
Concerto 1970s
oil on canvas 50 x 74
CBSO2

Royal Birmingham Society of Artists

The Royal Birmingham Society of Artists (RBSA) is an independent institution led by artists and dedicated to the enjoyment and understanding of the visual arts through exhibitions and workshops. It has its roots at the beginning of the nineteenth century when drawing schools were founded by Joseph Barber and Samuel Lines. A group of artists met for life-drawing and founded the Birmingham Academy of Arts in 1814 which became the Birmingham Society of Arts when it acquired its own premises in 1821. The first annual exhibition was held in 1827 and Autumn Exhibitions have continued in an unbroken sequence ever since (apart from the war years of 1940 and 1941). In 1842 the artists split away to form the Birmingham Society of Artists which received royal patronage from Queen Victoria in 1868. The annual exhibitions attracted all the fashionable artists of the day and leading members of the Royal Academy acted as President including Leighton, Millais, Alma-Tadema and Burne-Jones. Members included Walter Langley, founder of the Newlyn School, Joseph Southall and David Cox. The Centenary Exhibition in 1927 and retrospective exhibition in 1968 provided an opportunity to show works by past and present members and celebrate the history of this important society. A move to new premises in the year 2000 allowed the Society to encompass the aspirations of the Academy of 1814 by providing facilities for teaching as well as exhibition space.

The RBSA's Permanent Collection was awarded full accreditation by the Museums, Libraries and Archives (MLA) Council in October 2006. The Collection consists of drawings, paintings, prints, sculpture, ceramics and jewellery by members and associates of the RBSA and by artists who have a connection with the Society or the Midlands. The RBSA aims to collect, conserve and maintain works of art which will reflect the artistic activity of Birmingham since the founding of the Society. Nowadays there is a policy that all artists have to submit a diploma piece and there is an aim to fill gaps in the historic collection when possible. The purchase of the Lines' family sketchbook in 2005 was funded by a generous legacy. Samuel Lines and his sons Henry

Harris and Samuel Rostill Lines are important to the history of the RBSA and to the emergence of the tuition of drawing in Birmingham. Work from the Permanent Collection is usually shown every two years, the next exhibition being planned is for 2009. Highlights from the Collection include Paul T. Bartlett's *Triangular Relationship*, Bernard Fleetwood-Walker's *Caroline* and Laurence Williamson's *Demonstration at Royal Birmingham Society of Artists*.

Barbara Fogarty, Research Assistant

Abell, Roy b.1931
Juggling Clown 1962
oil on card 24.8 x 15.2
BIRSA:2005.413

Abell, Roy b.1931
Rocks at Llanberis 1996
oil on board 76 x 100.5
BIRSA:2006X.453

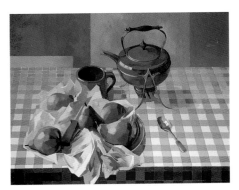

Bailey, Terry b.1937
Still Life with Brass Kettle 1986
oil on board 48.6 x 59.1
BIRSA:2005X.19

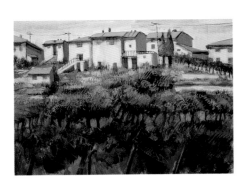

Barfield, Marylane b.1937
Village Houses, Monti Lessini, Italy c.1990
acrylic on paper 51.8 x 71.1
BIRSA:2005X.31

Barker, Tom active mid-20th C
Members and Associates, RBSA
oil on canvas 100 x 130
BIRSA:2005X.32

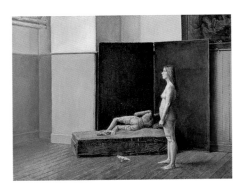

Bartlett, Paul T. b.1955
Triangular Relationship 1979–1980
oil on board 19.1 x 25.4
BIRSA:2006.445

Benton, Graham b.1934
The Sinking of 'Le Grice' 1993
oil on board 61 x 51
BIRSA:2006.464

Bowman, Sylvia active c.1990–2001
Umbria c.1990
oil on canvas 49.4 x 59.5
BIRSA:2005X.56

Brookes, Malcolm John b.1943
Rooftops, Brixham 1989
oil on board 45.5 x 53
BIRSA:2005X.60

Clarke, Margaret b.1953
Alishya Gallagher
oil on canvas 30.5 x 25.3
BIRSA:2006.429

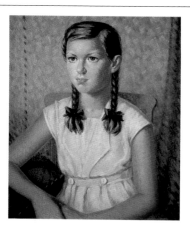

Clarke, Teresa 1886–1987
Betsy
oil on canvas 59.5 x 49.3
BIRSA:2005X.89

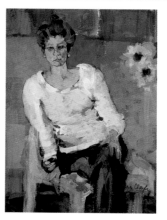

Clough, Ann b.1940
Lizzie c.1990
acrylic on paper 35.6 x 25.5
BIRSA:2005X.90

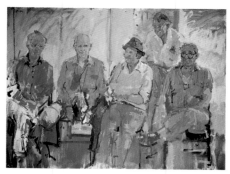

Coates, Tom b.1941
The Birmingham Five c.1970
oil on canvas 92 x 122
BIRSA:2005X.91

Cole, Sibylle active 1987–1993
Humphries Head, Grange-over-Sands 1987
oil on board 29.3 x 36.8
BIRSA:2005X.93

Cole, Sibylle active 1987–1993
Poppies 1993
oil on board 53.9 x 69.2
BIRSA:2005X.94

Cookson, Dawn 1925–2005
Old Boots with Cobwebs c.1970
oil & tempera on board 35 x 69.6
BIRSA:2005X.96

Cox, David the elder 1783–1859
Bolton Abbey c.1850
oil & pencil on panel 21.1 x 37.5
BIRSA:2005X.103

Crews, Anne Irby active c.1950–2006
January Washing Line c.1950
oil on canvas 24.8 x 19.2
BIRSA:2006.430

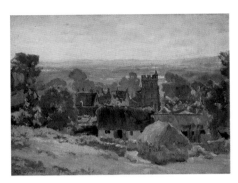

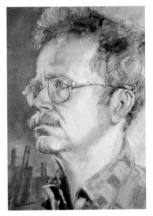

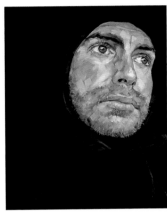

Currie, Sidney d.1930
Burton-on-the-Hill
oil on panel 24.2 x 34.4
BIRSA:2005X.113

Davenport, John b.1938
*Paul T. Bartlett (b.1955), RBSA, Winner of the
Not the Turner Prize (2004)* 2005
acrylic on paper 49 x 32.3
BIRSA:2005.400

Davis, Simon b.1968
Self Portrait
oil on board 35.5 x 27.5
BIRSA:2006.418

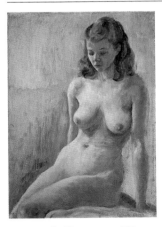

Devey, Phyllis 1907–1982
Model Resting
oil on canvas laid on board 51.3 x 36.7
BIRSA:2005X.119

Deville, Joseph Vickers 1856–1925
A Cotswold Farm
oil on panel 39.4 x 49.5
BIRSA:2005X.118

Donne, Eithne b.1934
San Polo, Venice
acrylic on paper 50.2 x 45.4
BIRSA:2005X.120

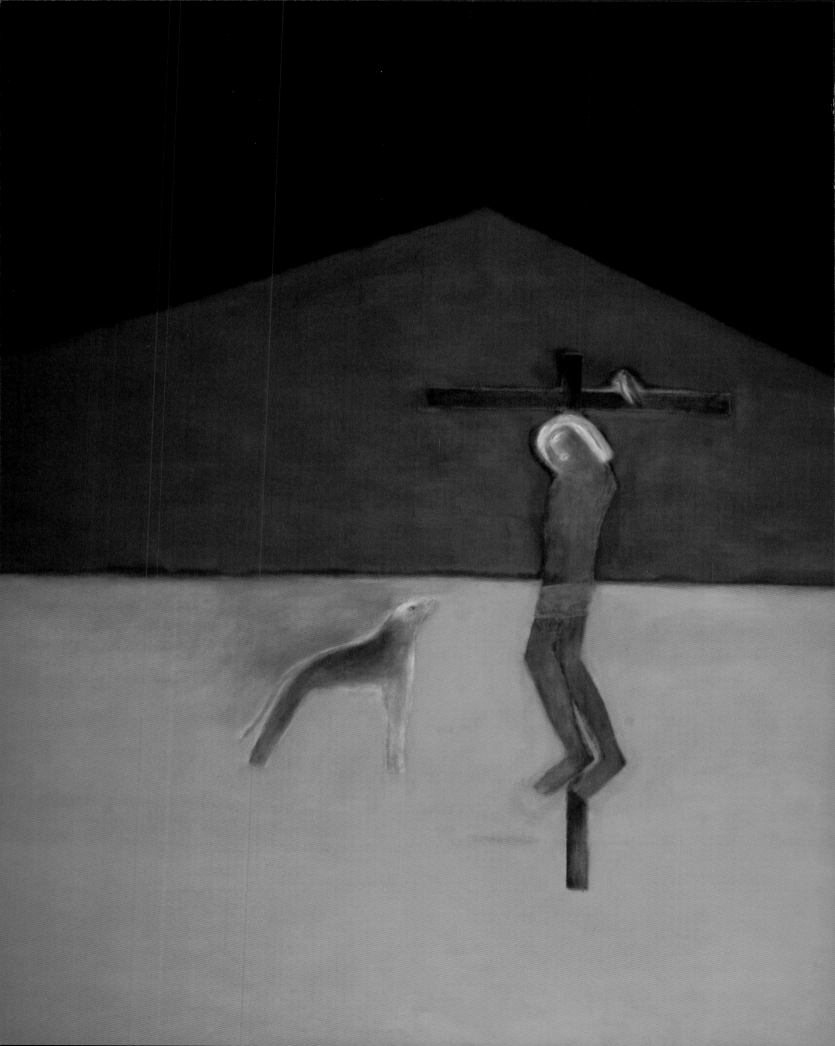

Dudleston, June b.1937
Forest in Fall 1980s
oil on board 44.5 x 59.8
BIRSA:2005X.128

Fleetwood-Walker, Bernard 1893–1965
Caroline
oil on panel 35 x 25.5
BIRSA:2005X.138

Fletcher, Brian b.1937
Self Portrait c.1990
oil on panel 58.5 x 49.5
BIRSA:2005X.141

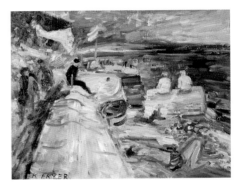

Fletcher, Brian b.1937
Self Portrait in Oil
oil on board 120.4 x 54.4
BIRSA:2006.427

Forbes, Roger b.1948
Motorway near Oldbury c.1990
acrylic on paper 35.5 x 52
BIRSA:2005X.144

Fryer, Katherine Mary b.1910
Undercliff Walk, Brighton 1986
oil on canvas 28.7 x 37
BIRSA:2005X.148

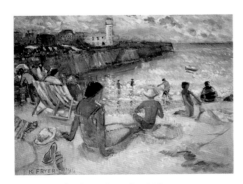

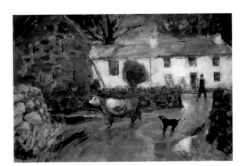

Fryer, Katherine Mary b.1910
Morning on the Beach, Scarborough 1994
oil on canvas 49.2 x 64.6
BIRSA:2005X.147

Gear, William 1915–1997
Caged Yellow 1996
acrylic & ink on paper 28.2 x 41.1
BIRSA:2005X.151

Goodby, Donald b.1929
Farm at Watendlath, Cumbria 1991
acrylic on paper 39 x 55.5
BIRSA:2005X.154

Facing page: Aitchison, Craigie Ronald John, b.1926, *Crucifixion* (detail), 1984–1986, Birmingham Museums
and Art Gallery, (p. 33)

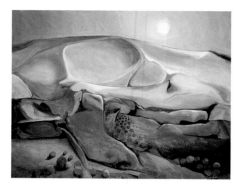

Gordon, David b.1929
Skull Landscape c.1980
oil on canvas 60 x 77
BIRSA:2006.417

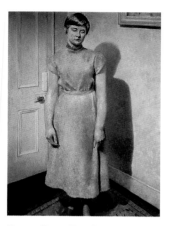

Gross, Peter Barrie 1924–1987
Joyce V. 1951
oil on canvas 74 x 54.6
BIRSA:2005X.163

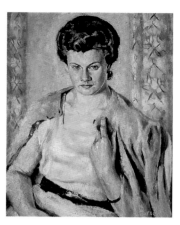

Gross, Peter Barrie 1924–1987
Gill 1952
oil on board 49.4 x 39.5
BIRSA:2005X.162

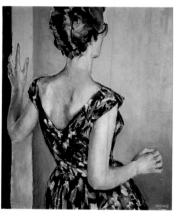

Gross, Peter Barrie 1924–1987
Euryl Stevens 1961
oil on board 58.8 x 48.6
BIRSA:2005X.161

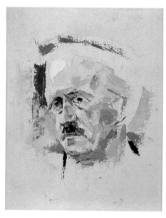

Gross, Peter Barrie 1924–1987
Sketch of James Priddey, Past President of the RBSA 1969
oil on board 32.8 x 25.5
BIRSA:2005X.166

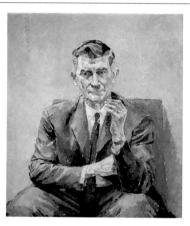

Gross, Peter Barrie 1924–1987
Alf Parry 1970
oil on board 55 x 46.2
BIRSA:2005X.159

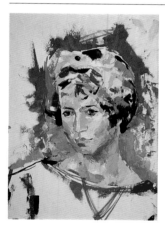

Gross, Peter Barrie 1924–1987
Demonstration Portrait of a Girl c.1972
oil on board 39 x 28.3
BIRSA:2005X.160

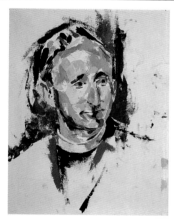

Gross, Peter Barrie 1924–1987
Demonstration Portrait of Reverend David Pendleton c.1979
oil on board 44.2 x 34
BIRSA:2005X.164

Gross, Peter Barrie 1924–1987
Sid Homer, RBSA
oil on paper 44.2 x 32.4
BIRSA:2005X.165

Harper, Edward Samuel 1854–1941
William John Wainwright (1855–1931) 1923
oil on panel 34.4 x 24.1
BIRSA:2005X.185

Harper, Edward Samuel 1854–1941
William John Wainwright (1855–1931) 1923
oil on canvas 74.7 x 54.7
BIRSA:2006.448

Hemsoll, Eileen Mary b.1924
Garden at Compton Acres 1984
oil on board 62.1 x 75
BIRSA:2005X.191

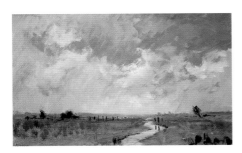

Hipkiss, Percy 1912–1995
Marshland in Somerset c.1975
oil on board 31.4 x 49.3
BIRSA:2005X.203

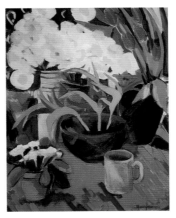

Honigsberger, Joy b.1928
A Birthday Bouquet c.1995
acrylic on paper 55 x 42
BIRSA:2005X.211

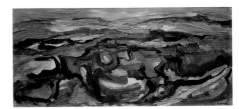

Hurn, Bruce b.1926
Moor Ring Fort 1966
oil on board 63 x 124
BIRSA:2006.441

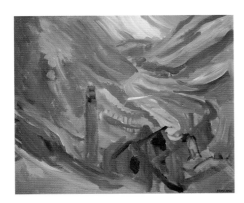

Hurn, Bruce b.1926
Derelict Mine, Wales c.1992
acrylic on board 68 x 81.4
BIRSA:2006.442

Hurn, Bruce b.1926
Norfolk Sand Bar 2002
acrylic on board 29.2 x 39.5
BIRSA:2006.443

Kempshall, Kim b.1934
Rocks c.1980
mixed media on board 39 x 44
BIRSA:2005.405

Kilfoyle, Michael b.1937
Dungeness, Evening
acrylic on board 28.2 x 35.6
BIRSA:2006.431

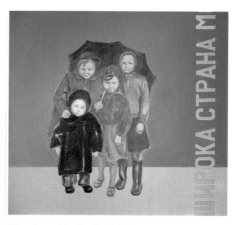

Kisseleva, Nadia b.1956
Wide and Rich: My Beloved Country 2006
oil on canvas 90 x 90
BIRSA:2006.444

Lines, John Woodward b.1938
Saved Again
oil on board 45 x 59.6
BIRSA:2005X.235

Longueville, James b.1942
Snow c.1980
oil on board 34.6 x 49.7
BIRSA:2005X.250

Mansfield, James b.1921
Oncoming Mistral, Provence
oil on canvas 49.2 x 59.6
BIRSA:2006.437

Martin, John Scott b.1943
Gurnard's Head, Cornwall
oil on paper 46.5 x 46.4
BIRSA:2005.398

Metson, Jack
Mellieha Heights, Malta c.1960
oil on board 39 x 51.6
BIRSA:2005X.263

Mills, Lionel
Cromer Pier on a Grey, Overcast Day
oil on board 29.1 x 38.9
BIRSA:2006.432

Mills, Lionel
Self Portrait and Breakfast Table
oil on board 82 x 60.6
BIRSA:2005X.267

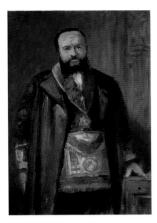

Morgan, Walter Jenks 1847–1924
Burgomeister
oil on paper 26 x 15
BIRSA:2005X.276

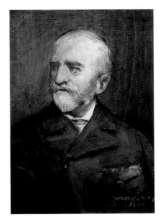

Morgan, Walter Jenks 1847–1924
H. Weiss
oil on paper 29 x 19.8
BIRSA:2005X.286

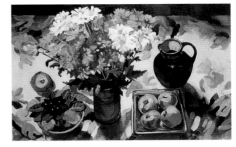

Mullins, Victoria
Still Life with Flowers c.1990
acrylic on paper 33.6 x 52.2
BIRSA:2005X.311

Perry, Robert b.1944
*Nightfall over the Black Country, View from
Turner's Hill, Dudley, the Habberleys just
Visible 6.45pm (…)* 2001
oil on board 31 x 52
BIRSA:2006X.451

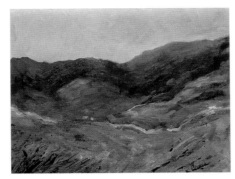

Powell, Joanne b.1943
Isolation
acrylic on board 21 x 26
BIRSA:2006.438

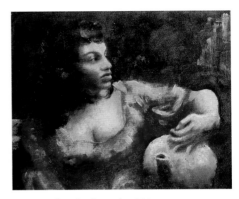

Reeve, John Graham b.1938
Carmen at Covent Garden 1954
oil on card 22.8 x 25.8
BIRSA:2006.428

Rhys-Davies, Norma b.1926
Three Cliffs, Gower III c.1980
acrylic on board 124 x 116
BIRSA:2005X.338

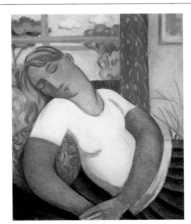

Ridgway, Elizabeth b.1964
Summer Nap
acrylic on paper 59.6 x 48.1
BIRSA:2006X.452

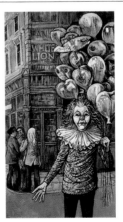

Sawbridge, Tony b.1929
The Balloon Seller c.1960
acrylic on cardboard 71.8 x 39.5
BIRSA:2005X.348

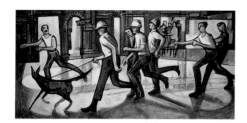

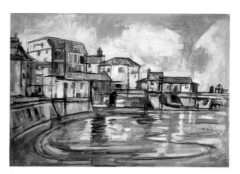

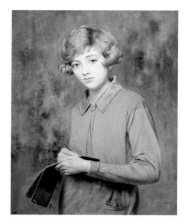

Sawbridge, Tony b.1929
War Requiem Riot 1990
acrylic on board 41.2 x 79.8
BIRSA:2006.436

Sawbridge, Tony b.1929
Harbour, St Ives 1993
acrylic on paper 43 x 55.3
BIRSA:2006.435

Shorthouse, Arthur Charles 1870–1953
Nature Study 1926
oil on board 58.5 x 46.2
BIRSA:2005X.350

Snow, Graham b.1948
Counterpoint
acrylic & card on board 55 x 55
BIFSA:2006.421

Spencer, Claire b.1937
The Fireplace 1956
oil on board 31 x 41
BIRSA:2006.439 ✸

Spencer, Claire b.1937
Clent Church, September 2003
oil on canvas 30 x 30
BIRSA:2006.440 ✸

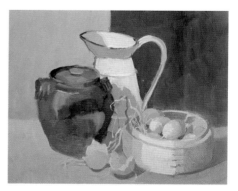

Stewart, Barbara b.1929
Yellow Scarf c.1990
oil on board 70.2 x 58
BIRSA:2005X.361

Storey, Terence b.1923
Bruges
oil on board 36 x 46
BIRSA:2006.450

Sutton, Jenny b.1943
New Laid Eggs 2005
oil on board 24 x 29
BIRSA:2006.434

Swingler, Brian Victor b.1939
Diglis Basin, Worcester c.1980
oil on board 61.5 x 91
BIRSA:2005X.363

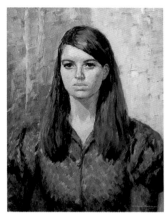

Townsend, Kathleen active 1965–1968
Portrait of Girl in Blue 1968
oil on board 58.8 x 43.5
BIRSA:2005X.370

Wainwright, William John 1855–1931
John Keeley, RBSA c.1880
oil on board 41.5 x 34
BIRSA:2005X.376

Webb, Arnold Bray active 2001–2006
Field 1 2001
oil on canvas 75.4 x 100.2
BIRSA:2006.433

Welburn, Irene active 1936–1955
Girls in Straw Boaters
oil on board 53.5 x 80
BIRSA:2005X.379

White, David b.1939
Red Window 2003
oil on board 43 x 32
BIRSA:2006.447

Williamson, Lawrie b.1932
*Demonstration at the Royal Birmingham
Society of Artists* c.1990
oil on canvas 60 x 76.2
BIRSA:2005X.385

Woollard, Joan Elizabeth b.1916
Master Conal Shields 1950s
oil on board 28 x 22
BIRSA:2005X465

Woollard, Joan Elizabeth b.1916
The Races 1950s
oil on canvas 46 x 29.8
BIRSA:2005.404

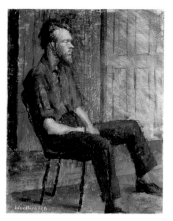

Woollard, Joan Elizabeth b.1916
Half Nude 1952
oil on board 30.5 x 23
BIRSA:2005X.392

Woollard, Joan Elizabeth b.1916
My Father, Frank 1956
oil on canvas 31.7 x 23.9
BIRSA:2005.403

Woollard, Joan Elizabeth b.1916
Seated Figure 1956
oil on canvas 40.7 x 35
BIRSA:2005.407

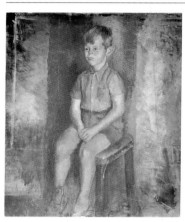

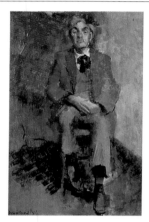

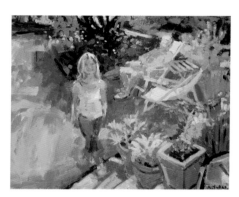

Woollard, Joan Elizabeth b.1916
Portrait of a Boy
oil on board 61 x 51
BIRSA:2005X.390

Woollard, Joan Elizabeth b.1916
The Artist
oil on board 42.8 x 27.6
BIRSA:2005X.393

Yates, Anthony b.1957
Marie and Lloyd in Their Garden 2006
oil on canvas 49 x 59
BIRSA:2006.463

Facing page: Hodgson, Frank, 1902–c.1977, *Self Portrait* (detail), c.1930, Birmingham City University, (p. 12)

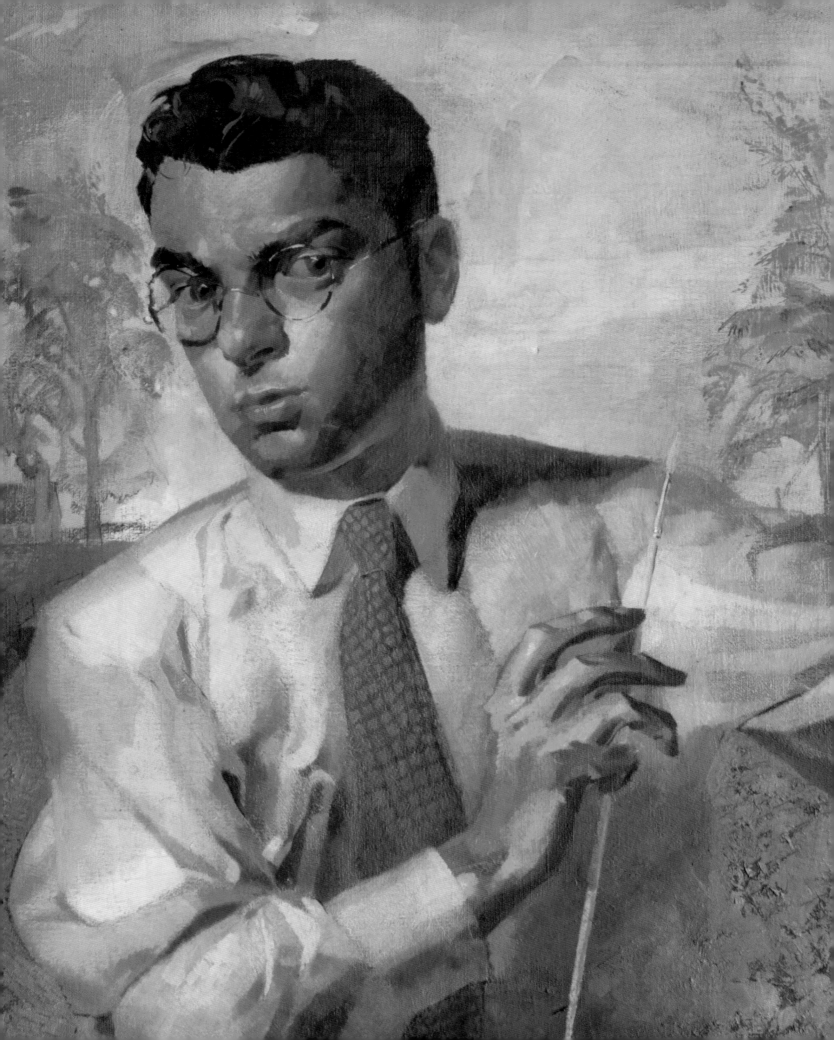

The Barber Institute of Fine Arts

The Barber Institute of Fine Arts was founded by Dame Martha Constance Hattie Barber (1869–1933) in 1932. Lady Barber was the wife of Sir William Henry Barber, Bt (1860–1927), a wealthy property developer and solicitor in Birmingham. The couple married in 1893 and, in the same year, retired to Culham Court, an eighteenth-century manor house at Henley-on-Thames. In 1923, Sir Henry endowed a Chair of Law at the University and, one year later, he was appointed a Life Governor of the University. Though the Barbers made other benefactions to the city, the University was to be the principal recipient of their generosity. When Sir Henry died, childless, in 1927, he appended a letter to his will instructing his widow to commence 'the scheme they had in mind'. This turned out to be the Barber Institute of Fine Arts, founded by Lady Barber only four months before her own death in 1933 and destined to become one of the finest small picture galleries in the world.

Several factors may have prompted the Barbers to establish an institute devoted to the arts at the University of Birmingham. Among these was their interest in music and the decorative arts and the fact that the University had been created to serve the commercial and industrial needs of the city and lacked a strong artistic base. The founding deed of trust bequeathed a sum of money to a Board of Trustees, who were instructed to erect a building on a site provided by the University which would 'serve both as an Art Gallery or Museum and a Music Room' which 'shall belong to and be used by the University for the study and encouragement of art and music'.

In 1934, the newly appointed Trustees of the Institute selected Robert Atkinson (1883–1952), FRIBA, as the architect of the building, and one year later, they chose Thomas Bodkin as the first Director and Professor of Fine Art. Working in close collaboration, the two men toured several of the recently built museums of northern Europe before settling on a design for the building. This was erected between 1936 and 1939 and opened by Queen Mary in July of that year. Though it has inevitably undergone some changes since then, it remains one of the finest museum buildings of its time and, at Atkinson's death in 1952, was proclaimed 'the purest example of his work'.

By the terms of the trust deed, the Collection was to consist of 'works of art or beauty of exceptional and outstanding merit'. These were to include not only paintings, but also furniture, tapestries, manuscripts, and *objets d'art*. Even more decisive in determining the character and quality of the collections were three other conditions stipulated by Lady Barber in her will: that the Trustees were not to accept gifts for the Collection; they were not to buy any works of art made after 1899; and that all of the works in the Collection should be of 'that standard of quality required by the National Gallery and the Wallace Collection'. When one combines these 'restrictions' with the fact that the benefactress effectively bequeathed no works herself to the Institute, the Trustees' brief was at once straightforward, and exalted, namely to create from nothing a collection of masterpieces of pre-twentieth century art, which was worthy of a major national museum and would remain undiluted by gifts or bequests.

The Trustees took the bold step of initiating a collecting policy that encompassed all of Western art, from antiquity to the late nineteenth century,

and embraced virtually all media. To give added breadth to the Collection, works of non-Western art were also acquired from the earliest days. The result is a collection which is comprehensive for its size and comparative youth and consists largely of one major work per artist. In this respect, the Barber Institute serves as a reduced version of a great national museum and aims to embrace the key developments in Western art through examples of uniformly high quality.

Among the first acquisitions were a group of old master drawings, including works by Fra Bartolommeo, Francesco Guardi and Tintoretto, from the collection of Henry Oppenheimer; and paintings by Nicolas Lancret, Richard Wilson and Jacopo Tintoretto. In 1937, Bodkin (previously Director of the National Gallery of Ireland) seized the opportunity to acquire a fine equestrian statue of King George I for the exterior of the building. Executed for the city of Dublin in 1722 by the workshop of John Nost the Elder, this was in danger of being destroyed in the new Republic of Ireland. Today it features magnificently as a landmark both for the Institute and the University campus, and as the oldest public sculpture in Birmingham. Among the most outstanding other early purchases were major paintings by Simone Martini, Cima da Conegliano, Poussin, Monet, and Rubens. In his later years, Bodkin also made some of his most spectacular acquisitions. Among these were Gainsborough's *The Harvest Wagon*, Murillo's *The Marriage Feast at Cana* and Degas's *Jockeys before the Race*.

After Bodkin's retirement in 1952, the Collection grew more slowly but at the same high level. Under the directorship of Professor Ellis Waterhouse, major works by Claude Lorrain, Van Dyck, Pissarro and Rossetti were acquired; and, in the following decade, pictures by Van Gogh, Delacroix and Cosimo Rosselli entered the Collection.

In 1967, the original trust deed was modified so as to admit works of twentieth century art, provided these were at least 30 years old. As a result, under the third Director, Professor Hamish Miles, key advances were made in securing modern works. Acquisitions included characteristic paintings by Redon, Léger and Magritte, in addition to earlier pictures by Jacopo Bassano il vecchio, Vigée-Lebrun and Renoir and the magnificent sculptural bust of Alexander Pope by Roubiliac. During this same period, the Institute also acquired two outstanding collections of ancient coins (mainly Roman and Byzantine) from the collections of G. C. Haines and P. D. Whitting. Together with the acquisition of twentieth-century paintings, this fundamentally altered the character of the Collection as originally envisaged by its benefactress.

In recent years, under the directorship of Professor Richard Verdi, there have been notable successes and further changes. Two of the most important of these have been the Trustees' decision to seek outside funding for major purchases, and their determination to increase rapidly the representation of twentieth-century art in the Institute through the purchase of important works on paper. The former has made possible the purchase of paintings by Matthias Stom, André Derain and Van Dyck, whose enchanting portrait, *François Langlois*, was jointly acquired with the National Gallery, London, in 1997. The latter has resulted in the addition of prints by Nolde, Beckmann, Picasso and others to the Collection.

The Barber Institute of Fine Arts is one of the most munificent bequests ever bestowed upon a British university, and contains one of the most

representative collections of Western art assembled in Britain in the twentieth century. Its collections will continue to grow in the twenty-first century to the ever-increasing advantage of students, researchers and visitors from within the University, the City of Birmingham and international, national and regional arenas.

Professor Richard Verdi, Director & Dr Paul Spencer-Longhurst, Senior Curator

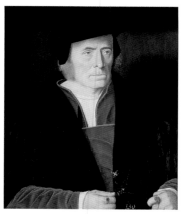

Amberger, Christoph c.1505–1561/1562
Portrait of a Man c.1530–1540
oil on wood 59.8 x 50.2
46.6

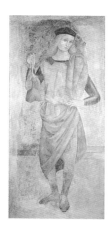

Assisi, Tiberio d' c.1470–1524
St Ansanus
tempera fresco transferred to canvas 153 x 70
44.48

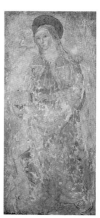

Assisi, Tiberio d' c.1470–1524
St Clare
tempera fresco transferred to canvas 153 x 70
44.4b

Assisi, Tiberio d' c.1470–1524
St Francis of Assisi
tempera fresco transferred to canvas 153 x 70
44.4c

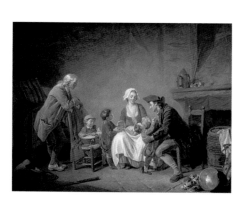

Aubry, Étienne 1745–1781
Paternal Love
oil on canvas 78.7 x 101.5
62.10

Baronzio, Giovanni (attributed to)
d. before 1362
The Angel of the Annunciation (top), *the Nativity and Annunciation (…)*
tempera on wood 44.3 x 20.3
42.10

Baschenis, Evaristo 1617–1677
Still Life with Musical Instruments c.1660
oil on canvas 95.5 x 129
97.5

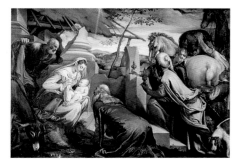

Bassano, Jacopo il vecchio c.1510–1592
The Adoration of the Magi late 1560s
oil on canvas 94.3 x 130
78.1

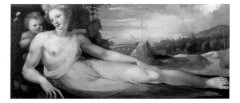

Beccafumi, Domenico 1484–1551
Reclining Nymph c.1519
oil on wood 71.1 x 138
62.6

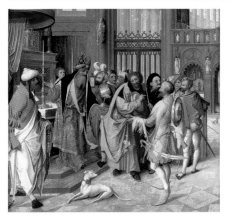

Beer, Jan de c.1475–1528
Joseph and the Suitors (recto) c.1515–1520
oil on wood 137 x 137
51.5

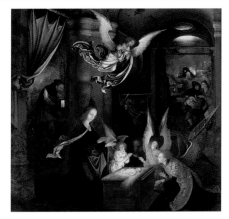

Beer, Jan de c.1475–1528
The Nativity (verso) c.1515–1520
oil on wood 137 x 137
51.5

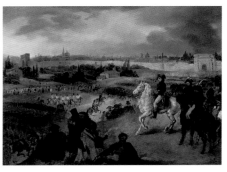

Bellangé, Hippolyte 1800–1866
The Entry of Bonaparte into Milan
oil on canvas 44.4 x 60.3
53.1

Bellini, Giovanni 1431–1436–1516
St Jerome in the Wilderness c.1450
tempera on wood 44 x 22.9
49.1

Bellini, Giovanni 1431–1436–1516
Portrait of a Boy probably 1470s
tempera on wood 38 x 23
46.11

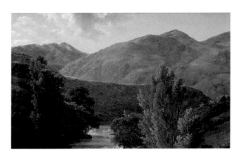

Bidauld, Jean Joseph Xavier 1758–1846
The Last Cascade of L'Isola di Sora 1789
oil on paper laid on canvas 25.4 x 39.4

Bonnard, Pierre 1867–1947
The Dolls' Dinner Party c.1903
oil on canvas 37.4 x 45.5
63.2

Bonvin, François 1817–1887
The Attributes of Painting 1875–1880
oil on canvas 50.2 x 61.3
2001.7

Bordone, Paris 1500–1571
Mythological Scene probably 1530s
oil on wood 41.7 x 96.3
61.3

Botticelli, Sandro (studio of)
1444/1445–1510
The Madonna and Child with the Infant St John 1490s
tempera on canvas 130.7 x 91.4
43.10

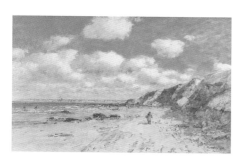

Boudin, Eugène Louis 1824–1898
A Beach near Trouville 1895
oil on canvas 54.3 x 81.2
51.1

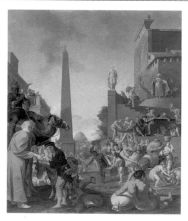

Breenbergh, Bartholomeus 1598–1657
Joseph Distributing Corn in Egypt 1655
oil on canvas 110.5 x 90
63.1

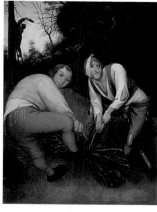

Brueghel, Pieter the younger
1564/1565–1637/1638
Two Peasants Binding Faggots
oil on wood 36.2 x 27.3
44.11

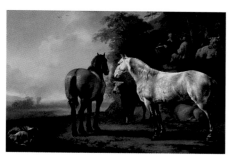

Calraet, Abraham Pietersz. van 1642–1722
Horses and Cattle in a Landscape
oil on wood 36 x 53.3
59.3

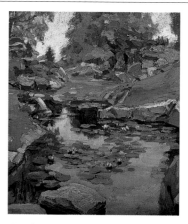

Cambier, Nestor 1879–1957
The Rock Garden at Culham Court 1915
oil on canvas 25 x 20
B/1/38

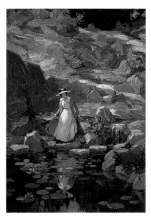

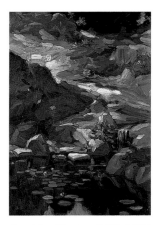

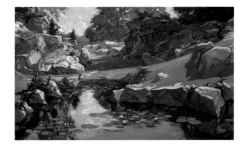

Cambier, Nestor 1879–1957
Lady Barber in Her Rock Garden 1916
oil on millboard 43.5 x 28.5
B/1/39

Cambier, Nestor 1879–1957
The Rock Garden at Culham Court (left wing)
1916
oil on board 43.5 x 29
B/1/40a

Cambier, Nestor 1879–1957
The Rock Garden at Culham Court (centre
panel) 1916
oil on board 43.5 x 69
B/1/40b

Cambier, Nestor 1879–1957
The Rock Garden at Culham Court (right wing)
1916
oil on board 43.5 x 29
B/1/40c

Cambier, Nestor 1879–1957
The Gardens at Culham Court 1917
oil on millboard 38 x 30
B/1/41

Cambier, Nestor 1879–1957
Lady Barber (1869–1933) 1919
oil on canvas 230 x 95
B/1/15

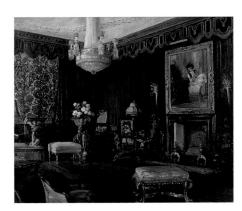

Cambier, Nestor 1879–1957
A Flower Piece 1931
oil on canvas 39.5 x 29.5
B/1/42

Cambier, Nestor 1879–1957
An Interior at Culham Court
oil on canvas 52.5 x 62.5
B/1/33

Cambier, Nestor 1879–1957
Lady Barber (1869–1933)
oil on canvas 227 x 95
B/1/11

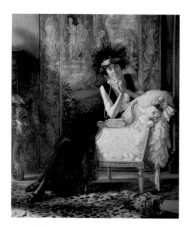

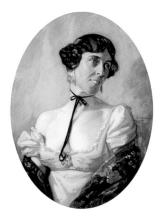

Cambier, Nestor 1879–1957
Lady Barber (1869–1933)
oil on canvas 74.5 x 53.5
B/1/12

Cambier, Nestor 1879–1957
Lady Barber (1869–1933)
oil on canvas 168 x 132
B/1/13

Cambier, Nestor 1879–1957
Lady Barber (1869–1933)
oil on canvas 75 x 53
B/1/14

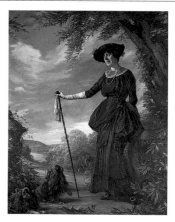

Cambier, Nestor 1879–1957
Lady Barber (1869–1933)
oil on canvas 90 x 59.5
B/1/16

Cambier, Nestor 1879–1957
Lady Barber (1869–1933)
oil on canvas 89.5 x 59
B/1/17

Cambier, Nestor 1879–1957
Lady Barber (1869–1933)
oil on canvas 216 x 157
B/1/18

Cambier, Nestor 1879–1957
Lady Barber (1869–1933)
oil on canvas 89 x 58.5
B/1/19

Cambier, Nestor 1879–1957
Lady Barber (1869–1933)
oil on canvas 89 x 59.5
B/1/20

Cambier, Nestor 1879–1957
Lady Barber (1869–1933)
oil on canvas 35 x 28.5
B/1/21

Cambier, Nestor 1879–1957
Lady Barber (1869–1933)
oil on canvas 21.5 x 27.5
B/1/22

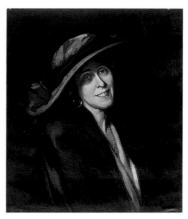

Cambier, Nestor 1879–1957
Lady Barber (1869–1933)
oil on canvas 62 x 52
B/1/23

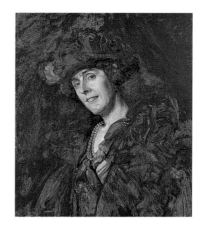

Cambier, Nestor 1879–1957
Lady Barber (1869–1933)
oil on canvas 62 x 52
B/1/24

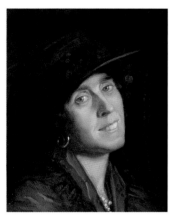

Cambier, Nestor 1879–1957
Lady Barber (1869–1933)
oil on canvas 35 x 28.5
B/1/25

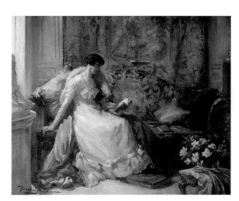

Cambier, Nestor 1879–1957
Lady Barber (1869–1933)
oil on canvas 22 x 27
B/1/26

Cambier, Nestor 1879–1957
Portrait of an Unidentified Widow
oil on canvas 57 x 47
B/1/32

Canaletto 1697–1768
The Loggetta, Venice
oil on canvas 45.5 x 75.4
54.1

Cappelle, Jan van de 1626–1679
Boats on Ruffled Water
oil on canvas 71 x 63.5
43.1

Castello, Valerio 1624–1659
The Madonna and Child with Saints Peter and Paul Appearing to St Bruno probably 1650s
oil on canvas 118 x 145.5
61.2

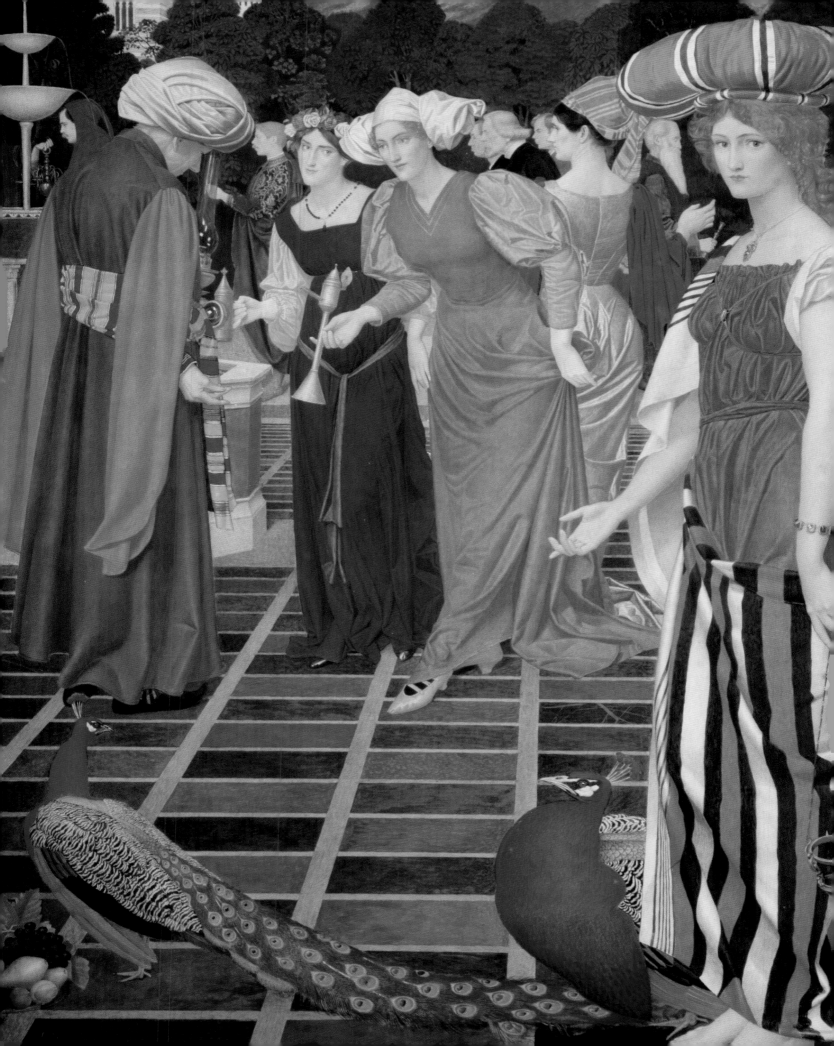

Castiglione, Giovanni Benedetto 1609–1664
Rebecca Led by the Servant of Abraham c.1650
oil on canvas 150 x 194.5
67.5

Cavallino, Bernardo 1616/1622–1654/1656
St Catherine of Alexandria
probably late 1640s
oil on canvas 71.7 x 59
65.8

Cesari, Giuseppe 1568–1640
St Lawrence among the Poor and Sick
before 1588
oil on canvas 61.5 x 73.5
88.1

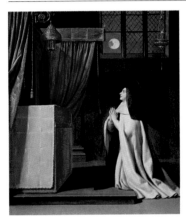 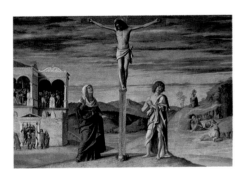 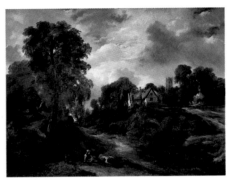

Champaigne, Philippe de 1602–1674
The Vision of St Juliana of Mont Cornillon
oil on canvas 47.5 x 38.7
63.4

Cima da Conegliano, Giovanni Battista
c.1459–1517
Christ on the Cross with the Virgin and St John the Evangelist
tempera on wood 82.5 x 115.2
38.4

Constable, John (imitator of) 1776–1837
The Glebe Farm after 1832
oil on canvas 99 x 124.5
40.2

 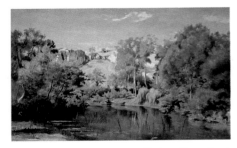 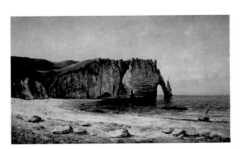

Corot, Jean-Baptiste-Camille 1796–1875
Landscape with Distant Mountains
c.1840–1845
oil on canvas 18 x 29.8
70.3

Corot, Jean-Baptiste-Camille (attributed to)
1796–1875
Wooded Landscape with a Pond
probably mid-1830s
oil on canvas 46.4 x 74.1
40.3

Courbet, Gustave 1819–1877
The Sea Arch at Étretat 1869
oil on canvas 76.2 x 123.1
47.2

Facing page: Southall, Joseph Edward, 1861–1944, *New Lamps for Old* (detail), 1900, Birmingham Museums
and Art Gallery, (p. 182)

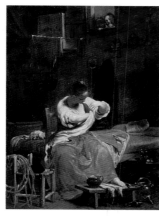

Crespi, Giuseppe Maria 1665–1747
The Flea probably c.1715–1720
oil on canvas 49.5 x 38
65.3

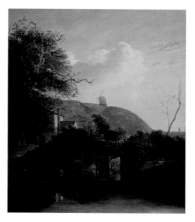

Crome, John 1768–1821 & **Crome, John
Berney** 1794–1842
A View near Harwich probably c.1832
oil on canvas 114.3 x 96.5
39.21

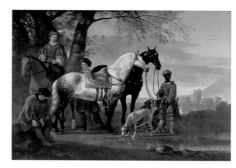

Cuyp, Aelbert 1620–1691
Huntsmen Halted probably early 1650s
oil on canvas 92.7 x 130.8
59.5

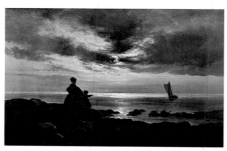

Dahl, Johan Christian Clausen 1788–1857
Mother and Child by the Sea 1840
oil on canvas 21 x 31
2002.5

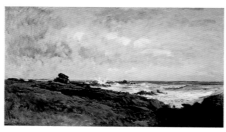

Daubigny, Charles-François 1817–1878
Seascape c.1867
oil on canvas 84 x 146.5
72.1

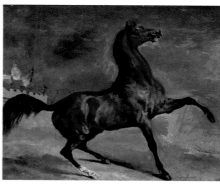

Dedreux, Alfred 1810–1860
A Horse in a Landscape
oil on canvas 34.3 x 44.4
54.7

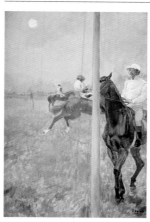

Degas, Edgar 1834–1917
Jockeys before the Race 1878–1879
oil, essence, gouache & pastel on paper
107.3 x 73.7
50.2

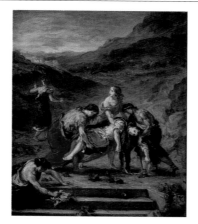

Delacroix, Eugène 1798–1863
St Stephen Borne away by His Disciples 1862
oil on canvas 46.6 x 38
62.1

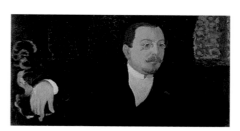

Denis, Maurice 1870–1943
Monsieur Huc 1892
oil on millboard 53.5 x 285
87.1

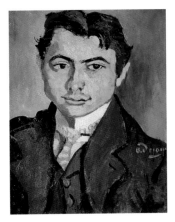

Derain, André 1880–1954
Bartolomeo Savona 1906
oil on canvas 45.7 x 35.4
97.1

Dosso, Dossi c.1486–1542
Scenes from the Aeneid: The Sicilian Games
1520s
oil on canvas 58.5 x 167.5
64.5

Dughet, Gaspard 1615–1675
Classical Landscape with Figures
probably 1672–1675
oil on canvas 36.8 x 47
69.8

Dujardin, Karel 1626–1678
Pastoral Landscape probably 1650s
oil on wood 28 x 34
67.2

Dusart, Cornelis 1660–1704
The Milk Seller 1679
oil on wood 38.8 x 29.5
49.8

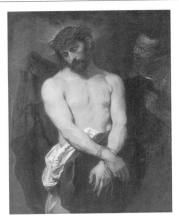

Dyck, Anthony van 1599–1641
Ecce Homo c.1625–1626
oil on canvas 101.5 x 78.7
54.4

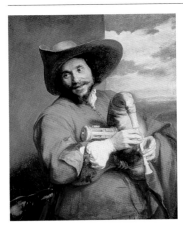

Dyck, Anthony van 1599–1641
François Langlois (1589–1647) probably 1637
oil on canvas 97.8 x 80
97.4/6567

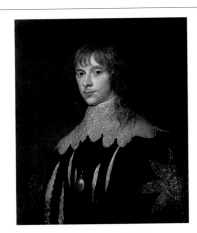

Dyck, Anthony van (after) 1599–1641
James Stuart (1612–1655), 4th Duke of Lennox
oil on canvas 74 x 61
B/1/45

Fearnley, Thomas 1802–1842
Ramsau 1832
oil on paper laid down on canvas 28 x 27
2005.5

Fetti, Domenico c.1589–1623
The Blind Leading the Blind 1621–1622
oil on wood 60.7 x 44.2
49.13

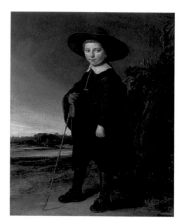

Flinck, Govaert 1615–1660
Portrait of a Boy 1640
oil on canvas 129.5 x 102.5
40.8

Gainsborough, Thomas 1727–1788
The Harvest Wagon 1767
oil on canvas 120.5 x 144.7
46.8

Gainsborough, Thomas 1727–1788
Giusto Ferdinando Tenducci (1734–1790)
c.1773–1775
oil on canvas 76.6 x 64
44.3

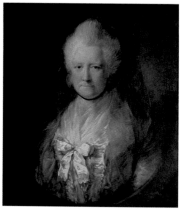

Gainsborough, Thomas 1727–1788
*The Honourable Harriott Marsham
(1721–1796)* probably late 1770s
oil on canvas 75 x 61
46.9

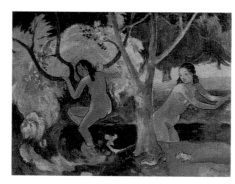

Gauguin, Paul 1848–1903
Bathers in Tahiti 1897
oil on sacking 73.3 x 91.8
49.9

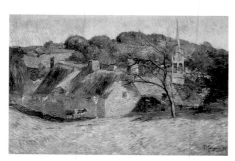

Gauguin, Paul (attributed to) 1848–1903
Landscape at Pont-Aven 1888
oil on canvas 66.1 x 100
48.12

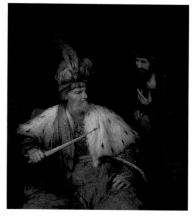

Gelder, Aert de 1645–1727
Ahasuerus and Haman
oil on canvas 138.5 x 116.8
47.3

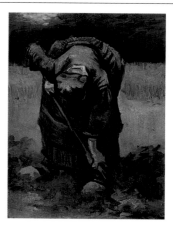

Gogh, Vincent van 1853–1890
A Peasant Woman Digging 1885
oil on canvas 42 x 32
61.8

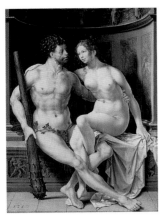

Gossaert, Jan c.1478–1532
Hercules and Deianira 1517
oil on wood 36.8 x 26.6
46.10

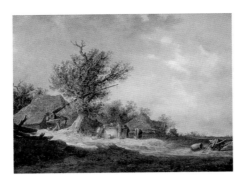

Goyen, Jan van 1596–1656
Landscape in the Dunes 1631
oil on wood 42.5 x 54.5
59.4

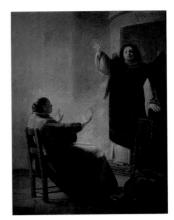

Grebber, Pieter Fransz. de (attributed to)
c.1600–c.1653
The Angel Appearing to Anna
oil on wood 38.7 x 29.8
51.2

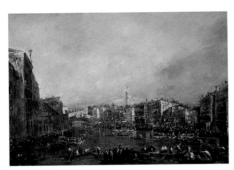

Guardi, Francesco 1712–1793
A Regatta on the Grand Canal, Venice
oil on canvas 67 x 92.1
41.1

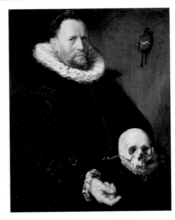

Hals, Frans c.1581–1666
Portrait of a Man Holding a Skull
c.1610–1614
oil on wood 94 x 72.5
38.6

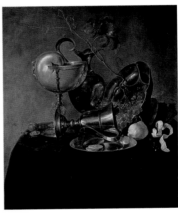

Heem, Jan Davidsz. de 1606–1683/1684
Still Life with a Nautilus Cup 1632
oil on wood 77.5 x 64.7
41.2

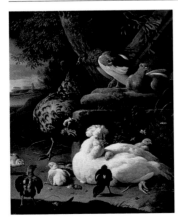

Hondecoeter, Melchior de 1636–1695
*A Hen with Chicks, a Rooster and Pigeons in a
Landscape* c.1670
oil on canvas 96.5 x 78.8
2001.2

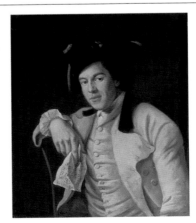

Hone, Nathaniel I 1718–1784
Charles Lee Lewes (1740–1803) after 1767
oil on canvas 71 x 61
59.6

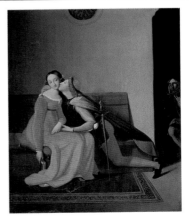

Ingres, Jean-Auguste-Dominique
1780–1867
Paolo and Francesca
oil on canvas 35 x 28
54.6

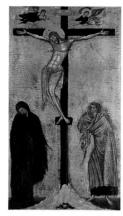

Italian School late 13th C
The Crucifixion
tempera on wood 50.8 x 27
39.1

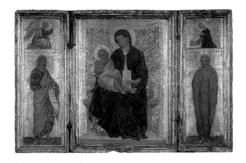

Italian School
Madonna and Child Enthroned (centre panel),
St John the Baptist (left wing) *with the Angel
of the Annunciation (…)* 1360s/1370s
tempera on wood 27 x 10; 27 x 20; 27 x 10
60.5

Italian School
St Dominic (left wing) *and an Unidentified
Female Saint* (right wing) (verso) 1360s/
1370s
tempera on wood 27 x 10; 27 x 20; 27 x 10
60.5

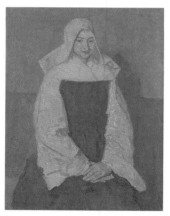

John, Gwen 1876–1939
Mère Pousseprin (1653–1744) c.1915–1920
oil on canvas 60.5 x 45.3
76.1

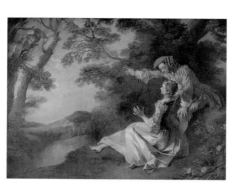

Lancret, Nicolas 1690–1743
Lovers in a Landscape
oil on canvas 75.3 x 97.5
37.10

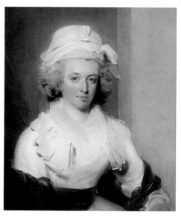

Lawrence, Thomas 1769–1830
Portrait of a Lady c.1790–1795
oil on canvas 73.6 x 60.9
58.17

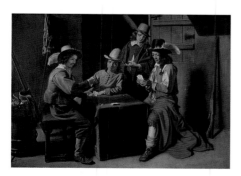

Le Nain, Mathieu (follower of) 1607–1677
The Gamesters probably early 1650s
oil on canvas 85 x 114.3
41.8

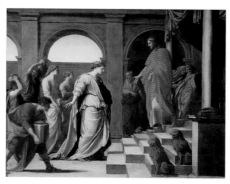

Le Sueur, Eustache 1616–1655
Solomon and the Queen of Sheba
oil on canvas 92.7 x 114.9
58.7

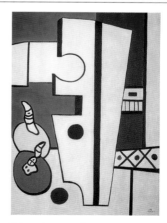

Léger, Fernand 1881–1955
Composition with Fruit 1938
oil on canvas 92 x 65
85.1

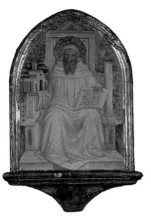

Lorenzo di Bicci c.1350–1427
St Romuald
tempera on wood 34.3 x 22.8
50.6

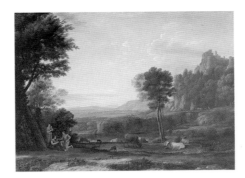

Lorrain, Claude 1604–1682
Pastoral Landscape c.1645
oil on canvas 101.5 x 134
53.6

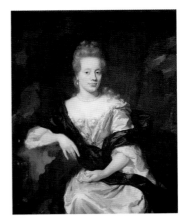

Maes, Nicolaes 1634–1693
Portrait of a Lady probably mid-1670s
oil on canvas 113.6 x 89.5
44.12

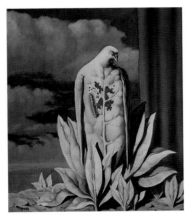

Magritte, René 1898–1967
The Flavour of Tears 1948
oil on canvas 59.4 x 49.5
83.1

Mancini, Antonio 1852–1930
The Peacock Feather 1875
oil on canvas 81 x 59.5
B/1/51

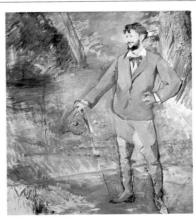

Manet, Édouard 1832–1883
Carolus-Duran (1838–1917) begun 1876
oil on canvas 191.8 x 172.7
37.12

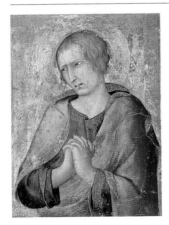

Martini, Simone c.1284–1344
St John the Evangelist
tempera on wood 41.7 x 30.3
38.12

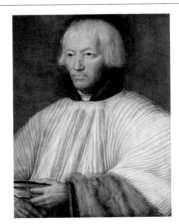

Massys, Quinten 1466–1530
Portrait of an Ecclesiastic
oil on wood 66.3 x 51
43.5

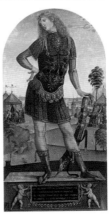

Master of the Griselda Legend
active late 15th-early 16th C
Alexander the Great (356–323 BC)
tempera on wood 105.4 x 50.8
51.4

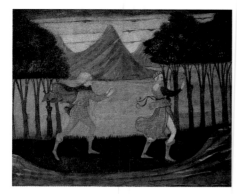

Master of the Judgement of Paris
active mid-15th C
Daphne Pursued by Apollo
tempera on wood 47.4 x 53.1
50.7a

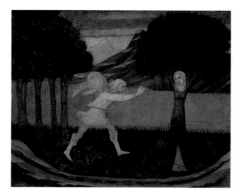

Master of the Judgement of Paris
active mid-15th C
The Metamorphosis of Daphne
tempera on wood 47.5 x 53.1
50.7b

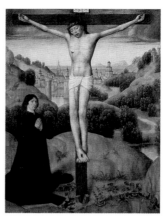

Master of the Saint Ursula Legend
active c.1485–1515
Christ on the Cross, with a Donor
oil on wood 44 x 33
60.8

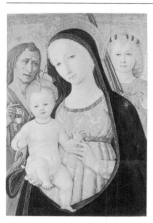

Matteo di Giovanni c.1430–1495
Madonna and Child with St John the Baptist and St Michael the Archangel c.1485–1495
tempera on wood 57.9 x 40.4
44.2

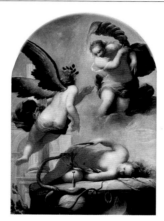

Mazzoni, Sebastiano c.1611–1678
The Three Fates c.1670
oil on canvas 210.5 x 153.3
90.1

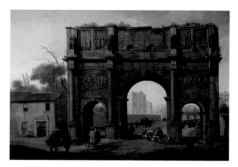

Miel, Jan 1599–1663
The Arch of Constantine, Rome 1640s
oil on canvas 126.3 x 175.2
69.3

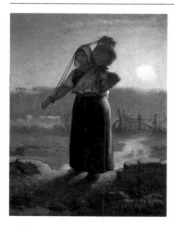

Millet, Jean-François 1814–1875
A Milkmaid c.1853
oil on canvas 32.5 x 24
77.1

Molijn, Pieter de 1595–1661
Landscape with a Huntsman
oil on wood 33 x 54.6
52.2

Monet, Claude 1840–1926
The Church at Varengeville 1882
oil on canvas 65 x 81.3
38.7

Facing page: Witte, Emanuel de, c.1617–1692, *Interior of the Oude Kerk, Amsterdam* (detail), The Barber Institute of Fine Arts, (p. 241)

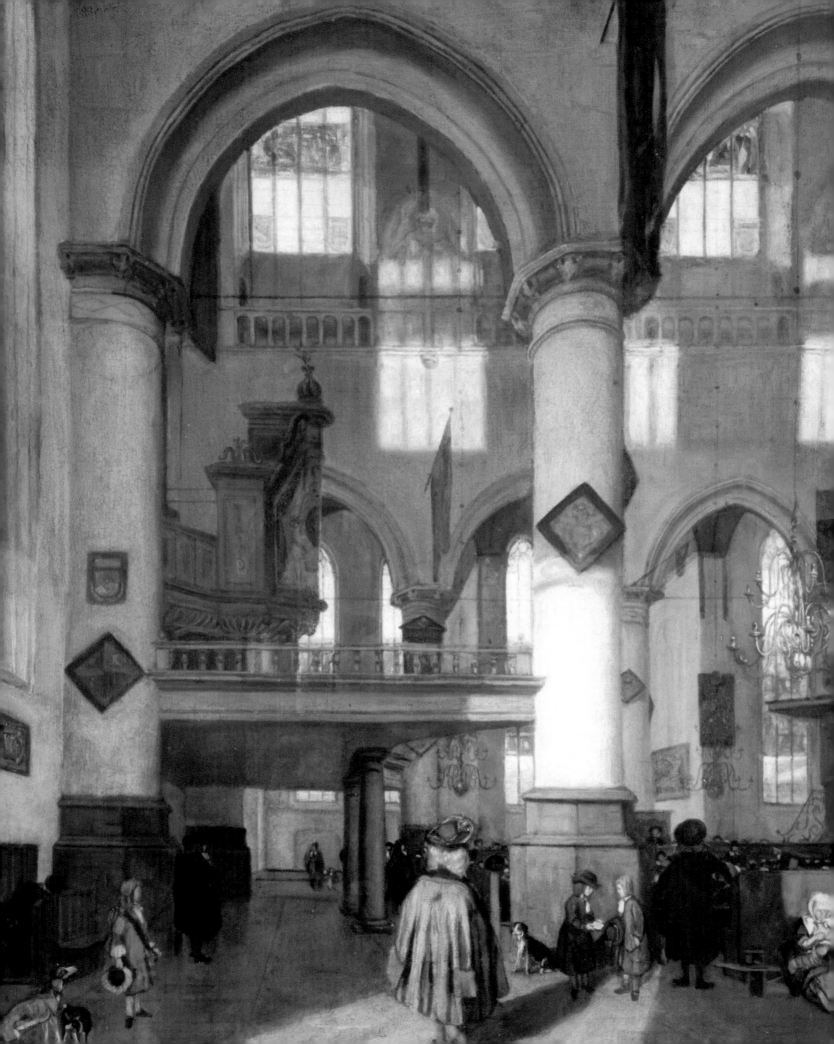

Murillo, Bartolomé Esteban 1618–1682
The Marriage Feast at Cana c.1672
oil on canvas 179 x 235
47.9

Neri di Bicci 1418–1492
St John the Baptist Leaving for the Desert 1470
tempera on wood 23.8 x 37.8
50.5

Netherlandish School
The Deposition (centre panel), *Adam and Eve Mourning Abel* (left wing), *Joseph's Coat Shown to Jacob* (right wing) (recto) c.1470
oil on wood 52.5 x 16.7; 53.3 x 42.8; 52.5 x 16.7
60.4

Netherlandish School
St Veronica (left wing), *St Helena* (right wing) (verso) c.1470
oil on wood 52.5 x 16.7; 52.5 x 16.7
60.4

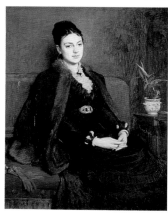

Orchardson, William Quiller 1832–1910
Lady Orchardson (1854–1917) 1873
oil on canvas 124.5 x 97.8
39.23

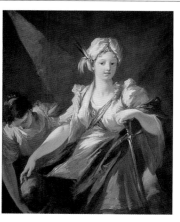

Pellegrini, Giovanni Antonio 1675–1741
Judith and Her Maidservant with the Head of Holofernes c.1710
oil on canvas 124.7 x 102
74.1

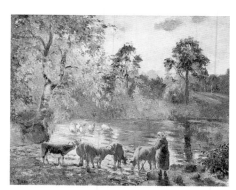

Pissarro, Camille 1831–1903
The Pond at Montfoucault 1875
oil on canvas 73.6 x 92.7
55.16

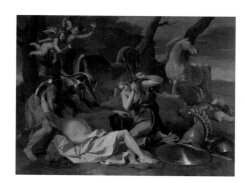

Poussin, Nicolas 1594–1665
Tancred and Erminia c.1634
oil on canvas 75.5 x 99.7
38.9

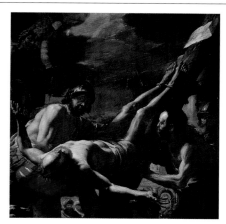

Preti, Mattia 1613–1699
The Martyrdom of St Peter c.1656–1660
oil on canvas 194.5 x 194.3
71.1

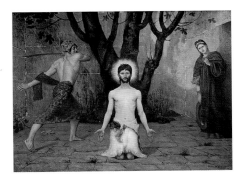

Puvis de Chavannes, Pierre 1824–1898
The Beheading of St John the Baptist 1869
oil on canvas 124.5 x 166
56.5

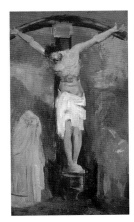

Redon, Odilon 1840–1916
The Crucifixion 1904
oil on canvas 46 x 27
81.1

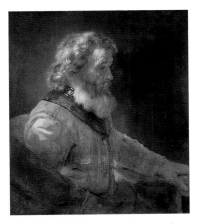

Rembrandt van Rijn (follower of)
1606–1669
An Old Warrior
oil on canvas 74.7 x 64.6
41.7

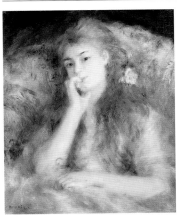

Renoir, Pierre-Auguste 1841–1919
Young Woman Seated c.1876–1877
oil on canvas 66 x 55.5
84.1

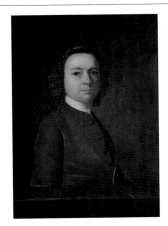

Reynolds, Joshua 1723–1792
Portrait of a Young Man c.1746
oil on canvas 34.3 x 24.1
69.10

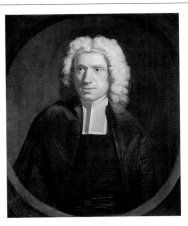

Reynolds, Joshua 1723–1792
The Reverend William Beele (1704–1757)
c.1748–1749
oil on canvas 76.2 x 63.5
70.1

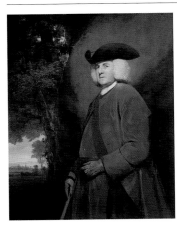

Reynolds, Joshua 1723–1792
Richard Robinson (1709–1794), DD 1779
oil on canvas 142.3 x 114.5
43.9

Ricci, Sebastiano 1659–1734
*Allegorical Tomb of the 1st Duke of
Devonshire* c.1725
oil on canvas 217.8 x 138.4
58.4

Robert, Hubert 1733–1808
A Caprice with a Hermitage 1796
oil on canvas 80 x 64.8
64.4

Romney, George 1734–1802
John Smith (1703–1787) 1782
oil on canvas 127 x 101.6
52.4

Rosselli, Cosimo 1439–1507
The Adoration of the Child Jesus
probably 1480s
tempera on wood 177.8 x 147.3
65.7

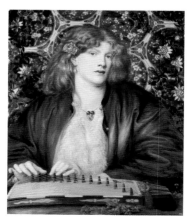

Rossetti, Dante Gabriel 1828–1882
The Blue Bower 1865
oil on canvas 84 x 70.9
59.1

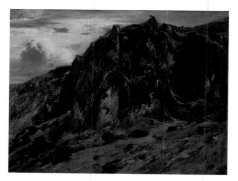

Rousseau, Théodore 1812–1867
Landscape in the Auvergne 1830
oil on paper laid on canvas 33 x 42.2
60.12

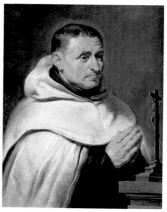

Rubens, Peter Paul 1577–1640
Portrait of a Carmelite Prior 1616
oil on wood 79.5 x 65.5
99.1

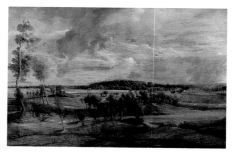

Rubens, Peter Paul 1577–1640
Landscape in Flanders
oil on wood 89.8 x 133.8
40.11

Rubens, Peter Paul (follower of) 1577–1640
Head of a Young Woman
oil on wood 56.5 x 48.4
50.1

Ruisdael, Jacob van 1628/1629–1682
A Woodland Landscape probably 1650s
oil on canvas 61 x 84.5
38.11

Sarto, Andrea del (after) 1486–1530
*The Madonna and Child with the Infant
St John*
oil on wood 55.3 x 39
46.1

Shannon, James Jebusa 1862–1923
*Lady Barber Seated with Yorkshire Terriers in
the Music Room at Culham Court* 1908
oil on wood 73.5 x 60.5
B/1/54

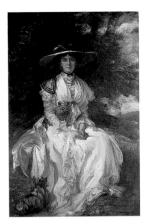

Shannon, James Jebusa 1862–1923
Lady Barber in a Landscape
oil on canvas 181 x 112.5
B/1/55

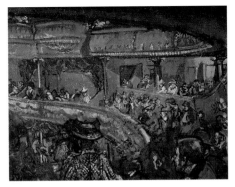

Sickert, Walter Richard 1860–1942
The Eldorado, Paris c.1906
oil on canvas 48.2 x 59
68.3

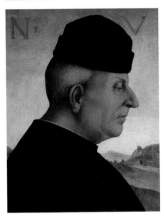

Signorelli, Luca c.1450–1523
Niccolò Vitelli (1414–1486)
tempera on wood 44.2 x 33
45.3

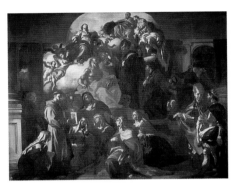

Solimena, Francesco 1657–1747
*The Holy Trinity with the Madonna and
Saints* c.1705
oil on canvas 101 x 128
67.6

Spanish School 19th C
Portrait of an Old Woman
oil on canvas 105 x 85
40.5

Steen, Jan 1626–1679
The Wrath of Ahasuerus c.1671–1673
oil on canvas 129 x 167
39.22

Stom, Matthias c.1600–after 1650
Isaac Blessing Jacob c.1635
oil on canvas 136.5 x 182
94.2

Strozzi, Bernardo 1581–1644
Head of an Old Woman
oil on canvas 48.3 x 38.8
66.8

Teniers, David II 1610–1690
The Bleaching Ground
oil on canvas 85 x 120.5
47.1

Tintoretto, Jacopo 1519–1594
Portrait of a Young Man 1554
oil on canvas 121 x 93.3
37.13

Toulouse-Lautrec, Henri de 1864–1901
A Woman Seated in the Garden 1890
oil on cardboard 49.4 x 31.3
48.6

Troy, Jean François de 1679–1752
Jason Taming the Bulls of Aeëtes 1742
oil on canvas 55.3 x 128.9
61.1

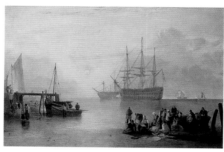

Turner, Joseph Mallord William 1775–1851
The Sun Rising through Vapour c.1809
oil on canvas 69.2 x 101.6
38.1

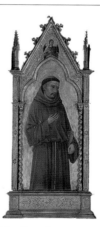

Ugolino di Nerio c.1300–1339/1349
St Francis of Assisi
tempera on wood 88.2 x 32.2
43.6

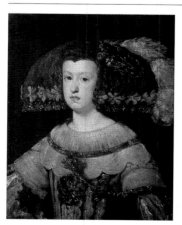

Velázquez, Diego (after) 1599–1660
Queen Mariana of Spain (1634–1696)
oil on canvas 62.5 x 52.5
B/1/56

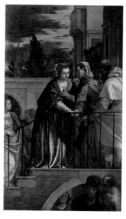

Veronese, Paolo 1528–1588
The Visitation
oil on canvas 277.5 x 156
53.5

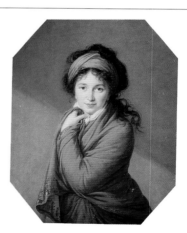

Vigée-LeBrun, Elisabeth Louise 1755–1842
Countess Golovine (1766–1821) 1797–1800
oil on canvas 83.5 x 66.7
80.1

Vliet, Hendrick Cornelisz. van c.1611–1675
A Grotto in an Imaginary Landscape
probably 1643
oil on wood 54.7 x 90.2
66.1

Vuillard, Jean Edouard 1868–1940
Madame Vuillard Arranging Her Hair 1900
oil on millboard 49.5 x 35.5
63.3

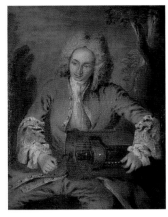

Watteau, Jean-Antoine (attributed to)
1684–1721
A Man Playing a Hurdy-Gurdy
oil on canvas 22.7 x 18
56.9

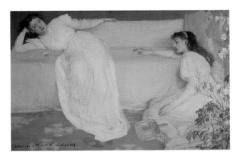

Whistler, James Abbott McNeill 1834–1903
Symphony in White, No.III 1865–1867
oil on canvas 51.4 x 76.9
39.24

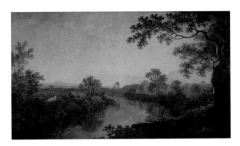

Wilson, Richard 1713/1714–1782
The River Dee, near Eaton Hall c.1759–1760
oil on canvas 54 x 88.6
37.11

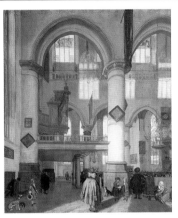

Witte, Emanuel de c.1617–1692
Interior of the Oude Kerk, Amsterdam
oil on canvas 83.5 x 66.5
74.2

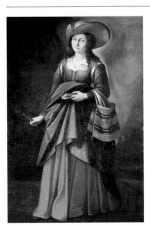

Zurbarán, Francisco de (studio of)
1598–1664
St Marina
oil on canvas 160 x 107
52.1

University of Birmingham

The oil painting collections at the University of Birmingham have grown from a nucleus of commemorative portraits of founders and initial benefactors into an important group of works in which portraiture is complemented by contemporary painting.

The core of the University's Collection of historic portraits began to develop soon after the foundation of the University in 1900 when it commissioned portraits in oil, marble and bronze of distinguished University figures such as chancellors, vice-chancellors, benefactors and pioneering academics. The Collection includes works by Herbert James Gunn, George Reid and Philip Alexius de László. Recent commissions include: *Sir Julian Bullard (1928–2006)* by Humphrey Ocean (1994), *Sir Michael Thompson* by Tom Wood (1996), *Professor Maxwell Irvine* by John Notter (2001), *Roger Burman, Pro-Chancellor (1994–2001)* by Peter Douglas Edwards (2002), and *David Hannay (b.1935), Baron Hannay of Chiswick* by Tom Phillips (2006). These portraits hang in the Great Hall and in corridors of the Aston Webb Building. Departments including Law, Earth Sciences and Physics also hold portraits of early pioneering professors. Other portraits include *Abd el-Ouahed ben Messaoud ben Mohammed Anoun (b.1558), Moorish Ambassador to Queen Elizabeth I* (1600) considered to be the inspiration for Othello.

Acquisitions have historically been driven by a particular individual, or a small *ad hoc* group, notably in the 1960s and 1970s the late Professors Kolbuszewski and Lewis and the then University Treasurer, the late Angus Skene. Together, they and others acquired woks by Peter Lanyon, Barbara Hepworth and William Gear. Peter Lanyon's *Arts Faculty Mural* (1963) mingles reflections on the Cornish landscape, weather and light with the red brick and icy spaces of the University in the snow. It is Lanyon's last large work painted a year before his untimely death.

Since the early 1990s gifts, commissions and purchases have included Sonia Lawson's *Guardian I* (1994) and *Guardian II* (1994), full of vivid poetic imagery evoking companionship and reliability; John Walker's *The Blue Cloud* (1996) which uses landscape, figures and literature to consider the cyclic nature of life and death; and David Prentice's series of mirror paintings, *Pleides* (1970), which relate to research into the formation of metallic lattices and grids on a micro scale.

Notable gifts are the group of paintings by Roger Eliot Fry, given by the artist's sister Margery Fry in the 1920s, and the bequest of John Galsworthy family portraits from Rudolf Sauter in 1977. More recently a group of six paintings from the Chantrey Bequest were given to the University in 2001. This includes works by John Arthur Malcolm Aldridge, Kum-Siew Mak and Brian Robb. A particularly popular part of the collections is the group of sunflowers and a self portrait by the late John Randall Bratby, decorating the Bratby Bar in Staff House. This was named for the artist, who was given an honorary degree by the University in 1992. Bratby died soon after the conferment.

The Campus Collection of Fine and Decorative Art is dispersed around sites in Edgbaston, Selly Oak, Birmingham city centre and Stratford-on-Avon, as well as being displayed throughout departments and indoor and outdoor spaces. They include works with commemorative and emblematic purpose,

and offer enlightenment whilst at the same time enhancing their surroundings, encouraging unexpected creative dialogues or responses. In public spaces the campus art Collection reaches thousands of people who may never venture into an art gallery.

Along with the Campus Collection of Fine and Decorative Art, the University owns, displays and teaches from groups of objects within seven distinct collections, including Archaeology, Physics, Pathology and the Danford Collection of West African Art and Artefacts. To see our Collections online, please visit: www.collections.bham.ac.uk.

Dr James Hamilton, University Curator & Clare Mullett, Assistant University Curator

Aldridge, John Arthur Malcolm 1905–1983
Villafranca di Verona 1974
oil on canvas 87 x 114.5
A0919

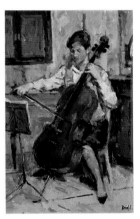

Bod, Laszlo b.1920
Cello Player c.1980
oil on canvas 60 x 40
A0963

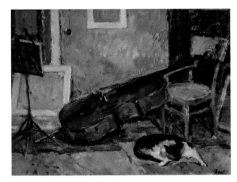

Bod, Laszlo b.1920
Dormant Cello c.1980
oil on panel 40 x 50
A0966 (P)

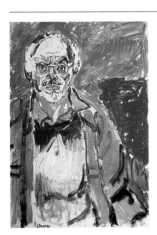

Bratby, John Randall 1928–1992
Self Portrait c.1980
oil on canvas 90 x 60
A0912

Bratby, John Randall 1928–1992
Sunflowers 1989
oil on canvas 120 x 60
A0909

Bratby, John Randall 1928–1992
Sunflowers 1989
oil on canvas 120 x 75
A0910

Bratby, John Randall 1928–1992
Sunflowers 1989
oil on canvas 120 x 90
A0911

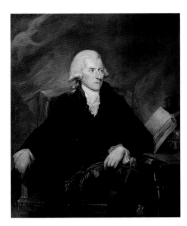

Breda, Carl Fredrik von (copy after)
1759–1818
William Withering (1741–1799) 20th C
oil on canvas 124.5 x 101.6
A0229

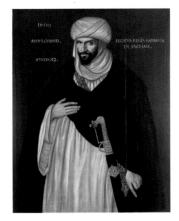

British (English) School
*Abd el-Ouahed ben Messaoud ben Mohammed
Anoun (b.1558), Moorish Ambassador to
Queen Elizabeth I* 1600
oil on canvas 113 x 87.6
A0427

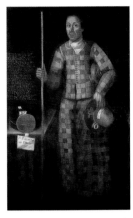

British (English) School 17th C
Tom Skelton
oil on canvas 182.9 x 121.9
A0435

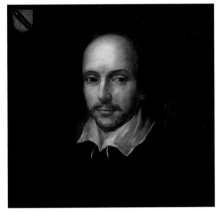

British (English) School 18th C
*William Shakespeare (1564–1616), with the
Arms of John Shakespeare*
oil on canvas 53.3 x 53.3
A0452

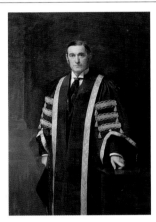

British (English) School
*Charles Gabriel Beale (1843–1912),
Pro-Chancellor* 1912
oil on canvas 151.1 x 99.1
A0025

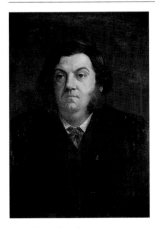

British School
*Robert Lawson Tait (1845–1899), President of
the Birmingham Medical Institute* 1880s
oil on canvas 76.5 x 51
A0245

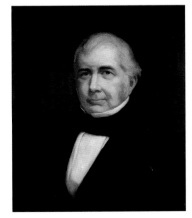

British School early 19th C
Dr John Tomlinson Ingleby
oil on canvas 55.9 x 48.3
A0272

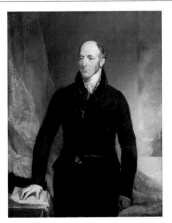

British School early 19th C
*George William Lyttelton (1817–1876), 4th
Baron Lyttelton, Principal of Queen's College,
Birmingham*
oil on canvas 130 x 104
A0902

Facing page: Pickenoy, Nicolaes Eliasz., c.1588–c.1655, *Portrait of a Woman* (detail), Birmingham Museums
and Art Gallery, (p. 158)

British School early 19th C
J. E. Piercey
oil on canvas 130 x 102 (E)
A0901

British School early 19th C
John Birt Davies
oil on canvas 130 x 102 (E)
A0900

Brook, Peter b.1927
Brighouse, Yorkshire c.1970
oil on canvas 50.8 x 61
A0058

Burden, Ruth b.1925
Sheep in a Landscape c.1960
oil on canvas 50.8 x 76.2
A0074

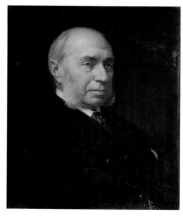

Calkin, Lance 1859–1936
Richard Peyton 1909
oil on canvas 50 x 44.5
A0226

Cambier, Nestor 1879–1957
Lady Hattie Barber (1869–1933) 1931
oil on canvas 109.2 x 59.7
A0189

Cambier, Nestor 1879–1957
Sir William Holdsworth (1871–1944),
Professor of Law 1932
oil on canvas 91.4 x 76.2
A0188

Cambier, Nestor 1879–1957
Charles Edward Smalley-Baker (1891–1972),
Professor of Law 1938
oil on canvas 91.4 x 76.2
A0187

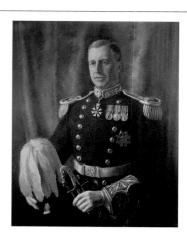

Charlton, Evan 1904–1984
Sir Reginald St Johnston (1881–1950),
Colonial Administrator 1936
oil on canvas 106.7 x 86.4
A0271

Copplestone, Trewin b.1921
Abstract Composition c.1960
oil on canvas 76.2 x 180.3
A0064

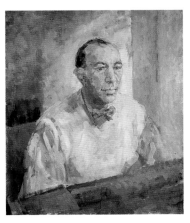

Dane, Clemence 1888–1965
Noël Coward (1899–1973) 1930s
oil on canvas 76.2 x 63.5
A0952

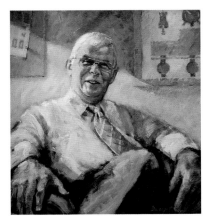

Davenport, John b.1938
*Professor Peter M. Marquis, Director of the
School of Dentistry (1999–2004)* 2005
oil on canvas 53.7 x 49
A0964

Dunlop, Ronald Ossory 1894–1973
Isle of Arran c.1960
oil on canvas 76 x 97
A0930

Edwards, John Uzzell b.1937
Awakening 1970
oil on canvas 121.9 x 121.9
A0314

Edwards, John Uzzell b.1937
'When I was born…' 1995
oil on canvas 129.5 x 119.4
A0877

Edwards, John Uzzell b.1937
'Once more unto the breach…' 1999
oil on canvas 91.4 x 91.4
A0918

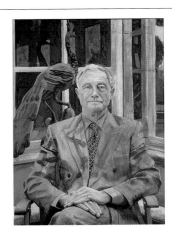

Edwards, Peter Douglas b.1955
Roger Burman, Pro-Chancellor (1994–2001)
2002
oil on canvas 107 x 77
A0926

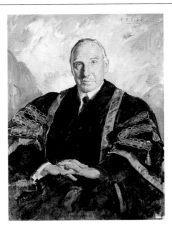

Eves, Reginald Grenville 1876–1941
*Sir Walter Barrow (1867–1954),
Pro-Chancellor* 1939
oil on canvas 121.9 x 94
A0934

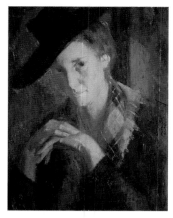

Fleetwood-Walker, Bernard 1893–1965
Peggy in a Black Hat c.1930
oil on canvas 48.3 x 41.9
A0962

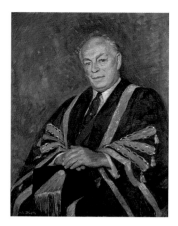

Freeth, Hubert Andrew 1913–1986
Sir Stephen Burman, Pro-Chancellor 1966
oil on canvas 99.1 x 76.2
A0003

Fry, Roger Eliot 1866–1934
Landscape with St George and the Dragon
1910
oil on canvas 83.8 x 114.3
A0339

Fry, Roger Eliot 1866–1934
Town in the Mountains with Poplars 1910s
oil on hessian 102.2 x 153
A0340

Fry, Roger Eliot 1866–1934
The Window 1918
oil on canvas 48.3 x 66
A0336

Fry, Roger Eliot 1866–1934
Large House with Terrace 1920
oil on canvas 67.3 x 58.4
A0334

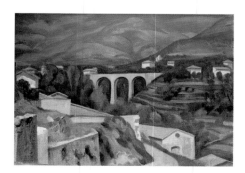

Fry, Roger Eliot 1866–1934
French Landscape 1920s
oil on canvas 53.3 x 72.4
A0337

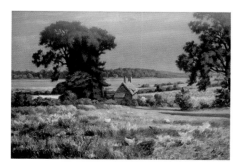

Fry, Roger Eliot 1866–1934
The Deben Estuary near Woodbridge 1920s
oil on canvas 54.6 x 78.7
A0335

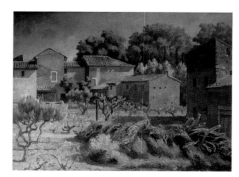

Fry, Roger Eliot 1866–1934
Beaumes de Venise 1930
oil on canvas 59.7 x 78.7
A0338

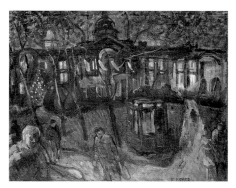

Fryer, Katherine Mary b.1910
City Centre, Old Style 1990
oil on canvas 58 x 72
A0908

Gear, William 1915–1997
White Structure 1954
oil on canvas 77.5 x 50.2
A0062

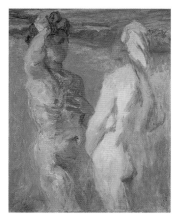

Gotlib, Henryk 1890–1966
Two Women in a Landscape 1950s
oil on canvas 111.8 x 86.4
A0223

Grant, Keith b.1930
Sunrise over Spitzbergen 1981
oil on canvas 96.5 x 150
A0278

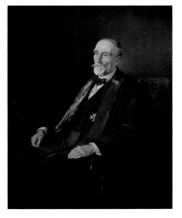

Griffiths, Gwenny b.1867
Robert F. C. Leith 1930
oil on canvas 106.7 x 76.2
A0031

Grillo, Yusuf b.1934
Musicians in Procession c.1960
oil on hardboard 54 x 47
D0132

Gross, Peter Barrie 1924–1987
Professor F. H. Garner, Professor of Chemical Engineering 1960
oil on canvas 81.3 x 55.9
A0218

Groves, Robert b.1935
Abstract in Blue 1968
tempera on panel 53.3 x 45.7
A0059

Gunn, Herbert James 1893–1964
Arthur Neville Chamberlain (1869–1940) 1938
oil on canvas 152.4 x 101.6
A0136

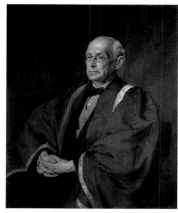

Gunn, Herbert James 1893–1964
Sir Charles Grant Robertson (1869–1948), Vice-Chancellor 1938
oil on canvas 109.2 x 91.4
A0024

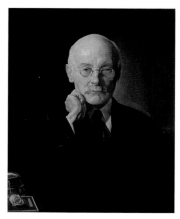

Harvey, Harold C. 1874–1941
John Humphreys (1850–1937), Professor of Dentistry 1938
oil on canvas 76.2 x 63.5
A0634 ✼

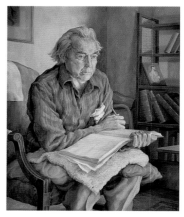

Harvey, Neil b.1960
Professor Philip Brockbank, Professor of English 1995
oil on canvas 94 x 77.5
A0451B

Heald, Gae
Promise
oil on canvas 63.5 x 76.2
A0117

Hepple, Norman 1908–1994
Lord Hunter of Newington, Vice-Chancellor 1979
oil on canvas 100.3 x 74.9
A0006 ✼

Hepple, Norman 1908–1994
Professor Norman Lancaster, Vice-Chancellor 1979
oil on canvas 100.3 x 74.9
A0008 ✼

Hepple, Norman 1908–1994
Charles Beale, Pro-Chancellor 1981
oil on canvas 99.1 x 73.7 (E)
A0022 ✼

Hepple, Norman 1908–1994
Sir Alex Jarratt, Chancellor 1985
oil on canvas 99.1 x 73.7 (E)
A0019 ✼

Hepple, Norman 1908–1994
Professor Edward A. Marsland, Vice-Chancellor 1986
oil on canvas 100.3 x 74.9
A0007 ✼

Hepple, Norman 1908–1994
Professor Jean R. F. Wilks, Pro-Chancellor 1987
oil on canvas 100.3 x 74.9
A0005

Hepworth, Barbara 1903–1975
Oval Form with Strings 1960
oil & pencil on board 44.5 x 85.1
A0215

Hewitt, Geoffrey b.1930
Landscape c.1960
oil on board 45.7 x 81.3
A0069

Hill, Derek 1916–2000
*The Right Honourable Earl of Avon
(1897–1977), Chancellor* 1974
oil on canvas 137.2 x 81.3
A0017

Hughes, John Joseph 1820–1909
A Pleasant Lane at Hamstead 1865
oil on canvas 61
A0261

Italian School
*Basilica di San Francesco d'Assisi with a
Procession* c.1940
oil on canvas 38.1 x 53.3
A0288

Jagger, David 1891–1958
Sir Horace Clarke 1949
oil on canvas 96.5 x 63.5
A0309

Johnson, R.
Yachts 1964
oil on canvas 76.2 x 55.9
A0068

Jones, Lucy b.1955
South Bank 1980s
oil on canvas 175.3 x 213.3
L0041 (P)

Lanyon, Peter 1918–1964
Arts Faculty Mural 1963
oil on board 259.1 x 513.1
A0083

László, Philip Alexius de 1869–1937
Viscount Cecil of Chelwood (1864–1958),
Chancellor 1932
oil on canvas 162.6 x 106.7
A0016

Lawson, Sonia b.1934
Guardian I 1994
oil on canvas 152.4 x 121.9
A0864

Lawson, Sonia b.1934
Guardian II 1994
oil on canvas 152.4 x 121.9
A0865

Leary, Alan
Zane-Zane 1993
acrylic on panel 107 x 147.5
A0860

Loe, Vera
Pear Tree with Fruit 1972
oil on canvas 84.2 x 75
A0920

Mak, Kum-Siew (Mai Jinyao) b.1940
Homage to Hsieh-Ho 1972
oil on canvas 168 x 183.2 (E)
A0921

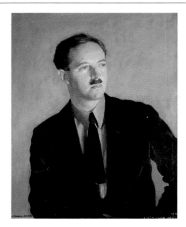

Mann, Cathleen 1896–1959
Francis Brett Young (1884–1954) 1922
oil on canvas 73.7 x 61
A0262

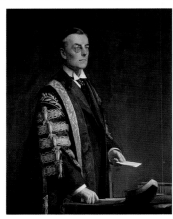

Mann, Harrington (attributed to)
1864–1936
The Right Honourable Joseph Chamberlain,
MP (1836–1914) c.1900
oil on canvas 124.5 x 99.1
A0020

Facing page: Poussin, Nicolas, 1594–1665, *Tancred and Erminia* (detail), c.1634, The Barber Institute of Fine Arts, (p. 236)

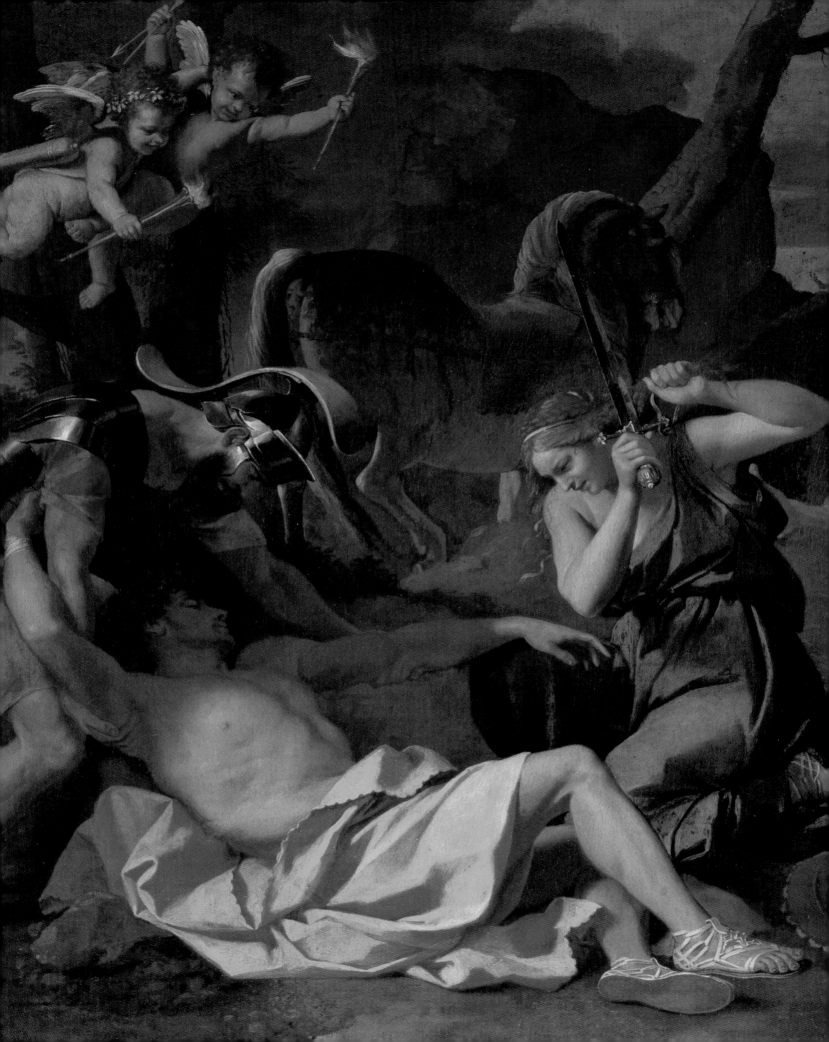

Mason, Gilbert 1913–1972
Coastal Harbour with Yachts 1963
oil on board 59.7 x 121.9
A0073

Mason, Gilbert 1913–1972
Landscape 1963
oil on paper 91.4 x 121.9
A0072

McClure, David 1926–1998
The Ritualists 1963
oil on board 61 x 76.2
A0222

McKnight, David
Javelin
acrylic on board 122 x 244
A0283

McKnight, David
Pole-vaulter
acrylic on board 183 x 183
A0282

McKnight, David
Runner
acrylic on board 122 x 244
A0281

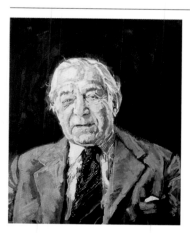

Mee, Henry b.1955
Sir Solly Zuckerman (1904–1993), Professor of Anatomy 1988
oil on canvas 90.2 x 76.2
A0228

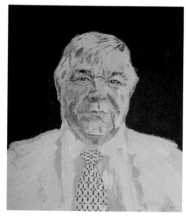

Mee, Henry b.1955
Robert Hicks (b.1941) 2002
oil on canvas 90.2 x 76.2
A0927

Middleton, Colin 1910–1983
Ballyclander, June 52 1952
oil on canvas 50.8 x 61
A0100

Muckley, William Jabez 1837–1905
Wild Flowers 1880
oil on canvas 45.1 x 57.8
A0371

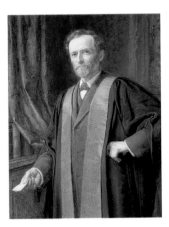

Munns, Bernard 1869–1942
George Jordan Lloyd, Professor of Surgery 1913
oil on canvas 106.7 x 76.2
A0243

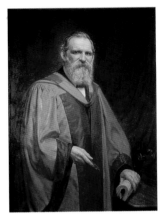

Munns, Bernard 1869–1942
Charles Lapworth (1842–1920), Professor of Geology 1914
oil on canvas 121.9 x 91.4
A0039

Munns, Bernard 1869–1942
Percy Faraday Frankland (1858–1946), Professor of Chemistry 1919
oil on canvas 106.7 x 76.2
A0032

Munns, Bernard 1869–1942
John Henry Poynting (1852–1914), Professor of Physics 1920
oil on canvas 114.3 x 86.4
A0301

Munns, Bernard 1869–1942
Professor Adrian J. Brown, MSc, FRS, Professor of Brewing 1920
oil on canvas 106.7 x 76.2
A0029

Munns, Bernard 1869–1942
Sir Granville Bantock (1868–1946), Professor of Music 1920
oil on canvas 76.2 x 107
A0224

Munns, Bernard 1869–1942
George Henry Morley, First Registar of the University 1924
oil on canvas 113 x 90.2
A0001

Munns, Bernard 1869–1942
Professor Gisbert Kapp (1852–1922), Professor of Electrical Engineering 1928
oil on canvas 143.5 x 133.4
A0318

Munns, Henry Turner 1832–1898
Sir Josiah Mason (1795–1881), Founder 1881
oil on canvas 140.2 x 109.7
A0129

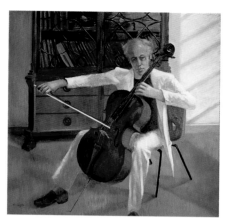

Newton, Donald
Basil Deane (1888–1978), Professor of Music
1992
oil on canvas 121 x 121
A0965

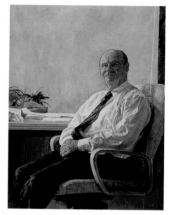

Notter, John b.1960
Professor Maxwell Irvine, Vice-Chancellor
2001
oil on canvas 120 x 90
A0925

Obi, F.
Inoyi Park c.1960
oil on canvas 53 x 63
D0134

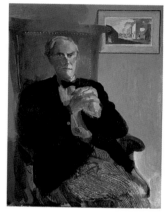

Ocean, Humphrey b.1951
Sir Julian Bullard (1928–2006),
Pro-Chancellor 1994
oil on canvas 101 x 76
A0866

Okeke, Uche b.1933
Fantasy and Masks c.1960
oil on hardboard 50 x 63
D0135

Phillips, Thomas 1770–1845
William Sands Cox (1802–1875), Surgeon and
Co-Founder of Queen's College, Birmingham
oil on canvas 121.9 x 96.5
A0251

Phillips, Tom b.1937
David Hannay (b.1935), Baron Hannay of
Chiswick, Pro-Chancellor 2006
oil on canvas 94 x 64
A0953

Polish School
Abstract 1966
oil on canvas 72.5 x 143.2
A0961

Prentice, David b.1936
Pleides (1) 1970
oil on mirrored glass 178 x 178
A0650a

Prentice, David b.1936
Pleides (2) 1970
oil on mirrored glass 89 x 445
A0650b

Prentice, David b.1936
Pleides (3) 1970
oil on mirrored glass 152.5 x 244
A0650c

Prentice, David b.1936
Pleides (4) 1970
oil on mirrored glass 89 x 89
A0650d

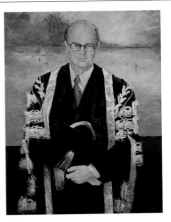

Prentice, David b.1936
Pleides (5) 1970
oil on mirrored glass 89 x 89
A0650e

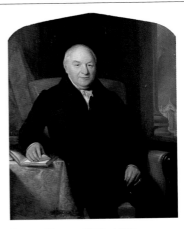

Pugh, Clifton Ernest 1924–1990
Sir Peter Scott (1909–1989), Chancellor 1976
oil on canvas 119.4 x 90.2
A0018

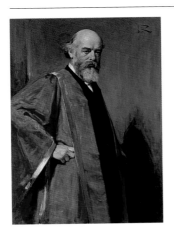

Reid, George 1841–1913
Sir Oliver Lodge (1851–1940), FRS, Principal
oil on canvas 121.9 x 91.4
A0128

Robb, Brian 1913–1979
Venetian Waterscape 1971
oil on canvas 68 x 103.6 (E)
A0922

Room, Henry 1803–1850
Edward Johnstone (1757–1851), Principal of Queen's College, Birmingham
oil on canvas 122 x 100
A0904

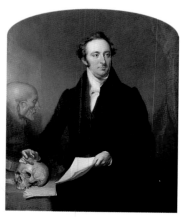

Room, Henry 1803–1850
William Sands Cox (1802–1875), Surgeon and Co-Founder of Queen's College, Birmingham
oil on canvas 122 x 100
A0903

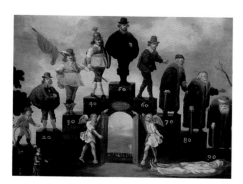

Saftleven, Cornelis 1607–1681
The Ages of Man
oil on canvas 44.4 x 58.4
A0266

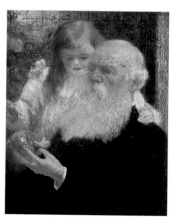

Sauter, Georg 1866–1937
Comrades c.1890
oil on canvas 68.6 x 55.9
A0164

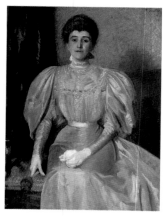

Sauter, Georg 1866–1937
Ada Galsworthy (d.1933) 1897
oil on canvas 101.6 x 76.2
A0168

Sauter, Georg 1866–1937
Maternity 1899
oil on canvas 69.9 x 49.5
A0169

Sauter, Georg 1866–1937
John Galsworthy (1867–1933) as a Young Man c.1905
oil on canvas 66 x 48.3
A0138

Sauter, Georg 1866–1937
Mabel Edith Reynolds (b.1871) 1915
oil on canvas 40 x 33
A0143

Sauter, Georg 1866–1937
Blanche Bailey Galsworthy (1837–1915)
oil on canvas 28 x 20.3
A0132

Sauter, Georg 1866–1937
(Blanche) Lilian Sauter (b.1897)
tempera on board 66 x 48.3
A0139

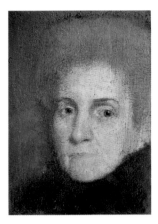

Sauter, Georg 1866–1937
(Blanche) Lilian Sauter (b.1897)
oil on canvas 68.6 x 55.9
A0141

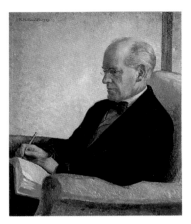

Sauter, Rudolf Helmut 1895–1977
John Galsworthy (1867–1933) 1923
oil on canvas 71.1 x 58.4
A0135

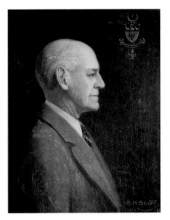

Sauter, Rudolf Helmut 1895–1977
John Galsworthy (1867–1933) 1923
oil on canvas 66 x 45.7
A0166

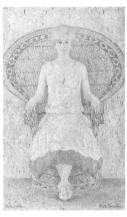

Sauter, Rudolf Helmut 1895–1977
Ada Galsworthy (1893–1933) 1926
oil on canvas 58.4 x 34.9
A0144

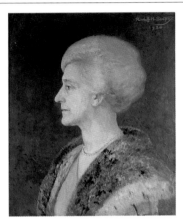

Sauter, Rudolf Helmut 1895–1977
Ada Galsworthy (1893–1933) 1930
oil on canvas 49.5 x 39.4
A0170

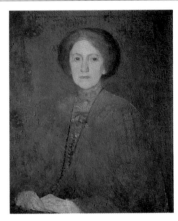

Sauter, Rudolf Helmut 1895–1977
Lilian Sauter (b.1897)
oil on canvas 71.1 x 55.9
A0134

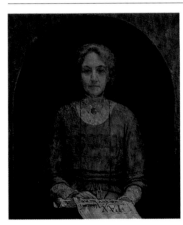

Sauter, Rudolf Helmut 1895–1977
Lilian Sauter (Pax) (b.1897)
oil on canvas 66 x 53.3
A0167

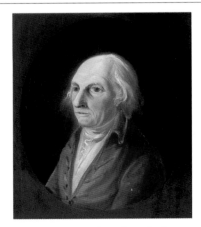

Serres, Dominic (attributed to) 1722–1793
William Sands
oil on canvas 39.4 x 34.3
A0273

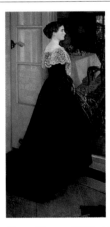

Shaw, Byam 1872–1919
*Margaret Nettlefold before Her Dining Room
at Winterbourne* 1904
oil on panel 180.3 x 86.4
A0356

Slade, Roy b.1933
Mount 1969
acrylic on cotton duck 61 x 61
A0097

Slade, Roy b.1933
Ness 1969
acrylic on cotton duck 61 x 61
A0098

Smith, Stan 1929–2001
Light Splash 1977
oil on canvas 154 x 139
A0923

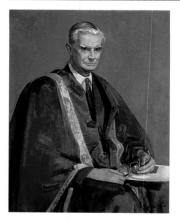

Spear, Ruskin 1911–1990
*Sir Robert Aitken (1901–1997),
Vice-Chancellor* 1968
oil on canvas 109.2 x 83.8
A0004

Thomasos, Denyse b.1964
Ice 1997
oil on canvas 188 x 163
L0042 (P)

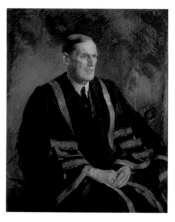

Todd, Arthur Ralph Middleton 1891–1966
*Edmund Phipson Beale (1872–1952),
Pro-Chancellor* 1947
oil on canvas 108 x 73.8
A0021

Todd, Arthur Ralph Middleton 1891–1966
*Sir Raymond Priestley (1886–1974),
Vice-Chancellor* 1954
oil on canvas 109.2 x 86.4
A0023

Townsend, Kathleen active 1965–1968
Alexander B. MacGregor 1965
oil on canvas 193 x 154.9
A0636

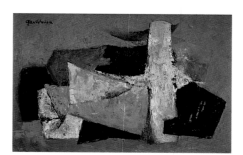

Ugbodaga, Clara b.c.1935
Abstract c.1960
oil on hardboard 60 x 90
D0133

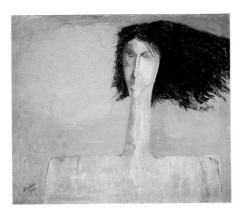

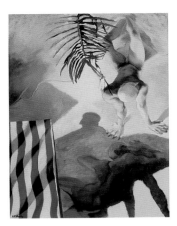

unknown artist mid-20th C
Woman's Head
oil on canvas 88.9 x 99.1
A0089

Vesely, Susan b.1953
Surface 2000
oil on canvas 135 x 100
A0932

Wade, Maurice 1917–1997
Barnfield Gardens
oil on panel 87 x 117
A0810

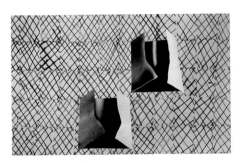

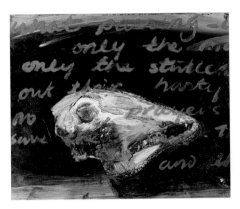

Walker, John b.1939
Anguish 1966
acrylic on canvas 246.5 x 368.5
L0043 (P)

Walker, John b.1939
The Blue Cloud (polyptych, panel 1 of 15)
1996
oil on canvas 80 x 80
A0884a

Walker, John b.1939
The Blue Cloud (polyptych, panel 2 of 15)
1996
oil on canvas 80 x 80
A0884b

Walker, John b.1939
The Blue Cloud (polyptych, panel 3 of 15)
1996
oil on canvas 80 x 80
A0884c

Walker, John b.1939
The Blue Cloud (polyptych, panel 4 of 15)
1996
oil on canvas 80 x 80
A0884d

Walker, John b.1939
The Blue Cloud (polyptych, panel 5 of 15)
1996
oil on canvas 80 x 80
A0884e

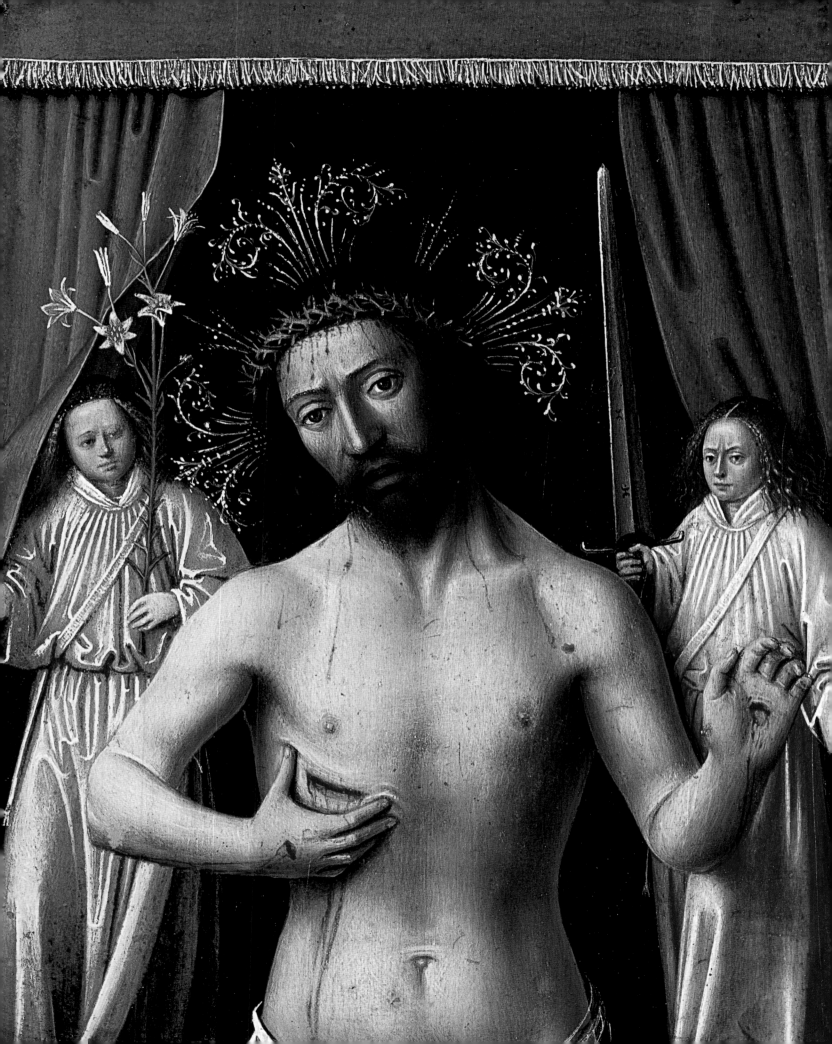

Walker, John b.1939
The Blue Cloud (polyptych, panel 6 of 15)
1996
oil on canvas 80 x 80
A0884f

Walker, John b.1939
The Blue Cloud (polyptych, panel 7 of 15)
1996
oil on canvas 80 x 80
A0884g

Walker, John b.1939
The Blue Cloud (polyptych, panel 8 of 15)
1996
oil on canvas 80 x 80
A0884h

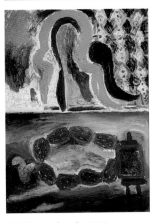

Walker, John b.1939
The Blue Cloud (polyptych, panel 9 of 15)
1996
oil on canvas 80 x 80
A0884i

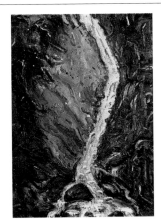

Walker, John b.1939
The Blue Cloud (polyptych, panel 10 of 15)
1996
oil on canvas 80 x 80
A0884j

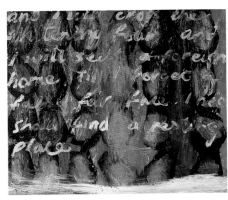

Walker, John b.1939
The Blue Cloud (polyptych, panel 11 of 15)
1996
oil on canvas 80 x 80
A0884k

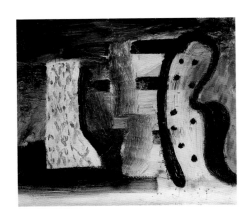

Walker, John b.1939
The Blue Cloud (polyptych, panel 12 of 15)
1996
oil on canvas 80 x 80
A0884l

Walker, John b.1939
The Blue Cloud (polyptych, panel 13 of 15)
1996
oil on canvas 80 x 80
A0884m

Walker, John b.1939
The Blue Cloud (polyptych, panel of 14 of 15)
1996
oil on canvas 80 x 80
A0884n

Facing page: Christus, Petrus, c.1410–c.1475, *Christ as the Man of Sorrows* (detail), c.1450, Birmingham Museums
and Art Gallery, (p. 72)

Walker, John b.1939
The Blue Cloud (polyptych, panel 15 of 15)
1996
oil on canvas 80 x 80
A0884o

Warsop, Mary b.1929
Emergent Shapes c.1955
oil on canvas 61 x 91.4
A0090

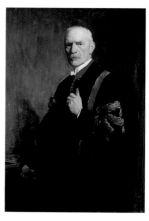

Watt, George Fiddes 1873–1960
*Sir Gilbert Barling (1855–1940),
Pro-Chancellor, CB, CBE, FRCS* 1924
oil on canvas 127 x 81.3
A0030

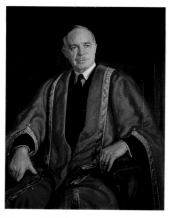

West, Waldron
*Humphrey F. Humphreys, Vice-
Chancellor* 1953
oil on canvas 99.1 x 78.7
A0002

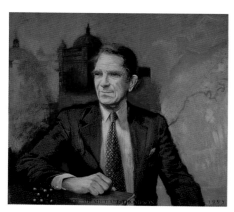

Wood, Tom b.1955
Sir Michael Thompson, Vice-Chancellor 1996
oil on canvas 96 x 106
A0878

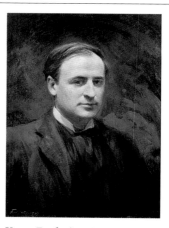

Yates, Frederic 1854–1919
*Ernest de Selincourt (1870–1943), Professor of
English* 1907
oil on canvas 62.2 x 49.5
A0449

Warwickshire
County Cricket
Club Museum

unknown artist
*View of the Pavilion, the County
Ground* 1893–1894
oil on canvas 58 x 95.2
WARCC10834

unknown artist
*View from the Pavilion, the County
Ground* 1893–1894
oil on canvas 59 x 97.5
WARWCC10835

West Midlands Fire Service Headquarters

Ashby, J. B.
Coventry Fire Station
oil on hardboard 36.6 x 45.8
PCF1

West Midlands Police Museum

Ball, Robert b.1918
Elmsley Lodge, Harborne, Home of Sir Charles Rafter, Late Chief Constable
oil on canvas 58 x 78 (E)
WM03

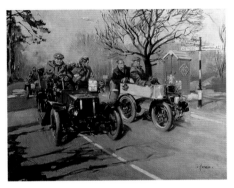

Cuneo, Terence Tenison 1907–1996
On the Brighton Road c.1950
oil on canvas 62 x 75
1991/3/1

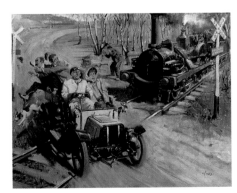

Cuneo, Terence Tenison 1907–1996
Veteran Crossing a French Railway c.1950
oil on canvas 61 x 75
1991/3/2

Edwards, John
A Different Ball Game c.1985
acrylic on canvas 124.5 x 160 (E)
WM02

Miles, W. A.
Mrs Evelyn Miles (d.1954)
oil on board 36.5 x 29
WM04

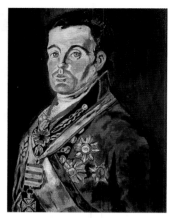

Westwood (Sergeant) (attributed to)
The Duke of Wellington (1769–1852)
(copy after Franciso de Goya)
oil on board 48 x 38
WM05

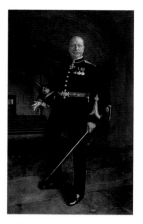

unknown artist
*Charles Horton Rafter, Chief Constable of
Birmingham (1899–1937)* c.1923
oil on canvas 240 x 147 (E)
WM01

Facing page: Shorthouse, Arthur Charles, 1870–1953, *Official Rat Catcher to the City of Birmingham* (detail), 1927,
Birmingham Museums and Art Gallery, (p. 178)

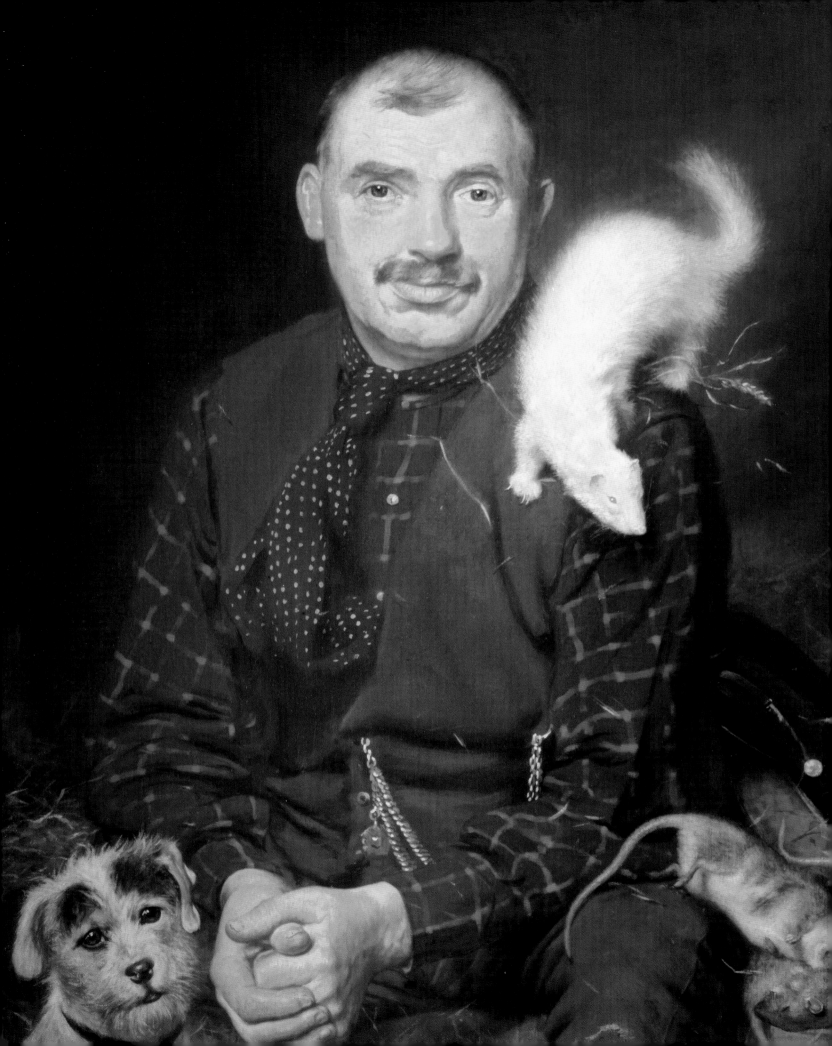

Paintings Without Reproductions

This section lists all the paintings that have not been included in the main pages of the catalogue. They were excluded as it was not possible to photograph them for this project. Additional information relating to acquisition credit lines or loan details is also included. For this reason the information below is not repeated in the Further Information section.

Birmingham Museums and Art Gallery

Baker-Clack, Arthur 1877–1955, *Old Houses in Provence*, 1928–1929, 46 x 55, oil on panel, 1930P377, presented by the John Feeney Bequest Fund, 1930, not available at the time of photography

Barber, Joseph 1757–1811, *A Waterfall*, 1811, 17.5 x 25.6, oil on card, 1978P777, presented by W. K. Barber, 1978, not available at the time of photography

Birley, Oswald Hornby Joseph 1880–1952, *The Right Honourable Neville Chamberlain (1889–1940)*, 1933, 158 x 100, oil on canvas, 1944P262, presented by Mrs Neville Chamberlain, 1944, not available at the time of photography

British School *Propper, Chapel Deritend*, c.1875–1900, 22.2 x 27.7, oil on canvas, 1971V2918, presented by Miss M. Haynes, not available at the time of photography

British School early 19th C, *Fire Office and Dispensary*, oil on canvas, 2005.3205, not available at the time of photography

British School early 19th C, *Reverend John Cook, MA, Headmaster of King Edward's School*, 92.5 x 72, oil on canvas, 1931P68, presented by M. E. Clifton, 1931, not available at the time of photography

British School 19th C, *Henry James Yates*, 134 x 110, oil on canvas, 1984S03746, presented by T. I. Glow-worm Ltd, 1984, not available at the time of photography

British School 19th C, *Horse and Farm, Babbs Mill, Birmingham*, 70 x 90, oil on canvas, 1988V1838, not available at the time of photography
British School 19th C, *The Dingles, Kings Heath*, oil on canvas, 1965V221.91, presented by Mrs J. Douglas, 1953, not available at the time of photography

British School 19th C, *Thomas Attwood*, oil on canvas, 2005.3319, not available at the time of photography

Canziani, Louisa Starr 1845–1909, *Portrait of an Old Man*, 61.2 x 50.9, oil on canvas, 1975P175, unaccessioned find, 1975, not available at the time of photography

Canziani, Louisa Starr 1845–1909, *Portrait of an Old Woman*, 62 x 42.3, oil on canvas, 1975P176, unaccessioned find, 1975, not available at the time of photography

Cozens, K. *Drilling Machine*, c.1955, 95 x 79, oil on canvas, 1984S03769, presented by Mr J. Ryley, 1984, not available at the time of photography

Crozier, William b.1930, *Elsham Road Garden I*, 1960, 39.5 x 50.2, oil on paper, 1968P27, presented by the Friends of Birmingham Museums and Art Gallery, 1968, not available at the time of photography

Emett, Frederick Rowland 1906–1990, *First Snow*, c.1930–1940, 61 x 50.9, oil on canvas, 1939P31, presented by the artist, 1939, not available at the time of photography

Everitt, Allen Edward 1824–1882, *Kings Norton Church*, oil on canvas, 2003.0383, bequeathed by Mrs Whitehouse, 2003, not available at the time of photography

Garrett, Mark *East*, 1993, 28.5 x 29.9, acrylic & spray on canvas, 1993Q9, on loan from the Friends of Birmingham Museums and Art Gallery, not available at the time of photography

Goodhall, George William 1863–1893, *Yardley Village*, 30.5 x 40.5, oil on canvas, 1978V1, purchased from Colmore Galleries Ltd, 1978, not available at the time of photography

Harper, Edward Samuel 1854–1941, *John Thackray Bunce (1828–1899)*, 31.7 x 24.5, oil on gesso, 1998V66, presented, 1998, not available at the time of photography

Haughton, Moses the elder 1734–1804, *Maria*, 1780s, 27.8 x 21.5, oil on panel, 1997P10, presented by the Friends of Birmingham Museums and Art Gallery, 1997, not available at the time of photography

Hervey, Leslie active 1893–1933, *Cassis Landscape*, c.1920–1933, 50.1 x 61.2, oil on canvas, 1933P317, presented anonymously, 1933, not available at the time of photography

Horsley, Hopkins Horsley Hobday 1807–1890, *Bob-Apple Scene, a Devonshire Village*, 1850, 61.1 x 91.5, oil on canvas, 1992P2, purchased, 1992, not available at the time of photography

Madagascan School mid-20th C, *The Rickshaw*, 31 x 17.8, oil on board, 1985A13, presented by Miss W. M. White, 1984, not available at the time of photography

Munns, Henry Turner 1832–1898, *William John Joshua Scofield*, 1868, 73.5 x 58.4, oil on canvas, 1966P15, bequeathed by Mrs A. S. van Ateren, 1966, not available at the time of photography

Payne, Henry Albert 1868–1940, 'His name that sat on him was death and hell followed', 1915, 54.4 x 35.9, tempera on canvas, 1979P319, presented by Edward Payne, 1979, not available at the time of photography

unknown artist 19th C, *City of Birmingham Locomotive*, 90 x 126, oil on canvas, 1972S02579, presented by Paul Twine, 1972, not available at the time of photography

unknown artist 19th C, *Girl with a Wooden Hoop*, 106 x 76.5, oil on canvas, 2002D01064, not available at the time of photography

unknown artist 19th C, *Midland Railway Express*, 42 x 55, oil on canvas, 1973S02692.00962, presented by G. S. Cattell, 1973, not available at the time of photography

unknown artist 19th C, *Museum of Science and Industry*, 59.5 x 84, oil on canvas, 2002D01051, not available at the time of photography

unknown artist 19th C, *Portrait of a Soldier*, 31 x 26, oil on canvas attached to panel, 2002D00927, not available at the time of photography

unknown artist *Tyburn Road in the Snow Showing Trams*, 1975, 104 x 133, oil on panel, 2000D00055, not available at the time of photography

Walker, John b.1939, *Anguish*, c.1965, oil on canvas, 2007. 1049, presented by Anthony Carter, 2004, not available at the time of photography

University of Birmingham

Sauter, Georg 1866–1937, *Blanche Galsworthy (1837–1915)*, c.1920, 66 x 48.3, oil on canvas, A0165, bequeathed by Rudolf Sauter, 1977, not available at the time of photography

STOLEN

University of Birmingham

Edwards, John Uzzell b.1937, *Leaping Figures*, 1970, 121.9 x 121.9, oil on canvas, A0311, purchased, 1970, stolen, 1980s

Further Information

The paintings listed in this section have additional information relating to one or more of the five categories outlined below. This extra information is only provided where it is applicable and where it exists. Paintings listed in this section follow the same order as in the illustrated pages of the catalogue.

I The full name of the artist if this was too long to display in the illustrated pages of the catalogue. Such cases are marked in the catalogue with a (…).

II The full title of the painting if this was too long to display in the illustrated pages of the catalogue. Such cases are marked in the catalogue with a (…).

III Acquisition information or acquisition credit lines as well as information about loans, copied from the records of the owner collection.

IV Artist copyright credit lines where the copyright owner has been traced. Exhaustive efforts have been made to locate the copyright owners of all the images included within this catalogue and to meet their requirements. Any omissions or mistakes brought to our attention will be duly attended to and corrected in future publications.

V The credit line of the lender of the transparency if the transparency has been borrowed. Bridgeman images are available subject to any relevant copyright approvals from the Bridgeman Art Library at www.bridgeman.co.uk

Aston University

Edwards, John b.1940, *Dr Joseph Albert Pope, Vice-Chancellor (1966–1979)*, commissioned on the Vice-Chancellor's retirement, © the artist
Edwards, John b.1940, *Lord Nelson of Stafford, 1st Chancellor of Aston (1966–1979)*, commissioned on the First-Chancellor's retirement, © the artist
Lewis, Reginald b.1901, *James Gracie*, unknown provenance
Shephard, Rupert 1909–1992, *Sir Joseph Hunt, MBE, Pro-Chancellor*, commissioned on the Pro-Chancellor's retirement, © the artist's estate
Shephard, Rupert 1909–1992, *Sir Peter Venables, Principal of the College of Advanced Technology (1955–1966) and Vice-Chancellor of Aston (1966–1969)*, commissioned on the Vice-Chancellor's retirement, © the artist's estate
unknown artist late 20th C, *Mount Fuji*, gift from Dr Seineman Inaba, 1997

Birmingham and Midland Institute

Manns, H. C. *John Alfred Langford (1823–1903)*, gift from the sitter's daughter, 1883
unknown artist *George Jabet*, gift from a number of proprietors and subscribers to Birmingham Library, 1863
unknown artist *John Henry Chamberlain (d.1883)*, unknown acquisition
unknown artist 19th C, *John Lee Junior (c.1803)*, bequeathed by the sitter's grandaughter, Miss Ellen Francis Lee, 1900
unknown artist *Reverend Samuel Wilson Warnefield (1763–1840), LLD, First Visitor*, gift from the Queen's Foundation, Birmingham, 2002

Birmingham Central Library

Priest, Alfred 1874–1929, *Sir Benjamin Stone (1838–1914)*, transferred from Sutton Coldfield Town Hall (possibly), probably 1974, Birmingham Central Library

Birmingham City University

Abell, Roy b.1931, *Woodland Scene*, © the artist
Abell, Roy b.1931, *Autumnal Scene*, © the artist
Abell, Roy b.1931, *Street Scene*, © the artist
Abell, Roy b.1931, *Woodland Scene*, © the artist
Barber, Natalie b.1984, *Now We Are Having Fun*
Barber, William James b.1946, *Design for an Axminster Carpet*
Barber, William James b.1946, *Design for an Axminster Carpet with Wool Samples* (detail)
Barnard, Elizabeth Fay b.1984, *Hastings: Past and Present*, purchased from the artist, 2006, © the artist
Baxter, Emma b.1984, *Cellular*, purchased from the artist, 2006
Bird, Daniel b.1984, *Persona*, purchased from the artist, 2006, © the artist
Bird, Daniel b.1984, *Persona*, purchased from the artist, 2006, © the artist
Bond, Joanna *Figure Study*
Bradley, Roy *Untitled*
Brindley, Amy b.1983, *Untitled*, © Amy Brindley
Brindley, Amy b.1983, *Untitled*, © Amy Brindley
Brindley, Amy b.1983, *Untitled*, © Amy Brindley
Brindley, Amy b.1983, *Untitled*, © Amy Brindley
Brockhurst, Gerald Leslie 1890–1978, *Study of a Standing Female Nude*
Burroughs, Matthew *Performance Scene*
Cam *Vuleen Jewell*
Capers, Hilary Jane b.1976, *Sunset*
Cestari, Clarissa b.1977, *Abstract Study*, © the artist
Chadwick, Mark b.1983, *Motor Painting by Random No.3*, purchased from the artist, 2006, © the artist
Clarke, Richard b.1975, *Fish Creature*
Cope, Diana b.1948, *Chips*, © the artist
Corby, Samantha b.1981, *Head of a Girl*, © the artist
Dubnyckyj, Alicia b.1979, *Half-Nice*, © the artist
Dubnyckyj, Alicia b.1979, *Untitled*, © the artist
Dubnyckyj, Alicia b.1979, *Untitled*, © the artist
Dubnyckyj, Alicia b.1979, *Untitled*, © the artist
Fleetwood-Walker, Bernard 1893–1965, *Joan*, © the estate of Mrs P. Fleetwood-Walker
Fryer, Katherine Mary b.1910, *Life's Journey*, commissioned by the City Council for the Marriage Room at Birmingham Register Office and returned to the University, 2006
Gear, William 1915–1997, *Untitled*, © the artist's estate
Gear, William 1915–1997, *Tall Structure No. 2*, gift, 1995, © the artist's estate
Gillot, Amanda b.1979, *Landscape*
Green, Suzanne Claire b.1968, *Abstract Study*
Green, Suzanne Claire (attributed to) b.1968, *Abstract Study*
Groves, Robert b.1935, *'In the Penal Settlement', Kafka*, © the artist
Harper, Edward Samuel 1854–1941, *Frank Jackson*
Hatch active late 20th C, *Dream*
Haugse, Jorunn b.1982, *Tree*
Heap, Nik b.1959, *Landscape*, © the artist
Hodgson, Frank 1902–c.1977, *Frank Hodgson's Wife*
Hodgson, Frank 1902–c.1977, *Self Portrait*
Holland, George H. Buckingham 1901–1986, *Christopher Edmunds (1899–1990), Fellow of Birmingham School of Music*
Holland, Michael 1947–2002, *Interior Scene*, © the artist's estate
Jiang, Pei Juan b.1983, *Mindscape*, purchased from the artist, 2006
Jones, Gareth *Lips*
Jones, H. *Landscape*
Kim, Jung Hyun b.1972, *Face*
Laurey, Madonna active late 20th C, *Landscape*
Lawrence *Male Figures*
Lee, Paul *Urban Scene*
Livingstone, Amy b.1983, *Patterns and Textures in Nature*, purchased from the artist, 2006, © the artist
Love, Alistair *Untitled*, purchased from the ArtLounge, 2005
Love, Alistair *Untitled*, purchased from the ArtLounge, 2005
Love, Alistair *Untitled*, purchased from the ArtLounge, 2005
Love, Alistair *Untitled*, purchased from the ArtLounge, 2005
Love, Alistair *Untitled*, purchased from the ArtLounge, 2005
Love, Alistair *Untitled*, purchased from the ArtLounge, 2005
Love, Alistair *Untitled*, purchased from the ArtLounge, 2005
Love, Alistair *Untitled*, purchased from the ArtLounge, 2005
Manna, Anita b.1973, *Iron Age, Round Houses*, © the artist
Marlowe, James active late 20th C, *Landscape*
Massey, David b.1975, *Figure*, © the artist
Matthew active late 20th C, *Legs*
Miller *Still Life with Bottles*
Munn, Michelle b.1981, *Untitled 1954*, © www.michellemunn.co.uk
Munns, Henry Turner 1832–1898, *William Stockley (1829–1919), Conductor*

Nelson, Thomas Christopher b.1982, *Abstract Study*, © Thomas Nelson

Newham, Teana *Abstract Study*

Normansell, Paul b.1978, *Untitled*, © the artist

Normansell, Paul b.1978, *Untitled*, © the artist

Ochman, Christina Faith b.1927, *Clothing*, © the artist

Ochman, Christina Faith b.1927, *Clothing*, © the artist

Ochman, Christina Faith b.1927, *Drapery*, © the artist

Odagir, Yuse Ke b.1980, *The Last Visions*

Price, Katie b.1980, *Step into the Complex*, purchased from the artist, 2004, © the artist

Rees, Amanda b.1959, *Women*, © the artist

Riley, Kay Louisa b.1974, *Abstract Study*, © the artist

Russell, Sarah b.1984, *Botanical*, purchased from the artist, 2006

Russell, Sarah b.1984, *Botanical*, purchased from the artist, 2006

Russell, Sarah b.1984, *Botanical*, purchased from the artist, 2006

Ryende, Claude *All Digested*

Sanders, Louise b.1981, *Cuba*

Sanderson, Kate b.1984, *The Nature of It*, purchased from the artist, 2006, © the artist

Skelcher, Mark J. b.1984, *Frozen*, purchased from the artist, 2006, © the artist

Southall, Joseph Edward 1861–1944, *Self Portrait*, © reproduced with permission of the Barrow family

Spencer *Nude with Cat*

Talifero, Janice b.1966, *Untitled*, © the artist

Tovey, Mark b.1956, *Disused Tin Mine* (Cornish Postcard Series), © the artist

Tovey, Mark b.1956, *Trevose Head* (Cornish Postcard Series), © the artist

unknown artist *Portrait of a Man*

unknown artist *Portrait of a Man Holding a Pen and Book*

unknown artist *Mythological Study*

unknown artist *Sir Granville Bantock, First Principal (1900–1934)*

unknown artist *Abstract Study*

unknown artist *Still Life with Flowers and Water Jug*

unknown artist *Landscape*

unknown artist *Mind to Motion No.4*, purchased from the artist, 2006

unknown artist late 20th C, *Abstract Study*

unknown artist late 20th C, *Abstract Study*

unknown artist late 20th C, *Abstract Study*

unknown artist late 20th C, *Abstract Study*

unknown artist late 20th C, *Abstract Study*

unknown artist late 20th C, *Abstract Study*

unknown artist late 20th C, *Abstract Study*

unknown artist late 20th C, *Abstract Study*

unknown artist late 20th C, *Abstract Study*

unknown artist late 20th C, *Abstract Study*

unknown artist late 20th C, *Abstract Study*

unknown artist late 20th C, *Abstract Study*

unknown artist late 20th C, *Abstract Study*

unknown artist late 20th C, *Abstract Study*

unknown artist late 20th C, *Abstract Study*

unknown artist late 20th C, *Abstract Study*

unknown artist late 20th C, *Abstract Study*

unknown artist late 20th C, *Abstract Study*

unknown artist late 20th C, *Abstract Study*

unknown artist late 20th C, *Abstract Study*

unknown artist late 20th C, *Abstract Study*

unknown artist late 20th C, *Abstract Study*

unknown artist late 20th C, *Abstract Study*

unknown artist late 20th C, *Abstract Study*

unknown artist late 20th C, *Clown Toy Lying Down*

unknown artist late 20th C, *Clown Toy Sitting*

unknown artist late 20th C, *Experimentation of Materials and Methods*

unknown artist late 20th C, *Figure in Landscape*

unknown artist late 20th C, *Figure Study*

unknown artist late 20th C, *Figure Study*

unknown artist late 20th C, *Figure with a Red Cloth*

unknown artist late 20th C, *Figure with Toys*

unknown artist late 20th C, *Girl and Dog*

unknown artist late 20th C, *Hanging Man*

unknown artist late 20th C, *Helmet and Butterfly*

unknown artist late 20th C, *Hinge*

unknown artist late 20th C, *Interior Scene*

unknown artist late 20th C, *Interior Scene*

unknown artist late 20th C, *Landscape*

unknown artist late 20th C, *Landscape*

unknown artist late 20th C, *Landscape*

unknown artist late 20th C, *Landscape*

unknown artist late 20th C, *Landscape*

unknown artist late 20th C, *Landscape*

unknown artist late 20th C, *Man in Sunglasses*

unknown artist late 20th C, *Woman in Sunglasses*

unknown artist late 20th C, *Marble*

unknown artist late 20th C, *Office Window*

unknown artist late 20th C, *Purple Abstract*

unknown artist late 20th C, *Red Abstract*

unknown artist late 20th C, *Red Figure*

unknown artist late 20th C, *Two Figures*

unknown artist *Figure*

unknown artist late 20th C, *Spots*

unknown artist late 20th C, *Still Life*

unknown artist late 20th C, *Still Life with Work Boots*

unknown artist late 20th C, *Surreal Landscape*

unknown artist late 20th C, *Three Men*

unknown artist late 20th C, *Three Women*

unknown artist late 20th C, *Tiger*

Wilkinson, Ann b.1940, *Interior Scene*, © the artist

Wood, Mary Anita Virginia b.1945, *666* (multiple work), © the artist

Wood, Mary Anita Virginia b.1945, *666* (multiple work), © the artist

Wood, Mary Anita Virginia b.1945, *666* (multiple work), © the artist

Wood, Mary Anita Virginia b.1945, *666* (multiple work), © the artist

Woodhall, Beryl Christina b.1944, *Coat*

Woodhall, Beryl Christina b.1944, *Denim Shirt*

Woodhall, Beryl Christina b.1944, *Dungarees*

Woodhall, Beryl Christina b.1944, *T-Shirt and Jeans*

Woodhall, Beryl Christina b.1944, *Underwear*

Woodward, F. *Still Life with Plate and Coffee Pot*

Woodward, Natalie b.1980, *Of Significance*, purchased from the artist, 2006, © the artist

Birmingham Museums and Art Gallery

Abbott, Lemuel Francis 1760–1803, *Matthew Boulton (1728–1809)*, presented by Sir John Holder, 1908

Abell, Roy b.1931, *Sea and Sky*, presented by the Friends of Birmingham Museums and Art Gallery, 1974, © the artist

Adams, Norman 1927–2005, *The Sun*, presented by the Friends of Birmingham Museums and Art Gallery, 1957, © the artist's estate

Aertsen, Pieter 1507/1508–1575, *Preparations for a Feast*, presented by J. Arthur Kenrick, 1925

Aitchison, Craigie Ronald John b.1926, *Crucifixion*, purchased with the assistance of the Museums and Galleries Commission/Victoria & Albert Museum Purchase Grant Fund, the National Art Collections Fund, the Public Picture Gallery Fund, the trustees of the L. J. Cadbury Fund and the Friends of Birmingham Museums and Art Gallery, 1999, © the artist/www.bridgeman.co.uk

Albani, Francesco (studio of) 1578–1660, *Faith, Hope and Charity*, on loan from Sir Denis Mahon, CBE, FBA, since 1999

Alcock, Edward d.1778, *William Shenstone (1714–1763)*, presented by Mr John Feeney, 1891

Aldin, Cecil 1870–1935, *Golfing*, presented by Cadbury's Schweppes Ltd, 1980

Alexander, Cosmo 1724–1772, *Portrait of a Man*, presented by Frederick Barratt, 1966

Allan, Robert Weir 1852–1942, *Home and Shelter*, presented by George Myers, 1912

Allen, Frank Humphrey 1896–1977, *Thames Ditton*, presented by Mrs D. Mitchell and A. E. Whitley, 1943, © the artist's estate

Allen, James Bayliss 1803–1876, *The Stream*, gift, 1920

Allen, W. *A Birmingham Prize Fight*, purchased, 1945

Alma-Tadema, Lawrence 1836–1912, *Pheidias and the Frieze of the Parthenon*, bequeathed by Sir John Holder, 1923

Alma-Tadema, Lawrence 1836–1912, *Autumn Vintage Festival*, presented by the family of Alfred Morcom, 1911

Anderson, Sophie 1823–1912, *The Children's Story Book*, bequeathed by Mrs Turton, 1892

Anderson, Stanley 1884–1966, *Richard Cadbury (1835–1899)*, presented by Sir Adrian Cadbury, accessioned, 1937

Appiani, Andrea the elder 1754–1817, *Comte Nicholas Frochot (1761–1828)*, purchased with the assistance of the Museums and Galleries Commission/Victoria & Albert Museum Purchase Grant Fund, 1976

Armfield, Maxwell Ashby 1882–1972, *Self Portrait*, purchased with the assistance of the Museums and Galleries Commission/Victoria & Albert Museum Purchase Grant Fund and the C. J. Robertson Charitable Trust, 1980, © the artist's estate/www.bridgeman.co.uk

Armstrong, John 1893–1973, *Lapping Waters*, presented by the Friends of Birmingham Museums and Art Gallery, 1946, © the artist's estate

Ash, Albert Edward active 1878–1898, *Moseley Village*, transferred from the Birmingham Reference Library, 1977

Ashford, William 1746–1824, *The Thunderstorm*, purchased with the assistance of the John Feeney Bequest Fund, 1925

Ashmore, Charles 1823/1824–1903, *Aston Hall from the Park*, bequeathed by Miss Muriel K. Edson, 1973

Assereto, Gioacchino 1600–1649, *The Guardian Angel*, presented by T. E. Harris, 1948

Aumonier, James 1832–1911, *A Nook in Nature's Garden*, presented by the Public Picture Gallery Fund, 1883

Ayres, Gillian b.1930, *A Midsummer Night*, purchased with the assistance of the National Art Collections Fund, the Museums and Galleries Commission/Victoria & Albert Museum Purchase Grant Fund and the Public Picture Gallery Fund, 1995, © the artist

Bacon, Francis 1909–1992, *Figures in a Landscape*, presented by the Contemporary Art Society, 1959, © estate of Francis Bacon/DACS 2008

Baker, Alfred 1850–1874, *A Cow Lying on the Ground*, presented by Harold Baker, 1934

Baker, Henry 1849–1875, *Selly Manor*, presented by W. Alexander Harvey, 1969

Baker, Samuel Henry 1824–1909, *Wigmore Church near Ludlow* (panel in the Everitt Cabinet), bequeathed by Mrs Allen Edward Everitt, 1892

Baker, Thomas 1809–1869, *Gorge and River in Ireland*, presented by Kate Elizabeth Bunce and Myra Bunce, 1918

Baker, Thomas 1809–1869, *Stoneleigh Park*, presented by Kate Elizabeth Bunce and Myra Bunce, 1912

Baker, Thomas 1809–1869, *Ullswater from Pooley Bridge*, bequeathed by John Sturges, 1906

Bardwell, Thomas 1704–1767, *View of Perry Hall, near Birmingham*, presented by the Right Honourable The Lord Calthorpe, 1920

Barnes, Samuel John 1847–1901, *Near Balmoral*, presented by C. F. Barnes, 1935

Barratt, Jerry 1824–1906, *Joseph Sturge (1793–1859)*, presented by Mrs Sturge, 1867

Bassano, Francesco II 1549–1592, *St John the Divine*, presented by T. E. Harris, 1948

Bates, David c.1840–1921, *On the Long Mynd, Church Stretton*, presented by Albert Cripwell, 1943

Bath, William active 1836–1851, *Wooded Landscape*, presented by Mrs W. Horton, 1974

Batoni, Pompeo 1708–1787, *Duchess Sforza Cesarini (d.1765)*, purchased from P. & D. Colnaghi Co. Ltd, 1961

Batten, John Dickson 1860–1932, *Beauty and the Beast*, presented by the John Feeney Bequest Fund, 1936

Beardmore, J. *View of Handsworth Parish Church*, presented by J. D. Pick, 1973

Beardmore, J. *Aston Hall from the West*, presented by Mrs Taylor, 1966

Beattie, Basil b.1935, *Tell Me*, on loan from the Contemporary Art Society Special Collection Scheme funded by the Arts Council Lottery and the Friends of Birmingham Museums and Art Gallery, © the artist

Beechey, William 1753–1839, *James Watt (1736–1819)*, presented by Sir John Holder, 1910

Beechey, William 1753–1839, *James Watt (1736–1819)*, presented by Sir John Holder, 1910

Beechey, William 1753–1839, *Matthew Boulton (1728–1809)*, purchased with the assistance of the Heritage Lottery Fund, the National Art Collections Fund, the Victoria & Albert Museum Purchase Grant Fund and Birmingham City Council, 2003

Behr, Carel Jacobus 1812–1895, *Town Hall, The Hague*, presented by the Municipality of The Hague, 1974

Bellini, Giovanni 1431–1436–1516, *Madonna and Child Enthroned with Saints and Donor*, purchased by public subscription, with the assistance of the Denis Mahon Trust, the National Art Collections Fund, the Pilgrim Trust, Birmingham City Council, West Midlands County Council, the Friends of Birmingham Museums and Art Gallery and a special Government grant in memory of David, Earl of Crawford and Balcarres, 1977

Berchem, Nicolaes 1620–1683, *Pastoral Landscape with Figures*, presented by Lieutenant Colonel Wilfred Martineau and Mrs Wilfred Martineau, 1932

Bevan, Robert Polhill 1865–1925, *The Ploughing Team, Dawn*, purchased with the assistance of the Museums and Galleries Commission/Victoria & Albert Museum Purchase Grant Fund, 1985

Bevan, Tony b.1951, *Rafters*, on loan from the Contemporary Art Society Special Collection Scheme funded by the Arts Council Lottery and Friends of Birmingham Museums and Art Gallery, © the artist

Birch, Samuel John Lamorna 1869–1955, *A Cornish Stream*, anonymous gift, 1928, © the artist's estate

Birkin, Edith b.1927, '*They Took My Child*', *Lodz Ghetto, 1942*, presented by the artist, 1995, © the artist

Birley, Oswald Hornby Joseph 1880–1952, *The Right Honourable Joseph Chamberlain (1836–1914), PC, MP*, presented by the Birmingham Unionist Association, 1937, © the artist's estate

Bisset, James 1762–1832, *John Freeth (1731–1808)*, presented by Eric Hancock, 1964

Blackham, George Warren active 1870–1906, *Self Portrait*, acquired from Professor G. W. Carter, 1977

Bladon, T. Murray Bernard 1864–1939, *Harold Wilson Painting*, purchased, 1990

Blaikley, Alexander 1816–1903, *The First Ragged School, Westminster*, bequeathed by William Middlemore, 1892

Blakiston, Douglas Yeoman 1810–1870, *Reverend Hugh Hutton (1795–1871)*, presented by Miss Hutton, 1874

Bles, Herri met de c.1510–after 1550, *Nativity*, bequeathed by Sir Leonard Woolley through the National Art Collections Fund, 1960

Boccaccino, Boccaccio before 1466–1525, *Virgin and Child with Saints and a Donor*, purchased from P. & D. Colnaghi Co. Ltd, 1957

Bolt, E. H. *James Webster*, unaccessioned find

Bomberg, David 1890–1957, *Carnival*, presented by Lilian Bomberg, 1981, © the artist's family

Bomberg, David 1890–1957, *Bab-Es-Siq, Petra*, purchased with the assistance of the Alfred Leadbeater Bequest Fund, 1928, © the artist's family

Bomberg, David 1890–1957, *Hezekiah's Pool*, presented by Lilian Bomberg, 1981, © the artist's family

Bomberg, David 1890–1957, *Self Portrait*, purchased from Lilian Bomberg, 1960, © the artist's family

Bond, John Daniel 1725–1803, *Interior with Woman on a Bed*, presented by Mary Charlton, 1992

Bonington, Richard Parkes 1802–1828, *An Italian Town*, presented by the John Feeney Bequest Fund, 1929

Booth, J. active 1838, *Old Pebble Mill Pool, Birmingham*, presented by Mrs J. Douglas, 1953

Borgognone, Ambrogio c.1455–1524, *The Crucifixion with the Virgin, St John and Mary Magdalen*, bequeathed by Sir Leonard Woolley through the National Art Collections Fund, 1960

Bott, R. T. c.1810–c.1865, *Portrait of a Woman*, purchased, 1967

Bott, R. T. c.1810–c.1865, *Portrait of a Man*, purchased, 1967

Botticelli, Sandro 1444/1445–1510, *The Descent of the Holy Ghost*, purchased with the assistance of the National Art Collections Fund, 1959

Bouguereau, William-Adolphe 1825–1905, *Charity*, presented by Charles Harding, 1897

Bowley, Edward Orlando active 1840–1874, *Hockley Abbey, Birmingham*, unaccessioned find, 1997

Bowley, Edward Orlando active 1840–1874, *Witton Brook, Witton*, presented by Mr and Mrs K. E. Crump, 1974

Bramer, Leonard 1596–1674, *Christ before Caiaphas*, presented by the Public Picture Gallery Fund, 1960

Brangwyn, Frank 1867–1956, *The Bridge, Subiano*, presented by the Public Picture Gallery Fund, 1928, © the artist's estate/www.bridgeman.co.uk

Brangwyn, Frank 1867–1956, *Enrico Canziani (1848–1931)*, unaccessioned find (thought to come from the estate of Louisa Starr Canziani), © the artist's estate/www.bridgeman.co.uk

Braque, Georges 1882–1963, *Pichet et fruits*, on loan from a private collection, © ADAGP, Paris and DACS, London 2008

Brasch, Wenzel Ignaz 1708–1761, *The Deer Hunt*, purchased from W. I. Charles, 1969

Bratby, John Randall 1928–1992, *Courtyard with Washing*, purchased with the assistance of The Art Fund, Resource/Victoria & Albert Museum Purchase Grant Fund and the Friends of Birmingham Museums and Art Gallery, 2001, © the artist's estate/www.bridgeman.co.uk

Breakspeare, William Arthur 1855–1914, *In Time of War*, transferred from Wolverhampton Art Gallery, 2000

Breda, Carl Fredrik von 1759–1818, *Matthew Boulton (1728–1809)*, purchased with the assistance of the National Art Collections Fund, 1987

Breda, Carl Fredrik von 1759–1818, *Mrs Joseph Priestley (1744–1796)*, presented by E. G. Wheler, 1906

Brett, John 1830–1902, *A North-West Gale off the Longships Lighthouse*, presented by the Public Picture Gallery Fund, 1873

Brett, John 1830–1902, *Caernarvon*, presented by Archibald S. Bennett, 1921

Brett, John 1830–1902, *Southern Coast of Guernsey*, presented by the Council of Birmingham University, 1927

Bridgwater, Emmy 1906–1999, *Night Work is about to Commence*, presented by the Friends of Birmingham Museums and Art Gallery, 2001, © the artist's estate

Briggs, Henry Perronet 1791/1793–1844, *The Challenge of Rodomont to Rogero*, presented by Sir Henry Wiggin, 1884

Bright, Beatrice 1861–1940, *Atlantic Rollers*, presented by Mrs R. Berthoud, 1940

Bright, Beatrice 1861–1940, *Trevose Head, Cornwall*, presented by Mrs R. Berthoud, 1940

Bril, Paul 1554–1626, *Christ Tempted in the Wilderness*, purchased from P. & D. Colnaghi Co. Ltd, 1963

British (English) School mid-19th C, *A Woodland Scene*, unaccessioned find

British School *Katherine, Lady Gresley*, presented by Henry A. Butler, 1933

British School 16th C, *Portrait of an Old Man*, presented by Alderman William A. Cadbury, 1944

British School *William Brereton, 3rd Lord of Laghlin (1631–1679)*, bequeathed by Charles Holte Bracebridge, 1872

British School *Prince Charles (1630–1685)*, bequeathed by Sir Theophilus Biddulp, 1969

British School early 17th C, *Lady of the Brereton Family*, bequeathed by Charles Holte Bracebridge, 1872

British School early 17th C, *Portrait of a Lady with a Fan*, bequeathed by Charles Holte Bracebridge, 1872

British School early 17th C, *Sir Thomas Holte (1751–1854), 1st Bt of Aston Hall*, bequeathed by Charles Holte Bracebridge, 1872

British School 17th C, *Portrait of a Man*, unaccessioned find

British School late 17th C, *Two Children of the Holte Family*, presented by J. L. Greenway, 1942

British School *Portrait of a Lady*, purchased from the National Trust, 1989

British School *Barbara Lister (d.1742)*, presented by the Friends of Birmingham Museums and Art Gallery, 1959

British School *Portrait of an Unknown Man*, presented by the Reverend James Compton Bracebridge, 1981

British School *Barbara Lister (d.1742)*, presented by Major General H. D. W. Sitwell, CB, MC, FSA, 1968

British School *Portrait of a Woman of the Holte Family*, presented by the Reverend James Compton Bracebridge, 1981

British School *John Freeth (1731–1808)*, purchased, 1874

British School *Portrait of a Lady of the Osler Family*, presented by F. & C. Osler Ltd, 1981

British School early 18th C, *Lieutenant Colonel Archibold John Macdonnell (d.1798)*, presented by the Public Picture Gallery Fund, 1935

British School early 18th C, *Portrait of a Man in Red*, presented by Martin Crabbe, 1960

British School early 18th C, *Reverend Dr John Holte (1694–1734)*, presented by the Reverend James Compton Bracebridge, 1981

British School early 18th C, *Sir Charles Holte (1649–1722), 3rd Bt of Aston Hall*, bequeathed by Charles Holte Bracebridge, 1872

British School mid-18th, *Sir Lister Holte (1720–1770), 5th Bt of Aston Hall*, presented by the Reverend James Compton Bracebridge, 1981

British School mid-18th C, *Sir Lister Holte (1720–1770) and Sir Charles Holte (1721–1782), as Boys*, bequeathed by Charles Holte Bracebridge, 1872

British School 18th C, *Dog Guarding a Dead Duck from Birds of Prey*, presented by N. F. Shorthouse in memory of his father A. C. Shorthouse, RBSA, 1953

British School 18th C, *Portrait of a Man*, unaccessioned find, 1978

British School 18th C, *Portrait of a Man in Brown*, unaccessioned find

British School 18th C, *Sir Thomas Holte (1571–1654)*, purchased from Mrs Charles Blount, 1969

British School 18th C, *William Hutton (1723–1816)*, purchased from the Birmingham Archaeological Society, 1968

British School late 18th C, *Birdingbury Hall, Warwickshire*, bequeathed by Sir Theophilus Biddulp, 1969

British School late 18th C, *Distant View of Birdingbury Hall, Warwickshire*, bequeathed by Sir Theophilus Biddulp, 1969

British School late 18th C, *Dr Joseph Priestly (1733–1804)*, presented by the executors of Mrs Herbert New, 1940

British School late 18th C, *Dr William Bache (1773–1814)*, bequeathed by Mrs J. E. Matthews, 1940

British School late 18th C, *Edward Jesson as a Cavalier*, presented by the Reverend James Compton Bracebridge, 1981

British School late 18th C, *Four Arches, Hall Green*, presented by Mrs W. F. Hobro, 1969

British School late 18th C, *Portrait of a Woman (possibly Anne Jesson, 1734–1799)*, presented by the Reverend James Compton Bracebridge, 1981

British School late 18th C, *Sarehole Mill, Hall Green*, presented by Mrs W. F. Hobro, 1969

British School *Mary Parker*, presented by Miss Dorothy Parker, 1978

British School *Fanny, Daughter of James Beale*, presented by Mrs Byng Kenrick, 1938

British School *Bull Ring, Birmingham*, presented by Mrs D. King, 1968

British School *James Tibbetts Willmore (1800–1863)*, presented by Charles Willmore Emlyn, 1940

British School *Christ Church, Birmingham New Street*, transferred from the Birmingham Reference Library, 1983

British School *Old Tree at Alum Rock*, presented by H. Boulton, 1978

British School *Washwood Heath*, presented by H. Boulton, 1978

British School *George Dawson*

271

(1821–1876), presented by Mrs George Dawson, 1935

British School *Saltley College, Birmingham*, presented by H. Boulton, 1978

British School *John Pix Weston*, presented by Q. A. Cooper, 1966

British School *Solihull Church, Birmingham*, transferred from the Birmingham Reference Library, 1978

British School *Tudor Garden Party*, unaccessioned find

British School *George Dawson (1821–1876)*, presented by W. J. Deeley, 1929

British School *Portrait of Man in Red*, unaccessioned find

British School early 19th C, *Birmingham by Moonlight*, presented by the Friends of Birmingham Museums and Art Gallery, 1984

British School early 19th C, *Charles Pemberton*, bequeathed by Mrs J. E. Matthews, 1940

British School early 19th C, *Elizabeth Pemberton*, bequeathed by Mrs J. E. Matthews, 1940

British School early 19th C, *James Luckock (1761–1835)*, presented by the Unitarian Brotherly Benefit Society, 1931

British School early 19th C, *John Bright (1811–1889)*, transferred from the Society of Friends, 1978

British School early 19th C, *Joseph Sturge (1793–1859)*, transferred from the Society of Friends, 1978

British School early 19th C, *Moonlight Scene*, presented by the Reverend James Compton Bracebridge, 1981

British School early 19th C, *Mr Messenger*, presented by Mrs A. C. Jones, 1929

British School early 19th C, *Mrs Thomas Harcourt*, presented by Miss Joan Hobson, 1988

British School early 19th C, *Mr Thomas Harcourt*, presented by Miss Joan Hobson, 1988

British School early 19th C, *Portrait of a Child*, presented by Miss Ivy Jones, 1992

British School early 19th C, *Portrait of a Clergyman*, presented by Bishop Ernest W. Barnes, 1940

British School early 19th C, *Thomas Wright Hill*, presented by the Unitarian Brotherly Benefit Society, 1882

British School early/mid-19th C, *John Freeth (1731–1808)*, purchased, 1864

British School mid-19th C, *Jane Elizabeth Weston*, presented by Q. A. Cooper, 1966

British School mid-19th C, *Portrait of a Young Man*, presented by the Friends of Birmingham Museums and Art Gallery, 1955

British School 19th C, *Aston Church and Village*, presented by Nelson W. Evans, 1975

British School 19th C, *Aston Parish Church*, transferred from Birmingham Reference Library

British School 19th C, *Cow in a Field*

British School 19th C, *Dead Game*, presented by the Misses Smythe, 1938

British School 19th C, *Dr Bell Fletcher*, purchased from the Midland Club, 1974

British School 19th C, *Erdington Church*, unaccessioned find

British School 19th C, *Four Arches, Yardley Wood*, presented by J. G. Bridges, 1969

British School 19th C, *George Attwood (1777–1834)*

British School 19th C, *George Dawson (1821–1876)*, unaccessioned find

British School 19th C, *George Dawson (1821–1876)*, unaccessioned find, 2005

British School 19th C, *George Edmonds*, presented by Joseph Fordred, 1880

British School 19th C, *Helen Howard Evans*, bequeathed by Elizabeth Tonks, 1986

British School 19th C, *Henry Port*, unaccessioned find, 2004

British School 19th C, *Hockley Abbey, Birmingham*, purchased from Christie's, 1979

British School 19th C, *Interior of Aston Parish Church*, presented by Miss I. M. Caswell, 1957

British School 19th C, *James Guidney 'Jimmy, the Rock Man'*, purchased by Mrs Donaldson, 1968

British School 19th C, *Load Street and Severn Bridge, Bewdley*, presented by Miss D. Tay, 1972

British School 19th C, *Path through a Wood*, presented by James Richardson Holliday, accessioned, 1970

British School 19th C, *Portrait of a Boy*

British School 19th C, *Portrait of a Gentleman*, unaccessioned find

British School 19th C, *Portrait of a Gentleman*, unaccessioned find

British School 19th C, *Portrait of a Gentleman with a Dog*, unaccessioned find

British School 19th C, *Portrait of a Man*

British School 19th C, *Portrait of a Man*, unaccessioned find, 2005

British School 19th C, *Portrait of a Town Crier*

British School 19th C, *Portrait of a Woman*, unaccessioned find

British School 19th C, *Portrait of a Woman (possibly Louisa Starr Canziani, 1845–1909)*, unaccessioned find

British School 19th C, *Portrait of an Elderly Gentleman*, unaccessioned find

British School 19th C, *River Scene*, unaccessioned find

British School 19th C, *Sarehole Mill (?)*, purchased from Mrs Kerr, 1977

British School 19th C, *Sir Rowland Hill (1795–1879)*, unaccessioned find, 1966

British School 19th C, *Unidentified Canal Man*, transferred from the Birmingham Reference Library, 1988

British School late 19th C, *E. R. Taylor (1838–1912)*, purchased from Joan Ferneyhough, 1984

British School late 19th C, *William Hutton (1723–1816)*, purchased from the Birmingham Archaeological Society, 1968

British School *Cottage Scene*, unaccessioned find

British School *Cottage Scene*, unaccessioned find

British School *The Right Honourable Joseph Chamberlain (1836–1914), PC, MP*, unaccessioned find made at Highbury Hall, 1987

British School *Portrait of a Man*, unaccessioned find

British School *Sir Frank Wiltshire, Town Clerk, Birmingham*, on loan from a private lender

British School early 20th C, *The Right Honourable Austen Chamberlain (1863–1937), MP*, unaccessioned find

British School early 20th C, *The Right Honourable Neville Chamberlain (1869–1940), MP*, presented by the Birmingham Unionists

British School 20th C, *'Jimmy the Rockman'*, unaccessioned find, 1996

British School 20th C, *John Mayon*

British School 20th C, *Mrs Mayon*

British School *Portrait of a Lady*, presented by Sutton Coldfield Town Council, 1977

Brockhurst, Gerald Leslie 1890–1978, *Basque Boy, Cypriano*, purchased from Dorrette Brockhurst, 1983

Bromley active 20th C, *The Judges Postillion*, transferred from the local history collection, before 1995

Brown, F. Gregory 1887–1941, *The Visit of the King and Queen to Bournville, 16 May 1919*, presented by Cadbury Schweppes plc., 1980

Brown, Ford Madox 1821–1893, *Portrait of a Boy*, presented by L. M. Angus Butterworth, 1960

Brown, Ford Madox 1821–1893, *Pretty Baa-Lambs*, purchased from P. & D. Colnaghi Co. Ltd, 1956

Brown, Ford Madox 1821–1893, *An English Autumn Afternoon*, presented by the Public Picture Gallery Fund, 1916

Brown, Ford Madox 1821–1893, *The Last of England*, purchased, 1891

Brown, Ford Madox 1821–1893, *Walton-on-the-Naze*, presented by the Public Picture Gallery Fund, 1915

Brown, Ford Madox 1821–1893, *Work*, bequeathed by James Richardson Holliday, 1927

Brown, Ford Madox 1821–1893, *Elijah and the Widow's Son*, presented by Sir John Middlemore, 1912

Brown, Ford Madox 1821–1893, *The Death of Sir Tristram*, presented by the Public Picture Gallery Fund, 1916

Brown, Ford Madox 1821–1893, *The Finding of Don Juan by Haidee*, presented by Henry Lucas, 1912

Brown, Ford Madox 1821–1893, *Wycliffe on His Trial*, presented by the executors of the estate of Frederic Shields, 1912

Brown, John Alfred Arnesby 1866–1955, *The Smug and Silver Trent*, presented by the Public Picture Gallery Fund, 1924

Bruton, Jesse b.1933, *Winding*, presented by Jesse Bruton, 1968, © the artist

Buckner, Richard 1812–1883, *Marie Adeline Plunket (1824–1910)*, presented by the Friends of Birmingham Museums and Art Gallery, 1937

Buhler, Robert A. 1916–1989, *Early Morning*, presented by the Contemporary Art Society, 1963, © the artist's estate/www.bridgeman.co.uk

Bunce, Kate Elizabeth 1858–1927, *Musica*, presented by Sir John Holder, 1897

Bunce, Kate Elizabeth 1858–1927, *The Keepsake*, bequeathed by the artist, 1928

Bundy, Edgar 1862–1922, *Stradivarius in His Workshop*, purchased from Henry A. Butler, 1925

Buonconsiglio, Giovanni c.1465–c.1537, *Head of a Bearded Man*, presented by the Public Picture Gallery Fund, 1950

Burch, Iain George active 1981–1991, *Interior with Blooms*, on permanent loan from the Friends of Birmingham Museums and Art Gallery

Burke, Peter *Wave Path*, on permanent loan from the Friends of Birmingham Museums and Art Gallery

Burne-Jones, Edward 1833–1898, *The Annunciation*, bequeathed by James Richardson Holliday, 1927

Burne-Jones, Edward 1833–1898, *Study of 'Fame Overthrowing Fortune' (Troy Triptych)*, presented by Mrs J. W. Mackail and James Richardson Holliday, 1922

Burne-Jones, Edward 1833–1898, *Study of 'Oblivion Conquering Fame' (Troy Triptych)*, presented by Mrs J. W. Mackail and James Richardson Holliday, 1922

Burne-Jones, Edward 1833–1898, *Study of 'Love Subduing Oblivion' (Troy Triptych)*, presented by Mrs J. W. Mackail and James Richardson Holliday, 1922

Burne-Jones, Edward 1833–1898, *The Feast of Peleus (predella of the Troy Triptych)*, presented by Wilfred Byng Kenrick, 1956

Burne-Jones, Edward 1833–1898, *Troy Triptych*, presented by Mrs J. W. Mackail and James Richardson Holliday, 1922

Burne-Jones, Edward 1833–1898,

Burne-Jones, Edward 1833–1898, *Cupid Finding Psyche Asleep by a Fountain (Palace Green Murals)*, presented by the family of George J. Howard, the 9th Earl of Carlisle, 1922

Burne-Jones, Edward 1833–1898, *The King and Other Mourners (Palace Green Murals)*, presented by the family of George J. Howard, the 9th Earl of Carlisle, 1922

Burne-Jones, Edward 1833–1898, *Zephyrus Bearing Psyche (Palace Green Murals)*, presented by the family of George J. Howard, the 9th Earl of Carlisle, 1922

Burne-Jones, Edward 1833–1898, *Psyche's Sisters Visit Her (Palace Green Murals)*, presented by the family of George J. Howard, the 9th Earl of Carlisle, 1922

Burne-Jones, Edward 1833–1898, *Psyche, Holding the Lamp, Gazes at Cupid (Palace Green Murals)*, presented by the family of George J. Howard, the 9th Earl of Carlisle, 1922

Burne-Jones, Edward 1833–1898, *Psyche Gazes in Despair at Cupid (Palace Green Murals)*, presented by the family of George J. Howard, the 9th Earl of Carlisle, 1922

Burne-Jones, Edward 1833–1898, *Cupid Flying away from Psyche (Palace Green Murals)*, presented by the family of George J. Howard, the 9th Earl of Carlisle, 1922

Burne-Jones, Edward 1833–1898, *Psyche at the Shrines of Juno and Ceres (Palace Green Murals)*, presented by the family of George J. Howard, the 9th Earl of Carlisle, 1922

Burne-Jones, Edward 1833–1898, *Psyche Sent by Venus (Palace Green Murals)*, presented by the family of George J. Howard, the 9th Earl of Carlisle, 1922

Burne-Jones, Edward 1833–1898, *Psyche Giving the Coin to Charon (Palace Green Murals)*, presented by the family of George J. Howard, the 9th Earl of Carlisle, 1922

Burne-Jones, Edward 1833–1898, *Psyche Receiving the Casket Back (Palace Green Murals)*, presented by the family of George J. Howard, the 9th Earl of Carlisle, 1922

Burne-Jones, Edward 1833–1898, *Psyche Entering the Portals of Olympus (Palace Green Murals)*, presented by the family of George J. Howard, the 9th Earl of Carlisle, 1922

Burne-Jones, Edward 1833–1898, *Wheel of Fortune, Nude Study of a Slave*, presented by Charles Fairfax Murray, 1903

Burne-Jones, Edward 1833–1898, *Pygmalion and the Image: The Heart Desires*, presented by Sir John Middlemore, 1903

Burne-Jones, Edward 1833–1898, *Pygmalion and the Image: The Hand Refrains*, presented by Sir John Middlemore, 1903

Burne-Jones, Edward 1833–1898, *Pygmalion and the Image: The Godhead Fires*, presented by Sir

John Middlemore, 1903

Burne-Jones, Edward 1833–1898, *Pygmalion and the Image: The Soul Attains*, presented by Sir John Middlemore, 1903

Burne-Jones, Edward 1833–1898, *The Wizard*, presented by Sir John Holder, 1912

Burt, Charles Thomas 1823–1902, *Metchley Park Farm, Harborne*, presented by John Palmer Phillips, 1903

Burt, Charles Thomas 1823–1902, *Lundy Island, Devon*, presented by the family of the late A. H. Wiggin, 1933

Burt, Charles Thomas 1823–1902, *Crossing the Sands*, presented by F. M. Lindner, 1909

Burt, Charles Thomas 1823–1902, *Near Llanbedr, Barmouth*, presented by W. E. Everitt, 1885

Burt, Charles Thomas 1823–1902, *Snowdon from Pensarn*, presented by Sir Austen Chamberlain, 1915

Burt, Charles Thomas 1823–1902, *The Skylark*, bequeathed by Charles Cartwright, 1887

Burt, Charles Thomas 1823–1902, *Sea Waves* (panel in the Everitt Cabinet), bequeathed by Mrs Allen Edward Everitt, 1892

Burt, Charles Thomas 1823–1902, *Sea Coast*, bequeathed, 1901

Burt, Charles Thomas 1823–1902, *The Grove, Harborne*, anonymous gift, 1938

Caletti, Giuseppe c.1600–c.1660, *David with the Head of Goliath*, presented by the Friends of Birmingham Museums and Art Gallery, 1960

Calkin, Lance 1859–1936, *John Feeney (1839–1905)*, presented by Peregrine M. Feeney, 1909

Calkin, Lance 1859–1936, *The Right Honourable Joseph Chamberlain (1836–1914), MP*

Callery, Simon b.1960, *Six Pace Painting*, on loan from the Contemporary Art Society Special Collection Scheme funded by the Arts Council Lottery and the Friends of Birmingham Museums and Art Gallery, © the artist

Calvert, Edward 1799–1883, *Pan and Pithys*, presented by the Public Picture Gallery Fund, 1904

Calvert, Edward 1799–1883, *The Grove of Artemis*, presented by the Public Picture Gallery Fund, 1904

Calvert, Edward 1799–1883, *Ulysses and the Sirens*, presented by the Public Picture Gallery Fund, 1904

Cambier, Nestor 1879–1957, *The Right Honourable Joseph Chamberlain (1836–1914), MP*, gift, 1924

Cameron, David Young 1865–1945, *Rambelli, near Rome, Italy*, presented by G. A. F. Chatwin, 1932

Cameron, David Young 1865–1945, *Sundown, Loch Rannoch*, presented by the Public Picture Gallery Fund, 1924

Campbell, James 1828–1903, *The*

Wife's Remonstrance, presented by the trustees of the Feeney Charitable Trust, 1958

Canaletto 1697–1768, *Warwick Castle, East Front from the Courtyard*, purchased by public subscription, with the assistance of special government grants and contributions from charitable trusts, industry, commerce, the City of Birmingham, West Midlands County Council, the National Art Collections Fund and the Friends of Birmingham Museums and Art Gallery, 1978

Canaletto 1697–1768, *Warwick Castle, East Front from the Outer Court*, purchased by public subscription, with the assistance of special government grants and contributions from charitable trusts, industry, commerce, the City of Birmingham, West Midlands County Council, the National Art Collections Fund and the Friends of Birmingham Museums and Art Gallery, 1978

Canziani, Estella Louisa Michaela 1887–1964, *Gepin e la vecchia, Biella, Piedmont*, presented by the artist, 1931

Canziani, Estella Louisa Michaela 1887–1964, *Procession of the Confraternity of Saint Croix, Aosta, Piedmont*, presented by the artist, 1931

Canziani, Estella Louisa Michaela 1887–1964, *Repentance, Pragelato, Piedmont*, presented by the artist, 1931

Canziani, Estella Louisa Michaela 1887–1964, *The Plains of Lombardy*, presented by the artist, 1931

Canziani, Estella Louisa Michaela 1887–1964, *Valdesi Reading the Bible*, presented by the artist, 1931

Canziani, Estella Louisa Michaela 1887–1964, *Wedding Costume of Fobello, Piedmont*, presented by the artist, 1931

Canziani, Estella Louisa Michaela 1887–1964, *When the Leaves Fall*, presented by the artist, 1931

Canziani, Estella Louisa Michaela 1887–1964, *Down from the Mountains, Cradle and Gerlo (basket), Antrona Piana, Piedmont*, presented by the artist, 1931

Canziani, Estella Louisa Michaela 1887–1964, *Pierres à cupules, Savoy*, presented by the artist, 1931

Canziani, Estella Louisa Michaela 1887–1964, *Costume de ma grandmère, Bourg Saint Maurice, Savoy*, presented by the artist, 1931

Canziani, Estella Louisa Michaela 1887–1964, *Costume for Mourning, Saint Colomban, Savoy*, presented by the artist, 1931

Canziani, Estella Louisa Michaela 1887–1964, *Everyday Working Costume of Saint Colomban, Savoy*, presented by the artist, 1931

Canziani, Estella Louisa Michaela 1887–1964, *Girl in Mourning, Costume of La Valloire*, presented by the artist, 1931

Canziani, Estella Louisa Michaela 1887–1964, *Girl Making Lace, Savoy, France*, presented by the artist, 1931

Canziani, Estella Louisa Michaela 1887–1964, *Girl's Costume of Jarrier, Savoy*, presented by the artist, 1931

Canziani, Estella Louisa Michaela 1887–1964, *Piemonte*, presented by the artist, 1931

Canziani, Estella Louisa Michaela 1887–1964, *Portrait of a Woman with a Garland*, unaccessioned find

Canziani, Estella Louisa Michaela 1887–1964, *Study for Costume Jewellery*, presented by the artist, 1931

Canziani, Estella Louisa Michaela 1887–1964, *Sunday, Saint Jean d'Arves*, presented by the artist, 1931

Canziani, Estella Louisa Michaela 1887–1964, *The Wedding Cap, Savoy*, presented by the artist, 1931

Canziani, Estella Louisa Michaela 1887–1964, *Woman of Saint Jean d'Arves in a Hat*, presented by the artist, 1931

Canziani, Louisa Starr 1845–1909, *Study of a Russian Peasant Girl*, presented by Estella Canziani, 1931

Canziani, Louisa Starr 1845–1909, *Fountain in a Garden, Cairate, Lombardy*, presented by Estella Canziani, 1931

Canziani, Louisa Starr 1845–1909, *The Village of Cairate, Lombardy*, presented by Estella Canziani, 1931

Canziani, Louisa Starr 1845–1909, *The Eternal Door (Cairate, Lombardy)*, presented by Estella Canziani, 1931

Canziani, Louisa Starr 1845–1909, *Sketch of the Honourables Dudley and Archie Hamilton Gordon*, presented by Estella Canziani, 1929

Canziani, Louisa Starr 1845–1909, *Study of a Boy Sitting on a Wheelbarrow*, presented by Estella Canziani, 1929

Canziani, Louisa Starr 1845–1909, *Study of a Boy Sitting in a Wheelbarrow*, presented by Estella Canziani, 1929

Canziani, Louisa Starr 1845–1909, *Enrico and Estella Louisa Michaela Canziani (1887–1964)*, presented by Estella Canziani, 1979

Canziani, Louisa Starr 1845–1909, *Head of a Woman Superimposed over an Italian Building*, presented by Estella Canziani, 1931

Canziani, Louisa Starr 1845–1909, *Italian Peasant in Stone Archway*, presented by Estella Canziani, 1931

Canziani, Louisa Starr 1845–1909, *Two Women in White Seated in a Wooded Glade*, presented by Estella Canziani, 1931

Canziani, Louisa Starr 1845–1909, *Woman in White, Seated on a Terrace*, presented by Estella Canziani, 1931

Carlevarijs, Luca 1663–1730, *Study of Two Gondolas and Figures*, presented by the Friends of Birmingham Museums and Art

Gallery, 1948

Carlevarijs, Luca 1663–1730, *The Arrival of the Earl of Manchester in Venice*, purchased with the assistance of the John Feeney Bequest Fund, 1949

Carpeaux, Jean-Baptiste 1827–1875, *Antoine Vollon (1833–1900)*, purchased from Roland, Browse & Delbanco Ltd, 1960

Cartwright, William P. 1864–1911, *Cottage Scene, Marston Green*, presented by L. Sanders, 1968

Cassatt, Mary 1844–1926, *Portrait of a Woman*, purchased, 1951

Castiglione, Giovanni Benedetto 1609–1664, *The Angel Appearing to the Shepherds*, purchased from Thomas Agnew & Son Ltd, 1958

Caulfield, Patrick 1936–2005, *Red and White Still Life*, purchased with the assistance of the Heritage Lottery Fund, the National Art Collections Fund and the Friends of Birmingham Museums and Art Gallery, 1998, © Patrick Caulfied 2008. All rights reserved, DACS

Chambers, George 1803–1840, *On the Thames, Tilbury Fort*, bequeathed by John Palmer Phillips, 1919

Chandler, Robert b.1952, *Untitled (Maroon)*, presented by the artist, 2007, © the artist

Chandler, Robert b.1952, *Untitled (Red)*, presented by the artist, 2007, © the artist

Chandler, Robert b.1952, *Untitled (Green)*, presented by the artist, 2006, © the artist

Chapelain-Midy, Roger 1904–1992, *La liseuse*, presented by the Friends of Birmingham Museums and Art Gallery, 1952

Cheadle, Henry 1852–after 1931, *Landscape with Trees*, presented by Albert J. Wilson, 1931

Cheadle, Henry 1852–after 1931, *Wooded Landscape with Boy Fishing in a Lock*, presented by Albert J. Wilson, 1931

Chinnery, George 1774–1852, *Bengal Village Scene*, purchased, 1943

Christus, Petrus c.1410–c.1475, *Christ as the Man of Sorrows*, presented by the Feeney Charitable Trust, 1935

Cima da Conegliano, Giovanni Battista c.1459–1517, *The Dead Christ*, presented by the Public Picture Gallery Fund, 1930

Clare, Oliver c.1853–1927, *Still Life with Peach and Plums*, bequeathed by Mrs Gwendoline May Tims, 1989

Clare, Oliver c.1853–1927, *Still Life with Strawberries*, bequeathed by Mrs Gwendoline May Tims, 1989

Clausen, George 1852–1944, *Building the Rick*, presented by Joseph, Henry and Howard Wilkinson, 1923, © Clausen estate

Clausen, George 1852–1944, *Albert Toft (1862–1949)*, presented by A. Toft, 1947, © Clausen estate

Clausen, George 1852–1944, *The Watcher*, presented by A. E.

Anderson, 1929, © Clausen estate

Clough, Prunella 1919–1999, *Electrical Installation III*, presented by the Friends of Birmingham Museums and Art Gallery, 1972, © estate of Prunella Clough 2008. All Rights Reserved DACS.

Clough, Prunella 1919–1999, *Enclosed Area*, presented by the Contemporary Art Society, 2005, © estate of Prunella Clough 2008. All Rights Reserved DACS.

Clough, Prunella 1919–1999, *Vegetation*, on loan from the Contemporary Art Society Special Collection Scheme funded by the Arts Council Lottery and the Friends of Birmingham Museums and Art Gallery, © estate of Prunella Clough 2008. All Rights Reserved DACS.

Coates, George James 1869–1930, *Sir Johnstone Forbes-Robertson (1853–1937)*, presented by Mrs D. M. Coates, 1932

Cohen, Harold b.1928, *Orestes Returning*, presented by the Friends of Birmingham Museums and Art Gallery, 1976, © the artist

Coker, Peter 1926–2004, *Gorse and Bracken, Audierne*, presented by the Friends of Birmingham Museums and Art Gallery, 1977, © Peter Coker, RA

Coldstream, William Menzies 1908–1987, *Sir Trenchard Cox (1905–1995)*, presented by the Friends of Birmingham Museums and Art Gallery, 1968, © the artist's estate/www.bridgeman.co.uk

Coleman, Edward 1795–1867, *Master Joseph Fussell*, presented by Joseph Fussell Junior, 1903

Coleman, Edward 1795–1867, *Dead Game*, purchased, 1884

Coleman, James active c.1750–1780, *Christopher Fuller (d.1786)*, presented by the Misses Smythe, 1930

Coleman, James active c.1750–1780, *Ann Fuller*, presented by the Misses Smythe, 1930

Coleman, Samuel active c.1820–1859, *The Delivery of Israel out of Egypt*, presented by the National Art Collections Fund, 1950

Coleman, Samuel active c.1820–1859, *Sir Edward Thomason (1769–1849)*, presented by Mrs Richardson, 1950

Colkett, Samuel David 1806–1863, *Walnut Tree Walk, Earlham*, presented by the John Feeney Bequest Fund, 1928

Colley, Reuben b.1976, *Brindley Light*, presented by the Halcyon Gallery, Birmingham, 2003, © the artist

Collins, Cecil 1908–1989, *The Pilgrim*, bequeathed by Elizabeth Collins through the National Art Collections Fund, 2001, © Tate, London 2008

Collins, Cecil 1908–1989, *The Sibyl*, bequeathed by Elizabeth Collins through the National Art Collections Fund, 2001, © Tate, London 2008

Collins, James Edgell 1819–1895, *Alderman Thomas Phillips, Mayor of Birmingham*, presented by John Palmer Phillips, 1899

Collins, James Edgell 1819–1895, *Alderman Thomas Phillips, Mayor of Birmingham*, presented by Miss K. M. Comber, 1967

Collins, William 1788–1847, *The Reluctant Departure*, presented by Timothy Kenrick, 1882

Colonia, Adam 1634–1685, *The Angel Appearing to the Shepherds*, presented by Martin Crabbe, 1957

Commère, Jean 1920–1986, *The Pheasant*, presented by the Friends of Birmingham Museums and Art Gallery, 1957

Conroy, Stephen b.1964, *Sorrow, Nature's Son*, presented by the Contemporary Art Society, 1988, © the artist

Constable, John 1776–1837, *James Lloyd*, purchased, 1992

Constable, John 1776–1837, *Harwich Lighthouse*, allocated by H. M. Government to Birmingham Museum and Art Gallery in lieu of tax, 2001

Constable, John 1776–1837, *Study of Clouds, Evening, 31 August 1822*, presented by the John Feeney Bequest Fund, 1929

Cook, Barrie b.1929, *Black Space*, presented by the Arts Council of Wales, 2006, © the artist

Cook, Barrie b.1929, *Dean*, presented by the Friends of Birmingham Museums and Art Gallery, 1987, © the artist

Cooper, Thomas Sidney 1803–1902, *Landscape with Cattle and Sheep*, bequeathed by H. C. Brunning, 1908

Cooper, Thomas Sidney 1803–1902, *Cattle in a Stream*, bequeathed by Miss Jessie Follett Osler, 1927

Cooper, Thomas Sidney 1803–1902, *Landscape with Cattle and Sheep*, bequeathed by Mrs E. J. Nettlefold, 1941

Copley, John Singleton 1738–1815, *Brook Watson and the Shark*, presented by the Misses Smythe, 1938

Correns, Jozef Cornelius 1814–1907, *The artist's Studio*, presented by the Misses Smythe, 1931

Cortona, Pietro da 1596–1669, *Landscape with a Lake and a Walled Town*, purchased from Matthieson Fine Art Ltd, 1985

Cortona, Pietro da 1596–1669, *The Holy Family with Angels*, presented by the Friends of Birmingham Museums and Art Gallery, 1973

Cossins, Jethro Anstice 1830–1917, *Self Portrait*, transferred from the Birmingham Reference Library, 1973

Cotes, Francis 1726–1770, *Miss Catherine Eld*, purchased from Major R. C. Eld, 1961

Couch, Christopher b.1946, *Afternoon*, purchased from the artist, 1982, © the artist

Courbet, Gustave 1819–1877, *Study for Venus in 'Venus and Psyche'*, purchased, 1949

Couture, Thomas 1815–1879, *Antoine Etex (1808–1888)*, presented by the Pubic Picture Gallery Fund, 1958

Cox, David the elder 1783–1859, *All Saints' Church, Hastings*, bequeathed by Joseph Henry Nettlefold, 1882

Cox, David the elder 1783–1859, *All Saints' Church, Hastings*, bequeathed by Joseph Henry Nettlefold, 1882

Cox, David the elder 1783–1859, *Fishing Boats, Hastings*, bequeathed by Joseph Henry Nettlefold, 1882

Cox, David the elder 1783–1859, *Welsh Shepherds*, bequeathed by Joseph Henry Nettlefold, 1882

Cox, David the elder 1783–1859, *Study of Fish, Skate and Cod*, bequeathed by James Richardson Holliday, 1927

Cox, David the elder 1783–1859, *An Old Woman Asleep*, presented by Mrs M. E. Morgan, 1958

Cox, David the elder 1783–1859, *Study of a Donkey*, presented by subscribers, 1907

Cox, David the elder 1783–1859, *The Wyndcliffe, River Wye*, presented by Mrs Rickards, 1912

Cox, David the elder 1783–1859, *Bolton Abbey*, bequeathed by Walter Turner, 1948

Cox, David the elder 1783–1859, *Windermere*, bequeathed by Joseph Henry Nettlefold, 1882

Cox, David the elder 1783–1859, *Cottage Interior, Trossavon near Betws-y-Coed*, bequeathed by Joseph Henry Nettlefold, 1882

Cox, David the elder 1783–1859, *A Farm at Betws-y-Coed*, bequeathed by John Palmer Phillips, 1919

Cox, David the elder 1783–1859, *The Church, Betws-y-Coed*, bequeathed by Joseph Henry Nettlefold, 1882

Cox, David the elder 1783–1859, *Waiting for the Ferry*, bequeathed by Joseph Henry Nettlefold, 1882

Cox, David the elder 1783–1859, *The Farmstead*, bequeathed by Joseph Henry Nettlefold, 1882

Cox, David the elder 1783–1859, *Changing Pasture*, bequeathed by Joseph Henry Nettlefold, 1882

Cox, David the elder 1783–1859, *Driving Cattle*, bequeathed by Joseph Henry Nettlefold, 1882

Cox, David the elder 1783–1859, *Crossing the Sands*, bequeathed by Joseph Henry Nettlefold, 1882

Cox, David the elder 1783–1859, *The Welsh Funeral*, presented by H. Dean, 1943

Cox, David the elder 1783–1859, *Sheep Shearing*, bequeathed by Joseph Henry Nettlefold, 1882

Cox, David the elder 1783–1859, *Tending Sheep, Betws-y-Coed*, bequeathed by Joseph Henry Nettlefold, 1882

Cox, David the elder 1783–1859, *The Skylark*, presented by Frederick John Nettlefold, 1947

Cox, David the elder 1783–1859, *Market Gardeners*, bequeathed by Joseph Henry Nettlefold, 1882

Cox, David the elder 1783–1859, *On the Sands*, bequeathed by Joseph Henry Nettlefold, 1882

Cox, David the elder 1783–1859, *The Crossroads*, bequeathed by Joseph Henry Nettlefold, 1882

Cox, David the elder 1783–1859, *The Peat Gatherers*, bequeathed by Joseph Henry Nettlefold, 1882

Cox, David the elder 1783–1859, *Waiting for the Ferry, Morning*, bequeathed by Joseph Henry Nettlefold, 1882

Cox, David the elder 1783–1859, *Evening*, bequeathed by Joseph Henry Nettlefold, 1882

Cox, David the elder 1783–1859, *The Missing Lamb*, bequeathed by Joseph Henry Nettlefold, 1882

Cox, David the elder 1783–1859, *Kilgerran Castle, Pembrokeshire*, bequeathed by Joseph Henry Nettlefold, 1882

Cox, David the elder 1783–1859, *Going to the Hayfield*, bequeathed by Joseph Henry Nettlefold, 1882

Cox, David the elder 1783–1859, *The Shrimpers*, bequeathed by Joseph Henry Nettlefold, 1882

Cox, David the elder 1783–1859, *Rhyl Sands*, bequeathed by Joseph Henry Nettlefold, 1882

Cox, David the elder 1783–1859, *The Skirts of the Forest*, bequeathed by Joseph Henry Nettlefold, 1882

Coxon, Raymond James 1896–1997, *Sussex Meadow*, presented by the Contemporary Art Society, 1931, © the artist's estate

Crespi, Giuseppe Maria 1665–1747, *Girl Holding a Dove*, bequeathed by Ernest E. Cook, 1955

Creswick, Thomas 1811–1869, *A Distant View of Birmingham*, presented by J. H. Dearson, 1896

Creswick, Thomas 1811–1869, *English Landscape*, presented by the family of the late Thomas Ryland, 1905

Creswick, Thomas 1811–1869, *View of the Thames at Battersea*, presented by Alderman Charles Gabriel Beale, 1912

Creswick, Thomas 1811–1869, *The Valley of Llangollen, North Wales*, presented by T. Allen, 1943

Crome, John 1768–1821, *View at Blofield, near Norwich*, presented by Frederick John Nettlefold, 1947

Crome, John 1768–1821, *The Way through the Wood*, purchased from Gooden & Fox Ltd, 1950

Cundall, Charles Ernest 1890–1971, *Minesweepers off Duty*, presented by H. M. Government, the War Artists' Advisory Committee, 1947, © the artist's estate/www.bridgeman.co.uk

Cundall, Charles Ernest 1890–1971, *Destruction of Birmingham Small Arms Factory Building*, presented by the Birmingham Small Arms Recreation Association, 1981, © the artist's estate/www.bridgeman.co.uk

Currie, Sidney d.1930, *Tennal Old Hall*, presented by Mrs Agnes Pearman, 1936

Dahl, Michael I 1656/1659–1743, *Elizabeth, Countess of Sandwich (c.1674–1757)*, presented by the Friends of Birmingham Museums and Art Gallery, 1957

Danby, Thomas 1818–1886, *Landscape*, bequeathed by Mrs E. J. Nettlefold, 1941

Dance-Holland, Nathaniel 1735–1811, *Miss Hargreaves*, gift, 1931

Daubigny, Charles-François 1817–1878, *La vigne*, presented by the Public Picture Gallery Fund, 1962

Davenport, Ian b.1966, *Untitled (Orange)*, presented by the Contemporary Art Society, 2006, © the artist

Dawson, Henry 1811–1878, *In Port: A Calm*, bequeathed by William Middlemore, 1892

Dawson, Henry 1811–1878, *The Wooden Walls of England*, bequeathed by William Middlemore, 1892

Dawson, Henry 1811–1878, *St Paul's from the River Thames*, presented by the trustees of the Public Picture Gallery Fund, 1890

De Karlowska, Stanislawa 1876–1952, *Snow in Russell Square*, presented by Mrs E. H. Baty, 1968, © the artist's estate/www.bridgeman.co.uk

De Wint, Peter 1784–1849, *Extensive Landscape*, presented by the John Feeney Bequest Fund, 1928

De Wint, Peter 1784–1849, *Jetty with Boats*, presented by the John Feeney Bequest Fund, 1928

Degas, Edgar 1834–1917, *A Roman Beggar Woman*, purchased from Arthur Tooth and Sons Ltd, 1960

Delacroix, Eugène (attributed to) 1798–1863, *Madame Simon*, purchased from the Hector Brame Gallery, 1963

Delane, Solomon 1727–1812, *Italian Landscape*, presented by Douglas Hillis, 1930

Delaney, Barbara b.1941, *Distant Sounds*, purchased from the artist, 2000, © the artist

Delaney, Barbara b.1941, *Light Gathers*, purchased from the artist, 2000, © the artist

Delaney, Barbara b.1941, *Pastorale*, purchased from the artist, 2000, © the artist

Delaney, Barbara b.1941, *Several Pleasures*, purchased from the artist, 2000, © the artist

Delle, M. R. *Sophia Sturge (1849–1936)*, presented by J. M. Hogwood, 2003

Derain, André 1880–1954, *Landscape near Cagnes*, purchased from Maurice d'Arquian, 1962, © ADAGP, Paris and DACS, London 2008

Deverell, Walter Howell 1827–1854, *As You Like It, Act IV Scene I*, ('Rosalind Tutoring Orlando in the Ceremony of Marriage' and 'The Mock Marriage of Orlando and Rosalind'), presented by James Richardson Holliday, 1912

Devey, Phyllis 1907–1982, *Myself when Young*, bequeathed by the artist, 1982

Devey, Phyllis 1907–1982, *Working at Night*, bequeathed by the artist, 1982

Devis, Arthur 1712–1787, *Portrait of a Man in Blue*, purchased, 1953

Devis, Arthur 1712–1787, *Portrait of a Man in Red*, purchased, 1953

Devis, Arthur 1712–1787, *Portrait of a Woman in Dark Blue*, purchased, 1953

Devis, Arthur 1712–1787, *Portrait of a Woman in Gold*, purchased, 1953

Devis, Arthur 1712–1787, *Portrait of a Woman in Light Blue*, purchased, 1953

Diaz de la Peña, Narcisse Virgile 1808–1876, *Woodland Scene*, presented by R. W. E. Allars, 1939

Dismorr, Jessica 1885–1939, *Superimposed Forms*, purchased with the assistance of the National Art Collections Fund and the Public Picture Gallery Fund, 1994, © the artist's estate

Dobson, William 1611–1646, *Portrait of a Woman*, presented by Miss Mary Annesley, 1951

Dolci, Carlo 1616–1686, *St Andrew Praying before His Martyrdom*, purchased from Thomas Agnew & Sons Ltd, 1962

Donley, John Gilbert *A Field of Swedes*, presented by the Friends of Birmingham Museums and Art Gallery, 1939

Downton, John 1906–1991, *The Battle*, presented by the executors of the artist's estate, © Birmingham Museum and Art Gallery

Dufrenoy, Georges Léon 1870–1942, *La Place des Vosges*, presented by Mrs D. M. Fulford, 1945

Dughet, Gaspard 1615–1675, *Classical Landscape*, purchased from Messrs Tooth, 1951

Duifhuyzen, Pieter Jacobsz. 1608–1677, *Interior with Figures*, anonymous gift, 1928

Dutch School 17th C, *Head of a Man*, presented by Mrs R. E. Giles, 1931

Dutch School 17th C, *Portrait of a Gentleman*, bequeathed by Lady Eleanor Biddulph, 1966

Dutch School 17th C, *Portrait of a Gentleman in Black*, presented by the executors of Sir Claude Phillips, 1925

Dyce, William 1806–1864, *Mrs John Clerk Maxwell (1792–1839), and Her Son, James (1831–1879)*, bequeathed by Mrs Albert Clay, 1941

Dyce, William 1806–1864, *The Woman of Samaria*, presented by the trustees of the Public Picture Gallery Fund, 1897

Dyce, William 1806–1864, *Head of*

a Man, unaccessioned find (thought to have come from Estella Canziani)

Dyck, Anthony van 1599–1641, *Lord Strafford (1593–1641), and His Secretary Sir Phillip Mainwaring (1589–1661)*, purchased from the Reverend James Compton Bracebridge, 1981

Dyck, Anthony van (after) 1599–1641, *King Charles I (1600–1649)*, purchased from the Reverend James Compton Bracebridge, 1981

Dyck, Anthony van (after) 1599–1641, *Queen Henrietta Maria (1609–1669)*, purchased from the Reverend James Compton Bracebridge, 1981

Dyck, Anthony van (after) 1599–1641, *Infanta Isabella Clara Eugenia (1566–1633), Regentess of the Netherlands*, presented by Alderman Oliver Morland, 1934

Dyck, Daniel van den 1610/1614–1670, *Antonio Canal (1567–1650)*, purchased from Thomas Agnew & Son Ltd, 1958

Eardley, Joan Kathleen Harding 1921–1963, *Winter Sun No.1*, purchased from Roland, Browse & Delbanco Ltd, 1963, © the Eardley estate

East, Alfred 1849–1913, *Reedy Mere and Sunlit Hills*, presented in memory of Mr and Mrs Fred Ryland by their daughters, 1920

East, Alfred 1849–1913, *Hayle from Lelant, Cornwall*, purchased from Messrs Dolman, 1892

Eastlake, Charles Lock 1793–1865, *The Champion*, purchased from A. E. Collins, 1956

Eckstein, Johannes 1736–1817, *John Freeth and His Circle (Birmingham Men of the Last Century)*, presented by subscribers, 1909

Edwards, Edwin 1823–1879, *The Pool, London*, presented by Mrs Edwin Edwards, 1905

Edwards, Edwin 1823–1879, *The Thames at Westminster*, presented by Mrs Edwin Edwards, 1905

Eertvelt, Andries van 1590–1652, *The Battle of Lepanto, 7 October 1571*, presented by Baron Graham Ash, 1933

Egg, Augustus Leopold 1816–c.1863, *The Travelling Companions*, purchased with the assistance of the Feeney Bequest Fund, 1956

Eldridge, Mildred E. 1909–1991, *Morning Flight*, presented by the Friends of Birmingham Museums and Art Gallery, 1936

Ellis, William 1747–1810, *Haymaking, Handsworth*, purchased from R. G. D. Brown, 1978

Emery, Louis 1918–1993, *Black Forest*, presented by the Friends of Birmingham Museums and Art Gallery, 1993

Engelbach, Florence 1872–1951, *Alpes Maritimes*, presented by C. R. F. Engelbach, 1931

Engelbach, Florence 1872–1951, *Summer*, presented by Lord Herbert Austin, 1932

Engelbach, Florence 1872–1951, *Cyclamen*, presented by the Friends of Birmingham Museums and Art Gallery, 1931

Etty, William 1787–1849, *Manlius Hurled from the Rock*, presented by Anthony W. Bacon, 1967

Etty, William 1787–1849, *Pandora Crowned by the Seasons*, presented by the Royal Birmingham Society of Artists, 1867

Etty, William 1787–1849, *'Gather the rose of love while yet 'tis time'*, presented by Alfred Coles, 1931

Etty, William 1787–1849, *Nude Study of a Reclining Woman*, presented by A. C. J. Wall, 1929

Eurich, Richard Ernst 1903–1992, *A Destroyer Escort in Attack*, presented by H. M. Government, the War Artists' Advisory Committee, 1947, © the artist's estate/www.bridgeman.co.uk

Eurich, Richard Ernst 1903–1992, *'Grock', a Dalmation Dog*, presented by the Contemporary Art Society, 1944, © the artist's estate/www.bridgeman.co.uk

Evans, Merlyn Oliver 1910–1973, *Paesaggio tragico*, purchased with the assistance of the Museums and Galleries Commission/Victoria & Albert Museum Purchase Grant Fund, 1988

Eves, Reginald Grenville 1876–1941, *Thomas Hardy (1840–1928)*, presented by an anonymous donor through the Friends of Birmingham Museums and Art Gallery, 1941

Fanner, Alice Maud 1865–1930, *Yacht Racing in the Solent*, presented by the Public Picture Gallery Fund, 1917

Fanner, Alice Maud 1865–1930, *Yachts Racing in Bad Weather, Burnham-on-Crouch*, presented by A. E. Taite, 1931

Fantin-Latour, Henri 1836–1904, *Mademoiselle Marie Fantin-Latour*, bequeathed by Arthur Colin Kenrick, 1956

Fantin-Latour, Henri 1836–1904, *Bouquet de dahlias*, presented by Mr Paul S. Cadbury, 1958

Fantin-Latour, Henri 1836–1904, *Roses dans un verre à pied*, presented by Miss Ruth Nettlefold, 1956

Fantin-Latour, Henri 1836–1904, *L'aurore et la nuit*, bequeathed by the executors of Sir George H. Kenrick, 1939

Fedden, Mary b.1915, *The Weighing Machine*, presented by the artist, 2001, © the artist

Feiler, Paul b.1918, *Atlantic Coast, Evening*, presented by the Contemporary Art Society, 1956, © the artist

Feiler, Paul b.1918, *Porth Ledden*, presented by Professor John Steer, 1999, © the artist

Feiler, Paul b.1918, *Aduton L11*, presented by the artist, 1999, © the artist

Fielding, Anthony V. C. 1787– 1855, *Packet Boat Entering Harbour*, presented by Miss Agnes Keep, 1930

Fielding, Brian 1933–1987, *Lune*, on loan from the Friends of Birmingham Museums and Art Gallery, © the artist's estate

Fisher, Mark 1841–1923, *The Halt*, presented anonymously through the National Art Collections Fund, 1907

Fleetwood-Walker, Bernard 1893–1965, *Joseph Wright*, presented by Mr David Millin and Alston Transport Ltd, 2005, © the estate of Mrs P. Fleetwood-Walker

Fleetwood-Walker, Bernard 1893–1965, *Washerwomen*, presented anonymously, 2002, © the estate of Mrs P. Fleetwood-Walker

Fleetwood-Walker, Bernard 1893–1965, *The Bane*, presented by Robert H. Butler, 1936, © the estate of Mrs P. Fleetwood-Walker

Fleetwood-Walker, Bernard 1893–1965, *The Family at Polperro*, presented by the artist, 1939, © the estate of Mrs P. Fleetwood-Walker

Fleetwood-Walker, Bernard 1893–1965, *Alderman A. H. James, CBE*, on loan from a private collection, © the estate of Mrs P. Fleetwood-Walker

Fleetwood-Walker, Bernard 1893–1965, *Professor Thomas Bodkin (1887–1961)*, presented by the Friends of Birmingham Museums and Art Gallery, 1955, © the estate of Mrs P. Fleetwood-Walker

Flemish School early 16th C, *Nicholas Gaze, His Son and St Nicholas*, presented by the Public Picture Gallery Fund, 1933

Flemish School 16th C, *Autumn*, unaccessioned find, 2007

Flemish School 16th C, *The Angels Appearing to the Shepherds*, presented by Mrs R. E. Giles, 1930

Flemish School 16th C, *The Angels Appearing to the Shepherds*, presented by Mrs R. E. Giles, 1930

Flemish School *Portrait of a Gentleman*, bequeathed by Mrs Mabel Arden Haworth Booth, 1965

Flemish School 19th C, *Landscape with Cattle*, unaccessioned find, 2006

Flint, William Russell 1880–1969, *Shipyard Gleaners*, presented by the John Feeney Bequest Fund, 1929, © the artist's estate

Flint, William Russell 1880–1969, *Silver and Gold*, presented by an anonymous donor, 1930, © the artist's estate

Florence, Mary Sargant 1857–1954, *The Nursemaid*, presented by the Friends of Birmingham Museums and Art Gallery, 1962, © Birmingham Museums and Art Gallery

Forbes, Stanhope Alexander 1857–1947, *The Village Philharmonic*, purchased from the Royal Birmingham Society of Artists, 1889, © the artist's estate/www.bridgeman.co.uk

Forbes, Stanhope Alexander 1857–1947, *Alderman G. J. Johnson (1826–1912)*, presented by Mrs George J. Johnson, 1912, © the artist's estate/www.bridgeman.co.uk

Forbes, Stanhope Alexander 1857–1947, *Alderman G. J. Johnson (1826–1912)*, purchased from the United Hospital Trust of Birmingham, 1983, © the artist's estate/www.bridgeman.co.uk

Foster, Cecilia C. active c.1870–1908, *View of the Long Gallery at Aston Hall*, unaccessioned find at Aston Hall, 1989

Frampton, Edward Reginald 1872–1923, *Flora of the Alps*, presented by Alderman William A. Cadbury, 1928

Francken, Frans II 1581–1642, *Landscape with Minerva Expelling Mars to Protect Peace and Plenty*, unaccessioned find, 1959

Freedman, Barnett 1901–1958, *Sicilian Puppets*, presented anonymously, 1935, © V. C. Freedman and descendants

Freeth, Hubert Andrew 1913–1986, *Raymond Teague Cowern (1913–1986)*, presented by Mrs Margaret Jean Cowern, 2006, © Freeth family

Freeth, Walter active c.1895–1941, *Portrait of the artist's Father*, bequeathed by the artist, 1941

Freeth, Walter active c.1895–1941, *Portrait of the artist's Mother*, bequeathed by the artist, 1941

French School 17th C, *The Conversion of Saint Paul*, presented by H. Wiseman, 1933

Frère, Pierre Edouard 1819–1886, *Supper Time*, presented by J. Arthur Kenrick, 1925

Frith, William Powell 1819–1909, *Garden Flowers (Making a Posy)*, presented by the Friends of Birmingham Museums and Art Gallery, 1947

Frith, William Powell 1819–1909, *Retribution*, presented by the Friends of Birmingham Museums and Art Gallery, 1962

Frost, Terry 1915–2003, *Black and Lemon*, presented by the Friends of Birmingham Museums and Art Gallery, 1977, © the estate of Terry Frost

Frost, Terry 1915–2003, *Black and Dust Pink*, presented by the Public Picture Gallery Fund, 1980, © the estate of Terry Frost

Fry, Roger Eliot 1866–1934, *A Surrey House*, purchased with the assistance of the Alfred Leadbeater Bequest Fund, 1928

Fuchs, Emil 1866–1929, *Mrs Olga Myers*, bequeathed by Mrs Olga Myers, 1972

Furini, Francesco 1603–1646, *Sigismunda with the Heart of Guiscardo*, presented by the trustees of Henry, 9th Duke of Newcastle, 1991

Fuseli, Henry 1741–1825, *Dispute between Hotspur, Glendower, Mortimer and Worcester (from William Shakespeare's 'Henry IV Part I')*, presented by Sir Alex Martin and Lady Ada Mary Martin, 1947

Gael, Barend c.1635–1698, *The Ford*, presented by the Friends of Birmingham Museums and Art Gallery, 1935

Gainsborough, Thomas 1727–1788, *Thomas Coward*, presented by the Public Picture Gallery Fund, 1955

Gainsborough, Thomas 1727–1788, *Matthew Hale (1728–1786)*, presented by the Public Picture Gallery Fund, 1960

Gainsborough, Thomas 1727–1788, *Lewis Bagot (1740–1802), Bishop of Bristol*, bequeathed by Mrs Mabel Arden Haworth Booth, 1965

Gainsborough, Thomas 1727–1788, *Sir Charles Holte (1721–1782)*, bequeathed by Charles Holte Bracebridge, 1872

Gainsborough, Thomas 1727–1788, *The Prodigal Son*, purchased from P. & D. Colnaghi Co. Ltd, 1948

Gainsborough, Thomas 1727–1788, *Isabelle Franks (c.1769/1770–1855)*, purchased with the assistance of the Museums and Galleries Commission/Victoria & Albert Museum Purchase Grant Fund, 1983

Gainsborough, Thomas 1727–1788, *Wooded Landscape with Cottage, Figures and Boat on a Lake*, bequeathed by James Leslie Wright, 1953

Gainsborough, Thomas 1727–1788, *Landscape with a Cottage and a Cart*, presented by the Public Picture Gallery Fund, 1953

Gainsborough, Thomas 1727–1788, *A Cattle Ferry*, bequeathed by James Leslie Wright, 1953

Gainsborough, Thomas 1727–1788, *Wooded Landscape with Figures on Horseback*, bequeathed by James Leslie Wright, 1953

Gainsborough, Thomas 1727–1788, *A Wooded Landscape, Autumn Evening*, presented by the John Feeney Bequest Fund, 1924

Garofalo 1481–1559, *The Agony in the Garden*, purchased from Thomas Agnew & Sons Ltd, 1964

Garvie, Thomas Bowman 1859–1944, *Barrow Cadbury*, transferred from the Birmingham Reference Library, 1979

Garvie, Thomas Bowman 1859–1944, *Geraldine Cadbury, née Southall*, transferred from the Birmingham Reference Library, 1979

Gaskin, Arthur Joseph 1862–1928, *Portrait of a Reflective Lady*, purchased, 1980

Gaskin, Arthur Joseph 1862–1928, *Mrs Henry Gaskin (The artist's Mother)*, presented by Georgie Gaskin, 1928

Gaskin, Arthur Joseph 1862–1928, *Fiammetta (Georgie Gaskin)*, purchased with the assistance of the Museums and Galleries

Commission/Victoria & Albert Museum Purchase Grant Fund and the W. A. Cadbury Charitable Trust, 1989

Gaskin, Arthur Joseph 1862–1928, *The Twelve Brothers*, purchased from Mr John Turner and Mary Anne Kunkel, 2002

Gaskin, Arthur Joseph 1862–1928, *Kilhwych, the King's Son*, presented anonymously, 1914

Gaskin, Arthur Joseph 1862–1928, *The Twelve Brothers Turned into Swans*, on loan from a private collection

Gaulli, Giovanni Battista 1639–1709, *The Virgin and Child Piercing the Head of the Serpent*, on loan from Sir Denis Mahon, CBE FBA, since 1999

Gear, William 1915–1997, *Mau, Mau*, presented by an anonymous donor in lieu of tax, © the artist's estate

Gear, William 1915–1997, *Landscape Image No.1*, purchased from the artist, presented by the Friends of Birmingham Museums and Art Gallery, 1971, © the artist's estate

Gear, William 1915–1997, *Cold Spring*, purchased with the assistance of the Museums and Galleries Commission/Victoria & Albert Museum Purchase Grant Fund and the Friends of Birmingham Museums and Art Gallery, 1989, © the artist's estate

Geeraerts, Marcus the younger 1561–1635, *Portrait of Two Brothers*, presented by subscribers, 1931

Geeraerts, Marcus the younger 1561–1635, *Elizabeth, Countess of Devonshire (1562–1607)*, on loan from a private collection

Geeraerts, Marcus the younger 1561–1635, *Robert Devereux (1566–1601), 2nd Earl of Essex*, presented by the Royal Town of Sutton Coldfield, 1977

Geeraerts, Marcus the younger 1561–1635, *Robert Devereux (1566–1601), Earl of Essex*, on loan from a private collection

Geets, Willem 1838–1919, *A Martyr of the Sixteenth Century, Johanna van Santhoven*, presented by the Right Honourable William Kenrick, 1884

Gennari, Benedetto the younger 1633–1715, *The Holy Family*, purchased with the assistance of the Museums and Galleries Commission/Victoria & Albert Museum Purchase Grant Fund, 1974

Gentileschi, Orazio 1563–1639, *The Rest on the Flight into Egypt*, purchased from the Duchess of Kent, 1947

Gere, Charles March 1869–1957, *A Cotswold Quarry*, presented by the Public Picture Gallery Fund, 1921

Gere, Charles March 1869–1957, *The View from Wyndcliffe*, presented anonymously, 1936

German School 19th C, *Man with a Winning Lottery Ticket*, unaccessioned find, 2006

Gerrard, Kaff 1894–1970, *Artemisia in a Glass Vase*, presented by Professor A. H. Gerrard, 1991, © Goldmark Gallery on behalf of Karen Gerrard

Gerrard, Kaff 1894–1970, *Haysom's Quarry, Isle of Purbeck*, presented by Professor A. H. Gerrard, 1991, © Goldmark Gallery on behalf of Karen Gerrard

Gerrard, Kaff 1894–1970, *Moonlight at Thetford Priory*, presented by Professor A. H. Gerrard, 1991, © Goldmark Gallery on behalf of Karen Gerrard

Gerrard, Kaff 1894–1970, *Phoenix Entering Paradise*, presented by Professor A. H. Gerrard, 1991, © Goldmark Gallery on behalf of Karen Gerrard

Gertler, Mark 1892–1939, *Portrait of the artist's Family, a Playful Scene*, bequeathed by Joseph Isaacs, 1949, © by permission of Luke Gertler

Ghosh, Amal b.1933, *Lunacy*, purchased with the assistance of the Museums and Galleries Commission/Victoria & Albert Museum Purchase Grant Fund and the Friends of Birmingham Museums and Art Gallery, 1994

Gilbert, John 1817–1897, *Sir John Falstaff Reviewing His Ragged Regiment*, presented by Mrs Godfrey Nettleford, 1918

Gilbert, John 1817–1897, *The Taming of the Shrew*, presented by Robert Lucas Chance, 1881

Gilbert, John 1817–1897, *Scene from Shakespeare's 'The Merchant Of Venice'*, purchased from Mrs Carol Manheim, 1984

Gilbert, John 1817–1897, *Preparing for the Charge*, presented by the artist, 1893

Gilbert, John 1817–1897, *Study of Trees*, presented by the artist, 1893

Gilbert, John 1817–1897, *Old Cottages at Lewisham*, presented by the artist, 1893

Gilbert, John 1817–1897, *Landscape Sketch*, presented by the artist, 1893

Gilbert, John 1817–1897, *The Return of the Victors*, presented by the artist, 1893

Gilbert, John 1817–1897, *The Baggage Wagon*, presented by the artist, 1893

Gilbert, John 1817–1897, *A Windy Day*, presented by the artist, 1893

Gilman, Harold 1876–1919, *The Nurse*, presented by the Friends of Birmingham Museums and Art Gallery, 1947

Gilman, Harold 1876–1919, *Portrait Study of a Woman*, presented by the Friends of Birmingham Museums and Art Gallery, 1959

Giordano, Luca 1634–1705, *Dives and Lazarus*, purchased from P. & D. Colnaghi Co. Ltd, 1954

Girard, Paul-Albert 1839–1920, *Ritual Slaying of Cockerels*, unaccessioned find at Highbury Hall, 1987

Girodet de Roucy-Trioson, Anne-Louis 1767–1824, *The Death of Hippolytus*, purchased, 1960

Glehn, Wilfred Gabriel de 1870–1951, *Mrs Neville Chamberlain*, presented by Mrs Neville Chamberlain, 1966

Gluckstein, Hannah 1895–1978, *The Village Church and Pond, Falmer, Sussex*, presented anonymously through the Fine Art Society, 1937, © the artist's estate

Gogin, Charles 1844–1931, *Portrait of the artist's Mother*, presented by Mrs Charles Gogin, 1935

Gogin, Charles 1844–1931, *Shoreham-on-Sea, Sussex*, presented by Mrs Charles Gogin, 1931

Goodman, Robert Gwelo 1871–1939, *The Karroo, Cape of Good Hope at Evening*, presented by A. W. Keep, H. F. Keep and C. E. Keep, 1924

Goodman, Robert Gwelo 1871–1939, *Welgelegen, near Groote Schuur, South Africa*, presented by Dame Elizabeth Cadbury, 1924

Gordon, John Watson 1788–1864, *David Cox (1783–1859)*, purchased from the Birmingham & Midland Institute, 1978

Gore, Spencer 1878–1914, *Portrait of the Artist*, presented by the Friends of Birmingham Museums and Art Gallery, 1962

Gore, Spencer 1878–1914, *Portrait of the artist's Wife*, purchased with the assistance of the Museums and Galleries Commission/Victoria & Albert Museum Purchase Grant Fund, 1983

Gore, Spencer 1878–1914, *Wood in Richmond Park*, presented by the Public Picture Gallery Fund, 1928

Goyen, Jan van 1596–1656, *A River Scene*, purchased from Roland, Browse and Delbanco Ltd, 1947

Graham-Gilbert, John 1794–1866, *William Murdoch (1754–1839)*, presented by W. Murdoch, 1884

Grainger, Gertrude active 1950–1953, *Landscape near Shoreham, Kent*, presented by the Friends of Birmingham Museums and Art Gallery, 1953

Grant, Duncan 1885–1978, *Boats at Twickenham*, presented by the Contemporary Art Society, 1942, © 1978 estate of Duncan Grant

Grant, Duncan 1885–1978, *Dancers, a Decoration*, presented by the Contemporary Art Society, 1947, © 1978 estate of Duncan Grant

Grant, Duncan 1885–1978, *On the Table*, presented by Sir Kenneth Clark and the Contemporary Art Society, 1946, © 1978 estate of Duncan Grant

Grant, Francis 1803–1878, *Katherine Boulton (d.c.1890)*, purchased from the Tew Hall sale, 1987

Greaves, Walter 1846–1930, *Portrait of the Artist*, presened by the Friends of Birmingham Museums and Art Gallery, 1945

Green, Alfred H. b.c.1822, *Ann Street School, Birmingham*, purchased with the assistance of the Christina Feeney Bequest Fund, 1928

Green, W. active 1829–1850, *Longmore Pool, Sutton Park*, unaccessioned find, 1952

Green, W. active 1829–1850, *The Old Toll Gate, Villa Road, Handsworth*, unaccessioned find, 1952

Green, W. active 1829–1850, *'Waggon and Horses Inn', Handsworth*, unaccessioned find, 1952

Greenberg, Mabel 1889–1933, *The Matriarch*, presented by Louis Greenhill, 1933

Guardi, Francesco 1712–1793, *Venice, Santa Maria delle Salute and the Dogana*, presented by Frederick John Nettlefold, 1947

Guercino 1591–1666, *Erminia and the Shepherd*, purchased with the assistance of the National Art Collections Fund and the Museums and Galleries Commission/Victoria & Albert Museum Purchase Grant Fund, 1962

Guillaumin, Armand 1841–1927, *Les environs de Paris*, presented by the Friends of Birmingham Museums and Art Gallery, 1958

Gwynne-Jones, Allan 1892–1982, *Spring Evening, Froxfield*, presented by the Public Picture Gallery Fund, 1923, © the artist's estate/www.bridgeman.co.uk

Hall, Oliver 1869–1957, *A Breezy Day, Bardsea Forest*, presented by A. E. Anderson, 1930

Hall, William Henry 1812–1880, *An English Cottage* (panel in the Everitt Cabinet), bequeathed by Mrs Allen Edward Everitt, 1892

Hambling, Maggi b.1945, *Max and Me: In Praise of Smoking*, presented by the Contemporary Art Society, 1986, © the artist

Hamilton, Richard b.1922, *Whitley Bay*, purchased with the assistance of the Heritage Lottery Fund, the National Art Collections Fund (The Art Fund) and the Resource/Victoria & Albert Museum Purchase Grant Fund, 2000, © Richard Hamilton 2008. All rights reserved DACS

Hamilton, William 1751–1801, *Scene from Shakespeare's 'A Winter's Tale'*, presented anonymously, 1958

Hamilton, William 1751–1801, *The Pilgrim*, bequeathed by Sir Leonard Woolley through the National Art Collections Fund, 1961

Hammond, Robert John b.c.1854, *Moseley Church, Birmingham*, transferred from the Birmingham Reference Library, 1977

Harlow, George Henry 1787–1819, *Benjamin Robert Haydon (1786–1846)*, purchased from Gooden & Fox Ltd, 1957

Harmar, Fairlie 1876–1945, *After a Game of Tennis*, presented by the Contemporary Art Society, 1924

Harper, Edward Steel II 1878–1951, *Mrs Alfred C. Osler*, presented by subscribers, 1918

Harper, Edward Steel II 1878–1951, *Self Portrait*, presented by the family of Edward Samuel Harper Senior, 1941

Harper, Edward Steel II 1878–1951, *Harry Lucas (d.1939)*

Harper, Edward Steel II 1878–1951, *A Street at Night in Wet Weather*, presented by the family of Edward Samuel Harper Senior, 1941

Harper, Edward Steel II 1878–1951, *'By untamable hope our bodies are enthralled'*, unaccessioned find, 2006

Harper, Edward Steel II 1878–1951, *Evening in South Devon*, presented by the family of Edward Samuel Harper Senior, 1941

Harper, Edward Steel II 1878–1951, *Guillotine Lock at Lifford*, presented by Mrs Steel Harper-Harborne, 1954

Harper, Edward Steel II 1878–1951, *Henry William Sambidge*, presented by the Sambidge Family, 2006

Harpignies, Henri-Joseph 1819–1916, *Le pont de Nevers*, presented by Mary E. Adam, 1936

Harris, Edwin 1855–1906, *Head of a Fisher Boy*, bequeathed by Mrs G. F. White, 1901

Harris, Edwin 1855–1906, *The Valentine*, bequeathed by Bessie Mullins and Mrs Emily Mullins, 1951

Harris, Frederick Henry Howard 1826–1901, *At Tangier* (panel in the Everitt Cabinet), bequeathed by Mrs Allen Edward Everitt, 1892

Harris, Jane b.1956, *Pine*, on loan from the Contemporary Art Society Special Collection Scheme funded by the Arts Council Lottery and the Friends of Birmingham Museums and Art Gallery, © the artist

Hartung, Hans Heinrich 1904–1989, *T 1966-H28*, presented by the Friends of Birmingham Museums and Art Gallery, 1968

Harvey, Harold C. 1874–1941, *The Critics*, presented by Sir Barry Jackson, 1922, © the artist's estate/www.bridgeman.co.uk

Harvey, John Rathbone 1862–1933, *A Scene in Surrey*, presented by the family of John Rathbone Harvey, 1943

Harvey, John Rathbone 1862–1933, *Landscape with a Distant View*, presented by the family of John Rathbone Harvey, 1943

Harvey, John Rathbone 1862–1933, *Windswept Hills*, presented by the family of John Rathbone Harvey, 1943

Haughton, Benjamin 1865–1924, *Mounts Bay, Cornwall*, presented by Mrs Janet M. Haughton, 1937

Haughton, Moses the elder 1734–1804, *An Owl*, presented by the Friends of Birmingham Museums and Art Gallery, 1935

Haughton, Moses the elder 1734–1804, *Fish*, presented by C. R. Cope, 1868

Haughton, Moses the elder 1734–1804, *Floral Piece*, on loan from a private collection

Haughton, Moses the elder 1734–1804, *Gypsies in a Landscape*, presented by Mrs Ray, 1935

Havell, William 1782–1857, *Driving Home the Flock*, presented by James Richardson Holliday, 1912

Hayden, Henri 1883–1970, *Cassis*, purchased with the assistance of the Museums and Galleries Commission/Victoria & Albert Museum Purchase Grant Fund, 1972, © ADAGP, Paris and DACS, London 2008

Haydon, Benjamin Robert 1786–1846, *The Meeting of the Birmingham Political Union*, presented by the Friends of Birmingham Museums and Art Gallery, 1936

Hayes, Frederick William 1848–1918, *Snowdon and Caernarvon from Llanddwyn Island*, presented by Mrs Frederick William Hayes, 1922

Hayman, Francis c.1708–1776, *Playing at Quadrille*, purchased from Thomas Agnew and Sons Ltd, 1955

Hayman, Francis c.1708–1776, *Sir John Falstaff Raising Recruits*, purchased from P. & D. Colnaghi Co. Ltd, 1956

Hemy, Charles Napier 1841–1917, *Homeward*, purchased, 1887

Henderson, Keith 1883–1982, *The Castle of St Hilarion, Cyprus, Early Morning*, presented by the Alfred Leadbeater Bequest Fund, 1929

Henshaw, Frederick Henry 1807–1891, *Sarzana, La Spezia, Italy*, bequeathed by Sir John Holder, 1923

Henshaw, Frederick Henry 1807–1891, *Valley Crucis*, bequeathed by Mary Richards, Director of the Birmingham Repertory Theatre

Henshaw, Frederick Henry 1807–1891, *Five-Barred Gate at Yardley*, purchased, 1929

Henshaw, Frederick Henry 1807–1891, *Worcestershire Scenery in Autumn*, purchased from J. H. Chance, 1885

Henshaw, Frederick Henry 1807–1891, *A Forest Glade, Arden, Warwickshire*, purchased from the family of Timothy Kenrick, 1885

Henshaw, Frederick Henry 1807–1891, *Edinburgh from Corstorphine*, bequeathed by Sir John Holder, 1923

Henshaw, Frederick Henry 1807–1891, *An Old Oak, Forest of Arden, Warwickshire*, purchased from George Dixon, 1867

Henshaw, Frederick Henry 1807–1891, *The Broken Bough* (panel in

the Everitt Cabinet), bequeathed by Mrs Allen Edward Everitt, 1892

Henshaw, Frederick Henry 1807–1891, *A Glimpse of Wharfdale, Yorkshire*, purchased, 1917

Henshaw, Frederick Henry 1807–1891, *The Old Footbridge over the River Cole at Yardley*, purchased from Cecil William Lowndes, 1957

Henshaw, Frederick Henry 1807–1891, *The Road to the Abbey, Bolton, Yorkshire*, purchased, 1917

Hepworth, Barbara 1903–1975, *Prelude I*, presented by the Friends of Birmingham Museums and Art Gallery, 1948, © Bowness, Hepworth estate

Herkomer, Hubert von 1849–1914, *Sir Edward George Jenkinson (1836–1919)*, presented by Miss M. L. Jenkinson, 1932

Herman, Josef 1911–2000, *The Washerwomen*, presented by the Friends of Birmingham Museums and Art Gallery, 1968, © the artist's estate

Heron, Patrick 1920–1999, *Standing Figure, Rachel*, presented in memory of Richard and Rachel Harris through the National Art Collections Fund, 2000, © estate of Patrick Heron 2008. All rights reserved, DACS

Heron, Patrick 1920–1999, *Porthmeor 1965, Rumbold 1970*, purchased with the assistance of the Resource/Victoria & Albert Museum Purchase Grant Fund, the Public Picture Gallery Fund and the Friends of Birmingham Museums and Art Gallery, 1999, © estate of Patrick Heron 2008. All rights reserved, DACS

Herp, Willem van I c.1614–1677, *The Blind Fiddler*, bequeathed by Sir Theophilus Biddulp, 1969

Hewitt, Geoffrey b.1930, *Cavalryman*, on permanent loan from the Friends of Birmingham Museums and Art Gallery

Highmore, Joseph 1692–1780, *John Whitehall of 'Furnivall's Inn'*, presented by Sir Bruce Ingram, 1936

Highmore, Joseph 1692–1780, *Portrait of a Man*, purchased, 1954

Highmore, Joseph 1692–1780, *Portrait of a Woman*, purchased, 1954

Hill, Derek 1916–2000, *Boxer Resting, Don Cockell*, purchased, 1962, © the artist's estate

Hill, Paul b.1959, *Little Street Fighter*, purchased with the assistance of the Friends of Birmingham Museums and Art Gallery, 2003, © the artist

Hill, Paul b.1959, *Getting His Bottle In*, presented by the Castle Vale Housing Action Trust, 2005, © the artist

Hill, Paul b.1959, *Changing of the Guard*, presented by the Castle Vale Housing Action Trust, 2005, © the artist

Hillier, Tristram Paul 1905–1983, *The Gate*, presented by the Friends of Birmingham Museums and Art

Gallery, 1979, © the artist's estate

Himid, Lubaina b.1954, *My Parents, Their Children* (detail), on loan from the Contemporary Art Society Special Collection Scheme funded by the Arts Council Lottery and the Friends of Birmingham Museums and Art Gallery, © the artist

Himid, Lubaina b.1954, *Plan B*, on loan from the Contemporary Art Society Special Collection Scheme funded by the Arts Council Lottery and the Friends of Birmingham Museums and Art Gallery, © the artist

Hirkby, Thomas active 19th C, *Reverend Henry Martin*, unaccessioned find, 2006

Hitchens, Ivon 1893–1979, *Tangled Pool Number Nine*, presented by the Friends of Birmingham Museums and Art Gallery, 1949, © Ivon Hitchens' estate/Jonathan Clark & Co.

Hobbema, Meindert 1638–1709, *The Watermill*, presented by the John Feeney Bequest Fund, 1938

Hobday, William Armfield 1771–1831, *Self Portrait*, presented by Messrs Vicars Bros, 1922

Hodges *Lady Holte (1734–1799), Wife of Sir Charles Holte of Aston Hall*, purchased from the Reverend James Compton Bracebridge, 1981

Hodgkin, Howard b.1932, *Gardening*, purchased with the assistance of the Heritage Lottery Fund, the National Art Collections Fund, the Museums and Galleries Commission/Victoria & Albert Museum Purchase Grant Fund and the Rowlands Trust, 1997, © Howard Hodgkin

Hodgkin, Howard b.1932, *Large Staff Room*, on loan from a private collection, © Howard Hodgkin

Hodgkin, Howard b.1932, *Room with Chair*, on loan from a private collection, © Howard Hodgkin

Hodgkin, Howard b.1932, *Venice Sunset*, on loan from a private collection, © Howard Hodgkin

Hogarth, William 1697–1764, *Scene from John Gay's 'The Beggar's Opera'*, purchased with the assistance of a special Capital Grant from the City of Birmingham, 1985

Hogarth, William 1697–1764, *The Distressed Poet*, presented by Sir Charles Hyde, 1934

Holl, Frank 1845–1888, *Head of an Old Man*, bequeathed by Elizabeth Tonks, 1986

Holl, Frank 1845–1888, *Edmund Tonks (1824–1898)*, bequeathed by Edmund Tonks, 1898

Holl, Frank 1845–1888, *Sir Thomas Martineau (1828–1893)*, presented by subscribers, 1887

Holland, James 1800–1870, *A Recollection of Venice*, presented by Mrs Rickards, 1912

Holmes, Charles John 1868–1936, *A Warehouse*, bequeathed by C. H. Collins Baker, 1960

Holyoake, William 1834–1894,

George Jacob Holyoake (1817–1906), bequeathed by G. J. Holyoake, 1906

Hook, James Clarke 1819–1907, *Fish from the Dogger Bank, Scheveningen, Holland*, purchased, 1892

Hook, James Clarke 1819–1907, *Breakfasts for the Porth*, bequeathed by the Right Honourable William Kenrick and Mrs William Kenrick, 1919

Horsley, Hopkins Horsley Hobday 1807–1890, *Heads of Children, Boy and Girl, Three Studies*, presented by the family of the artist, 1928

Horsley, Hopkins Horsley Hobday 1807–1890, *On the Sands at Rhyl, North Wales*, purchased, 1992

Horsley, Hopkins Horsley Hobday 1807–1890, *Andermatt, Switzerland* (panel in the Everitt Cabinet), bequeathed by Mrs Allen Edward Everitt, 1892

Howitt, Samuel c.1765–1822, *Lion and Leopard*, purchased from Gooden & Fox Ltd, 1972

Hoyland, John b.1934, *10.9.75*, purchased with the assistance of the Museums and Galleries Commission/Victoria & Albert Museum Purchase Grant Fund and the Public Picture Gallery Fund, 1980, © the artist/www.bridgeman. co.uk

Hughes, Arthur 1832–1915, *Study for 'The Young Poet (Portrait of the Artist)'*, presented by Charles Alexander Munro, 1957

Hughes, Arthur 1832–1915, *The Young Poet (Portrait of the Artist)*, presented by Miss E. Hughes, 1935

Hughes, Arthur 1832–1915, *Study for 'Musidora Bathing'*, presented by Charles Alexander Munro, 1957

Hughes, Arthur 1832–1915, *Musidora Bathing*, presented by Miss E. Hughes, 1935

Hughes, Arthur 1832–1915, *The Annunciation*, purchased, 1892

Hughes, Arthur 1832–1915, *The Nativity*, purchased, 1892

Hughes, Arthur 1832–1915, *Amy* (study for 'The Long Engagement'), purchased, 1925

Hughes, Arthur 1832–1915, *The Long Engagement*, presented by the executors of Dr Edwin T. Griffiths, 1902

Hughes, Arthur 1832–1915, *Study of a Girl's Head*, presented by Thomas Devitt, Bt, 1922

Hughes, Arthur 1832–1915, *The Lost Child*, presented by Mr and Mrs Cotterill Deykin, 1926

Hughes, John Joseph 1820–1909, *Aston Hall, East Front*, purchased from the Reverend James Compton Bracebridge, 1981

Hughes, John Joseph 1820–1909, *View of a Farm in Wood Lane, Handsworth*, presented by Miss N. M. Wakelin, 1965

Hughes, John Joseph 1820–1909, *View of Hamstead Mill, Handsworth*, presented by Mrs Flavell, 1960

Hughes, John Joseph 1820–1909,

View of Hay Time, Hamstead Mill, Handsworth, presented by Mrs Flavell, 1960

Hughes, Patrick b.1939, *Superduperspective*, purchased with the assistance of the Art Fund, the Museums, Libraries and Archives Council/Victoria & Albert Museum Purchase Grant Fund, the Public Picture Gallery Fund, the Friends of Birmingham Museums and Art Gallery, a donation from Richard and Judith Bailey and by public subscription, 2003, © the artist

Hunt, Alfred William 1830–1896, *Whitby Scar, Yorkshire*, presented by J. Arthur Kenrick, 1925

Hunt, Alfred William 1830–1896, *A Norwegian Midnight*, presented by the Public Picture Gallery Fund, 1879

Hunt, Alfred William 1830–1896, *Leafy June*, presented by J. Arthur Kenrick, 1925

Hunt, William Holman 1827–1910, *Self Portrait*, purchased from Mrs M. Burth, 1961

Hunt, William Holman 1827–1910, *Valentine Rescuing Sylvia from Proteus*, purchased from Christie's, 1887

Hunt, William Holman 1827–1910, *Dante Gabriel Rossetti (1828–1882)*, purchased with the assistance of the bequest of W. T. Wiggins-Davies Bequest to commemorate the service of Alderman W. Byng Kenrick to the City of Birmingham, 1961

Hunt, William Holman 1827–1910, *The Finding of the Saviour in the Temple*, presented by Sir John Middlemore, 1896

Hunt, William Holman 1827–1910, *The Lantern Maker's Courtship (Cairo Street Scene)*, presented by the family of Wilfred Byng Kenrick, 1962

Hunt, William Holman 1827–1910, *May Morning on Magdalen College Tower, Oxford, Ancient Annual Ceremony*, presented by Mr Barrow Cadbury and Dame Geraldine S. Cadbury, 1907

Hurlstone, Frederick Yeates 1800–1869, *A Young Savoyard*, bequeathed by William Middlemore, 1892

Ibbetson, Julius Caesar 1759–1817, *Gypsies with an Ass Race*, presented by Mrs W. H. Ryland, 1915

Inchbold, John William 1830–1888, *Springtime in Spain, near Gordella*, presented by Miss Hipkins, 1913

Innes, Callum b.1962, *Exposed Painting, Paynes Grey, Red Violet on White*, on loan from the Contemporary Art Society Special Collection Scheme funded by the Arts Council Lottery and the Friends of Birmingham Museums and Art Gallery, © the artist

Innes, Callum b.1962, *Exposed Painting, Paynes Grey, Yellow Oxide on White*, on loan from the

Lines, Samuel 1778–1863, *Birmingham from the Dome of St Philip's Church*, presented by Frederick Thomas Lines, 1893

Lines, Samuel 1778–1863, *Birmingham Town Hall and Queen's College*, presented by the Friends of Birmingham Museums and Art Gallery, 1935

Lines, Samuel 1778–1863, *The Duke of Cambridge Leaving the Town Hall, Birmingham*, presented by Mrs Maxwell, 1902

Lines, Samuel 1778–1863, *The Opening of Calthorpe Park, Birmingham*, presented by Mrs Maxwell, 1902

Lines, Samuel 1778–1863, *Llyn Idwal, North Wales*, purchased from the Birmingham and Midland Institute, 1978

Lines, Samuel 1778–1863, *Panoramic View of the Severn Estuary*, purchased from Phillips, 1991

Lines, Samuel (circle of) 1778–1863, *Gordale Scar, Yorkshire*, transferred from the Birmingham Reference Library, 1977

Lines, Samuel (circle of) 1778–1863, *Grove*, transferred from the Birmingham Reference Library, 1977

Lines, Samuel (circle of) 1778–1863, *Kirkstall Abbey*, transferred from the Birmingham Reference Library, 1977

Lines, Samuel (circle of) 1778–1863, *Mountain Scene with Trees*, transferred from the Birmingham Reference Library, 1977

Lines, Samuel (circle of) 1778–1863, *Mountain Stream and Rocks*, transferred from the Birmingham Reference Library, 1977

Lines, Samuel (circle of) 1778–1863, *Pastoral Scene with Cattle*, transferred from the Birmingham Reference Library, 1977

Lines, Samuel (circle of) 1778–1863, *Rural Scene with Buildings and Trees*, transferred from the Birmingham Reference Library, 1977

Lines, Samuel (circle of) 1778–1863, *Stone Ruin on Hilltop*, transferred from the Birmingham Reference Library, 1977

Lines, Samuel Restell 1804–1833, *Landscape with Trees*, purchased, 1937

Linnell, John 1792–1882, *The Sheep Drive*, presented by the Public Picture Gallery Fund, 1897

Linnell, William 1826–1906, *A Wooded Valley and Hill*, presented by Walter Chance, 1936

Lobley, James 1829–1888, *The Free Seat*, purchased from M. Newman Ltd, 1937

Lockwood, Frank Taylor 1895–1961, *Town by the Sea*, presented by Arthur Lockwood and Jean T. Barnsby, 1995, © the artist's estate

Lockwood, Frank Taylor 1895–1961, *Town by the Sea*, presented by Arthur Lockwood and Jean T. Barnsby, 1995, © the artist's estate

Logsdail, William 1859–1944, *St Mark's Square, Venice*, presented by Sir John Holder, 1898, © the artist's estate/www.bridgeman.co.uk

Loo, Jean-Baptiste van 1684–1745, *Sir Richard Temple (1675–1749), 4th Viscount of Birmingham*, presented by H. M. Government, Arts and Libraries Department, 1987

Loo, Jean-Baptiste van 1684–1745, *The 4th Earl of Chesterfield (1694–1773)*, presented by H. M. Government, Arts and Libraries Department, 1987

Lorrain, Claude 1604–1682, *Landscape near Rome with a View of the Ponte Molle*, bequeathed by Ernest E. Cook, 1955

Lorrain, Claude 1604–1682, *Coast Scene with the Embarkation of Saint Paul*, purchased from Norman Crompton, 1962

Loutherbourg, Philip James de 1740–1812, *Christ Appearing to the Disciples at Emmaus*, purchased with the assistance of the National Art Collections Fund and the Museums and Galleries Commission/Victoria & Albert Museum Purchase Grant Fund, 1982

Loutherbourg, Philip James de 1740–1812, *The Betrayal of Christ*, purchased with the assistance of the National Art Collections Fund and the Museums and Galleries Commission/Victoria & Albert Museum Purchase Grant Fund, 1982

Loutherbourg, Philip James de 1740–1812, *The Milkmaid*, presented by the John Feeney Bequest Fund, 1920

Lowry, Laurence Stephen 1887–1976, *An Industrial Town*, presented by the Friends of Birmingham Museums and Art Gallery, 1946, © courtesy of the estate of L. S. Lowry

Luard, Lowes Dalbiac 1872–1944, *Chestnut Horses*, presented by Mrs Lyell, 1946

Lucas, Eugenio the elder 1824–1870, *The Ambush*, purchased, 1965

Manzuoli, Tommaso 1531–1571, *Madonna and Child with the Infant St John*, presented by the Public Picture Gallery Fund, 1966

Marcoussis, Louis 1883–1941, *Le lecteur*, presented by the Friends of Birmingham Museums and Art Gallery, 1951, © ADAGP, Paris and DACS, London 2008

Marks, Henry Stacey 1829–1898, *Dominicans in Feathers*, presented by Sir John Holder, 1890

Marks, Henry Stacey 1829–1898, *Where Is It?*, bequeathed by Joseph Beattie, 1890

Marlow, William 1740–1813, *The Temple of Venus, Bay of Baiae*, presented by Hugh Morton, 1930

Maron, Anton von 1733–1808, *Peter du Cane (1741–1823)*, presented by F. F. Madan, 1951

Marquet, Albert 1875–1947, *The Port of Cette, Marseilles*, presented by the Honourable Clare Stuard-Wortley, 1946, © ADAGP, Paris and DACS, London 2008

Martin, Jason b.1970, *Serengetti*, on loan from the Contemporary Art Society Special Collection Scheme funded by the Arts Council Lottery and the Friends of Birmingham Museums and Art Gallery, © the artist

Martineau, Robert Braithwaite 1826–1869, *The Last Chapter*, presented by Miss Helen Martineau, 1942

Martini, Simone c.1284–1344, *A Saint Holding a Book*, purchased with the assistance of the Museums and Galleries Commission/Victoria & Albert Museum Purchase Grant Fund, 1959

Mason, George Heming 1818–1872, *Cattle at a Drinking Place in the Campagna, Rome*, presented by the Fine Art Society, 1983

Mason, Gilbert 1913–1972, *Self Portrait*, bequeathed by Professor J. H. Wolstencroft, 1984

Master of Castelsardo active c.1475–c.1525, *The Virgin and Child with Angels and Donors*, presented by William Scott, 1884

Master of the Annunciation to the Shepherds *The Angel Appearing to the Shepherds*, presented by the Public Picture Gallery Fund, 1949

Master of the Prado Adoration of the Magi (attributed to) active c.1470–1500, *Nativity*, presented by John Heathcote-Amory, 1973

Master of the San Lucchese Altarpiece *Madonna and Child Enthroned with Saints*, purchased 1958

Matteo di Giovanni c.1430–1495, *Angel Appearing to Joachim*, purchased from P. & D. Colnaghi Co. Ltd, 1959

Mauperché, Henri 1602–1686, *Jephthah and His Daughter*, presented by the Public Picture Gallery Fund, 1967

Mayson, S. active c.1840–1860, *The Approach to the Celestial City*, presented by the Friends of Birmingham Museums and Art Gallery, 1945

McEvoy, Ambrose 1878–1927, *Cottages at Aldbourne*, presented by the Friends of Birmingham Museums and Art Gallery, 1945

McEvoy, Ambrose 1878–1927, *Mrs Richard Jessel*, presented in memory of Percy Tonks by his wife and daughter, 1948

McFadyen, Jock b.1950, *Ian Paisley: 'You can knock me down, steal my car, drink my liquor from an old fruit jar, but don'tcha…'*, presented by the Friends of Birmingham Museums and Art Gallery, 1984, © the artist

McGowan, Richard b.1950, *Late Witness*, on permanent loan from the Friends of Birmingham Museums and Art Gallery, © the artist

McKeever, Ian b.1946, *Assumptio II (Breathing)*, on loan from the Contemporary Art Society Special Collection Scheme funded by the Arts Council Lottery and the Friends of Birmingham Museums and Art Gallery, © the artist

McLean, Bruce b.1944, *Spoon 2 Spoon, II*, presented by Dasha Shenkman through the Contemporary Art Society, 2005, © the artist

Medley, Robert 1905–1994, *The Perambulator*, presented by the Friends of Birmingham Museums and Art Gallery, 1955, © James Hyman Fine Art on behalf of the estate of Robert Medley

Melville, Elizabeth *Joseph Chamberlain (1836–1914)*, unaccessioned find

Melville, John 1902–1986, *Portrait of the artist's Wife*, presented by Mrs Lily Melville, 1989

Meteyard, Sidney Harold 1868–1947, *Hope Comforting Love in Bondage*, presented by O. E. Meteyard, 1948

Methuen, Paul Ayshford 1886–1974, *Town of Richelieu, Indre-et-Loire*, presented by Mrs Moresby White, 1955, © trustees of the Corsham estate

Meulen, Adam Frans van der (attributed to) 1631/1632–1690, *View of Versailles with Louis XIV and Huntsmen*, presented by Miss D. M. Smith, 1966

Middleton, W. H. active 19th C, *Autumn at Olton Mill*, presented by Miss M. O. Middleton, 1983

Millais, John Everett 1829–1896, *Three Sword Hilts*, presented by the Misses Frere, 1946

Millais, John Everett 1829–1896, *Elgiva Seized by Order of Archbishop Odo*, purchased with the assistance of the Museums and Galleries Commission/Victoria & Albert Museum Purchase Grant Fund and the Public Picture Gallery Fund, 1980

Millais, John Everett 1829–1896, *The Blind Girl*, presented by the Right Honourable William Kenrick, 1892

Millais, John Everett 1829–1896, *My Second Sermon*, presented by Mrs Edward Nettlefold, 1909

Millais, John Everett 1829–1896, *Waiting*, presented by Mrs Edward Nettlefold, 1909

Millais, John Everett 1829–1896, *The Enemy Sowing Tares (St Matthew XIII, 24–25)*, presented by the Public Picture Gallery Fund, 1925

Millais, John Everett 1829–1896, *A Widow's Mite*, purchased, 1891

Millais, John Everett 1829–1896, *Mrs Joseph Chamberlain*, purchased with the assistance of the Museums and Galleries Commission/Victoria & Albert Museum Purchase Grant Fund, the Pilgrim Trust, the John Feeney Charitable Trust, the George Henry Collins Charity and the W. D. Cadbury Trust, 1989

Millar, James 1735–1805, *Self Portrait*, purchased by the Friends of Birmingham Museums and Art Gallery, 1982

Millar, James 1735–1805, *John Baskerville (1706–1775)*, presented by the Reverend A. H. Caldicott, 1940

Millar, James 1735–1805, *Francis Eginton (1736/1737–1805)*, bequeathed by Mrs Haynes, 1912

Millar, James 1735–1805, *Robert Mynors and His Family*, purchased with the assistance of the John Feeney Bequest Fund and the Museums and Galleries Commission/Victoria & Albert Museum Purchase Grant Fund, 1977

Millar, James 1735–1805, *Artist's Advertisement*, presented by the Friends of Birmingham Museums & Art Gallery, 1988

Millar, James 1735–1805, *Dr John Derrington (1747–1805)*, presented by W. A. Albright, 1923

Millar, James 1735–1805, *John Freeth (1731–1808)*, bequeathed by Frank Manton, 1922

Millar, James 1735–1805, *William Westley*, presented by Montague Bernard, 1979

Millet, Jean-François the elder 1642–1679, *Regulus Returning to Carthage*, purchased from P. & D. Colnaghi Co. Ltd, 1958

Modigliani, Amedeo 1884–1920, *Madame Z*, on loan from a private collection

Mola, Pier Francesco 1612–1666, *Mercury and Argus*, on loan from Sir Denis Mahon, CBE FBA, since 1999

Mola, Pier Francesco 1612–1666, *Landscape with Saint in Ecstasy*, bequeathed by Sir Leonard Woolley through the National Art Collections Fund, 1960

Montford, Arnold G. active 19th C, *Alderman Samuel Edwards, 1st Lord Mayor of Birmingham*, presented by Chesterton International, 2004

Moon, Mick b.1937, *Varengeville*, presented by the Contemporary Art Society, 1979, © the artist

Moore, Albert Joseph 1841–1893, *Canaries*, presented by the Right Honourable Sir Austen Chamberlain, 1914

Moore, Albert Joseph 1841–1893, *Sapphires*, presented by the Right Honourable Sir Austen Chamberlain, 1914

Moore, Albert Joseph 1841–1893, *Dreamers*, presented by Sir Richard Tangye and George Tangye, 1885

Moore, Edward d.1920, *Coastal Scene*, unaccessioned find, 1987

Moore, Henry 1831–1895, *Rough Weather on the Coast, Cumberland*, bequeathed by A. E. Fridlander, 1929

Moore, Henry 1831–1895, *Near Lossiemouth*, presented by T. S. Walker, 1929

Moore, Henry 1831–1895, *Summertime off Cornwall*,

279

presented by the Public Picture Gallery Fund, 1883

Moore, Henry 1831–1895, *Newhaven Packet*, purchased, 1886

Moore, William I 1790–1851, *James Millar (1735–1805)*, presented by the family of William Moore, 1933

Morandi, Giorgio 1890–1964, *Still Life*, purchased from the artist, 1959, © DACS 2008

Morland, George 1763–1804, *Shooting Sea Fowl*, presented by Frederick John Nettlefold, 1947

Morland, George 1763–1804, *Pigs*, presented by Mrs Howard Luckock, 1887

Morland, Henry Robert c.1716–1797, *Oyster Girl*, purchased, 1972

Morris, Desmond b.1928, *The Jumping Three*, purchased with the assistance of the Museums and Galleries Commission/Victoria & Albert Museum Purchase Grant Fund, 1991, © Desmond Morris

Muirhead, David 1867–1930, *Blue and Silver*, presented by the Feeney Charitable Trust, 1929

Muller, William James 1812–1845, *Font, Walsingham Church*, presented by William Archer Clark, 1933

Muller, William James 1812–1845, *Street Scene in Cairo*, presented by the Right Honourable Joseph Chamberlain, 1881

Muller, William James 1812–1845, *Prayers in the Desert*, presented by the Right Honourable Joseph Chamberlain, 1881

Muller, William James 1812–1845, *View at Gillingham with Cottages*, presented by the John Feeney Bequest Fund, 1921

Muller, William James 1812–1845, *Arab Shepherds*, presented by the Public Picture Gallery Fund, 1881

Muller, William James 1812–1845, *Hampstead Heath, the Bird Trap*, presented by Mrs Rickards, 1919

Muncaster, Claude 1903–1979, *Getting the Fish in Winter Weather, North Atlantic*, presented anonymously, 1937, © the artist's estate

Munnings, Alfred James 1878–1959, *In Cornwall (Portrait of the Artist's Wife)*, presented by the Feeney Charitable Trust, 1921, © the artist's estate

Munnings, Alfred James 1878–1959, *Arrival at Epsom Downs for Derby Week*, presented by the Feeney Charitable Trust, 1921, © the artist's estate

Munnings, Alfred James 1878–1959, *Barry Jackson (1879–1961)*, on loan from the Barry Jackson Trust, © the artist's estate

Munns, Bernard 1869–1942, *Portrait of John Baptist Kramer (1874–1952)*, presented by Mrs R. P. Kramer, 1997

Munns, Henry Turner 1832–1898, *Alderman T. C. Sneyd Kinnersley*, unaccessioned find, 2006

Munns, Henry Turner 1832–1898, *Joseph Gillot (1799–1872)*, presented by N. Gillott, 1973

Munns, Henry Turner 1832–1898, *Sir Josiah Mason (1795–1881)*, presented by subscribers, 1874

Munns, Henry Turner 1832–1898, *George Dawson (1821–1876)*, bequeathed, 1884

Munns, Henry Turner 1832–1898, *Alderman William Brinsley*, bequeathed by William Brinsley, 1905

Munns, Henry Turner 1832–1898, *Boat (panel in the Everitt Cabinet)*, bequeathed by Mrs Allen Edward Everitt, 1892

Munns, Henry Turner 1832–1898, *Girl at a Gate*, bequeathed by G. F. White, 1901

Munns, Henry Turner 1832–1898, *Alderman Thomas Avery*, presented by W. Beilby Averry, 1896

Munns, John Bernard 1869–1942, *Isaac Bradley*, presented by the family of Isaac Bradley, 1927

Munns, John Bernard 1869–1942, *Sir Oliver Lodge (1851–1940)*, presented by Miss V. E. Munns, 1943

Munns, John Bernard 1869–1942, *Self Portrait*, presented by Miss V. E. Munns, 1943

Murillo, Bartolomé Esteban 1618–1682, *The Vision of St Anthony of Padua*, presented by H. M. Government's Treasury, 1974

Muziano, Girolamo 1528/1532–1592, *The Raising of Lazarus*, purchased with the assistance of the Museums and Galleries Commission/Victoria & Albert Museum Purchase Grant Fund, 1975

Nash, Paul 1889–1946, *Oxenbridge Pond*, purchased, 1950, © Tate, London 2008

Nash, Paul 1889–1946, *Landscape of the Moon's First Quarter*, purchased from Arthur Tooth & Sons Ltd, 1953, © Tate, London 2008

Nasmyth, Patrick 1787–1831, *Carisbrooke Castle, Isle of Wight*, presented by the John Feeney Bequest Fund, 1924

Neiland, Brendan b.1941, *Torquay, Window Reflections*, purchased from Angela Flowers, 1975, © the artist

Nevinson, Christopher 1889–1946, *Column on the March*, presented by Sir Adrian Hayhurst Cadbury, 1988, © the artist's estate/www.bridgeman.co.uk

Nevinson, Christopher 1889–1946, *La patrie*, presented by Sir Adrian Hayhurst Cadbury, 1988, © the artist's estate/www.bridgeman. co.uk

Newton, Algernon Cecil 1880–1968, *Birmingham with the Hall of Memory*, presented by the Public Picture Gallery Fund, 1929

Nicholas of Greece 1872–1938, *Sunrise on the Parthenon, Athens*, presented, 1935, © the artist's estate

Nicholls, Bertram 1883–1974, *Orvieto*, presented by the Public Picture Gallery Fund, 1926

Nicholson, Ben 1894–1982, *1944–1945 (painted relief - Arabian desert)*, presented by the Public Picture Gallery Fund, 1980, © Angela Verren Taunt 2008. All rights reserved, DACS

Nicholson, Ben 1894–1982, *1950 (still life, Dolomites)*, presented by the Friends of Birmingham Museums and Art Gallery, 1951, © Angela Verren Taunt 2008. All rights reserved, DACS

Nicholson, William 1872–1949, *The Brown Veil (Mrs Harrington Mann)*, presented by the John Feeney Bequest Fund, 1929, © Elizabeth Banks

Nicholson, William 1872–1949, *The Silver Sunset*, presented by the Friends of Birmingham Museums and Art Gallery, 1954, © Elizabeth Banks

Nicholson, William 1872–1949, *The Pink Dress*, presented by Alderman Oliver Morland and the Friends of Birmingham Museums and Art Gallery, 1944, © Elizabeths Banks

Nicholson, William 1872–1949, *Pink Still Life with Jug*, presented by Florence Engelbach, 1942, © Elizabeth Banks

Nicholson, Winifred 1893–1981, *Flowers at a Window*, purchased with the assistance of the Resource/Victoria & Albert Museum Purchase Grant Fund, the Public Picture Gallery Fund and the Friends of Birmingham Museums and Art Gallery in honour of the chairmanship of Pat Welch, 2001, © trustees of Winifred Nicholson

Nickele, Isaak van active 1660–1703, *Interior of St Bavo, Haarlem*, purchased with the assistance of the Museums and Galleries Commission/Victoria & Albert Museum Purchase Grant Fund

Nicklin, Gary *Vernon Burgess*, presented to the Lord Mayor of Birmingham by Vernon Burgess, 2006

North, John William 1842–1924, *Sweet Water Meadows of the West*, presented by the Right Honourable William Kenrick, 1894

Ochtervelt, Jacob 1634–1682, *The Music Lesson*, bequeathed by Ernest E. Cook, 1955

O'Donoghue, Hughie b.1953, *Incident at Huppy*, purchased with the assistance of the National Art Collections Fund and the Museums and Galleries Commission/Victoria & Albert Museum Purchase Grant Fund, the Public Picture Gallery Fund and the Friends of Birmingham Museums and Art Gallery, 2003, © the artist

Oliver, William 1823–1901, *Portrait of a Young Woman Sitting on a Marble Seat*, found at Highbury Hall, 1987

Olsson, Albert Julius 1864–1942, *The White Squall*, presented by Alderman William A. Cadbury, 1904

O'Neil, Henry Nelson 1817–1880, *The Trial of Queen Catherine of Aragon*, presented by Colonel Ratcliffe, 1881

Opie, John 1761–1807, *The Angry Father (The Discovery… Correspondence)*, presented by the Birmingham Society of Arts, 1867

Orpen, William 1878–1931, *Sir Edwin Ray Lankester (1847–1929)*, presented by the Public Picture Gallery Fund, 1942

Ouless, Walter William 1848–1933, *Alderman Charles Gabriel Beale*, presented by subscribers, 1901

Ouless, Walter William 1848–1933, *Alderman Charles Gabriel Beale*, presented by subscribers, 1901

Owen, George Elmslie 1899–1964, *Abstract*, bequeathed by Thomas Balsdon, 1968

Owen, Mark b.1963, *Untitled*, on loan from the Friends of Birmingham Museums and Art Gallery

Owen, William 1769–1825, *Captain Gilbert Heathcote (1779–1831), RN*, purchased, 1938

Owen, William 1769–1825, *Portrait of a Man and a Woman*, purchased from Gooden & Fox Ltd, 1956

Pacheco, Ana Maria b.1943, *In illo tempore I*, purchased with the assistance of the Museums and Galleries Commission/Victoria & Albert Museum Purchase Grant Fund, the Public Picture Gallery Fund and the Elephant Trust, 1995, © Ana Maria Pacheco, courtesy of Pratt Contemporary Art

Palma, Jacopo il giovane (attributed to) 1544/1548–1628, *Portrait of a Collector*, purchased with the assistance of the National Art Collections Fund, 1961

Pasmore, Victor 1908–1998, *Girl in a Straw Hat*, presented by the Friends of Birmingham Museums and Art Gallery, 1952, © the estate of Victor Pasmore, courtesy of Marlborough Fine Art (London) Limited

Pasmore, Victor 1908–1998, *Spiral Motif, Sea and Sky*, presented by the Friends of Birmingham Museums and Art Gallery, 1963, © the estate of Victor Pasmore, courtesy of Marlborough Fine Art (London) Limited

Paterson, Emily Murray 1855–1934, *The Baths of Diocletian, Rome*, presented by the executors of the artist, 1935

Payne, Henry Albert 1868–1940, *Mrs Lester of Slad Valley, Stroud*, presented by Mr J. J. Tingay, 1983

Payne, Steve b.1949, *Notes towards a Definition of Culture*, on loan from a private collection, © the artist

Pearson, Mary Martha 1799–1871, *Thomas Wright Hill (1763–1851)*, bequeathed by Frederick Hill, 1897

Pellegrini, Giovanni Antonio 1675–1741, *The Continence of Scipio*, on loan from the trustees of the late Miss Margaret Longhurst, 1970

Pellegrini, Giovanni Antonio 1675–1741, *Caesar before Alexandria*, presented by the Public Picture Gallery Fund, purchased with the assistance of the Museums and Galleries Commission/Victoria & Albert Museum Purchase Grant Fund and the Henry Foyle Trust, 1965

Penny, Edward 1714–1791, *Jane Shore Led in Penance to Saint Paul's*, purchased, 1960

Peploe, Samuel John 1871–1935, *Still Life with Bowl of Fruit, Bottle, Cup and Glass*, on loan from a private collection

Peploe, Samuel John 1871–1935, *Still Life with Bowl of Fruit, Jug, Cup and Saucer*, presented by the Lefevre Gallery

Perry, Robert b.1944, *Blockhouse near Jenlain, France*, purchased with the assistance of the Museums, Libraries Archives Council/Victoria & Albert Museum Purchase Grant Fund and the Friends of Birmingham Museums and Art Gallery, 2006, © the artist

Perry, Robert b.1944, *Black Country Night, 10.45pm, 4 October 2005*, on loan from the artist, © the artist

Phillip, John 1817–1867, *The Orange Girl*, bequeathed by Mrs Rickards, 1939

Phillips, Thomas 1770–1845, *The Scott Family*, purchased, 1994

Phillips, Thomas 1770–1845, *Joseph Jennens (1769–1848)*, bequeathed by the executors of Joseph Jennings, 1923

Phillips, Thomas 1770–1845, *Sir John Franklin (1770–1847), RN*, presented by the Birmingham Society of Arts, 1867

Phillips, Thomas 1770–1845, *William Phipson (1770–1845)*, presented by Alderman Charles Gabriel Beale, 1941

Pickenoy, Nicolaes Eliasz. c.1588–c.1655, *Portrait of a Woman*, bequeathed by the Alexander Bequest, 1973

Pierre, Jean Baptiste Marie 1713–1789, *Psyche Rescued by Naiads*, bequeathed by Mrs Jennens, 1906

Piper, John 1903–1992, *Ruined Cottage, Llanthony, Wales*, presented by Sir Kenneth Clark and the Contemporary Art Society, 1946, © the artist's estate

Pissarro, Camille 1831–1903, *Le pont Boieldieu à Rouen, soleil couchant*, purchased, 1950

Pissarro, Lucien 1863–1944, *Mimosa, Lavendou*, presented by Enid Andrews, 1982, © the artist's estate

Pissarro, Lucien 1863–1944, *Notre Dame de Constance, Bormes*, presented by A. Morton Patrick, 1929, © the artist's estate

Pitati, Bonifazio de' 1487–1553, *The Adoration of the Shepherds*, purchased, 1955

Platzer, Johann Georg 1704–1761, *An Allegory of Misrule*, presented by the Public Picture Gallery Fund, purchased with the assistance of the Museums and Galleries Commission/Victoria & Albert Museum Purchase Grant Fund, 1951

Poole, Paul Falconer 1807–1879, *Portrait of a Man*, bequeathed by Mrs E. J. Nettlefold, 1941

Poole, William 1764–1837, *William Poole*, presented by Merrel Charlotte Hodgetts, 2003

Pope, Henry Martin 1843–1908, *The Old Bridge, Yardley Wood*, unaccessioned find

Pountney, H. E. active 1890–1895, *Gateway, Aston Hall*, presented by Mrs M. D. Knight, 1972

Poussin, Nicolas (copy after) 1594–1665, *The Blind Men of Jericho*, presented by Mrs Maud Lowndes, 1933

Poynter, Edward John 1836–1919, *The Bells of Saint Mark's, Venice*, presented by Mrs Alfred Baldwin, 1916

Pratt, Claude 1860–1935, *Still Life of Newspaper, Pipe, Decanter and Jar*, bequeathed by Mrs G. F. While, 1901

Pratt, Jonathan 1835–1911, *John Skirrow Wright (1823–1880)*, presented by subscribers, 1882

Pratt, Jonathan 1835–1911, *Allen E. Everitt* (panel in the Everitt Cabinet), bequeathed by Mrs Allen Edward Everitt, 1892

Pratt, Jonathan 1835–1911, *Mrs Allen E. Everitt* (panel in the Everitt Cabinet), bequeathed by Mrs Allen Edward Everitt, 1892

Pratt, Jonathan 1835–1911, *The Right Honourable Jesse Collings (1831–1920)*, presented by subscribers, 1881

Pratt, Jonathan 1835–1911, *Lady Mason, Wife of Sir Josiah Mason*, presented by Miss Julia Smith, 1900

Pratt, Jonathan 1835–1911, *Reverend Arthur G. O'Neill (1819–1896)*, presented by subscribers, 1886

Pratt, Jonathan 1835–1911, *A Breton Cottage Interior*, bequeathed by Mrs G. F. While, 1901

Pratt, Jonathan 1835–1911, *James Watt's Work Room, Heathfield Hall*, transferred from Walsall Museums and Art Gallery, 1979

Pratt, Jonathan 1835–1911, *George Haynes*, presented by C. H. H. Franklin, 1978

Pratt, Jonathan 1835–1911, *Mrs George Haynes*, presented by C. H. H. Franklin, 1978

Pratt, Jonathan 1835–1911, *Interior with Mother and Child*, transferred from Birmingham General Hospital, 1972

Preece, Lawrence b.1942, *Cloche*, presented by the Linbury Trust through the Contemporary Art Society, 1983

Prentice, David b.1936, *Field Grid-Tycho B*, gift from an anonymous donor to commemorate the second anniversary of the Ikon Gallery, Birmingham, 1968, © the artist

Priest, Alfred 1874–1929, *Alderman John Townsend*, presented by the Royal Town of Sutton Coldfield, 1978

Priestman, Bertram 1868–1951, *Suffolk Water Meadows*, presented by Catherine M. Allbright, 1906

Pringle, William J. active c.1805–1860, *Stourbridge to Birmingham Royal Mail Coach*, bequeathed by Mrs Elizabeth Smith, 1934

Prinsep, Valentine Cameron 1838–1904, *The Avenue, Wildernesse, Kent*, purchased from Robert Frank, 1948

Pritchett, Edward active c.1828–1879, *The Dogana, Venice*, bequeathed by the Reverend Richard John Marshall Amplett, 1984

Pryce, George Willis 1866–1949, *Handsworth Church, Birmingham*, presented by Mrs Ruth Rendall, 1998

Pryce, George Willis 1866–1949, *View of Handsworth, Birmingham*, presented by Mrs Ruth Rendall, 1998

Pryce, George Willis 1866–1949, *Sarehole Mill, Birmingham*, purchased from the Colmore Galleries Ltd, 1977

Pryce, N. W. active 19th C, *The Dingles, Hall Green, Yardley*, presented by Mr M. E. Rose

Pryce, N. W. active 19th C, *The Dingles, Hall Green, Yardley*

Pryde, James 1869–1941, *An Old Beggar*, purchased, 1946

Pyne, James Baker 1800–1870, *The Island of Burano, Venetian Lagoon*, presented by Mrs Rickards, 1919

Quellinus, Erasmus II 1607–1678, *The Miracle of St Bernard in a Garland of Flowers*, purchased with the assistance of the Museums and Galleries Commission/Victoria & Albert Museum Purchase Grant Fund and the Public Picture Gallery Fund, 1981

Quinquela Martín, Benito 1890–1977, *Ship under Repair*, presented by the Charles Feeney Bequest Fund, 1930

Radclyffe, Charles Walter 1817–1903, *River Scene* (panel in the Everitt Cabinet), bequeathed by Mrs Allen Edward Everitt, 1892

Rae, Fiona b.1963, *Dark Star*, on loan from the Contemporary Art Society Special Collection Scheme funded by the Arts Council Lottery and the Friends of Birmingham Museums and Art Gallery, © the artist, courtesy of the Timothy Taylor Gallery, London

Raeburn, Henry 1756–1823, *Mrs Farquarson of Finzean*, presented by Mrs Jane Edwards, 1995

Raffaelli, Jean-François 1850–1924, *Le reveil*, purchased, 1953

Ramsay, Allan 1713–1784, *Philip Yorke (1690–1764), 1st Earl of Hardwicke*, presented by H. M. Government, Arts and Libraries Department, 1987

Ramsay, Allan 1713–1784, *Sir William Pulteney (1684–1764), Earl of Bath*, presented by H. M. Government, Arts and Libraries Department, 1987

Ramsay, Allan 1713–1784, *Mrs Mary Martyn*, purchased from Leggatt Bros, 1957

Raven, Samuel 1775–1847, *Self Portrait*, presented by the Friends of Birmingham Museums and Art Gallery, 1935

Raven, Samuel 1775–1847, *Sleeping Lion and Lioness*, presented by the Friends of Birmingham Museums and Art Gallery, 1933

Raven, Samuel 1775–1847, *William Scholefield (1809–1867)*, presented by Councillor C. Broomhead, 1944

Ravesteyn, Hubert van 1638–before 1691, *Portrait of a Man*, presented by Henry van den Bergh, 1960

Redgrave, Richard 1804–1888, *The Valleys Stand Thick with Corn*, presented by Mrs Redgrave, 1890

Redgrave, Richard 1804–1888, *The Firing of the Beacon*, purchased, 1963

Régnier, Nicolas c.1590–1667, *The Penitent Magdalen*, purchased from Thomas Agnew & Son Ltd, 1958

Reid, Flora 1860–c.1940, *The First Communion*, presented by George Myers, 1896

Rembrandt van Rijn (after) 1606–1669, *Portrait of a Man*, bequeathed by Sir Theophilus Biddulp, 1969

Renard, Fredericus Theodorus 1778–c.1820, *Landscape*, presented by A. H. Brown, 1946

Renard, Fredericus Theodorus 1778–c.1820, *Landscape with Buildings and Figures*, presented by A. H. Brown, 1946

Reni, Guido 1575–1642, *Portrait of a Woman* (possibly Artemisia), (*Lady with a Lapis Lazuli Bowl*), purchased with the assistance of the Victoria & Albert Museum Purchase Grant Fund, 1961

Renoir, Pierre-Auguste 1841–1919, *Still Life*, on loan from a private collection

Renoir, Pierre-Auguste 1841–1919, *St Tropez, France*, transferred from H. M. Government, Arts and Libraries Department, 1980

Reynolds, Joshua 1723–1792, *William, Lord Bagot (1728–1798)*, on loan from a private collection

Reynolds, Joshua 1723–1792, *The Roffey Family*, purchased with the assistance of the National Art Collections Fund, 1954

Reynolds, Joshua 1723–1792, *Louisa, Lady Bagot (c.1744–1820)*, on loan from a private collection

Reynolds, Joshua 1723–1792, *The Masters Gawler*, purchased with the assistance of the Museums and Galleries Commission/Victoria & Albert Museum Purchase Grant Fund, 1983

Reynolds, Joshua (studio of) 1723–1792, *Mrs Luther*, presented by the Public Picture Gallery Fund, 1940

Reynolds, Joshua (studio of) 1723–1792, *Dr John Thomas (1712–1793), Bishop of Rochester*, presented by the Public Picture Gallery Fund and subscribers, 1898

Rhys-James, Shani b.1953, *Caught in the Mirror*, purchased from Shani Rhys-James, 1999, © the artist

Richards, Ceri Geraldus 1903–1971, *The Rape of the Sabines*, purchased with the assistance of the Museums and Galleries Commission/Victoria & Albert Museum Purchase Grant Fund, 1976, © estate of Ceri Richards/DACS 2008

Richardson, Jonathan the elder 1665–1745, *Josiah Bateman*, presented by the Friends of Birmingham Museums and Art Gallery, 1933

Richardson, Jonathan the elder 1665–1745, *Elizabeth, 1st Countess of Aylesford (d.1743)*, purchased from the executors of the 7th Earl of Dartmouth, 1964

Richmond, George 1809–1896, *A Copy of the Aldobrandini Marriage*, presented by Mrs M. Richmond, 1955

Richmond, George 1809–1896, *Self Portrait*, bequeathed by Miss A. E. Kennedy, 1941

Richmond, George 1809–1896, *The Burial of the Virgin*, bequeathed by Miss A. E. Kennedy, 1941

Richmond, William Blake 1842–1921, *An Audience in Athens during 'Agamemnon' by Aeschylus*, purchased with the assistance of the Public Picture Gallery Fund

Ricketts, Charles S. 1866–1931, *Tobias and the Angel*, bequeathed by Katherine Harris Bradley, 1914

Riley, Bridget b.1931, *Cherry Autumn*, purchased from the artist, 1997, © the artist

Riley, John 1646–1691, *Sir Edward Waldo (1632–1716)*, presented by Martin Crabbe, 1958

Riley, John 1646–1691, *Sir Christopher Musgrave*, purchased, 1964

Riopelle, Jean-Paul 1923–2002, *Le temoin*, presented by the Friends of Birmingham Museums and Art Gallery, 1968, © DACS 2008

Riviere, Briton 1840–1920, *Phoebus Apollo*, presented by the Public Picture Gallery Fund, 1898

Robatto, Giovanni Stefano 1649–1733, *The Annunciation*, presented by Mr and Mrs J. C. Neale, 1972

Robatto, Giovanni Stefano 1649–1733, *The Holy Family*, presented by Mr and Mrs J. C. Neale, 1972

Roberts, David 1796–1864, *The Departure of the Israelites*, presented by Mrs Wahl, 1986

Roberts, David 1796–1864, *Interior of the Cathedral of St Stephen, Vienna*, presented by the Public Picture Gallery Fund, 1937

Roberts, William 1788–1867, *Old Watermill, North Wales*, presented by Mrs W. H. Ryland, 1915

Robinson, W. H. *The Dingles Sarehole, near Moseley*, presented by D. C. Cross, 1970

Roden, William Thomas 1817–1892, *Joseph Chamberlain (1836–1914), as a Young Man*, unaccessioned find,1978

Roden, William Thomas 1817–1892, *Joseph Moore (1817–1892)*, bequeathed by Joseph Moore, 1893

Roden, William Thomas 1817–1892, *Samuel Lines (1778–1863)*, purchased from the Birmingham & Midland Institute, 1978

Roden, William Thomas 1817–1892, *John Henry Chamberlain (1831–1883)*, presented by Mrs John Henry Chamberlain, 1884

Roden, William Thomas 1817–1892, *Oliver Pemberton (1825–1897)*, presented by Mrs C. O. Pemberton, 1936

Roden, William Thomas 1817–1892, *Peter Hollins (1800–1886)*, presented by subscribers, 1872

Roden, William Thomas 1817–1892, *Alderman Edward Corn Osborne (1809–1886)*, presented by subscribers, 1873

Roden, William Thomas 1817–1892, *John Birt Davies*, presented by subscribers, 1876

Roden, William Thomas 1817–1892, *Alderman Henry Hawkes*, presented by subscribers, 1876

Roden, William Thomas 1817–1892, *Samuel Timmins (1826–1902)*, presented by the Birmingham Reference Library, 1974

Roden, William Thomas 1817–1892, *William Ewart Gladstone (1809–1898)*, presented by subscribers, 1879

Roden, William Thomas 1817–1892, *John Thackray Bunce (1828–1899)*, presented by the family of John Thackray Bunce, 1928

Roden, William Thomas 1817–1892, *Cardinal Newman (1801–1890)*, presented by subscribers, 1879

Roden, William Thomas 1817–1892, *Edwin Yates*

Roden, William Thomas 1817–1892, *George Edmonds*, transferred from the Birmingham Reference Library, 1973

Roden, William Thomas 1817–1892, *Jacob Wilson (1799–1892)*, presented by Leslie H. Barnwell, 1935

Romney, George 1734–1802, *Anne, Lady Holte (1734–1799)*, bequeathed by Charles Holte Bracebridge, 1872

Romney, George 1734–1802, *Mrs Bracebridge and Her Daughter Mary*, purchased with the assistance of the National Art Collections Fund and a special

Capital Grant from Birmingham City Council, 1985

Romney, George (attributed to) 1734–1802, *Portrait of a Lady*, presented by Mrs Freda Forrester, 1999

Rooke, Thomas Matthews 1842–1942, *Labourers in the Vineyard*, presented by Mrs Richard Fenwick in memory of her husband, 1925

Room, Henry 1803–1850, *Self Portrait*, presented by the Friends of Birmingham Museums and Art Gallery, 1935

Room, Henry 1803–1850, *Joseph Goodyear (1797–1839)*, presented by Edward Goodyear, 1877

Room, Henry 1803–1850, *The Messenger Boy*, presented by Howard Henry Room, 1900

Rosa, Salvator 1615–1673, *Head of a Man with a Turban*, on loan from Sir Denis Mahon, CBE FBA, since 1999

Rosoman, Leonard Henry b.1913, *The Studio*, presented by the Friends of Birmingham Museums and Art Gallery, 1972, © the artist

Rossetti, Dante Gabriel 1828–1882, *The Boat of Love* (unfinished), purchased, 1883

Rossetti, Dante Gabriel 1828–1882, *Beata Beatrix*, purchased, 1891

Rossetti, Dante Gabriel 1828–1882, *La donna della finestra* (unfinished), purchased, 1883

Rossetti, Dante Gabriel 1828–1882, *Proserpine*, presented by the Public Picture Gallery Fund, 1927

Rossetti, Dante Gabriel (after) 1828–1882, *A Persian Youth*, presented by the Feeney Bequest Fund, 1930

Rossiter, Charles 1827–1897, *To Brighton and Back for Three and Sixpence*, presented by James A. Marigold, 1930

Rothenstein, William 1872–1945, *Oakridge Farm, Late Summer*, presented by Alderman William A. Cadbury, 1935, © the artist's estate/www.bridgeman.co.uk

Rousseau, Jacques (school of) 1630–1693, *Landscape with Castle in Distance* (detail), accessioned *in situ* at Aston Hall, 1976

Rousseau, Jacques (school of) 1630–1693, *Landscape with Ruin*, accessioned *in situ* at Aston Hall, 1976

Rowe, Elsie Hugo *Three Blouses*, presented by Mrs Wilson Browne, 1936

Rubens, Peter Paul 1577–1640, *King James I (1566–1625) Uniting England and Scotland*, purchased with the assistance of the National Heritage Memorial Fund, the National Art Collections Fund, the Museums and Galleries Commission/Victoria & Albert Museum Purchase Grant Fund, the Wolfson Foundation and a special Capital Grant from Brimingham City Council, 1984

Russell, Walter Westley 1867–1949, *Scene in a Theatre*, presented

by the executors of the artist's estate, 1950

Russell, Walter Westley 1867–1949, *Widecombe-in-the-Moor, Devon*, presented by Queen's College, Edgbaston, 1971

Russell, Walter Westley 1867–1949, *River Scene*, presented by the executors of the artist's estate, 1950

Russell, Walter Westley 1867–1949, *The Little Quay, Shoreham*, presented by the executors of the artist's estate, 1950

Rutter, Thomas William b.1874, *Polperro by Moonlight*, bequeathed by Alfred Leadbeater, 1928

Sadun, Piero 1919–1974, *Abstract*, presented by the Contemporary Art Society, 1962

Salt, John b.1937, *White Chevy, Red Trailer*, presented by the Friends of Birmingham Museums and Art Gallery and the artist, 1975, © the artist

Sandys, Emma 1843–1877, *A Lady Holding a Rose*, on loan from a private collection

Sandys, Frederick 1829–1904, *Autumn*, presented by George Tangye, 1906

Sandys, Frederick 1829–1904, *Morgan-le-Fay*, presented by the John Feeney Bequest Fund, 1925

Sandys, Frederick 1829–1904, *Medea*, presented by the Public Picture Gallery Fund, 1925

Santerre, Jean-Baptiste 1651–1717 *Philippe, Duc d'Orleans (1674–1723)*, purchased from David Peel & Co. Ltd, 1967

Sargent, John Singer 1856–1925, *Miss Katherine Elizabeth Lewis (d.1961)*, bequeathed by Miss Katherine Elizabeth Lewis, 1961

Sayers, Reuben T. W. 1815–1888, *Elizabeth Stockdale Wilkinson (1799–1871)*, purchased from the Tew Park sale, 1987

Schaak, J. S. C. active 1759–1780, *Matthew Boulton (1728–1809)*, purchased from the Tew Park sale, 1987

Schiavone, Andrea c.1500–1563, *The Execution of St John the Baptist*, purchased from P. & D. Colnaghi Co. Ltd, 1963

Scorel, Jan van 1495–1562, *Noli me tangere*, purchased with the assistance of the National Art Collections Fund, 1952

Scott, John 1850–1919, *Laundress Startled by a Blackbird*, unaccessioned find at Highbury Hall, 1987

Scott, William George 1913–1989, *Flowers and a Jug*, presented by the Contemporary Art Society, 1950, © 2008 estate of William Scott

Scott, William George 1913–1989, *Brown and Black*, presented by the Friends of Birmingham Museums and Art Gallery, 1977, © 2008 estate of William Scott

Scully, Sean b.1945, *Wall of Light Blue*, purchased from the Timothy Taylor Gallery, 2002

Seabrooke, Elliott 1886–1950, *Surrey Garden*, presented by the

family of John Mavrogordato, 1938

Sedgley, Peter b.1930, *Cycle*, presented by the Friends of Birmingham Museums and Art Gallery, 1974, © the artist

Seemann, Enoch the younger 1694–1744, *Lady Maynard*, purchased from the executors of the 7th Earl of Dartmouth, 1964

Shackleton, John d.1767, *The Right Honourable Henry Pelham (c.1695–1754)*, presented by H. M. Government, Arts and Libraries Department, 1987

Shannon, James Jebusa 1862–1923, *Sir James Smith*, presented by subscribers, 1897

Shannon, James Jebusa 1862–1923, *Alderman Edward Lawley Parker*, presented by subscribers, 1905

Shannon, James Jebusa 1862–1923, *Alderman Edward Lawley Parker*, presented by Joseph L. Gamgee, 1956

Shave, Terry b.1952, *Pandemonium*, on permanent loan from the Friends of Birmingham Museums and Art Gallery, © the artist

Shaw, Byam 1872–1919, *Boer War (1900–1901), Last Summer Things Were Greener*, presented anonymously, 1928

Shayer, William 1788–1879, *Pony and Dogs*, on permanent loan from the Friends of Birmingham Museums and Art Gallery

Shayer, William 1788–1879, *Pony and Hounds*, on permanent loan from the Friends of Birmingham Museums and Art Gallery

Shayer, William 1788–1879, *Travelling Tinkers*, presented by Joyce Drake, 1950

Shayer, William 1788–1879, *Two Young Women and Goats in a Landscape*, presented in memory of James Whitfield by Mrs Whitfield and their family, 1940

Shemza, Anwar Jalal 1928–1985, *The Wall*, purchased with the assistance of the National Art Collections Fund and the Friends of Birmingham Museums and Art Gallery, 1997, © the artist's estate

Shemza, Anwar Jalal 1928–1985, *Sea, Moon and Boat*, presented by J. Payne, 2002, © the artist's estate

Shorthouse, Arthur Charles 1870–1953, *The Old Guard*, presented by John Gibbins, 1929

Shorthouse, Arthur Charles 1870–1953, *Official Rat Catcher to the City of Birmingham*, presented by H. S. Shorthouse, 1934

Sickert, Walter Richard 1860–1942, *La Rue Notre Dame and the Quai Duquesne*, presented by Mrs Gerald Kenrick, 1953, © estate of Walter R. Sickert/DACS 2008

Sickert, Walter Richard 1860–1942, *La rue Pecquet, Dieppe, France*, purchased, 1948, © estate of Walter R. Sickert/DACS 2008

Sickert, Walter Richard 1860–1942, *The Horses of St Mark's, Venice*, presented by Edward

Evershed of Reid, Alex & Lefevre Ltd, 1944, © estate of Walter R. Sickert/DACS 2008

Sickert, Walter Richard 1860–1942, *Noctes Ambrosianae, Gallery of the Old Mogul*, purchased, 1949, © estate of Walter R. Sickert/DACS 2008

Sickert, Walter Richard 1860–1942, *Dieppe Races*, presented by Mrs D. M. Fulford through the National Art Collections Fund, 1945, © estate of Walter R. Sickert/DACS 2008

Sickert, Walter Richard 1860–1942, *The Miner*, presented by the Public Picture Gallery Fund, 1944, © estate of Walter R. Sickert/DACS 2008

Sisley, Alfred 1839–1899, *The Church at Moret in the Rain*, presented by the Public Picture Gallery Fund, 1948

Skelton, Pam b.1949, *Displacement Ahwaz, 1978*, on permanent loan from the Friends of Birmingham Museums and Art Gallery, © the artist

Sleigh, Bernard 1872–1954, *Ivy A. Ellis*, presented by Cornelius Madden, 1968

Sleigh, Bernard 1872–1954, *Self Portrait*, presented by Cornelius Madden, 1968

Sleigh, Bernard 1872–1954, *William Downing*, presented by Mrs T. Downing, 1982

Smetham, James 1821–1889, *Imogen and the Shepherds*, presented by Mrs D. A. Turnbull through the National Art Collections Fund, 1947

Smetham, James 1821–1889, *Jacob at Bethel*, bequeathed by Sir Arthur Newsholme, 1942

Smetham, James 1821–1889, *The Many-Wintered Crow*, bequeathed by Sir Arthur Newsholme, 1942

Smith, A. Freeman active 1880–1924, *Worcester Street, Birmingham*

Smith, Jack b.1928, *Child Walking with Wicker Stool*, purchased with the assistance of the Museums and Galleries Commission/Victoria & Albert Museum Purchase Grant Fund and the Public Picture Gallery Fund, 1996, © the artist

Smith, Matthew Arnold Bracy 1879–1959, *Sunflowers*, purchased, 1952, © by permission of the copyright holder

Smith, Matthew Arnold Bracy 1879–1959, *Reclining Nude*, on loan from a private collection, © by permission of the copyright holder

Smith, Matthew Arnold Bracy 1879–1959, *Aix-en-Provence*, presented by the Public Picture Gallery Fund, 1946, © by permission of the copyright holder

Smith, Matthew Arnold Bracy 1879–1959, *Chrysanthemums in a Jug*, purchased from Arthur Tooth & Sons Ltd, 1954, © by permission of the copyright holder

Smith, Ray b.1949, *Alien Cofactor*, on loan from the artist, © the artist

Solimena, Francesco 1657–1747, *The Vision of Saint John the Divine*, purchased from P. & D. Colnaghi Co. Ltd, 1964

Solomon, Abraham 1824–1862, *Conversation Piece*, presented by Mrs Ionides, 1956

Solomon, Simeon 1840–1905, *A Deacon*, purchased with the assistance of the Public Picture Gallery Fund and from a donation in memory of Dr Joseph Li, 2003

Solomon, Simeon 1840–1905, *Bacchus*, bequeathed by Miss Katherine Elizabeth Lewis, 1961

Sondermann, Hermann 1832–1901, *Childhood*, presented anonymously, 1954

Southall, Joseph Edward 1861–1944, *Anne Elizabeth Baker (1859–1947)*, purchased with the assistance of the Museums and Galleries Commission/Victoria & Albert Museum Purchase Grant Fund, 1980, © reproduced with permission of the Barrow family

Southall, Joseph Edward 1861–1944, *Sigismonda Drinking the Poison*, bequeathed by Mrs A. E. Southall, 1948, © reproduced with permission of the Barrow family

Southall, Joseph Edward 1861–1944, *Beauty Receiving the White Rose from Her Father*, bequeathed by Mrs A. E. Southall, 1948, © reproduced with permission of the Barrow family

Southall, Joseph Edward 1861–1944, *New Lamps for Old*, presented by Miss Jeanne Heaton and Miss Angela Heaton, 1952, © reproduced with permission of the Barrow family

Southall, Joseph Edward 1861–1944, *Portrait of the artist's Mother*, presented by the John Feeney Bequest Fund, 1945, © reproduced with permission of the Barrow family

Southall, Joseph Edward 1861–1944, *The Sleeping Beauty*, presented by Alderman William A. Cadbury, 1908, © reproduced with permission of the Barrow family

Southall, Joseph Edward 1861–1944, *Fisherman Carrying a Sail*, presented anonymously, 1918, © reproduced with permission of the Barrow family

Southall, Joseph Edward 1861–1944, *Changing the Letter*, presented by subscribers, 1918, © reproduced with permission of the Barrow family

Southall, Joseph Edward 1861–1944, *Head of a Boy*, presented by the family of Wilfred Byng Kenrick, 1964, © reproduced with permission of the Barrow family

Southall, Joseph Edward 1861–1944, *Ariadne on Naxos*, bequeathed by Mrs A. E. Southall, 1948, © reproduced with permission of the Barrow family

Southall, Joseph Edward 1861–1944, *Sir Whitworth Wallis (1855–1927)*, presented by subscribers, 1927, © reproduced with

permission of the Barrow family
Souza, Francis Newton 1924–2002, *Negro in Mourning*, purchased with the assistance of the Museums and Galleries Commission/Victoria & Albert Museum Purchase Grant Fund and the Friends of Birmingham Museums and Art Gallery, 1999, © estate of Francis Newton Souza/DACS 2008

Spear, Ruskin 1911–1990, *Mother and Child*, presented by Sir Kenneth Clark through the Contemporary Art Society, 1946, © the artist's estate/www.bridgeman.co.uk

Spear, Ruskin 1911–1990, *A London Street*, purchased from the Friends of Birmingham Museums and Art Gallery, 1945, © the artist's estate/www.bridgeman.co.uk

Speed, Harold 1872–1957, *William Holman Hunt (1827–1910)*, presented by the artist, 1932

Spencelayh, Charles 1865–1958, *Dig for Victory*, presented by the artist, 1943, © the artist's estate/www.bridgeman.co.uk

Spencer, Jean 1942–1998, *Square Painting No.1* (diptych), presented by the artist's estate through the Contemporary Art Society, 2002, © the artist's estate

Spencer, Jean 1942–1998, *Four Part Painting*, presented by the artist's estate through the Contemporary Art Society, 2002, © the artist's estate

Spencer, Jean 1942–1998, *Four Part Painting*, presented by the artist's estate through the Contemporary Art Society, 2002, © the artist's estate

Spencer, Jean 1942–1998, *Four Part Painting*, presented by the artist's estate through the Contemporary Art Society, 2002, © the artist's estate

Spencer, Jean 1942–1998, *Four Part Painting*, presented by the artist's estate through the Contemporary Art Society, 2002, © the artist's estate

Spencer, Stanley 1891–1959, *Old Tannery Mills, Gloucestershire*, presented by the Public Picture Gallery Fund, 1945, © estate of Stanley Spencer 2008. All rights reserved, DACS

Spencer, Stanley 1891–1959, *Rock Gardens, Cookham Dene*, presented by Major E. O. Kay, 1947, © estate of Stanley Spencer 2008. All rights reserved, DACS

Spencer, Stanley 1891–1959, *The Psychiatrist (Mrs Charlotte Murray)*, presented by the Friends of Birmingham Museums and Art Gallery, 1950, © estate of Stanley Spencer 2008. All rights reserved, DACS

Spencer, Stanley 1891–1959, *The Resurrection, Tidying*, purchased from Arthur Tooth & Sons Ltd, 1950, © estate of Stanley Spencer 2008. All rights reserved, DACS

Stanfield, Clarkson 1793–1867,

Fishing Boats off the Coast, unaccessioned find, 2006

Stanfield, Clarkson 1793–1867, *Vessels off the Dutch Coast*, presented by Alderman William A. Cadbury, 1934

Stanley, Colin A. *Sheepcote Barn, Chapel House Farm*, presented by E. H. C. Johnson, 1980

Stark, James 1794–1859, *Cottage in a Wood*, presented by the Public Picture Gallery Fund, 1910

Steel, George Hammond 1900–1960, *Conksbury Bridge, Derbyshire*, presented by the John Feeney Bequest Fund, 1929

Steer, Philip Wilson 1860–1942, *Springtime*, presented by the Public Picture Gallery Fund, 1936, © Tate, London 2008

Steer, Philip Wilson 1860–1942, *The Posy*, presented by the Feeney Bequest Fund, 1945, © Tate, London 2008

Steer, Philip Wilson 1860–1942, *Brill, Buckinghamshire*, presented by Alderman Oliver Morland and the Friends of Birmingham Museums and Art Gallery, 1944, © Tate, London 2008

Steer, Philip Wilson 1860–1942, *A Shipyard, Shoreham, Sussex*, presented by the Friends of Birmingham Museums and Art Gallery, 1944, © Tate, London 2008

Stom, Matthias c.1600–after 1650, *An Old Woman and a Boy by Candlelight*, purchased from Matthieson Fine Art Ltd, 1958

Stone, W. *Elan Valley, Radnorshire*, presented by the Severn Trent Water Authority, 1975

Stothard, Thomas 1755–1834, *Amphitrite*, presented by the executors of Sir Claude Phillips, 1925

Strozzi, Bernardo 1581–1644, *Portrait of a Genoese Nobleman*, purchased with the assistance of the Museums and Galleries Commission/Victoria & Albert Museum Purchase Grant Fund, 1971

Subleyras, Pierre Hubert 1699–1749, *San Juan de Ávila (c.1499–1569)*, purchased with the assistance of the National Art Collections Fund and the Museums and Galleries Commission/Victoria & Albert Museum Purchase Grant Fund, 1959

Subleyras, Pierre Hubert 1699–1749, *Unidentified Papal Ceremony*, presented by the Friends of Birmingham Museums and Art Gallery, 1961

Such, William Thomas 1820–1893, *Heathfield Hall*, unaccessioned find, 2006

Suringer, Maud *Arc de Triomphe, Orange*, presented by A. Morton Patrick, 1928

Sutherland, Graham Vivian 1903–1980, *The Honourable Edward Sackville West (1901–1965)*, purchased from the artist, 1958, © estate of Graham Sutherland

Sutton, Philip b.1928, *Gorse Landscape*, purchased, 1958, © Philip Sutton RA

Sutton, Philip b.1928, *All the Kingdom for a Stage*, presented by the artist, 1986, © Philip Sutton RA

Swan, Cuthbert Edmund 1870–1931, *Tiger and Prey*, bequeathed by Christian Feeney, 1929

Swynnerton, Annie Louisa 1844–1933, *Assisi*, presented by the Friends of Birmingham Museums and Art Gallery, 1934

Tàpies, Antoni b.1923, *Grey Relief with an Ochre Line*, presented by the Friends of Birmingham Museums and Art Gallery, 1962, © Foundation Antoni Tàpies, BarcelonA/VEGAP, Madrid and DACS, London 2008

Tayler, Albert Chevallier 1862–1925, *The Departure of the Fishing Fleet, Boulogne*, presented by Richard Peyton, 1891

Taylor, Edward Richard 1838–1912, *Lincoln Cathedral, the Cloisters* (panel in the Everitt Cabinet), bequeathed by Mrs Allen Edward Everitt, 1892

Taylor, Edward Richard 1838–1912, *Birmingham Reference Library, the Reading Room*, presented by the Right Honourable William Kenrick, 1884

Taylor, Edward Richard 1838–1912, *'Twas a Famous Victory'*, purchased from Richard J. M. Howson, 1987

Taylor, Edward Richard 1838–1912, *Ellen Bennett*, presented by John Speir, 2006

Taylor, Edward Richard 1838–1912, *Self Portrait*, presented by Mrs Shaw, 1976

Taylor, Edwin d.1888, *Meadow Scene* (panel in the Everitt Cabinet), bequeathed by Mrs Allen Edward Everitt, 1892

Teniers, David II 1610–1690, *The Feast of Herod*, presented by the executors of Sir Claude Phillips, 1925

Thomas, Thomas active 1854–1896, *Harborne Railway Line (?)*, purchased, 1971

Thomas, Thomas active 1854–1896, *Kings Norton Church*

Thompson, Ernest Lancaster active 1873–1879, *George Dawson and His Friends*, presented by subscribers, 1880

Thornton, Patricia b.1946, *Guns with Fig Leaf*, on loan from the artist

Thornton, Patricia b.1946, *Repeat Action*, purchased with the assistance of the Friends of Birmingham Museums and Art Gallery, 2001

Thornton, Patricia b.1946, *Vest Pocket Pistol*, purchased from the artist, 2001

Tift, Andrew b.1968, *Repeat*, purchased with the assistance of the Friends of Birmingham Museums and Art Gallery, 2006, © Andrew Tift

Toft, J. Alfonso 1866–1964, *Ludlow*

Castle, presented by Mrs Phillys Richardson

Tonks, Henry 1862–1937, *The Hat Shop*, presented by the Friends of Birmingham Museums and Art Gallery, 1951, © family of the artist

Tonks, Henry 1862–1937, *The China Cabinet*, bequeathed by Miss Annie Tonks, 1953, © family of the artist

Tonks, Henry 1862–1937, *The Crystal Gazers*, presented by the Public Picture Gallery Fund, 1945, © family of the artist

Tonks, Henry 1862–1937, *The Orchard*, presented by the John Feeney Bequest Fund, 1938, © family of the artist

Towne, Charles 1763–1840, *A View across an Estuary*, presented by the Friends of Birmingham Museums and Art Gallery, 1941

Townsend, William 1909–1973, *Winter, Hexden Channel*, presented by the Friends of Birmingham Museums and Art Gallery, 1957, © the artist's estate

Tranter, E. Butler active c.1850–1890s, *Mrs Tranter*, presented by Miss C. A. Watson, 1978

Tranter, E. Butler active c.1850–1890s, *William Tranter*, presented by Miss C. A. Watson, 1978

Trembath, Su b.1965, *Beautiful Undercurrent*, on permanent loan from the Friends of Birmingham Museums and Art Gallery

Troyon, Constant 1810–1865, *Landscape with Meadowland in the Foreground*, bequeathed by Sir Leonard Woolley through the National Art Collections Fund, 1960

Tudor-Hart, Percyval 1873–1954, *Evening in Huntingdinshire*, bequeathed by Mrs C. J. Tudor-Hart, 1974

Tudor-Hart, Percyval 1873–1954, *Study of Sky in Rosshire*, bequeathed by Mrs C. J. Tudor-Hart, 1974

Turner, Joseph Mallord William 1775–1851, *The Pass of Saint Gotthard, Switzerland*, presented by the Public Picture Gallery Fund, 1935

unknown artist 19th C, *Farm in Wood Lane, Handsworth*, acquired, 1965

unknown artist 19th C, *Golden Cross*, acquired, 1975

Urwick, Walter Chamberlain 1864–1943, *Portrait of the artist's Wife*, presented by the trustees of the artist, 1967

Utrillo, Maurice 1883–1955, *Rue à Pontoise*, on loan from a private collection, © ADAGP, Paris and DACS, London 2008/Jean Fabris 2008

Vale *Tower, Edgbaston Pumping Station*, bequeathed by Miss Nicholds Mary, 1988

Vaughan, John Keith 1912–1977, *Harvest Assembly*, presented by the Friends of Birmingham Museums and Art Gallery, 1968, © the estate of Keith Vaughan/DACS 2008

Velde, Willem van de II 1633–1707, *The English Ship 'Hampton Court' in a Gale*, purchased with the assistance of the National Art Collections Fund, 1972

Venton, Patrick 1925–1987, *Studio Table Number 1*, on permanent loan from the Friends of Birmingham Museums and Art Gallery, © the artist's estate

Verhaecht, Tobias c.1560–1631, *Orpheus Returning from the Underworld*, bequeathed by Sir Leonard Woolley through the National Art Collections Fund, 1960

Vernet, Claude-Joseph 1714–1789, *Harbour Scene with Man-of-War and Figures on a Quay*, presented by the executors of Sir Claude Phillips, 1925

Verwer, Justus de c.1626–before 1688, *Distant View of the Dutch Coast*, presented by the Public Picture Gallery Fund, 1933

Vincent, George 1796–1831, *Landscape, Cattle Crossing a Stream*, presented by the John Feeney Bequest Fund, 1925

Vlaminck, Maurice de 1876–1958, *La route (avec peupliers)*, presented by the Honourable Clare Stuart-Wortley through the National Art Collection's Fund, 1945, © ADAGP, Paris and DACS, London 2008

Vos, Cornelis de (attributed to) c.1584–1651, *Portrait of a Man*, purchased from Horace A. Buttery, 1957

Vos, Cornelis de (attributed to) c.1584–1651, *Portrait of a Woman*, purchased from Horace A. Buttery, 1957

Vries, Roelof van c.1631–after 1681, *Travellers at the Edge of a Village*, presented by the Public Picture Gallery Fund, 1987

Vuillard, Jean Edouard 1868–1940, *Le repas*, presented by the Friends of Birmingham Museums and Art Gallery, 1958, © ADAGP, Paris and DACS, London 2008

Wainwright, William John 1855–1931, *The Old Burgomaster*, presented by Walter Turner, 1924

Wainwright, William John 1855–1931, *Leonard Brierley*, purchased from Bearne's Salesrooms, 1970

Wainwright, William John 1855–1931, *Parable of the Wise and Foolish Virgins*, purchased, 1899

Wainwright, William John 1855–1931, *Howard S. Pearson*, transferred from Birmingham Reference Library, 1974

Walker, Ethel 1861–1951, *A Symphony in Bronze and Silver*, presented by the Friends of Birmingham Museums and Art Gallery, 1948, © the artist's estate/www.bridgeman.co.uk

Walker, Frederick 1840–1875, *The Old Gate*, presented by the Public Picture Gallery Fund, 1894

Walker, John b.1939, *Serenade*, purchased with the assistance of the Museums and Galleries Commission/Victoria & Albert

Undercliff Walk, Brighton, gift from the artist, 1986
Fryer, Katherine Mary b.1910, *Morning on the Beach, Scarborough*, gift from the artist, 1994
Gear, William 1915–1997, *Caged Yellow*, diploma work, 1966, © the artist's estate
Goodby, Donald b.1929, *Farm at Watendlath, Cumbria*, gift from the artist, 1992, © the artist
Gordon, David b.1929, *Skull Landscape*, diploma work, 2006, © the artist
Gross, Peter Barrie 1924–1987, *Joyce V.*, gift from June Gross, 1994, © the artist's estate
Gross, Peter Barrie 1924–1987, *Gill*, gift from June Gross, 1994, © the artist's estate
Gross, Peter Barrie 1924–1987, *Euryl Stevens*, gift from June Gross, 1994, © the artist's estate
Gross, Peter Barrie 1924–1987, *Sketch of James Priddey, Past President of the RBSA*, gift from June Gross, 1994, © the artist's estate
Gross, Peter Barrie 1924–1987, *Alf Parry*, gift from June Gross, 1994, © the artist's estate
Gross, Peter Barrie 1924–1987, *Demonstration Portrait of a Girl*, gift from June Gross, 1994, © the artist's estate
Gross, Peter Barrie 1924–1987, *Demonstration Portrait of Reverend David Pendleton*, gift from June Gross, 1994, © the artist's estate
Gross, Peter Barrie 1924–1987, *Sid Homer, RBSA*, gift from June Gross, 1994, © the artist's estate
Harper, Edward Samuel 1854–1941, *William John Wainwright*, gift from W. Midgley
Harper, Edward Samuel 1854–1941, *William John Wainwright*, gift from W. Midgley, 2006
Hemsoll, Eileen Mary b.1924, *Garden at Compton Acres*, gift from the artist, © the artist
Hipkiss, Percy 1912–1995, *Marshland in Somerset*, © the artist's estate
Honigsberger, Joy b.1928, *A Birthday Bouquet*, diploma work, © the artist
Hurn, Bruce b.1926, *Moor Ring Fort*, gift from the artist, 2006, © the artist
Hurn, Bruce b.1926, *Derelict Mine, Wales*, gift from the artist, 2006, © the artist
Hurn, Bruce b.1926, *Norfolk Sand Bar*, gift from the artist, 2006, © the artist
Kempshall, Kim b.1934, *Rocks*, diploma work, 2005, © the artist
Kilfoyle, Michael b.1937, *Dungeness, Evening*, gift from the artist, 2006, © the artist
Kisseleva, Nadia b.1956, *Wide and Rich: My Beloved Country*, diploma work, 2006, © the artist
Lines, John Woodward b.1938, *Saved Again*, gift from the artist, © the artist
Longueville, James b.1942, *Snow,*

gift from the artist
Mansfield, James b.1921, *Oncoming Mistral, Provence*, gift from the artist, 2006, © the artist
Martin, John Scott b.1943, *Gurnard's Head, Cornwall*, diploma work, 2005, © the artist
Metson, Jack *Mellieha Heights, Malta*, gift from Mrs Metson, 1990
Mills, Lionel b.1933, *Cromer Pier on a Grey, Overcast Day*, gift from the artist, 2006, © the artist
Mills, Lionel b.1933, *Self Portrait and Breakfast Table*, gift from the artist, © the artist
Morgan, Walter Jenks 1847–1924, *Burgomeister*, unknown provenance
Morgan, Walter Jenks 1847–1924, *H. Weiss*, unknown provenance
Mullins, Victoria *Still Life with Flowers*, diploma work
Perry, Robert b.1944, *Nightfall over the Black Country, View from Turner's Hill, Dudley, the Habberleys just Visible 6.45pm, Thursday 18 October 2001*, gift from the artist, © the artist
Powell, Joanne b.1943, *Isolation*, diploma work, 2006, © the artist
Reeve, John Graham b.1938, *Carmen at Covent Garden*, gift from the artist, 2006, © the artist
Rhys-Davies, Norma b.1926, *Three Cliffs, Gower III*, gift from the artist, © the artist
Ridgway, Elizabeth b.1964, *Summer Nap*, diploma work
Sawbridge, Tony b.1929, *The Balloon Seller*, gift from the artist, c.2006, © the artist
Sawbridge, Tony b.1929, *War Requiem Riot*, gift from the artist, 2006, © the artist
Sawbridge, Tony b.1929, *Harbour, St Ives*, gift from the artist, 2006, © the artist
Shorthouse, Arthur Charles 1870–1953, *Nature Study*, purchased from the Hicks Gallery, 1990
Snow, Graham b.1948, *Counterpoint*, gift from the artist, 2006
Spencer, Claire b.1937, *The Fireplace*, gift from the artist, 2006, © the artist/www.bridgeman.co.uk
Spencer, Claire b.1937, *Clent Church, September*, gift from the artist, 2006, © the artist/www.bridgeman.co.uk
Stewart, Barbara b.1929, *Yellow Scarf*, diploma work, © the artist
Storey, Terence b.1923, *Bruges*, diploma work, 2006, © the artist
Sutton, Jenny b.1943, *New Laid Eggs*, gift from the artist, 2006, © the artist
Swingler, Brian Victor b.1939, *Diglis Basin, Worcester*, gift from the artist, © the artist
Townsend, Kathleen active 1965–1968, *Portrait of Girl in Blue*, purchased from the artist's estate, 1991
Wainwright, William John 1855–1931, *John Keeley, RBSA*, unknown provenance
Webb, Arnold Bray active 2001–

2006, *Field 1*, gift from the artist, 2006
Welburn, Irene active 1936–1955, *Girls in Straw Boaters*, gift from the artist
White, David b.1939, *Red Window*, diploma work, 2006
Williamson, Lawrie b.1932, *Demonstration at the Royal Birmingham Society of Artists*, unknown provenance
Woollard, Joan Elizabeth b.1916, *Master Conal Shields*, gift from the artist
Woollard, Joan Elizabeth b.1916, *The Races*, gift from the artist, 2005
Woollard, Joan Elizabeth b.1916, *Half Nude*, gift from the artist
Woollard, Joan Elizabeth b.1916, *My Father, Frank*, gift from the artist, 2005
Woollard, Joan Elizabeth b.1916, *Seated Figure*, gift from the artist, 2005
Woollard, Joan Elizabeth b.1916, *Portrait of a Boy*, gift from the artist
Woollard, Joan Elizabeth b.1916, *The Artist*, gift from the artist
Yates, Anthony b.1957, *Marie and Lloyd in Their Garden*, diploma work, 2006

The Barber Institute of Fine Arts

Amberger, Christoph c.1505–1561/1562, *Portrait of a Man*, purchased, 1946
Assisi, Tiberio d' c.1470–1524, *St Ansanus*, purchased, 1944
Assisi, Tiberio d' c.1470–1524, *St Clare*, purchased, 1944
Assisi, Tiberio d' c.1470–1524, *St Francis of Assisi*, purchased, 1944
Aubry, Étienne 1745–1781, *Paternal Love*, purchased, 1962
Baronzio, Giovanni (attributed to) d. before 1362, *The Angel of the Annunciation* (top), *the Nativity and Annunciation to the Shepherds* (centre) *and the Adoration of the Magi* (bottom), purchased, 1942
Baschenis, Evaristo 1617–1677, *Still Life with Musical Instruments*, purchased, 1997
Bassano, Jacopo il vecchio c.1510–1592, *The Adoration of the Magi*, purchased, 1978
Beccafumi, Domenico 1484–1551, *Reclining Nymph*, purchased, 1962
Beer, Jan de c.1475–1528, *Joseph and the Suitors* (recto), purchased, 1951
Beer, Jan de c.1475–1528, *The Nativity* (verso), purchased, 1951
Bellangé, Hippolyte 1800–1866, *The Entry of Bonaparte into Milan*, purchased, 1953
Bellini, Giovanni 1431–1436–1516, *St Jerome in the Wilderness*, purchased, 1949
Bellini, Giovanni 1431–1436–1516, *Portrait of a Boy*, purchased, 1946
Bidauld, Jean Joseph Xavier 1758–1846, *The Last Cascade of L'Isola di*

Sora, purchased with the assistance of the National Art Collections Fund, 2005
Bonnard, Pierre 1867–1947, *The Dolls' Dinner Party*, purchased, 1963, © ADAGP, Paris and DACS, London 2008
Bonvin, François 1817–1887, *The Attributes of Painting*, purchased with the assistance of the Resource/Victoria & Albert Museum Purchase Grant Fund and the Friends of the Barber Institute, 2001
Bordone, Paris 1500–1571, *Mythological Scene*, purchased, 1961
Botticelli, Sandro (studio of) 1444/1445–1510, *The Madonna and Child with the Infant St John*, purchased, 1943
Boudin, Eugène Louis 1824–1898, *A Beach near Trouville*, purchased, 1951
Breenbergh, Bartholomeus 1598–1657, *Joseph Distributing Corn in Egypt*, purchased, 1963
Brueghel, Pieter the younger 1564/1565–1637/1638, *Two Peasants Binding Faggots*, purchased, 1944
Calraet, Abraham Pietersz. van 1642–1722, *Horses and Cattle in a Landscape*, purchased, 1959
Cambier, Nestor 1879–1957, *The Rock Garden at Culham Court*, bequeathed by Lady Barber, 1933
Cambier, Nestor 1879–1957, *Lady Barber in Her Rock Garden*, bequeathed by Lady Barber, 1933
Cambier, Nestor 1879–1957, *The Rock Garden at Culham Court (left wing)*, bequeathed by Lady Barber, 1933
Cambier, Nestor 1879–1957, *The Rock Garden at Culham Court (centre panel)*, bequeathed by Lady Barber, 1933
Cambier, Nestor 1879–1957, *The Rock Garden at Culham Court (right wing)*, bequeathed by Lady Barber, 1933
Cambier, Nestor 1879–1957, *The Gardens at Culham Court*, bequeathed by Lady Barber, 1933
Cambier, Nestor 1879–1957, *Lady Barber (1869–1933)*, bequeathed by Lady Barber, 1933
Cambier, Nestor 1879–1957, *A Flower Piece*, bequeathed by Lady Barber, 1933
Cambier, Nestor 1879–1957, *An Interior at Culham Court*, bequeathed by Lady Barber, 1933
Cambier, Nestor 1879–1957, *Lady Barber (1869–1933)*, bequeathed by Lady Barber, 1933
Cambier, Nestor 1879–1957, *Lady Barber (1869–1933)*, bequeathed by Lady Barber, 1933
Cambier, Nestor 1879–1957, *Lady Barber (1869–1933)*, bequeathed by Lady Barber, 1933
Cambier, Nestor 1879–1957, *Lady Barber (1869–1933)*, bequeathed

by Lady Barber, 1933
Cambier, Nestor 1879–1957, *Lady Barber (1869–1933)*, bequeathed by Lady Barber, 1933
Cambier, Nestor 1879–1957, *Lady Barber (1869–1933)*, bequeathed by Lady Barber, 1933
Cambier, Nestor 1879–1957, *Lady Barber (1869–1933)*, bequeathed by Lady Barber, 1933
Cambier, Nestor 1879–1957, *Lady Barber (1869–1933)*, bequeathed by Lady Barber, 1933
Cambier, Nestor 1879–1957, *Lady Barber (1869–1933)*, bequeathed by Lady Barber, 1933
Cambier, Nestor 1879–1957, *Lady Barber (1869–1933)*, bequeathed by Lady Barber, 1933
Cambier, Nestor 1879–1957, *Lady Barber (1869–1933)*, bequeathed by Lady Barber, 1933
Cambier, Nestor 1879–1957, *Lady Barber (1869–1933)*, bequeathed by Lady Barber, 1933
Cambier, Nestor 1879–1957, *Portrait of an Unidentified Widow*, bequeathed by Lady Barber, 1933
Canaletto 1697–1768, *The Loggetta, Venice*, purchased, 1954
Cappelle, Jan van de 1626–1679, *Boats on Ruffled Water*, purchased, 1943
Castello, Valerio 1624–1659, *The Madonna and Child with Saints Peter and Paul Appearing to St Bruno*, purchased, 1961
Castiglione, Giovanni Benedetto 1609–1664, *Rebecca Led by the Servant of Abraham*, purchased, 1967
Cavallino, Bernardo 1616/1622–1654/1656, *St Catherine of Alexandria*, purchased, 1965
Cesari, Giuseppe 1568–1640, *St Lawrence among the Poor and Sick*, purchased, 1988
Champaigne, Philippe de 1602–1674, *The Vision of St Juliana of Mont Cornillon*, purchased, 1963
Cima da Conegliano, Giovanni Battista c.1459–1517, *Christ on the Cross with the Virgin and St John the Evangelist*, purchased, 1938
Constable, John (imitator of) 1776–1837, *The Glebe Farm*, purchased, 1940
Corot, Jean-Baptiste-Camille 1796–1875, *Landscape with Distant Mountains*, purchased, 1970
Corot, Jean-Baptiste-Camille (attributed to) 1796–1875, *Wooded Landscape with a Pond*, purchased, 1940
Courbet, Gustave 1819–1877, *The Sea Arch at Étretat*, purchased, 1947
Crespi, Giuseppe Maria 1665–1747, *The Flea*, purchased, 1965
Crome, John 1768–1821 &
Crome, John Berney 1794–1842 *A View near Harwich*, purchased,

1939

Cuyp, Aelbert 1620–1691, *Huntsmen Halted*, purchased, 1959

Dahl, Johan Christian Clausen 1788–1857, *Mother and Child by the Sea*, purchased with the assistance of the Heritage Lottery Fund, the National Art Collections Fund, the Resource/Victoria & Albert Museum Purchase Grant Fund and the R. D. Turner Charitable Trust, 2002

Daubigny, Charles-François 1817–1878, *Seascape*, purchased, 1972

Dedreux, Alfred 1810–1860, *A Horse in a Landscape*, purchased, 1954

Degas, Edgar 1834–1917, *Jockeys before the Race*, purchased, 1950

Delacroix, Eugène 1798–1863, *St Stephen Borne away by His Disciples*, purchased, 1962

Denis, Maurice 1870–1943, *Monsieur Huc*, purchased, 1987, © ADAGP, Paris and DACS, London 2008

Derain, André 1880–1954, *Bartolomeo Savona*, purchased with the assistance of the Heritage Lottery Fund and the National Art Collections Fund, 1997, © ADAGP, Paris and DACS, London 2008

Dosso, Dossi c.1486–1542, *Scenes from the Aeneid: The Sicilian Games*, purchased, 1964

Dughet, Gaspard 1615–1675, *Classical Landscape with Figures*, purchased, 1969

Dujardin, Karel 1626–1678, *Pastoral Landscape*, purchased, 1967

Dusart, Cornelis 1660–1704, *The Milk Seller*, purchased, 1949

Dyck, Anthony van 1599–1641, *Ecce Homo*, purchased, 1954

Dyck, Anthony van 1599–1641, *François Langlois (1589–1647)*, purchased with the National Gallery, London, with financial assistance from the Heritage Lottery Fund, 1997

Dyck, Anthony van (after) 1599–1641, *James Stuart (1612–1655), 4th Duke of Lennox*, bequeathed by Lady Barber, 1933

Fearnley, Thomas 1802–1842, *Ramsau*, purchased in memory of G. J. Brooks with the assistance of the Friends of the Barber Institute and private subscriptions, 2005

Fetti, Domenico c.1589–1623, *The Blind Leading the Blind*, purchased, 1949

Flinck, Govaert 1615–1660, *Portrait of a Boy*, purchased, 1940

Gainsborough, Thomas 1727–1788, *The Harvest Wagon*, purchased, 1946

Gainsborough, Thomas 1727–1788, *Giusto Ferdinando Tenducci (1734–1790)*, purchased, 1944

Gainsborough, Thomas 1727–1788, *The Honourable Harriott Marsham (1721–1796)*, purchased, 1946

Gauguin, Paul 1848–1903, *Bathers in Tahiti*, purchased, 1949

Gauguin, Paul (attributed to) 1848–1903, *Landscape at Pont-Aven*, purchased, 1948

Gelder, Aert de 1645–1727, *Ahasuerus and Haman*, purchased, 1947

Gogh, Vincent van 1853–1890, *A Peasant Woman Digging*, purchased, 1961

Gossaert, Jan c.1478–1532, *Hercules and Deianira*, purchased, 1946

Goyen, Jan van 1596–1656, *Landscape in the Dunes*, purchased, 1959

Grebber, Pieter Fransz. de (attributed to) c.1600–c.1653, *The Angel Appearing to Anna*, purchased, 1951

Guardi, Francesco 1712–1793, *A Regatta on the Grand Canal, Venice*, purchased, 1941

Hals, Frans c.1581–1666, *Portrait of a Man Holding a Skull*, purchased, 1938

Heem, Jan Davidsz. de 1606–1683/1684, *Still Life with a Nautilus Cup*, purchased, 1941

Hondecoeter, Melchior de 1636–1695, *A Hen with Chicks, a Rooster and Pigeons in a Landscape*, purchased with the assistance of the Resource/Victoria & Albert Museum Purchase Grant Fund, 2001

Hone, Nathaniel I 1718–1784, *Charles Lee Lewes (1740–1803)*, purchased, 1959

Ingres, Jean-Auguste-Dominique 1780–1867, *Paolo and Francesca*, purchased, 1954

Italian School late 13th C, *The Crucifixion*, purchased, 1939

Italian School *Madonna and Child Enthroned* (centre panel), *St John the Baptist* (left wing) *with the Angel of the Annunciation* (above), *St Mary Magdalene* (right wing) *with* (above) *the Madonna Annunciate* (recto), purchased, 1960

Italian School *St Dominic* (left wing) *and an Unidentified Female Saint* (right wing) (verso), purchased, 1960

John, Gwen 1876–1939, *Mère Poussepin (1653–1744)*, purchased, 1976, © estate of Gwen John/DACS 2008

Lancret, Nicolas 1690–1743, *Lovers in a Landscape*, purchased, 1937

Lawrence, Thomas 1769–1830, *Portrait of a Lady*, purchased, 1958

Le Nain, Mathieu (follower of) 1607–1677, *The Gamesters*, purchased, 1941

Le Sueur, Eustache 1616–1655, *Solomon and the Queen of Sheba*, purchased, 1958

Léger, Fernand 1881–1955, *Composition with Fruit*, purchased, 1985, © ADAGP, Paris and DACS, London 2008

Lorenzo di Bicci c.1350–1427, *St Romuald*, purchased, 1950

Lorrain, Claude 1604–1682, *Pastoral Landscape*, purchased, 1953

Maes, Nicolaes 1634–1693, *Portrait of a Lady*, purchased, 1944

Magritte, René 1898–1967, *The Flavour of Tears*, purchased, 1983, © ADAGP, Paris and DACS, London 2008

Mancini, Antonio 1852–1930, *The Peacock Feather*, bequeathed by Lady Barber, 1933

Manet, Édouard 1832–1883, *Carolus-Duran (1838–1917)*, purchased, 1958

Martini, Simone c.1284–1344, *St John the Evangelist*, purchased, 1938

Massys, Quinten 1466–1530, *Portrait of an Ecclesiastic*, purchased, 1943

Master of the Griselda Legend active late 15th-early 16th C, *Alexander the Great (356–323 BC)*, purchased, 1951

Master of the Judgement of Paris active mid-15th C, *Daphne Pursued by Apollo*, purchased, 1950

Master of the Judgement of Paris active mid-15th C, *The Metamorphosis of Daphne*, purchased, 1950

Master of the Saint Ursula Legend active c.1485–1515, *Christ on the Cross, with a Donor*, purchased, 1960

Matteo di Giovanni c.1430–1495, *Madonna and Child with St John the Baptist and St Michael the Archangel*, purchased, 1944

Mazzoni, Sebastiano c.1611–1678, *The Three Fates*, purchased, 1990

Miel, Jan 1599–1663, *The Arch of Constantine, Rome*, purchased, 1969

Millet, Jean-François 1814–1875, *A Milkmaid*, purchased, 1977

Molijn, Pieter de 1595–1661, *Landscape with a Huntsman*, purchased, 1952

Monet, Claude 1840–1926, *The Church at Varengeville*, purchased, 1938

Murillo, Bartolomé Esteban 1618–1682, *The Marriage Feast at Cana*, purchased, 1947

Neri di Bicci 1418–1492, *St John the Baptist Leaving for the Desert*, purchased, 1950

Netherlandish School *The Deposition* (centre panel), *Adam and Eve Mourning Abel* (left wing), *Joseph's Coat Shown to Jacob* (right wing) (recto), purchased, 1960

Netherlandish School *St Veronica* (left wing), *St Helena* (right wing) (verso), purchased, 1960

Orchardson, William Quiller 1832–1910, *Lady Orchardson (1854–1917)*, purchased, 1939

Pellegrini, Giovanni Antonio 1675–1741, *Judith and Her Maidservant with the Head of Holofernes*, purchased, 1974

Pissarro, Camille 1831–1903, *The Pond at Montfoucault*, purchased, 1955

Poussin, Nicolas 1594–1665, *Tancred and Erminia*, purchased, 1938

Preti, Mattia 1613–1699, *The Martyrdom of St Peter*, purchased, 1971

Puvis de Chavannes, Pierre 1824–1898, *The Beheading of St John the Baptist*, purchased, 1956

Redon, Odilon 1840–1916, *The Crucifixion*, purchased, 1981

Rembrandt van Rijn (follower of) 1606–1669, *An Old Warrior*, purchased, 1941

Renoir, Pierre-Auguste 1841–1919, *Young Woman Seated*, accepted in lieu of inheritance tax by H. M. Government and allocated to the Barber Institute, 1984

Reynolds, Joshua 1723–1792, *Portrait of a Young Man*, purchased, 1969

Reynolds, Joshua 1723–1792, *The Reverend William Beele (1704–1757)*, purchased, 1970

Reynolds, Joshua 1723–1792, *Richard Robinson (1709–1794), DD*, purchased, 1943

Ricci, Sebastiano 1659–1734, *Allegorical Tomb of the 1st Duke of Devonshire*, purchased, 1958

Robert, Hubert 1733–1808, *A Caprice with a Hermitage*, purchased, 1964

Romney, George 1734–1802, *John Smith (1703–1787)*, purchased, 1952

Rosselli, Cosimo 1439–1507, *The Adoration of the Child Jesus*, purchased, 1965

Rossetti, Dante Gabriel 1828–1882, *The Blue Bower*, purchased, 1959

Rousseau, Théodore 1812–1867, *Landscape in the Auvergne*, purchased, 1960

Rubens, Peter Paul 1577–1640, *Portrait of a Carmelite Prior*, purchased with the assistance of the National Art Collections Fund and the Friends of the Barber Institute, 1999

Rubens, Peter Paul 1577–1640, *Landscape in Flanders*, purchased, 1940

Rubens, Peter Paul (follower of) 1577–1640, *Head of a Young Woman*, purchased, 1950

Ruisdael, Jacob van 1628/1629–1682, *A Woodland Landscape*, purchased, 1938

Sarto, Andrea del (after) 1486–1530, *The Madonna and Child with the Infant St John*, purchased, 1946

Shannon, James Jebusa 1862–1923, *Lady Barber Seated with Yorkshire Terriers in the Music Room at Culham Court*, bequeathed by Lady Barber, 1933

Shannon, James Jebusa 1862–1923, *Lady Barber in a Landscape*, bequeathed by Lady Barber, 1933

Sickert, Walter Richard 1860–1942, *The Eldorado, Paris*, purchased, 1968, © estate of Walter R. Sickert/DACS 2008

Signorelli, Luca c.1450–1523, *Niccolò Vitelli (1414–1486)*, purchased, 1945

Solimena, Francesco 1657–1747, *The Holy Trinity with the Madonna and Saints*, purchased, 1967

Spanish School 19th C, *Portrait of an Old Woman*, purchased, 1940

Steen, Jan 1626–1679, *The Wrath of Ahasuerus*, purchased, 1948

Stom, Matthias c.1600–after 1650, *Isaac Blessing Jacob*, purchased with the assistance of the National Art Collections Fund and the Museums and Galleries Commission/Victoria & Albert Museum Purchase Grant Fund, 1994

Strozzi, Bernardo 1581–1644, *Head of an Old Woman*, purchased, 1966

Teniers, David II 1610–1690, *The Bleaching Ground*, purchased, 1947

Tintoretto, Jacopo 1519–1594, *Portrait of a Young Man*, purchased, 1937

Toulouse-Lautrec, Henri de 1864–1901, *A Woman Seated in the Garden*, purchased, 1948

Troy, Jean François de 1679–1752, *Jason Taming the Bulls of Aeëtes*, purchased, 1961

Turner, Joseph Mallord William 1775–1851, *The Sun Rising through Vapour*, purchased, 1938

Ugolino di Nerio c.1300–1339/1349, *St Francis of Assisi*, purchased, 1943

Velázquez, Diego (after) 1599–1660, *Queen Mariana of Spain (1634–1696)*, bequeathed by Lady Barber, 1933

Veronese, Paolo 1528–1588, *The Visitation*, purchased, 1953

Vigée-LeBrun, Elisabeth Louise 1755–1842, *Countess Golovine (1766–1821)*, purchased, 1980

Vliet, Hendrick Cornelisz. van c.1611–1675, *A Grotto in an Imaginary Landscape*, purchased, 1966

Vuillard, Jean Edouard 1868–1940, *Madame Vuillard Arranging Her Hair*, purchased, 1963, © ADAGP, Paris and DACS, London 2008

Watteau, Jean-Antoine (attributed to) 1684–1721, *A Man Playing a Hurdy-Gurdy*, purchased, 1956

Whistler, James Abbott McNeill 1834–1903, *Symphony in White, No.III*, purchased, 1939

Wilson, Richard 1713/1714–1782, *The River Dee, near Eaton Hall*, purchased, 1937

Witte, Emanuel de c.1617–1692, *Interior of the Oude Kerk, Amsterdam*, purchased, 1974

Zurbarán, Francisco de (studio of) 1598–1664, *St Marina*, purchased, 1952

University of Birmingham

Aldridge, John Arthur Malcolm 1905–1983, *Villafranca di Verona*, gift from the Chantrey Bequest, 2001

Bod, Laszlo b.1920, *Cello Player*, purchased

Bod, Laszlo b.1920, *Dormant Cello*, on loan from a private individual

bequeathed by Rudolf Sauter, 1977
Sauter, Georg 1866–1937, *(Blanche) Lilian Sauter (b.1897)*, bequeathed by Rudolf Sauter, 1977
Sauter, Georg 1866–1937, *(Blanche) Lilian Sauter (b.1897)*, bequeathed by Rudolf Sauter, 1977
Sauter, Rudolf Helmut 1895–1977, *John Galsworthy (1867–1933)*, bequeathed by the artist, 1977
Sauter, Rudolf Helmut 1895–1977, *John Galsworthy (1867–1933)*, bequeathed by the artist, 1977
Sauter, Rudolf Helmut 1895–1977, *Ada Galsworthy (1893–1933)*, bequeathed by the artist, 1977
Sauter, Rudolf Helmut 1895–1977, *Ada Galsworthy (1893–1933)*, bequeathed by the artist, 1977
Sauter, Rudolf Helmut 1895–1977, *Lilian Sauter (b.1897)*, bequeathed by the artist, 1977
Sauter, Rudolf Helmut 1895–1977, *Lilian Sauter (Pax) (b.1897)*, bequeathed by the artist, 1977
Serres, Dominic (attributed to) 1722–1793, *William Sands*, gift
Shaw, Byam 1872–1919, *Margaret Nettlefold before Her Dining Room at Winterbourne*, gift from the Nettlefold family
Slade, Roy b.1933, *Mount*, purchased, © the artist
Slade, Roy b.1933, *Ness*, purchased, © the artist
Smith, Stan 1929–2001, *Light Splash*, gift from the Chantrey Bequest, 2001, © the artist's estate/ www.bridgeman.co.uk
Spear, Ruskin 1911–1990, *Sir Robert Aitken (1901–1997), Vice-Chancellor*, commissioned, 1968, © the artist's estate/www.bridgeman. co.uk
Thomasos, Denyse b.1964, *Ice*, on loan from a private individual
Todd, Arthur Ralph Middleton 1891–1966, *Edmund Phipson Beale (1872–1952), Pro-Chancellor*, commissioned, 1947, © the artist's estate
Todd, Arthur Ralph Middleton 1891–1966, *Sir Raymond Priestley (1886–1974), Vice-Chancellor*, commissioned, 1954, © the artist's estate
Townsend, Kathleen active 1965–1968, *Alexander B. MacGregor*, commissioned, 1965
Ugbodaga, Clara b.c.1935, *Abstract*, bequeathed by H. A. Lidderdale, 1992
unknown artist mid-20th C, *Woman's Head*, purchased
Vesely, Susan b.1953, *Surface*, purchased, © the artist
Wade, Maurice 1917–1997, *Barnfield Gardens*, gift from Professor R. Smith, 1993, © the artist's estate
Walker, John b.1939, *Anguish*, on loan from a private individual, © the artist
Walker, John b.1939, *The Blue Cloud* (polyptych, panel 1 of 15), commissioned, © the artist
Walker, John b.1939, *The Blue Cloud* (polyptych, panel 2 of 15),

commissioned, © the artist
Walker, John b.1939, *The Blue Cloud* (polyptych, panel 3 of 15), commissioned, © the artist
Walker, John b.1939, *The Blue Cloud* (polyptych, panel 4 of 15), commissioned, © the artist
Walker, John b.1939, *The Blue Cloud* (polyptych, panel 5 of 15), commissioned, © the artist
Walker, John b.1939, *The Blue Cloud* (polyptych, panel 6 of 15), commissioned, © the artist
Walker, John b.1939, *The Blue Cloud* (polyptych, panel 7 of 15), commissioned, © the artist
Walker, John b.1939, *The Blue Cloud* (polyptych, panel 8 of 15), commissioned, © the artist
Walker, John b.1939, *The Blue Cloud* (polyptych, panel 9 of 15), commissioned, © the artist
Walker, John b.1939, *The Blue Cloud* (polyptych, panel 10 of 15), commissioned, © the artist
Walker, John b.1939, *The Blue Cloud* (polyptych, panel 11 of 15), commissioned, © the artist
Walker, John b.1939, *The Blue Cloud* (polyptych, panel 12 of 15), commissioned, © the artist
Walker, John b.1939, *The Blue Cloud* (polyptych, panel 13 of 15), commissioned, © the artist
Walker, John b.1939, *The Blue Cloud* (polyptych, panel of 14 of 15), commissioned, © the artist
Walker, John b.1939, *The Blue Cloud* (polyptych, panel 15 of 15), commissioned, © the artist
Warsop, Mary b.1929, *Emergent Shapes*, purchased
Watt, George Fiddes 1873–1960, *Sir Gilbert Barling (1855–1940), Pro-Chancellor, CB, CBE, FRCS*, commissioned, 1924
West, Waldron *Humphrey F. Humphreys, Vice-Chancellor*, commissioned, 1953
Wood, Tom b.1955, *Sir Michael Thompson, Vice-Chancellor*, commissioned, 1996, © the artist
Yates, Frederic 1854–1919, *Ernest de Selincourt (1870–1943), Professor of English*, gift from the sitter

Warwickshire County Cricket Club Museum

unknown artist *View of the Pavilion, the County Ground*, gift, 1950s
unknown artist *View from the Pavilion, the County Ground*, gift, 1950s

West Midlands Fire Service Headquarters

Ashby, J. B. *Coventry Fire Station*, gift from the artist to the Central Fire Station

West Midlands Police Museum

Ball, Robert b.1918, *Elmsley Lodge, Harborne, Home of Sir Charles Rafter, Late Chief Constable*, unknown provenance
Cuneo, Terence Tenison 1907–1996, *On the Brighton Road*, on loan from West Midlands Police Museum, c.1999, © reproduced with kind permission of the Cuneo estate
Cuneo, Terence Tenison 1907–1996, *Veteran Crossing a French Railway*, on loan from West Midlands Police Museum, c.1999, © reproduced with kind permission of the Cuneo estate
Edwards, John *A Different Ball Game*, transferred from the police force
Miles, W. A. *Mrs Evelyn Miles (d.1954)*, gift from the artist, daughter of the sitter
Westwood (Sergeant) (attributed to) *The Duke of Wellington (1769–1852)* (copy after Franciso de Goya), unknown provenance
unknown artist *Charles Horton Rafter, Chief Constable of Birmingham (1899–1937)*, commissioned by officers and men of Birmingham City Police, c.1923, transferred from the police force

Facing page: Shaw, Byam, 1872–1919, *Margaret Nettlefold before Her Dining Room at Winterboune* (detail), 1904, University of Birmingham, (p. 259)

288

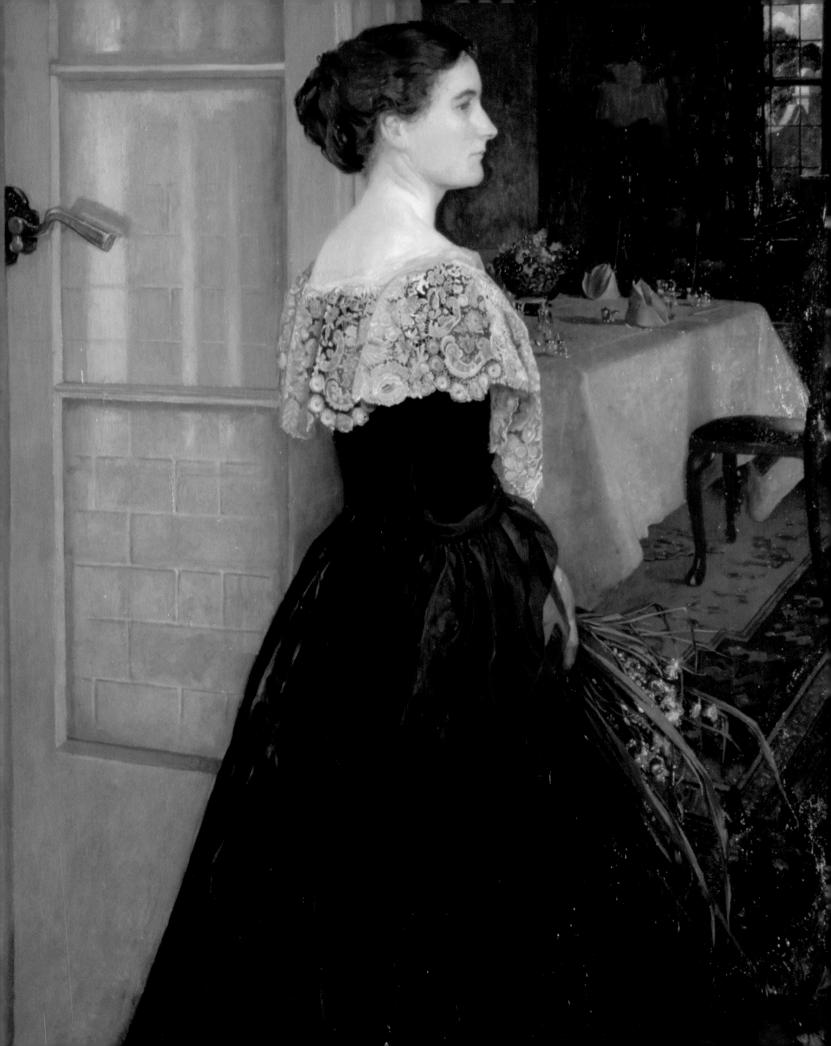

Collection Addresses

Aston University
Aston Triangle, Birmingham B4 7ET
Telephone 0121 204 3000

Birmingham and Midland Institute
Margaret Street, Birmingham B3 3BS
Telephone 0121 236 3591

Birmingham Central Library
Chamberlain Square, Birmingham B3 3HQ
Telephone 0121 303 4511

Birmingham City University

Birmingham City University
Perry Barr, Birmingham B42 2SU
Telephone 0121 331 5595

> Birmingham Conservatoire
> Birmingham City University, Paradise Place
> Birmingham B3 3HG
> Telephone 0121 331 5901/2

> Birmingham Institute of Art and Design
> Gosta Green, Corporation Street
> Birmingham B4 7DX
> Telephone 0121 331 5800/1

> City North Campus
> Perry Barr, Birmingham B42 2SU
> Telephone 0121 331 5595

> Edgbaston Campus
> Westbourne Road, Edgbaston
> Birmingham B15 3TN

> New Technology Institute
> 15 Bartholomew Row, Birmingham B5 5JU
> Telephone 0121 202 4800

> School of Art
> Margaret Street, Birmingham B3 3DX
> Telephone 0121 331 5970

> Technology Innovation Centre
> Millennium Point, Curzon Street
> Birmingham B4 7XG
> Telephone 0121 331 5400

Birmingham Museums and Art Gallery

Birmingham Museums and Art Gallery
Chamberlain Square, Birmingham B3 3DH
Telephone 0121 303 2834

> Assay Office
> Newhall Street, Birmingham B3 1SB
> Telephone 0121 236 6951

> Aston Hall
> Trinity Road, Aston
> Birmingham B6 6JD
> Telephone 0121 327 0062

> Blakesley Hall
> Blakesley Road, Yardley
> Birmingham B25 8RN
> Telephone 0121 464 2193

> Council House
> Birmingham City Council, Victoria Square
> Birmingham B1 1BB
> Telephone 0121 303 9944

> Hagley Hall
> Hagley, Worcestershire DY9 9LG
> For all enquiries contact Joyce Purnell
> Telephone 01562 885823/882408

> Highbury Hall
> 4 Yew Tree Road, Moseley
> Birmingham B13 8QG
> Telephone 0121 449 6549

> Museum of the Jewellery Quarter
> 75–79 Vyse Street, Hockley
> Birmingham B18 6HA
> Telephone 121 554 3598

> Sarehole Mill
> Cole Bank Road, Hall Green
> Birmingham B13 0BD
> Telephone 121 777 6612

> Soho House
> Soho Avenue, Handsworth
> Birmingham B18 5LB
> Telephone 0121 554 9122

City of Birmingham Symphony Orchestra Centre
Berkley Street, Birmingham B1 2LF
Telephone 0121 616 6500

Royal Birmingham Society of Artists
4 Brook Street, St Paul's, Birmingham B3 1SA
Telephone 0121 236 4353

The Barber Institute of Fine Arts
University of Birmingham, Edgbaston
Birmingham B15 2TS
Telephone 0121 414 7333

University of Birmingham

University of Birmingham
Edgbaston, Birmingham B15 2TT
Telephone 0121 414 3344

Danford Collection of Art and West African
Artefacts
Centre for West African Studies
School of Historical Studies
University of Birmingham, Edgbaston
Birmingham B15 2TT
Telephone 0121 414 3228

Lapworth Museum of Geology
University of Birmingham, Edgbaston
Birmingham B15 2TT
Telephone 0121 414 7294/6751

School of Dentistry
University of Birmingham, St Chad's Queensway
Birmingham B4 6NN
Telephone 0121 236 8611

Shakespeare Institute
Mason Croft, Church Street
Stratford-upon-Avon, Warwickshire CV37 6HP
Telephone 0121 414 9500

Winterbourne Botanical Garden
University of Birmingham
58 Edgbaston Park Road, Birmingham B15 2RT
Telephone 0121 414 3832

Warwickshire County Cricket Club Museum
The County Ground, Edgbaston Road
Edgbaston, Birmingham B5 7QU
Telephone 0121 446 4422

West Midlands Fire Service Headquarters
Lancaster Circus, Queensway, Birmingham B4 7DE
Telephone 0121 359 5161

West Midlands Police Museum

West Midlands Police Museum
Sparkhill Police Station, 639 Stratford Road
Sparkhill, Birmingham B11 4EA
Telephone 0845 113 5000

Coventry Transport Museum
Hales Street Coventry CV1 1JD
Telephone 02476 234270

Index of Artists

In this catalogue, artists' names and the spelling of their names follow the preferred presentation of the name in the Getty Union List of Artist Names (ULAN) as of February 2004, if the artist is listed in ULAN.

The page numbers next to each artist's name below direct readers to paintings that are by the artist; are attributed to the artist; or, in a few cases, are more loosely related to the artist being, for example, 'after', 'the circle of' or copies of a painting by the artist. The precise relationship between the artist and the painting is listed in the catalogue.

Supporters of the Public Catalogue Foundation

Master Patrons

The Public Catalogue Foundation is greatly indebted to the following Master Patrons who have helped it in the past or are currently working with it to raise funds for the publication of their county catalogues. All of them have given freely of their time and have made an enormous contribution to the work of the Foundation.

Peter Andreae *(Hampshire)*
Sir Henry Aubrey-Fletcher, Bt, Lord Lieutenant of Buckinghamshire *(Berkshire and Buckinghamshire)*
Sir Nicholas Bacon, DL, High Sheriff of Norfolk *(Norfolk)*
Peter Bretherton *(West Yorkshire: Leeds)*
Richard Compton *(North Yorkshire)*
George Courtauld, DL, Vice Lord Lieutenant of Essex *(Essex)*
The Marquess of Downshire *(North Yorkshire)*
Jenny Farr, MBE, DL, Vice Lord Lieutenant of Nottinghamshire *(Nottinghamshire)*

Mark Fisher, MP *(Staffordshire)*
Patricia Grayburn, MBE DL *(Surrey)*
The Lady Mary Holborow, Lord Lieutenant of Cornwall *(Cornwall)*
Tommy Jowitt *(West Yorkshire)*
Sir Michael Lickiss *(Cornwall)*
Lord Marlesford, DL *(Suffolk)*
The Most Hon. The Marquess of Salisbury, PC, DL *(Hertfordshire)*
Malcolm Pearce *(Somerset)*
Julia Somerville *(Government Art Collection)*
Phyllida Stewart-Roberts, OBE, Lord Lieutenant of East Sussex *(East Sussex)*
Leslie Weller, DL *(West Sussex)*

The Public Catalogue Foundation is particularly grateful to the following organisations and individuals who have given it generous financial support since the project started in 2003.

National Sponsor

Christie's

Benefactors (£10,000–£50,000)

The 29th May 1961 Charitable Trust
City of Bradford Metropolitan District Council
Deborah Loeb Brice Foundation
The Bulldog Trust
A.& S. Burton 1960 Charitable Trust
Christie's
The John S. Cohen Foundation
Covent Garden London
Department for Culture, Media and Sport
Sir Harry Djanogly, CBE
Mr Lloyd Dorfman
Fenwick Ltd
The Foyle Foundation

Hampshire County Council
The Charles Hayward Foundation
Peter Harrison Foundation
Hiscox plc
David Hockney CH, RA
ICAP plc
Kent County Council
The Linbury Trust
The Manifold Trust
Robert Warren Miller
The Monument Trust
Miles Morland
National Gallery Trust
Stavros S. Niarchos Foundation
Norfolk County Council

De La Rue Charitable Trust
Mr Robert Dean
Deborah Gage (Works of Art) Ltd
J. N. Derbyshire Trust
The Duke of Devonshire's Charitable
 Trust
Sir Harry Djanogly, CBE
Marquess of Douro
Professor Patrick & Dr Grace
 Dowling
Dunn Family Charitable Trust
East Sussex County Council
Eastbourne Borough Council
EEMLAC, through the Association
 for Suffolk Museums
Lord & Lady Egremont
Sir John & Lady Elliott
Andrew & Lucy Ellis
Essex County Council
Mrs Jenny Farr
John Feeney Charitable Trust
Marc Fitch Fund
Elizabeth & Val Fleming
The Follett Trust
Christopher & Catherine Foyle
The Friends of Historic Essex
The Friends of the Royal Pavilion,
 Art Gallery & Museums, Brighton
The Friends of Southampton's
 Museums, Archives and Galleries
The Friends of York Art Gallery (E. J.
 Swift Bequest)
Lewis & Jacqueline Golden
Gorringes
Charles Gregson
The Gulland Family
David Gurney
Philip Gwyn
Sir Ernest Hall
The Hartnett Charitable Trust
Hazlitt, Gooden & Fox Ltd
Heartwood Wealth Management Ltd
The Lady Hind Trust
Hobart Charitable Trust
David Hockney CH, RA
Patrick Holden & Lin Hinds
David & Prue Hopkinson
Isle of Wight Council
The J. and S. B. Charitable Trust
Alan & Penny Jerome
Tommy Jowitt
The Keatley Trust
Kent Messenger Group
Kirklees Council

Garrett Kirk, Jr
Friends of the Laing Art Gallery
Lord Lea of Crondall OBE
The Leche Trust
Leeds Art Collections Fund
Leeds City Council
Leeds Philosophical and Literary
 Society
Mark & Sophie Lewisohn
Tom Lugg & the Lane Family
The Orr Mackintosh Foundation
Maidstone Borough Council
The Marlay Group
Marshall Charitable Trust
The Piet Mendels Foundation
The Mercers' Company
MLA East of England
MLA North East of England
Mr Paul Myners
Rupert Nabarro
Newcastle City Council
Bryan Norman
Oakmoor Trust
The Orr Mackintosh Foundation
The Owen Family Trust
Sir Idris Pearce
The Pennycress Trust
Mrs Margaret Pollett
The Portland Family
Portsmouth City Council
Provident Financial plc
Mr John Rank
Rathbone Investment Management
 Ltd
The Hans and Märit Rausing
 Charitable Trust
Roger & Jane Reed
Renaissance North East
Renaissance South East
Renaissance South West
Michael Renshall, CBE MA FCA
Sir Miles & Lady Rivett-Carnac
Rothschild Foundation
Royal Cornwall Museum
Russell New
Scarfe Charitable Trust
Shaftesbury PLC
The Shears Foundation
Smith & Williamson
South West of England Regional
 Development Agency
Caroline M. Southall
Stuart M. Southall
Southampton City Council